To Emily
Enjoy reading
Love Sharon.

CW01024764

THE RENAISSANCE PALACE IN FLORENCE

For my wife Rebecca
our baby Jacob
and my parents Andrea and Peter

The Renaissance Palace in Florence

Magnificence and Splendour in Fifteenth-Century Italy

James R. Lindow

ASHGATE

Published by
Ashgate Publishing Limited
Gower House
Croft Road
Aldershot
Hampshire GU11 3HR
England

Ashgate Publishing Company
Suite 420
101 Cherry Street
Burlington, VT 05401-4405
USA

Ashgate website: http://www.ashgate.com

British Library Cataloguing in Publication Data
Lindow, James R.
 The Renaissance palace in Florence : magnificence and
 splendour in fifteenth-century Italy
 1. Palaces - Italy - Florence 2. Architecture, Renaissance
 - Italy - Florence 3. Florence (Italy) - Civilization
 I. Title
 728.8'2'094551

Library of Congress Cataloging-in-Publication Data
Lindow, James R.
 The Renaissance palace in Florence : magnificence and splendour in fifteenth-
 century Italy / James R. Lindow.
 p. cm.
 Includes bibliographical references and index.
 ISBN 978-0-7546-6092-7 (hardcover : alk. paper)
 1. Palaces--Italy--Florence. 2. Architecture, Renaissance--Italy--Florence.
 3. Florence (Italy)--Civilization--15th century. I. Title.

NA7756.F487L56 2007
728.8'2094551--dc22
 2006103258

ISBN 978-0-7546-6092-7

Printed and bound in Great Britain by MPG Books Ltd, Bodmin, Cornwall.

Contents

List of illustrations

Colour plates

1. Janos Argyropoulos' Aristotle, Latin translation including the *Ethica Nicomachea, c.* 1473–8, fol. 2r. On parchment, 380 × 268mm. Made for Lorenzo de' Medici and illuminated by Francesco Rosselli, the border includes classical motifs with simulated cameos of Roman emperors. Argyropoulos' portrait introduces the text, while Cosimo de' Medici appears centre right with his son Piero bottom centre. Biblioteca Medicea Laurenziana, Florence. © Photo SCALA, Florence – courtesy of the Ministero Beni e Att. Culturali.

2. Palazzo Medici, Florence. Interior view of chapel. © Photo SCALA, Florence – courtesy of the Ministero Beni e Att. Culturali.

3. Workshop of Apollonio di Giovanni, *forziere, c.* 1475. The gilding, lid and feet of a later date. Carved and gilt walnut, painted in tempera. V&A Images/Victoria & Albert Museum (7852–1862), London.

4. Giovanni Stradano, *Joust of the Saracen in Via Larga*, 1540s.

Apartment of Eleonora, Sala di Gualdrada, Palazzo Vecchio, Florence. © Photo SCALA, Florence.

5. Workshop of Domenico Ghirlandaio, fresco in the oratory San Martino del Vescovo, Florence. Late fifteenth century. Photo by the author.

6. Domenico Ghirlandaio, *Adoration of the Magi*, 1487. Tempera on panel, diameter 171.5 cm. Galleria degli Uffizi (Inv 1619), Florence. © Photo SCALA – courtesy of the Ministero Beni e Att. Culturali.

7. Standing cup and cover with applied red, blue and green glass, enamelled and gilt decoration. Height: 24.5 cm. Venice, late fifteenth century. V&A Images/Victoria & Albert Museum (677&A–1884), London.

8. Two-handled maiolica vase with the *imprese* of Piero or Lorenzo de' Medici. Leaf design in lustre and cobalt blue. Valencia, Spain, *c.* 1465–92. Height: 57 cm. © The Trustees of the British Museum (Godman Bequest 619), London.

Illustrations

1497. MPAP 181 fol.141r, Archivio di Stato, Florence.

32. Maso Fineguerra, Drawing of *Susanna and the Elders, c.* 1460. © The Trustees of the British Museum, London.

33. 'The Davanzati bed'. Various woods, probably Florentine workshop. Previously considered to be fifteenth century but now re-attributed to the late nineteenth or early twentieth century. The Metropolitan Museum of Art, Gift of George R. Hann, 1965 (65.221.1) Image © The Metropolitan Museum of Art, New York.

34. *Lettuccio.* Inlaid and carved walnut. Late fifteenth century. 250 (length) × 85 (width) × 290 (height) cm. Museo Horne (Inv 6519), Florence. Photo by the author.

35. Antonio Tubini and workshop, woodcut from Savonarola's *Predica dell'arte del ben morire, il 2 novembre 1496.* Florence, c. 1496. © The British Library (IA.27321, fol.biv), London.

36. Francesco Granacci, *Scenes from the Life of Saint John the Baptist, c.* 1510. Oil tempera and gold on wood. 80 × 152.4 cm. The Metropolitan Museum of Art, Purchase, Gwynne Andrews, Harris Brisbane Dick, Dodge, Fletcher, and Rogers Funds, funds from various donors, Ella Morris de Peyster Gift, Mrs. Donald Oenslager Gift, and Gifts in Memory of Robert Lehman, 1970 (1970.134.1) Image © The Metropolitan Museum of Art, New York.

37. Circular footed brass bowl engraved and damascene with silver. Damascus, Syria, second half of the fifteenth century. Foot possibly shaped and decorated in Venice, the coat-of-arms of the Priuli family inside.

The handles are a nineteenth-century addition. Height: 22 cm Diameter: 30.7 cm. V&A Images/Victoria & Albert Museum (311–1854), London.

38. Marriage beaker in *lattimo* glass with enamelled and gilt decoration. Venice, late fifteenth century. 10.2 × 7.4 cm. © The Cleveland Museum of Art, Ohio, 2003. Purchase from the J.H. Wade Fund 1955.70.

39. Luca della Robbia, *Labours of the month (August) c.* 1450–56. One of 12 tin-glazed terracotta roundels from the ceiling of Piero de' Medici's *studietto.* Diameter: 59.7 cm. The borders are coloured dark and light blue to indicate the period of light and darkness. Each bears an inscription giving the number of daylight hours and the relevant sign of the zodiac. V&A/Victoria & Albert Museum (7639–1861), London.

40. Domenico Ghirlandaio *Birth of the Virgin c.* 1485, detail, bottom right section. *Cappella maggiore,* Santa Maria Novella, Florence. © Photo SCALA, Florence.

41. Jacopo del Sellaio, *Triumph of Love* and *Triumph of Chastity.* 75.5 × 89.5 cm and 76 × 86.5 cm. Museo Bandini, Fiesole. © Photo SCALA, Florence.

42. Palazzo della Stufa, Florence. Prominently located in Piazza San Lorenzo, the original fourteenth-century palace with its ground floor rustication and loggia on the upper storey, was greatly enlarged during the seventeenth century through the acquisition of adjoining properties. Photo by the author.

Preface

In quoting from published Latin or Italian sources I have generally used standard translations where these exist, specifying in the endnotes if I have made any alterations. As a general rule all Latin and vernacular terms listed in the main text of this book are cited as they appear in the original passage and not in their nominative form. This is intended to assist the reader in following the translation with the original text provided in the corresponding endnote as well as identifying key terms.

The transcriptions of the inventories or other unpublished archival sources are my own, except where I have acknowledged a particular individual in the footnotes. I have focused on providing as literal a record of the archival material as possible, and therefore only minimal punctuation has been added in order to give the reader a true sense of the original source. Similarly, transcriptions including names have been left in their original spelling, which often differs from modern Italian conventions. Damaged or illegible parts of documents are indicated by the use of square brackets ('[]'). Unless otherwise indicated all manuscript sources are from the Archivio di Stato, Florence. The abbreviation MPAP is used throughout the notes to represent *Magistrato dei Pupilli avanti il Principato*.

The Florentine monetary system during the fifteenth century was particularly complex. In its simplest terms it was based around two systems, the gold *fiorino* and the silver *lira*. The *lira* was strictly used as a money of account, and although its value varied during the period a broad standard is 1 *lira* = 20 *soldi* = 240 *denari*. Similarly complicated are the range of weights and measurements detailed in the inventories. The most common unit of measurement for length was the *braccio* (plural *braccia*), which was the equivalent to approximately 0.583 metres. For more detailed information on other weights and measurements detailed in the Appendices of this book, the reader is encouraged to consult M. Spallanzani and G.C. Bertelà eds., *Libro d'inventario dei beni di Lorenzo il Magnifico*. Florence (1992): pp.xiv–xvi.

I have incurred several debts in completing this book. The themes explored here evolved out of my doctoral thesis, completed at the joint institutions of the Royal College of Art and the Victoria & Albert Museum in 2004. I would especially like to thank Jaqueline Marie Musacchio and Patricia Allerston who acted as external examiners for my thesis and have continued to give friendship and support, as well as encouraging me to write this book. Alison Brown and Giorgia Mancini were especially gracious with their time during my early forays into the Florentine State Archives, discussing archival transcriptions and highlighting possible inaccuracies. Any omissions or transcription errors that remain are my own. The archival research in Florence was made possible through a six months research scholarship granted from the Italian Cultural Institute, and I am particularly grateful to Marco Spallanzani who served as my supervisor during this time.

I would also like to thank the following in whose company many of the ideas explored in this book were discussed: Marta Ajmar Wollheim, Frances Ames Lewis, Robert Black, Antonia Boström, Richard Cocke, Donal Cooper, Jonathan Foyle, Patricia Fortini Brown, Richard Goldthwaite, Rab Hatfield, Paul Hills, Mary Hollingsworth, Megan Holmes, Charles Hope, Maurice Howard, Benjamin Kohl, Jill Kraye, Reino Liefkes, Luca Molà, Peta Motture, Roberta Olson, John Onians, Debra Pincus, Brenda Preyer, Katrina Royall, Rupert Shepherd, John Styles, David Thomson, Rowan Watson, Evelyn Welch and Timothy Wilson. I also wish to express my gratitude to colleagues at AXA Art Insurance for their financial contribution towards the illustration costs. Finally, my editor Erika Gaffney and her colleagues at Ashgate Publishing have never wavered in their enthusiasm for this project, and I am deeply indebted to them.

By far the greatest contribution, however, has been the encouragement and support provided by my wife, Rebecca, and my parents Andrea and Peter. Their unending belief in me has been the true inspiration in enabling this book to be completed.

Introduction

> It is appropriate to join splendour (*splendor*) to magnificence (*magnificentiae*), because they both consist of great expense and have a common matter that is money. But magnificence (*magnificentia*) derives its name from the concept of grandeur and concerns building, spectacle and gifts while splendour (*splendor*) is primarily concerned with the ornament of the household (*ornamentis domesticis*), the care of the person, and with furnishings (*supelectile*) and in the display of different things.[1]
>
> Giovanni Pontano, *De splendore* (1498)

These words, written by the Neapolitan court theorist Giovanni Pontano (1428–1503), are fundamental to the subject of this book. The above passage appears in the first chapter of his text discussing the virtue of splendour. As Pontano makes clear, splendour is an entirely appropriate extension of magnificence into the domestic interior. While magnificence and splendour consist of major expense and financial outlay – where magnificence includes the concept of building, splendour is concerned with furnishings, decoration and display of the household.

Published in Naples in 1498, though possibly the result of a protracted period of writing dating back to the early 1470s, the edition consisted of five books on the related virtues of liberality, charity, magnificence, splendour and hospitality.[2] Each of the five virtues are concerned with the issue of appropriate financial expenditure. As such, Pontano demonstrates his debt to the writings of Aristotle (384–322 BC) and in particular the *Ethica Nicomachea*, where the virtues of liberality and magnificence had been discussed in some detail. Aristotle's *Ethica*, together with texts by Cicero such as *De Officiis*, proved the greatest influence on the Renaissance interpretation of the virtue of magnificence. In his discussion of magnificence, Aristotle had provided a model for the extension of magnificent display into the domestic interior when he stated: 'It is also characteristic of him to furnish his house in a way suitable to his wealth (because even this is a kind of public ornament)'.[3]

Though particularly refined, Pontano's discussion of magnificence and its related virtue of splendour should be interpreted within the wider fifteenth-century humanist tradition from which it evolved. Leonardo Bruni's *Laudatio florentinae urbis*, written in around 1403, was one of the first texts to make the linguistic connection between magnificence and splendour. In the *Laudatio*, these terms are listed both collectively and singularly to praise different aspects of the virtues possessed by Florence. In particular, Bruni is specific in repeatedly linking magnificence and splendour with the buildings and architecture of Florence, together with the important related theme of the collective impact the magnificent and splendid buildings of Florence have on visitors to the city:

> As soon as they have seen the city and inspected with their own eyes its great mass of architecture and the grandeur of its buildings, its magnificence (*magnificentia*) and splendour (*splendor*), the lofty towers, the marble churches, the domes of the basilicas, the most superb (*superbissimas*) palaces, the turreted walls and the numerous villas, its charm, brilliance (*nitorem*), and decor (*ornatum intuentur*), instantly everyone's mind and thought changes so that they are no longer amazed by the greatest and most important exploits accomplished by Florence![4]

The inter-relationship between magnificence and splendour is reinforced by the correlations that exist in the Latin meanings of these terms and the contexts of their classical usage. In Lewis and Short's Latin Dictionary, *magnificentia* is characterized by two principal definitions.[5] The first is applicable in a more general sense and comprises 'greatness in action or in sentiment, nobleness, distinction, eminence, high-mindedness, magnanimity'.[6] An example of this broader meaning of *magnificentia* can be found in Cicero's *De inventione* where in Book II, magnificence had been discussed as an attribute of fortitude (*fortitudo*) and was significantly connected with splendour: 'Magnificence consists in the contemplation and execution of great and sublime projects with a certain grandeur and splendid (*splendida*) imagination.'[7] The second definition is applicable when used in relation to inanimate property or possessions, such as Cicero's reference in *De Officiis* to the magnificent villas constructed by Lucius Lucullus,[8] and comprises: 'grandeur, magnificence, splendour, sumptuousness'.[9]

The term *splendor* is derived from the verb *splendeo* that means 'to shine, be bright; to gleam, glitter, glisten.'[10] Lewis and Short define *splendor* as 'sheen, brightness, brilliance, lustre, splendour'.[11] The general classical usage of the word appears in poetry and prose, as well as orations where it is used to praise the 'polished' or 'splendid' character of particular individuals or classes of citizens. In Cicero's oration in defence of Aulus Cluentius Habitus for example, reference had been made to the 'splendour (*splendore*) of the virtuous L. Volusienus',[12] as well as 'those who have estates, business

interests, or stock in the district of Larinum – all of them honourable men of great splendour (*splendore*).'[13] Similarly, in Cicero's oration of Lucius Valerius Flaccus, Hermippus is credited as 'a most honourable and upright man and an old friend of mine, the most splendid (*splendidissimum*) and distinguished man of his city.'[14] Importantly, the oration to Flaccus also provides an example of the second major definition for splendour qualified by Lewis and Short as applying to a particular 'style of living', synonymous with *magnificentia* and defined as 'splendour, magnificence, sumptuousness'.[15] In chapter 28, Cicero recounts how the decrees of the Senate stated:

The policy and high principles of our ancestors provided that, although in their private lives and personal expenditure they were content with very little and lived in an extremely frugal manner, yet glory and splendour (*gloriam splendoremque*) were their standards in government and in the grandeur of public life. In home life praise for self-restraint was the aim, in public life praise for impressiveness.[16]

The concept of magnificence has received increased attention since Ernst Gombrich first discussed the term in 1960.[17] His discussion of magnificence focused on the architectural patronage of Cosimo de' Medici and in particular the text written in around 1454 by Timoteo Maffei, rector of the Badia at Fiesole.[18] Fraser Jenkins later examined Maffei's text in greater detail when he argued for the consideration of a complex 'theory of magnificence'.[19] The contemporary theory of magnificence had its origins in classical literature, but was reworked in a number of theoretical texts to apply more closely to the needs of wealthy Florentine patrons. Maffei shows himself to be well versed in both the classical arguments of magnificence presented in Aristotle's *Ethica* and the Christian reinterpretation penned by Saint Thomas Aquinas in *Summa Theologiae* (*c.* 1273), providing a powerful and persuasive justification for secular and religious building projects undertaken by private citizens.

The publication of Louis Green's article in 1990 caused historians to reassess the magnificence debate.[20] Green drew attention to the chronicle written by the Dominican Galvano Fiamma, praising the building projects of Azzone Visconti of Milan in terms of magnificence. This broadened the parameters for the intellectual debate on magnificence to the court of Milan in the 1330s and expanded the discussion away from the exclusivity of Florence. Since Green's discussion, several other articles have been published that highlight the geographical currency of the theory of magnificence beyond Florence. Rupert Shepherd has considered magnificence in Ferrara principally through the text of the Bolognese writer Giovanni Sabadino degli Arienti's *De triumphis religionis* (1497).[21] Dedicated by Arienti in 1497 to Ercole I d'Este, Duke of Ferrara and Modena, Book V discusses *magnificentia* in some detail, applying the term liberally to a range of virtues from building projects to weddings, banquets and lavish hospitality, that collectively demonstrate the Duke's and

by extension the city's, magnificence. Georgia Clarke has explored a similar theme for fifteenth-century Bologna, connecting the magnificence of the city with the architectural projects initiated by the *de facto* ruler Giovanni II Bentivoglio.[22] Clarke demonstrates how, as Bologna's first citizen, Bentivoglio deliberately presented himself during the 1480s and 1490s as the true instigator of the programme of urban renewal initiated for the benefit of the city and its populace.

In the fifteenth century the significant connection between the virtue of wealth and its logical reflection in the art of building became firmly established. As a range of texts illustrate, there was a continual need throughout the period not merely to discuss wealth and building, but also to explain and justify their positive uses. The debate was theorized in courtly and republican cities alike and this underlines the geographical currency of the concept of magnificence in the major city-states of Renaissance Italy. While the emphasis of these texts varied depending on their purpose, location, author or intended audience, the classical and theological sources that the Renaissance theorists used as authority reappear with remarkable consistency.

As Lewis and Short's definitions suggest, the terms magnificence and splendour could be used both concurrently and independently. For example, where magnificence was frequently used as a conventional form of address and a desirable personal attribute, the term splendour could also be used in a similar way. This is demonstrated in a letter of 1505 written to Isabella d'Este in which Giovanni Sabadino degli Arienti concludes that she is 'a lady of singular intelligence (*ingegno*) and splendour (*splendore*).'[23] In other examples, the terms are used collectively, in a manner recalling Bruni, to praise the city and its public and private buildings. In *De maiestate* (*c.* 1492), the Neapolitan humanist Giuniano Maio, citing Cicero as his source, commends 'the sumptuous and splendid magnificence (*la suntuosa e splendida magnificenza*)' of architectural projects when used for the benefit of the community.[24] A similar example can be found in the Lombard humanist Platina's (1421–81) treatise on citizenship which was dedicated to Lorenzo de' Medici in 1474. In *De optimo cive*, Platina praises the 'great reputation' secured by Lorenzo's grandfather, Cosimo de' Medici, through his construction of temples, monasteries, libraries and palaces, stating: 'no one, not simply in your city but in the whole of Italy, has built more magnificently (*magnificentius*) and more splendidly (*splendidius*) than you'.[25]

If the broad development of the theory of magnificence is familiar through modern studies, the usage and application of the term splendour has received insufficient attention. *The Renaissance Palace* argues for a reassessment of the theory of magnificence in light of the related social virtue of splendour. It demonstrates how magnificence, when applied to private palaces, extended beyond the exterior to include the interior as a series of spaces where virtuous

'splendid' expenditure could and should be displayed. Considering the Florentine *palazzo* as a complete entity, this book calls for a far more nuanced approach that highlights the relationship between fifteenth-century theoretical debates and Renaissance building and furnishing practices.

To achieve this objective, four fundamental categories of research have been adopted: (1) a reappraisal of fifteenth and early sixteenth-century texts that discuss magnificence, splendour and the concept of decorum; (2) the palaces themselves, which although much altered internally today, bear testament to the Aristotelian prescription that magnificent building should be 'long-lasting'; (3) an examination of extant furnishings and domestic objects housed in leading museums; and finally (4) analysis of several hundred unpublished post-mortem inventories, account books and memoranda in the *Archivio di Stato* in Florence, which provide fascinating information on the acquisition and display of a range of household goods across a diverse stratum of society.

In excess of 750 inventories contained in the registers of the *Magistrato* or *Ufficio dei Pupilli* archives, covering the period 1418 to 1526 were consulted. Established in 1388, this Office of Wards functioned as a civic agency for all Florentines, irrespective of wealth or status, who died intestate leaving dependent minors.[26] For administrative purposes the *Pupilli* connected the quarters of Santa Maria Novella with San Giovanni and Santa Croce with Santo Spirito. Consultation of the 1427 *catasto* confirms that Santa Maria Novella and San Giovanni collectively had the greatest concentration of wealth.[27] Although due attention was given to the quarters of Santa Croce and Santo Spirito, my archival research predominantly focused on a broad section of society from the wealthier *quartieri*: families in Santa Maria Novella included the Gianfigliazzi, Rucellai, Tornabuoni and Strozzi, while San Giovanni comprised the Medici, Pazzi and Portinari.[28]

Transcribed in full in the Appendices are the inventories of the wealthy and prominent citizens Gabriello Panciatichi (1430) and Gismondo della Stufa (1495). Gabriello was rated as the fourth richest individual in the 1424 *catasto* with a total assessment of 80,994 florins, while the large palace of Gismondo was located on the Piazza San Lorenzo, a short distance from his Medicean allies. Collectively these inventories – separated by 65 years – demonstrate the extensive information contained in such documents, together with the increased range, type and number of domestic goods available by the end of the fifteenth century.

The first chapter introduces the reader to the complex debates provoked by the concepts of magnificence and splendour. Steeped in the classical writings of Aristotle, Cicero and others, these terms were adopted by Renaissance humanists in Republican Florence. Through the use of unpublished archival material, it is argued that literate Florentines had access to, and an understanding of, the theory of magnificence. Examining a range of fourteenth and fifteenth-century texts, chronicles and eulogies that promoted Florence,

it demonstrates how theories of magnificence could be used to glorify the achievements of the city and provide a social justification for the public virtue of private building.

Chapter two discusses the motivations behind the construction of major houses and palaces in the city. Expanding the debate on magnificent private building away from issues of the mere self-aggrandizement of the palace builder, the discussion demonstrates how such structures served a public function by bringing honour to the city. Using Cosimo de' Medici as an exemplar of Renaissance magnificence, it is shown how the construction of the new Medici palace in an antique style, was interpreted by contemporaries as a worthy successor to the architectural achievements of the classical past. Finally, the importance of decorum in the magnificence debate, both in the suitability, decoration and plan of a building is addressed through the architectural treatises of Alberti and Filarete.

Going beyond the architectural shell, the third chapter argues that it is only when the façade and the interior are considered collectively that a more complete picture can be created of the fifteenth-century Florentine palace. An analysis of shared elements, such as coats-of-arms, and of the use of architectonic forms in interior furnishings, demonstrates the conscious efforts made to establish an integrated structure. Using visual sources and written accounts, it emphasizes the key roles played by private palaces during public and semi-public occasions, ranging from the official reception of dignitaries, to the more mundane daily experiences of those seeking an audience with the palace owner.

The final chapter examines the interior of the fifteenth-century Florentine palace through extensive analysis of unpublished post-mortem inventories of families of differing status and professions. Using select visual sources, together with examples of surviving furnishings and domestic objects, it is possible to interpret the interior of Florentine palaces from the contemporary perspective of the 'invited' and 'uninvited' visitor. Particular attention is given to the major types of furniture forms together with smaller wares, which collectively confirm the attributes of the splendid interior debated in theoretical texts.

In the epilogue the themes discussed throughout the book are amalgamated to reinforce the importance of magnificence and splendour during the Renaissance. Ancient theory and Renaissance practice are summarized to underline the importance of Florentine palaces as living structures and emblems of civic pride. The revived classical theory of magnificence is placed in the precise context of the fifteenth-century Renaissance palace and its furnishings, throwing new light on the social and cultural history of the period.

Notes

1. 'Non inepte autem magnificentiae splendor statim subiungitur, quod et ipse in magnis versatur sumptibus et habet pecuniam communem quidem cum illa materiam. Sed magnificentia ipsa sumpsit nomen a magnitudine, versaturque in aedificiis, spectaculis, muneribus. At splendor, quod in ornamentis domesticis, in cultu corporis, in supelectile, in apparatu rerum diversarum praelucet…' Giovanni Pontano *De splendore* (1498); in F. Tateo ed., *Giovanni Pontano I Libri delle Virtù Sociali*. Rome (1999): p. 224, trans E. Welch, 'Public Magnificence and Private Display: Giovanni Pontano's "De Splendore" (1498) and the Domestic Arts', *Journal of Design History*, 15 (2002): p. 222.

2. Giovanni Pontano, *De Liberalitate, De Beneficentia, De Magnificentia, De Splendore, De Conviventia*. Naples, 1498. Pontano was born in Perugia in 1428. In 1448 he entered into the service of Alfonso I of Aragon and Naples, remaining within the Aragonese court until the 1490s, serving various roles including secretary, advisor and diplomat. On Pontano's life and career see: C. Kidwell, *Pontano: Poet and Prime Minister*. London, 1991.

3. Aristotle *Nicomachean Ethics* IV, ii, 16–17, trans J.A.K. Thomson. London (1953) revised edition (1976): p. 151.

4. 'Nam simul atque urbem conspicati sunt, cum occurrat oculis tanta moles rerum, tanta edificiorum collatio, tanta magnificentia, tantus splendor, cum precelsas turres, cum marmorea templa, cum basilicarum fastigia, cum superbissimas domos, cum turritia, cum villarum multitudinem, cum delitias, nitorem, ornatum intuentur: illico omnium mentes animeque ita mutantur ut non iam de maximas atque amplissimas rebus ab hac urbe gestis obstupescant, non!' Leonardo Bruni, *Panegirico della città di Firenze*, ed. G. de Toffol. Florence (1974): pp. 26–28; trans B.G. Kohl and R.G. Witt, *The Earthly Republic*. Philadelphia (1978): p. 143.

5. C.T. Lewis and C. Short, *A Latin Dictionary founded on Andrew's edition of Freund's Latin Dictionary, revised, enlarged and in great part rewritten*. Oxford, 1945.

6. Lewis and Short (1945).

7. 'Magnificentia est rerum magnarum et excelsarum cum animi ampla quadam et splendida propositione cogitatio atque administratio.' Cicero *De Inventione*, II, liv, 163; trans H.M. Hubbell. Cambridge, Mass. (1949, reprinted 2000): p. 330.

8. 'Studiose enim plerique praesertium in hanc partem facta principum imitantur, ut L. Lucilli, summi viri, virtutem quis? at quam multi villarum magnificentiam imitati!' Cicero *De Officiis* Book I, xxxix, 140; trans W. Miller. Cambridge, Mass. (1913): p. 142.

9. Lewis and Short (1945).

10. Ibid.

11. Ibid.

12. 'Quam dileo abesse ab huius iudicio L. Volusienem, summo splendore hominem ac virtute praeditum.' Cicero *Orations: Pro Cluentio*, LXX; trans H.G. Hodge. Cambridge, Mass. (1927 reprinted 2000): p. 434.

13. 'Iam qui in agro Larinati praedica, qui negotia, qui res pecuarias habent, honesti homines et summo splendore praediti…' Ibid., p.434.

14. 'Hermippum vero ipsum, prudentissimum atque optimum virum, veterem amicum atque hospitem meum, splendidissimum atque ornatissimum civitatis suae.' Cicero *Orations: Pro Flacco*, 48, trans C. Macdonald. Cambridge, Mass. (1977 reprinted 2001): p. 497.

15. Lewis and Short (1945).

16. 'Haec enim ratio ac magnitudo animorum in maioribus nostris fuit ut, cum in privatis rebus suisque sumptibus minimo contenti tenuissimo cultu viverent in imperio atque in publica dignitate omnia ad gloriam splendoremque revocarent. Quaeritur enim in re domestica continentiae laus, in publica dignitatis.' Cicero *Orations: Pro Flacco*, 28, Macdonald (2001): pp. 471–3.

17. E. Gombrich, 'The Early Medici as Patrons of Art: A Survey of Primary Sources', in *Italian Renaissance Studies*, ed. E.F. Jacobs. London, 1960; reprinted as 'The Early Medici as Patrons of Art' in *Norm and Form*. London (1966 reprinted 1993): pp. 35–57.

18. Timoteo Maffei, *In magnificentiae Cosmi Medicei Florentini detractores libellus* (*c.* 1454–6).

19. A.D. Fraser Jenkins, 'Cosimo de' Medici's Patronage of Architecture and the Theory of Magnificence', *Journal of the Warburg and Courtauld Institutes*, 33 (1970): pp. 162–70. See also his MPhil Thesis: *Timoteo Maffei's 'In Magnificentiae Cosmi Medicei detractors libellus' and the problem of patronage in mid-fifteenth century Florence.* MPhil Thesis, Warburg Institute, University of London, 1969.

20. L. Green, 'Galvano Fiamma, Azzone Visconti, and the Revival of the Classical Theory of Magnificence,' *Journal of the Warburg and Courtauld Institutes*, 53 (1990): pp. 98–113.

21. See R. Shepherd, 'Giovanni Sabadino degli Arienti and a practical definition of magnificence in the context of Renaissance architecture', in *Concepts of Beauty in Renaissance Art*, ed. F. Ames-Lewis and M. Rogers. Aldershot (1998): pp. 52–65; and *An examination of Giovanni Sabadino degli Arienti's writings on art and architecture.* PhD thesis, Courtauld Institute, 1997. On Ferrara and magnificence see also: R.G. Brown, *The Politics of Magnificence in Ferrara 1450–1505: a study of socio-political implications of Renaissance spectacle.* PhD thesis, University of Edinburgh, 1982.

22. G. Clarke, 'Magnificence and the city: Giovanni II Bentivoglio and architecture in fifteenth-century Bologna', *Renaissance Studies*, 13 (1999): pp. 397–411.

23. '...la quale da acogitare cum acuto ochio cerviero, et cum iudicio ultimate, che la Vostra Excellentia è Madonna de singular ingegno: & di splendore et questo laudando Dio patientemente per la verita gustate.' Letter by Arienti to Isabella d'Este, 18 Aug 1505. Shepherd (1997): Appendix II, F.iv.

24. Maio was born before 1435 and a friend of Giovanni Pontano. He taught at the University in Naples between 1465 and 1488, becoming an official courtier in 1491. See Giuniano Maio, *De maiestate*, ed. F. Gaeta. Bologna (1956): p. 224.

25. Platina: 'Magnam certe luadem hac in re, Cosme, consecutus es: nemo enim non dico in urbe tua, verum in tota Italia magnificentius te ac splendidius aedificavit: cernuntur tot templa, tot monasteria, tot bibliothecae, tot aedes tua impensa aedificatae et ornatae, ut nil ulterius ad hanc magnificentiam operum addi posse videatur.' Platina *De optimo cive*, ed. F. Battaglia. Bologna (1944): p. 208.

26. As an indication of the number of inventories contained within each volume, register number 181 includes 56 complete inventories and at least a further 40 recorded as conducted but incomplete.

27. The collective wealth of the households in 1427 with total assessments of more than 10,000 florins was 1,736,841 florins for San Giovanni and Santa Maria Novella. This compares with 1,263,831 florins for Santo Spirito and Santa Croce. Herlihy, D. and Klapisch-Zuber, C, *Tuscans and their Families: A Study of the Florentine Catasto of 1427.* New Haven and London, 1985; see also the Online *catasto*: www.stg.brown.edu/projects/catasto.

28. The majority of registers cover two *quartieri* in one volume, except where indicated. The volumes consulted were numbers: 153 (1418–22), 155 (1421–25), 159 (1425–27, Santa Maria Novella only), 160 (1425–27, San Giovanni only), 165 (1429–30), 171 (1439–54, Santa Maria Novella only), 173 (1467–75), 175 (1475–79), 177 (1479–84), 179 (1484–95), 181 (1497–1501), 185 (1510–26). In addition, the following registers from Santa Croce and Santo Spirito were also consulted: 170 (1439–54, Santa Croce only), 178 (1484–95) and 183 (1501–13). Prominent families from Santo Spirito quarter include the Uzzano, Bardi and Barbadori; while Santa Croce could claim the Alberti and Rinuccini amongst its residents.

Debated concepts: Magnificence and Splendour

1. The classical and medieval precedents for magnificence

The fundamental starting point for the development of the magnificence debate in fourteenth- and fifteenth-century Italy was Aristotle's (384–322 BC) great ethical treatise the Ethica Nicomachea. Composed as mere lecture notes, the Ethica was rediscovered and promoted in the Middle Ages, notably through the works of St Thomas Aquinas (c. 1225–74) who incorporated Aristotle's philosophy into Catholic theology.

Aristotle considered magnificence, or *megaloprepeia*, to be a moral 'virtue concerned with wealth'.[1] In Book IV of the *Ethica*, Aristotle describes magnificence as a special kind of liberality differing from that virtue since 'unlike liberality it does not extend to all financial transactions, but only to such as involve expenditure. In these it surpasses liberality in scale because (as its very name implies) it is befitting expenditure on a large scale.'[2] Both virtues relate to the acquiring and spending of money, though liberality pertains to 'minor' outlays and magnificence to 'major' expenditure. Where liberality is the mean between prodigality and meanness or illiberality, magnificence lies between tastelessness or vulgarity and pettiness[3] (Plate 1).

The underlying principle of Aristotle's *Ethica Nicomachea* is the 'doctrine of the mean'.[4] This standpoint guides the reader through the moral virtues by calling for moderation in all things and avoidance of both excess and deficiency. The notion of a mean is, however, more than simply the mid-point in any selected scale. In matters of conduct or behaviour it is not the mean of the object that dictates, but rather the mean relative to us. The man who spends in 'small or moderate transactions… is not called magnificent – only the one who does so on a grand scale; because although the magnificent man is liberal, the liberal man is not necessarily magnificent.'[5]

Aristotle argues that the virtue of magnificence remains the possession of the wealthy, stating that 'a poor man cannot be magnificent, because he has not the means to meet heavy expenses suitably… But such expenditure befits those who have appropriate resources acquired either by themselves or from ancestors or connections, and persons of noble birth or great reputation or other such qualities, because they all involve grandeur and distinction.'[6] In the following section, Aristotle describes the attributes of the magnificent:

> The magnificent man is a sort of connoisseur; he has an eye for fitness, and can spend large sums with good taste… The motive of the magnificent man in making such outlays will be fine, because this is a feature common to all the virtues. Moreover he will spend gladly and generously, because precise reckoning is petty. He will consider how he can achieve the finest and most appropriate result rather than how much it will cost and how it can be done most cheaply.[7]

Aristotle significantly outlines the occasions when magnificence can be demonstrated. The greatest deeds were those undertaken for the gods; second those for the good of the public; and third those for the individual: 'it is shown also on private occasions that are unique, such as a wedding or something of that sort, or any event that excites the interest of the whole community; or entertainments to mark the arrival or departure of foreign guests, or the exchange of complimentary presents.'[8] One of the most suitable means of expenditure for the magnificent individual was the building of a house appropriate to the builder's wealth and means. Due consideration is also to be given for results which are of a permanent nature:

> It is also characteristic of him to furnish his house in a way suitable to his wealth (because even this is a kind of public ornament), and spend his money for preference upon results that are long-lasting (because they are the finest), and in every set of circumstances to spend what is appropriate… since the greatness of any expenditure depends upon the kind of object for which it was incurred.[9]

It is the acceptance by Aristotle of the 'characteristic' of the magnificent man 'to furnish his house in a way suitable to his wealth' which most concerns us here. The extension of magnificent expenditure from mere building to also include appropriate interior furnishing is subtle but significant. By making a connection between the exterior of a building and its interior, domestic space is elevated to the status of virtuous display. It provided both an acknowledgement and a classical exemplar for Renaissance readers and writers that appropriate building extended from beyond merely the architectural shell to include the interior of a magnificent house.[10]

Marcus Tullius Cicero's (106–43 BC) *De Officiis* (completed by 44 BC) also discussed expenditure in some detail translating Aristotle's principle of *megaloprepeia* as *magnificentia*.[11] In Book II, he connects it to public building

that serves and is for the benefit of the whole city: 'the expenditure of money is better justified when it is made for walls, docks, harbours, aqueducts, and all those works which are of service to the community… public improvements win us greater gratitude with posterity.'[12] Personal property should, however, also be valued and cared for, though one must be careful to choose the appropriate path between excess and deficiency.[13] This supplements Cicero's earlier analysis of wealth in Book I entitled 'Moral Goodness', where he had stated 'there is nothing more honourable and magnificent (*magnificentius*) than to be indifferent to money, if one does not possess it, and to devote it to beneficence and liberality, if one does possess it'.[14]

One of the most detailed literary discussions of private exemplary building to survive from classical literature is contained within Book I. Here, Renaissance theorists significantly found both a justification and model for appropriate display. Many of the public building projects enumerated for praise in the classical world, such as baths, theatres, sports arenas or aqueducts, had little relevance to the Renaissance reader. Indeed, even the more extensive writings on villa life contained in the letters of Pliny the Younger (*c.* 61–112 AD) betrayed a different set of concerns from those of the city-orientated Italy of the Renaissance. Cicero writes:

…I must discuss also what sort of house a man of rank and station should, in my opinion, have. Its prime object is serviceableness. To this the plan of the building should be adapted; and yet careful attention should be paid to its convenience and distinction. We have heard that Gnaeus Octavius – the first of that family to be elected consul – distinguished himself by building upon the Palatine an attractive and imposing house. Everybody went to see it, and it was thought to have gained votes for the owner, a new man, in his canvass for the consulship. That house Scaurus demolished, and on its site he built an addition to his own house. Octavius, then, was the first of his family to bring the honour of a consulship to his house; Scaurus, though the son of a very great and illustrious man, brought to the same house, when enlarged, not only defeat, but disgrace and ruin.[15] (Illustration 1)

In contrast to Aristotle's more abstract praises of magnificence, this passage provided later readers with many of the necessary tangible qualities of appropriate expenditure on private building. The foremost purpose of an imposing house is its 'serviceableness', for which the 'plan of the building should be adapted' together with its 'convenience and distinction'. Gnaeus Octavius had 'distinguished himself' by constructing an 'attractive and imposing house,' that 'everyone went to see'. This is magnificence within firmly Aristotelian lines. Octavius, an elected consul, has built according to his 'rank and station' and therefore observed the principles of decorum.

Cicero makes clear, however, that the balance between appropriate and inappropriate building is a delicate one. Where Octavius succeeded, Scaurus failed. The demolition of Octavius' house and subsequent enlargement of his

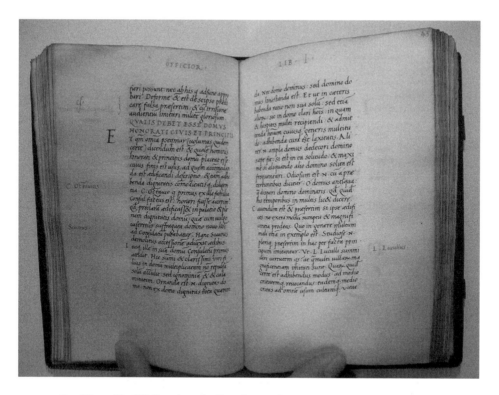

1. Cicero *De Officiis* written by Bartolomeo Sanvito. Rome,
1495, showing the passage on Gnaeus Octavius

own, brought 'disgrace and ruin' upon Scaurus. Here there appears to be a
more refined shift of Aristotle's theories. Cicero informs us that Scaurus was
'the son of a very great and illustrious man' and, therefore, from an Aristotelian
standpoint, entitled to undertake grand expenditure.[16] The distinction would
appear to be in the dignity of the builder. Scaurus is merely the son of a
magnificent man, whereas Octavius himself was 'a new man' and 'the first of
his family to bring the honour of a consulship to his house'. The importance
of this as exemplary behaviour would not have been lost on the '*gente nuova*'
of *quattrocento* Florence.[17] As Cicero pointedly argued: 'The truth is, a man's
dignity may be enhanced by the house he lives in, but not wholly secured by
it; the owner should bring honour to his house, not the house to its owner.'[18]

For Cicero, decorum or appropriateness is particularly important in
private building. The builder must keep within 'proper bounds in expense
and magnificence' and apply 'a standard of moderation' to the 'comforts and
wants of life'. Similarly, it is not appropriate merely to 'imitate zealously the
foibles of the great' by replicating the private building of others:

One must be careful, too, not to go beyond proper bounds in expense and magnificence (*magnificentia*), especially if one is building for oneself. For much mischief is done in this way, if only in the example set. For many people imitate zealously the foibles of the great, particularly in this direction: for example, who copies the virtues of Lucius Lucullus, excellent man that he was? But how many there are who have copied the magnificence (*magnificentiam*) of his villas! Some limit should surely be set to this tendency and it should be reduced at least to a standard of moderation; and by that same standard of moderation the comforts and wants of life generally should be regulated.[19]

The writings of the thirteenth-century theologian Saint Thomas Aquinas (*c.* 1225–74) demonstrate a renewed interest in Aristotle's discussion of magnificence. In both his Commentary on the *Ethica Nicomachea* and the *Summa Theologiae* (written before 1273), Aquinas used Aristotle to clarify and reappraise the ethics of expenditure. In the *Summa*, which reviewed current theology, Aquinas elected to take Aristotle as both his source and his authority. This link between the Christian discourse of Aquinas and the pagan philosophical writings of Aristotle was fundamental to the positive interpretation of magnificence. Aquinas responds to the question of whether magnificence is a virtue in clear Aristotelian terms, and once again private architecture is connected with magnificent expenditure:

It belongs to magnificence (*magnificentiam*) to do something great. But that which regards a man's person is little in comparison with that which regards Divine things, or even the affairs of the community at large. Wherefore the magnificent (*magnificus*) man does not intend principally to be lavish towards himself, not that he does not seek his own good, but because to do so is not something great. Yet if anything regarding himself admits of greatness, the magnificent (*magnifice*) man accomplishes it magnificently (*magnificus*): for instance, things that are done once, such as a wedding, or the like; or things that are of a lasting nature; thus it belongs to a magnificent (*magnificum*) man to provide himself with a suitable dwelling, as stated in Ethic. iv.[20]

While Aquinas unsurprisingly considered religious works to be most readily indicative of magnificence, the validation of personal expenditure for unique events, such as a wedding, or things of an enduring nature, such as private building, is surprising. Again citing Aristotle, Aquinas distinguishes between magnificence and liberality: 'The Philosopher says that [Ethic iv, 2] "magnificence (*magnificentia*) does not extend, like liberality, to all transactions in money, but only to expensive ones, wherein it exceeds liberality in scale."'[21] Similarly, magnificent expenditure will produce a greater result: 'the Philosopher says that [Ethic iv, 2] "a magnificent (*magnificus*) man will produce a more magnificent (*magnificum*) work with equal, or proportionate, expenditure."'[22] Although the 'poor are able to possess all the virtues', only 'the rich are capable of great expenditure.'[23] Above all, magnificence is to observe the mean, 'which it neither falls short of or exceeds'[24] and is subject to the rules

of decorum: 'it belongs to magnificence (*magnificentiam*) to intend doing some great work. Now for the doing of a great work, proportionate expenditure is necessary, for great works cannot be produced without great expenditure. Hence it belongs to magnificence (*magnificentiam*) to spend much in order that some great work may be accomplished in a becoming manner.'[25]

The discussion of magnificence by the Dominican Galvano Fiamma (born 1283) moves us from a world of theoretical literary praise to one of practice. As part of an ambitious project to set the achievements of the ruling Visconti family within the wider context of the history of Milan, Fiamma composed the 'Opusculum de rebus gestis ab Azone, Luchino et Johanne Vicecomitibus'. Writing during the 1330s, Fiamma's text purports to record the actual building projects of the *signore* Azzone Visconti (ruled 1329–1339). In the years following Aquinas' canonization in 1323, his teachings obtained increased influence across Italy.[26] Nevertheless, although Fiamma's chronicle reflects Aquinas' discussion of expenditure, it is Aristotle who is again presented as the justification for the developed connection between magnificent expenditure and building.

Fiamma was a noted scholar at the university of Pavia, where he taught moral philosophy, theology and canonical law.[27] When referring to Visconti's religious building, Fiamma makes no reference to the more recent theological writings of Aquinas, adopting Aristotle as his sole source as propagandistic justification for his patron's public and private building programme. In Chapter XV entitled *De magnificentia edificiorum*, Fiamma states: 'the Philosopher says in the fourth book of the Ethics that it is a work of a magnificent man (*opus magnifici*) to construct an appropriate house (*domum decentem*).'[28] In his enthusiastic praise for Visconti, Fiamma provides a new rationale for architectural patronage – no longer is it merely a virtue to build, but rather it is now 'required of a magnificent prince (*requiritur ad magnificum principem*)' that he construct magnificent secular and religious structures.[29]

2. The debate in fifteenth-century Florence

Discussion on the theory of magnificence and the formulation of its major principles received significant attention by theorists in Florence during the opening decades of the fifteenth century. This section demonstrates how the arguments of Aristotle, Cicero and Aquinas were assimilated to promote magnificence as a social justification for the public virtue of private building.

In 1416 the Florentine humanist and future chancellor of the city Leonardo Bruni (1370–1444) translated into Latin Aristotle's *Ethica Nicomachea*. This was followed in 1420 by his translation and commentary on the *Economica*, then thought to have been written by Aristotle. In the commentary on the pseudo-

Aristotelian *Economica*, dedicated to Cosimo de' Medici, Bruni specifically connected the positive uses of wealth to building and furnishing a house:

Wealth will lend ornament and honour (for that is what Aristotle says: we must learn how to make it an adornment) if we make our outlays opportunely and with decorum. These will include building a house in keeping with our wealth, having a good staff of servants, abundant furniture, a decent array of horses and clothing.[30]

Some years earlier, Bruni had demonstrated his familiarity with Aristotelian thought in his *Laudatio florentinae urbis* (*c.* 1403–4). Bruni wrote his panegyric at a time of huge political success for Florence, with the sudden death of the Milanese leader Giangaleazzo Visconti in 1402, against whom Florence had been at war. This monumental event, widely seen in Florence as divine intervention, ended the imminent and very real threat to Florentine liberty. Against this background of exuberant civic pride, Bruni discusses a wide range of virtues possessed by Florence – including her classical origins; position as defender of Italian liberty; equitable constitution; and the nobility of her people and trades – all of which demonstrate the city's magnificence.[31]

Although an established literary tradition of praises (*laudes*) existed from medieval writers, Bruni was the first to use an ancient Greek text – that of Aelius Aristides' *Panathenaicus* (AD 155) – as a model.[32] The central premise of this text was well suited to Bruni's argument. In the *Panathenaicus* Aristides had praised Athens as the sole defender of Greek liberty against the threat of Persian autocracy, as well as an exemplar of both political and cultural progress. As with the medieval tradition of *laudes*, Aristides' text reflected the general convention of focusing on the unique virtues of the city so as to reinforce its pre-eminence above all others. What is striking in Bruni's panegyric is the extensive role that architecture plays in his discussion of Florence. This serves as an important point of departure from Aristides' text, where the architecture of Athens had served a far more subsidiary function.

In chapter one of the *Laudatio*, Bruni comments that: 'if you are looking for contemporary architecture, there is surely nothing more magnificent (*magnificentius*) or splendid (*splendidus*) than Florence's new buildings',[33] and asks: 'What in the whole world is more splendid (*splendidum*) or magnificent (*magnificum*) as the architecture of Florence?'[34] The explicit connection made by Bruni between magnificence, splendour and architecture is particularly innovative occurring over ninety years before the Neapolitan Giovanni Pontano singled out these concepts for detailed and distinct attention in his books on the five social virtues.[35]

The notion that virtuous buildings could add to the city's magnificence became a popular theme during the *quattrocento*. Significantly, this association built upon a *trecento* tradition that is reflected in the *volgare* chronicle writing of the merchants Dino Compagni (*c.* 1260–1324) and Giovanni Villani (*c.* 1276–

1348). In the first book of Compagni's *Cronica*, the private houses of Florence are specifically singled out for praise: 'The large houses are very beautiful, and better supplied with comforts and conveniences than those in other cities of Italy. On this account many people come from distant lands to visit the city, not from necessity, but by reason of her flourishing industries, and for the sake of her beauty and decoration.'[36] The *Cronica* (1333–1348) of Giovanni Villani provided a similar, if more detailed, account of Florence's 'beautiful houses'. As with the texts of Compagni and Bruni, the impact of Florence's buildings on outsiders is again specifically detailed:

[Florence] was so well situated and furnished with many beautiful houses, and buildings were going up all the time and improved in order to make them comfortable and rich, drawing on fine examples from elsewhere of every kind of improvement... and besides there was no citizen who did not engage in the construction of large and rich properties and rich dwellings in the country, with fine buildings, better than in town... And it was such a magnificent (*magnifica*) thing to see that foreigners, coming from outside with no experience of Florence, believed for the most part that the rich and beautiful palaces which were within a radius of three miles outside the city were all part of the city as in Rome.[37]

Around the same time as Leonardo Bruni was composing his *Laudatio*, the Florentine chancellor and humanist Coluccio Salutati (1331–1406) wrote his *Invectiva in Antonium Luschum Vicentinum* (*c.* 1403). Salutati's text was written as a direct response to the invective penned by Antonio Loschi of Vicenza against Florence. Loschi had studied in Florence immediately prior to his appointment as secretary to Giangaleazzo Visconti in 1399. Conscious of this first-hand experience of Florence, Salutati directly responded to Loschi's attack by drawing on his familiarity with the city:

I cannot believe that my Antonio Loschi, who has seen Florence, or anyone else at all who saw Florence, could deny that it is the flower of Italy and its choicest part, unless he were downright foolish. Which city, not only in Italy but in the whole world, is more safely guarded by its walls, more superb in palaces (*superbior palatiis*), more ornamented (*ornatior*) in respect to temples, more beautiful by virtue of its buildings (*formosior aedificiis*), more illustrious (*clarior*) in its porticoes, more imposing (*speciosior*) in its piazzas, richer (*laetior*) in respect of the breadth of its streets; which is greater in population, more glorious in its citizens, more infinite in riches or more cultivated in its fields?[38]

The chronicle of Gregorio Dati (1362–1435) entitled *Istoria di Firenze dal 1380 al 1405* (*c.* 1423), also includes a short section detailing the virtue of Florence's notable structures and appreciation of the architectural features within the city. Dati's text is important, since he was not a humanist scholar like Bruni or Salutati writing within a classical tradition but was, like Compagni and Villani, a member of the merchant class, inspired by the buildings that surrounded

him. He refers more generally to private building stating: 'the palaces of the citizens are such that no place in the world has royal palaces that are superior, and all the city consists of beautiful and ornate dwellings.'[39]

In *De avaritia* the Florentine humanist Poggio Bracciolini (1380–1459) also chose to elaborate on the civic benefits served by magnificent building. Composed in 1428 while Bracciolini was employed at the papal court in Rome as a copyist and secretary, *De avaritia* is constructed in the form of an imaginary conversation involving fellow curialists.[40] The use of a dialogue form enables different aspects of the 'vice' to be addressed and expanded to consider the wider issues involving the utility, or otherwise, of wealth. Thus Bartolomeo da Montepulciano uses a range of classical references to attack avarice, while the theologian Andrea of Constantinople takes a similarly critical approach supported through biblical and patristic texts. Only through the words of Antonio Loschi is avarice defended as a virtue. Appealing to the needs of governments and individuals alike, Loschi praises the application of wealth to facilitate architectural projects as a clear example of the positive uses of avarice:

Suppose no one did anything except to provide the necessities for himself and his family. You would soon see what total confusion would result if we wanted only enough to provide for ourselves… How can anyone be munificent who has only enough for himself? Every magnificence (*magnificentia*), every refinement, every ornament would be lacking. No one would build temples or colonnades; all artistic activity would cease, and confusion would result in our lives and in public affairs if everyone were satisfied with only enough for himself.[41]

Later Loschi argues that 'desire for money has grown, so that avarice is not considered a vice but a virtue; the richer a man is, the more he is honoured.'[42] He continues his defence presenting public and private, secular and religious architectural projects as positive examples of wealth that ornament and distinguish the city:

In no way have the avaricious been harmful. I might add that they have often brought great ornament and embellishment to their cities. Not counting antiquity, how many magnificent houses (*magnificae domus*), distinguished villas, temples, colonnades, and hospitals have been constructed in our own time with the money of the avaricious? Without these ornaments our cities would be deprived of their largest and most beautiful monuments.[43]

Through Leon Battista Alberti's (1404–72) *I libri della famiglia* (1430s) the theoretical debate on magnificence entered the Tuscan *volgare*. In the introduction to Book III, Alberti eloquently defends his decision not to write in Latin. By writing in Tuscan, Alberti claimed he was following ancient writers who wanted to reach the widest possible audience. The *volgare* text, Alberti argues, will 'educate many' and enable even 'the ignorant to read me':

I fully admit that the ancient Latin language was rich and beautiful, but I see no reason why our present-day Tuscan is so contemptible that anything written in it, however excellent, should fail to satisfy us… I cannot approve of the contempt so many people show for what they themselves speak…[44]

Drafted during the 1430s, Alberti's work is divided into four books.[45] Alberti took Xenophon's (c. 428–c. 354 BC) *Oeconomicus* and the pseudo-Aristotle *Economica* (recently translated by Leonardo Bruni in 1421) as his major sources, though he demonstrates his classical erudition with further ancient textual references. In the Prologue, Alberti 'speaks' in his own voice, and outlines his themes for the family: household management, restraint, and appropriate behaviour.

Like Bracciolini, Alberti structured *I libri della famiglia* in the form of a dialogue where extreme views could be extolled by the different interlocutors. The reader is left to determine the correct path to follow or where the appropriate mean between the set parameters lay. This approach is given a further Aristotelian emphasis in Book II entitled *De Re Uxoria*. Although Lionardo states that 'the pursuit of wealth is not as glorious as are other great pursuits', it can bring recognition and distinction if used for lofty purposes: 'With wealth, if it is used to do great and noble things and to show a fine magnificence (*magnificenza*) and greatness (*larghezza*), fame and dignity can be attained.'[46] In Book III on *Economicus*, the learned Giannozzo is asked by Lionardo to provide advice on the occasions when the family 'ought to undertake some expense for the honour and fame of our house.' Lionardo refers to various 'public and private edifices (*publici e privati edificii*)' constructed by the Alberti, and asks 'what rule or method would you say applied to this kind of spending?'[47]

In response, Giannozzo replies that 'expenses are either necessary or unnecessary'. Where necessary expenses are deemed to be those 'without which the family cannot be honourably maintained,' by contrast unnecessary expenses are those which 'give pleasure if undertaken wisely, but which it does no harm to omit' including 'painting the loggia, buying the silver, embellishments that add pomp to one's way of life.'[48] Here personal honour and family comfort become connected. 'Unnecessary expenses' are singled out as a distinct area and usage for wealth. These too, however, can provide pleasure if undertaken within an appropriate level of decorum. 'Anything unneeded' brings us closer to the complex debate on luxury, but significantly Alberti does not refer to *luxuria* in his text. The unnecessary categories include interior decoration and domestic objects which, if they cause no harm to omit, are by extension neither detrimental to include.

Also written in *volgare*, the humanist Matteo Palmieri's (1406–1475) *Della vita civile* (c. 1431–38) was an influential text. Divided into four books, Palmieri's work is written in the form of a dialogue that takes place in the Mugello to

the north of Florence, where the interlocutors have taken refuge from the plague of 1430. In Book III, Palmieri devotes a section to magnificence (*Della magnificenzia*) stating that it 'consists of great expense on marvellous and notable works.'[49] Magnificent expenditure is to be demonstrated in public works, such as 'in buildings and ornaments of temples, theatres, loggias, public entertainments, games and banquets.'[50] In Book IV, Palmieri states 'riches and abundant wealth are the instruments by which worthy men act virtuously'.[51] A later section is described in the marginalia as 'Of the beauty and ornament of the city'.[52] Here Palmieri discusses those 'things in the city that are less necessary but contain a great appearance and grand splendour (*splendida*)'.[53] The reference to ornaments that are 'less necessary' recalls Alberti's discussion of necessary and unnecessary expenditure. In Palmieri's account of the 'civic ornaments' that beautify the city, private palaces are integrated with public structures as collectively contributing to the wider general embellishment of the city:

The beauty and the unique ornament of buildings is to be found in the public structure: it is contained in the continued extension of the high and very strong walls of the city…; the high and superb palaces built for the outstanding glory of the magistrates; the sublime and notable magnificence (*magnificentia*) of the sacred temples, and the comfort and most appropriate beauty of private dwellings.[54]

Referring specifically to private building, Palmieri states it is 'not to the master for the house, but to the house for its master one would wish and ought to give honour.'[55] Continuing this argument, Palmieri warns 'he who would follow and would wish to emulate the magnificent houses (*le magnifiche case*) of noble citizens would merit blame if first he has not reached or surpassed their virtue.'[56] In these two quotes Palmieri recalls both Aristotle and Cicero. In the latter, Palmieri applies the Aristotelian principle that magnificent expenditure should be directly proportionate to the magnificence of the builder: 'the expenditure is related to the position and resources of the agent; because it must be worthy of these, and appropriate not only to the result produced but also to the man who produces it.'[57] In the former, Palmieri closely paraphrases Cicero's stern warning in *De Officiis* that 'a man's dignity may be enhanced by the house he lives in, but not wholly secured by it.'[58]

3. The currency of the magnificence debates in fifteenth-century Florence

This section places the texts discussed in this chapter within a wider context, by illustrating the extent to which the theory of magnificence was accessible to fifteenth-century Florentines, and the potential impact that the written word had on a diverse range of the populace. Moving us from theoretical discourse into the world of the

Renaissance reader, it demonstrates through extensive archival analysis of post-mortem inventories, the broad levels of ownership of such texts and their relationship with other written works whether 'antique' or 'modern', manuscript or printed. Against such material is placed the particularly Florentine custom of writing personal memoranda that further suggest the accessibility of these texts.

In Book XI of his popular vernacular chronicle Giovanni Villani provided an estimate of the number of children studying reading, writing and arithmetic within Florence in 1338: 'We find that 8,000 to 10,000 boys and girls are learning to read. There are 1,000 to 1,200 boys learning arithmetic (*abbaco e algorismo*) in six schools. And those who study grammar (*grammatica*) and logic (*loica*) in four large schools are 550 to 600.'[59] According to Villani's statistics this represented around ten percent of the total population, which he estimated to be at least 90,000 excluding foreigners and those in religious institutions.

Although Villani's statistics are inflated and cannot be considered accurate they are nevertheless suggestive. The account occurs in a section specifically devoted to the 'grandeur, condition and magnificence (*magnificenza*) of the commune of Florence'.[60] Like much of Villani's text that attempts to weave biblical and classical elements together, so as to present Florence as the daughter of Rome, here the data is presented within a long list of virtuous achievements that collectively reflect the city's modern magnificence. Civic pride may well have been a factor in Villani's statement regarding his city's exemplary schooling practices, but it also reflected a wider *trecento* phenomenon. Along with Dino Compagni (*c.* 1260–1324) – the other great Florentine chronicler of the fourteenth century and, like Villani, a member of the mercantile class – both writers were indicative of a newly evolving literate stratum of society.

Though unrealistic in terms of the number of children attending school, Villani's account does reflect the general practice followed by those privileged and wealthy enough to receive a formal education.[61] Teaching commenced with reading and then progressed to writing and finally to arithmetic. Pupils began by learning the alphabet using a sheet known in English as the 'hornbook'.[62] Once they had progressed to syllables and then words, children would learn an increasing number of Latin prayers, known as the *salterio* or English 'Psalter'. If their education proceeded further, children would then study an elementary Latin grammar referred to variously as the *donato*, *donadello* or *donatello*.[63] Literacy was not spread evenly among the population and, contrary to Villani's assertion, the chances of being able to read strongly favoured males. Analysis of the 1480 *catasto* demonstrates that girls are never recorded as receiving education and though they could, like boys, receive instruction within the home through a male tutor, this appears to have rarely occurred.[64]

The particular importance to Florentines of reading and writing is reflected in the trend from the mid-fourteenth century onwards to keep not only detailed accounts but also to write family memoranda or diaries, known as *ricordi* or *ricordanze*.[65] Leon Battista Alberti's *I libri della famiglia* (1430s) expands the Florentine mercantile tradition of keeping accounts and suggests an environment suitable for creating *ricordanze*. During a discussion in Book III on the general inability of agents to place their client's interests above their own, one of the leading interlocutors, Giannozzo, states how 'it was a good sign if a merchant had ink-stained fingers'[66] and 'that he should almost always have his pen in his hand'.[67]

Alberti's advice to his readers to always have their pen in hand was consistent with the accounting mentality of the merchant class. As the number of *ricordanze* and account books indicate, the notion of the diligent merchant having 'ink-stained fingers' reflected the practices of a society disposed to recording and accounting for every minute income or expenditure. Nevertheless, neither Alberti's insight into the commercial attitudes of the city's merchant class, nor the high literacy levels suggested by Giovanni Villani, fully explains the Florentine penchant for *ricordanze* writing. This is demonstrated by a comparison with Venice, a centre analogous in commercial aspirations as well as literacy levels, yet where only one known *ricordanza* exists.[68] It is clearly significant that while Venetians were similarly regular keepers of account books, these were not expanded to books on family memory. A possible explanation for this would seem to rest in the more open political structure of Florence. Central to this interpretation is the absence in Florence of any reform comparable to that of the *serrata* initiated in Venice in 1297 which, though greatly extending the political class, also made it more difficult for new families to enter in the future.[69]

As several *ricordanze* confirm, a major concern was the extent of the family's participation in the political structure of the city, together with issues such as history, status and inheritance. Collectively these requirements often motivated Florentines' desire to write. Giovanni di Pagolo Morelli was just 22 when he set out in 1393 to record for his 'sons and relatives' the ancestral history of his extended family. He outlines his reasons for putting pen to paper as being his wish to write about the family's 'ancient condition and ancestry, so far as I can remember, and also about our current and coming situation.' Morelli emphasizes the importance of this since 'everyone today pretends to a family background of great antiquity and I want to establish the truth about ours.'[70]

The range of details and information included in *ricordanze* is vast, making them sources of inestimable value to historians of all disciplines. As Francesco Guicciardini stated in his *ricordanze*, these records were to include 'anything pertinent in general to the whole house',[71] together with political

and ceremonial occasions, foreign events and natural catastrophes. *Ricordanze* often record in some detail key moments in the family's life such as the birth, marriage, or death of family members. In addition, the records also chart events in the economic life of the family including the acquisition and selling of goods, divisions and inheritance, infighting and disputes, and the drawing up of contracts or documents.

The 'priceless' value attached to *ricordanze* is demonstrated by the manner in which they were closely guarded and locked away within the house. In *I libri della famiglia*, Alberti describes how Giannozzo escorts his new wife around the whole house so that 'at the end there were no household goods of which my wife had not learned both the place and purpose.' Then having returned to his chamber, he locks the door and shows his wife his 'treasures, silver, tapestry, garments, jewels, and where each thing had its place'.[72] While these family heirlooms are to be shared and confided in with his wife, significantly Giannozzo does not extend this to his 'books and records', which were 'locked up and arranged in order' in his study (*studio*) 'almost like sacred and religious objects'.[73]

From this text the significance of family records to the individual is clear. Surviving examples of *ricordanze* show that these books were designed for their utility and longevity rather than as luxury objects. 'Arranged in order' and distinguished by alphabetical letter, colour or the material of the binding, these books appear to have been stored securely and yet were easily accessible for further acts of reading or writing. Something of the importance of studies as controlled areas of contemplation can be found in *De politia litteraria*, which was composed by the Milanese humanist Angelo Decembrio and dedicated to Pope Pius II in 1462. The text consists of a number of dialogues involving key figures in the Ferrarese court of Leonello d'Este. As the title suggests, central to Decembrio's text is the issue of how a prince, his entourage and his scholarly advisors should select and study books. In one dialogue, Decembrio has Leonello himself outline the requirements of an ideal library. The need to keep this area ordered and clean fits in well with Alberti's reference that 'each thing had its place':

If you are making a diligent enquiry about everything that pertains to creating a polished (*poliendam*) library... it is proper to have your library in the more private part of the house; this sort of special room for a collection is seen in Pliny, and contains, as he says, the books that are to be re-read rather than read: it should be proof against noises not only from the household but also from next door... Therefore let everything in the library be seen to be polished (*perpolitum*) and elegantly laid out – the paving, the wall, the beams.[74]

The concept of 'polish' was an inherent quality of the splendid interior. References to polish occur frequently in Giovanni Pontano's *De splendore* (1498). There,

as in Leonello's account, an Aristotelian sense of order and appropriateness underpins domestic display. Elsewhere in *De politia*, Decembrio describes the more modest study-library of Giovanni Gualengo. The content of Gualengo's collection is presented as entirely appropriate to his status and means, while the ordered nature of his study is reinforced by the diligent practice of recording the author's name on the spine of each manuscript. The collection, which we are told he read regularly, included: 'all the works of Cicero, especially in moral philosophy, in one volume' as well as 'a very correct copy of Terence' with the commentaries by Donatus. He continues: 'when I look at and study the ranks of my books…I feel as if I am looking at the holy graves of those who wrote them.'[75]

The notion of classical texts symbolizing the 'holy graves' of their authors should not be dismissed as mere humanist metaphor. The potential for classical texts to persuade, inform and instruct was felt beyond the learned intellectual circles in which Decembrio and other humanists moved. The *ricordanza* of Giovanni di Pagolo Morelli provides an insight into the effect of such texts on the Florentine merchant class. In one entry Morelli discusses at some length the benefits attained through literary learning. Writing directly to his son, Morelli urges his heir to incorporate into each day at least one hour to study 'Virgil, Boethius, Seneca or other authors as you read in school.'[76] Such ordered study brings wide rewards: 'your intellect (*intelletto*) will start to taste the reason of things and the sweetness of theory (*iscienza*), you will get from this such pleasure, so much delight, so much satisfaction, more than any other thing.'[77] Morelli continues:

From this will follow to you great virtue (*virtù*) in your intellect: you will learn, speculating on the teachings of the authors that you have to follow in the present life and so bring health to your soul and usefulness and honour to the body… You have at your disposal all the able men: you will be able to be in your study (*istudio*) with Virgil… with Boethius, with Dante and with other poets, with Tullio [Cicero] who teaches you to speak perfectly, with Aristotle who teaches you philosophy: you will know the reason of things, and not least, every little part will give you the highest pleasure. You will be with the holy prophets in the Holy Scripture, you will read and study the Bible… and from this virtue of knowledge you will be so well taught and educated that I do not need to go further on this matter.[78]

Morelli's account refers to a diverse range of literary models, from ancient to modern and secular to religious. The juxtaposition of such sources is not presented as problematic or contradictory. Collectively, these texts provide the reader with both pleasure and knowledge, which in turn bring 'high and great honour'.[79] Morelli's admonishment to his son to read and study the great Latin and *volgare* writers of the classical and more recent past underlines the importance of the written word. Just as reading is to take place in a structured way on a daily basis, so the texts were seen to bring order to the reader and improve his conduct.

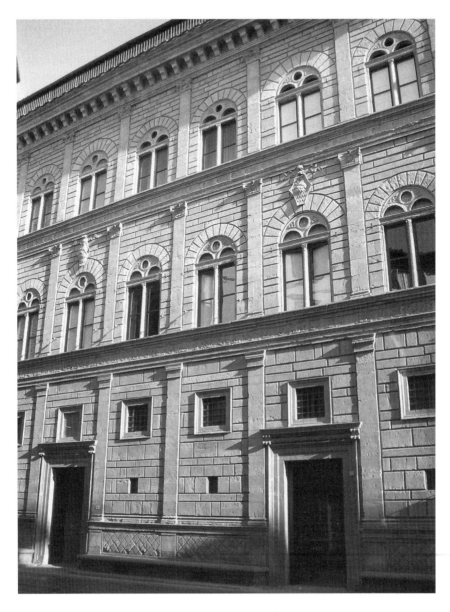

2. Palazzo Rucellai, Florence, 1446–51. Acting architect
Bernardo Rossellino, to Alberti's designs

Occasionally, the impact of such exemplary or didactic texts is demonstrated
by direct quotation or paraphrase in the *ricordanza*. This is notably found in
a lengthy entry from around 1464 in Giovanni Rucellai's *zibaldone* that makes

detailed reference to Cicero's account in *De Officiis* of the palace constructed on the Palatine Hill by Gnaeus Octavius.[80] Here the message of the merits of appropriate palace construction and the rewards bestowed upon its builder, is surely intended to provide a thinly veiled allusion to Rucellai's own palace being built at that time, as well as his political ambition (Illustration 2). Rucellai's ability to find in Cicero a clear application to his own situation points to the importance of such texts to contemporary Florentines. Equally significant is the fact that Rucellai was familiar enough with the classical text to adapt its message to suit his purpose, focusing on the benefits and rewards bestowed upon Octavius' palace – not the potentially problematic account of Scaurus' inappropriate subsequent building project.

Rucellai had clearly read, or had read to him, *De Officiis* and presumably owned a copy of Cicero's text. For those unable to purchase such works, borrowing or receiving a manuscript as a loan was a potential solution. That this was a common method for the assimilation of texts and the ideas contained therein is indicated by the trend for individuals to make their own copies of a work. A number of inventories record the presence of texts by different authors copied out or written in the hand of its owner. These ranged from the Bible to works of Boethius and Sallust and from Dante to Leonardo Bruni.[81]

While certain papers and writings were, as Alberti reminds us in *I libri della famiglia*, designed to remain secret and hidden from outsiders, within the family unit *ricordanze* appear to have been more accessible. As the Morelli, Rucellai and other *ricordanze* confirm, these family memoirs were designed to be read and re-read by future generations. In addition to recording a family's genealogy or key familial events, such memoranda served as an aid for the writer's heirs on appropriate conduct and civility. Both Rucellai and Morelli directly address their sons at certain moments in their *ricordanze*. Just as the classical authors continued to 'speak' to the fifteenth-century readers from their 'holy graves', so too were the *ricordi* and *ricordanze* intended to record key information for the family's future generations. In a period of high mortality and limited life expectancy, recording family history provided a permanent source of memory. The content and style of many *ricordanze* suggest that they may have been read out aloud to the family and close relatives. The possible auxiliary function of *ricordanze* to literally 'speak' to the extended family would have provided an important medium for the dissemination of both familial history and literary textual sources.

The potential for ideas to spread in this way should not be underestimated. The wider importance of an oral tradition for textual sources was well established in Florence and often could be seen in public areas of the city. Readings of diverse texts regularly took place at both the university (*studio*) of Florence as well as the devotional centres of the *Duomo* and *Orsanmichele*.

3. Inventory of Gismondo di Messer Agniolo della Stufa, 1495, detailing part of the impressive book collection listed in the study (scrittoio)

In addition, more 'popular' texts, including satirical jokes and poems (burle e baie) or burlesque fantasies (ghirbizzi), were also read aloud and enacted out in the piazza outside the church of San Martino al Vescovo.[82] The importance of 'popular' texts is further demonstrated by their frequent appearance in

inventories throughout the *quattrocento*. These demonstrate a currency that transcended merely the broad *popolo minuto* class and extended to the private collections of wealthy merchants, doctors and notaries.

The range of such texts was as broad as their general appeal. *Trecento* works such as Giovanni Villani's *Cronica* or the travels of Marco Polo demonstrate their enduring interest by appearing in inventories during the *quattrocento*, while *volgare* verse such as the silk merchant Gregorio Dati's *La Sfera* or the barber-poet Burchiello's *Sonnetti* each attained frequent and regular incunabula printings.[83] The appearance of Dati's *La Sfera* in the 1418 inventory of Cosimo de' Medici's *scrittoio*[84] or Giovanni Betti's *Ghiribizzi* in the 1495 inventory of Gismondo della Stufa is revealing[85] (Illustration 3). Integrated within their extensive collections of classical and religious texts, such works provide a further dimension to the literary exemplars that Morelli instructed his son to study and denote the diverse literary interests of fifteenth-century Florentines.

Alberti may have correctly commented on the general contemporary practice of forbidding women to read their husbands' memoranda, but select examples can also be found of women writing their own *ricordanze*. This could occur out of necessity following the death of a husband or his extended absence away from the home due to business pursuits abroad, but it does suggest that certain high-ranking women had both familiarity with such male dominated *ricordanze* conventions, and the written dexterity to maintain such memoranda. The post-mortem inventory of the wealthy merchant Gismondo della Stufa records two *quadernucci* amongst his extensive collection of literary texts and account books, specifically described as written in the hand of his wife Mona Chaterina. One appears to have been a typical account book recording debits and credits, while the other is described as '*ricordi*'.[86]

Analysis of a range of fifteenth-century inventories from the *Magistrato dei Pupilli* registers confirms the study (*scrittoio, studio*) as the principal domestic space for the storage and consultation of books and other writings.[87] Though presented by Alberti and Decembrio as closed off areas suitable for private contemplative pursuits, both the location and the contents of studies also suggest they could serve as more accessible office spaces.[88] This is most readily demonstrated in the range of account books, *ricordanze* and other writings that are frequently detailed within these spaces. Appropriately ordered within studies, such personal memoranda merged amongst, and became uniquely interconnected with, the classical and vernacular texts that similarly graced the chests and cupboards of the *scrittoi* and *studi*. Here the importance of Alberti's 'sacred and religious' family records accorded closely with Leonello's prescription for the re-reading of literary texts.

The number and type of texts located in the study could vary greatly. The study (*studio*) of the successful physician Maestro Ugolino da Montecatini

(1429), for example, included 115 manuscripts. Of this total just over a hundred were works on medicine or philosophy, 13 were of theological or devotional content, while just one volume was of a secular theme relating to the travels of Marco Polo.[89] Maestro Ugolino's book collection was, in fact, significantly larger than the 115 manuscripts listed in the 1429 inventory. This is demonstrated in a later inventory in the same *Magistrato dei Pupilli* register that records the loan of a further 38 books to a fellow local doctor, Maestro Jacopo da Montecatini, which were kept at the nearby *Ospedale di Lemmo* in Pistoia.[90]

Maestro Ugolino was an important figure in early *quattrocento* Tuscany, serving as court doctor to the lords of Pisa and Lucca, Pietro Gambacorta and Paolo Guinigi.[91] A close friend of the Florentine chancellor, Coluccio Salutati, he taught at the *studio* during the 1390s and eventually established a private practice in Florence shortly before his death in 1425. As the post-mortem inventory confirms, Maestro Ugolino was also an active writer and several texts are cited as being composed by his own hand. Of these, the treatise he composed on the therapeutic powers of natural and artificial baths, the *Tractactus de balneis*, was the most widely read.[92] Completed in 1417, the treatise had a wide circulation during the period and was eventually printed and edited in the sixteenth century.

The extensive book collection of Maestro Ugolino reflects, to a large extent, the interests and requirements of his occupation. Declarations by physicians for the 1427 *catasto* demonstrate a particularly high rate of book ownership, suggesting the importance of literary education and training to the profession.[93] Nevertheless, as with other literate sections of society, doctors and physicians could also demonstrate a range of diverse textual interests. Where Maestro Ugolino showed a secondary interest in religious texts, the *ricordanze* of Maestro Giovanni Chellini da San Miniato records the possession of several classical works. As his account book readily demonstrates, Chellini had a particularly advanced network of connections including extensive contacts with the Florentine elite. The loan of diverse objects seems to have been an integral part of this social network and served to reinforce ties of friendship. Loans of silver plate and other precious objects are, for example, frequently recorded in the *ricordanze* to celebrate prestigious marriages or important political appointments. Books were also regularly the subjects of loans. One entry from 1430 significantly records the loan of Chellini's 'beautiful and new' copy of Leonardo Bruni's translation of Aristotle's *Ethica*:

I record that this day [] of January 1430 I loan my *Ethics*, beautiful and new of tooled (*stampato*) red leather according to the translation of Messer Lionardo Arezzo [Bruni] to Manovello di Dattaro da San Miniato for two months. I gave it to him in my house and his father Abrano brought it to San Miniato. He returned it to me through Dattaro, his brother, this day [] of June 1431.[94]

Along with such entries were also records of loans of medical texts. Particularly frequent in Chellini's *ricordanze* was the loan of different medical volumes to the doctor Maestro Girolamo de Broccardi da Imola.[95] The extent of the loans to Maestro Girolamo indicates a close friendship. One entry from 1456 demonstrates the function served by books in the process of gift giving. Here a newly copied treatise on pestilence is given to reinforce Chellini's relationship with Maestro Girolamo in return for the 'treatment and services' he gave to his youngest son Tommaso.[96]

Something of the value of books as both a commodity and as bearers of knowledge is demonstrated in this entry. The reference to Chellini's Avicenna manuscript being 'more correct' than that of Girolamo de Broccardi's suggests the preoccupation with textual accuracy went beyond mere humanist circles. The language used to describe the loaned Avicenna volumes as 'almost worn' together with the information that Girolamo had borrowed the book before is interesting. In customary meticulous detail, entries elsewhere in the *ricordanza* confirm the book's use and loan on numerous occasions. Age as well as usage may well have contributed to the 'worn' (*stracciato*) state of the Avicenna. Here Chellini's specific reference that the volumes had belonged to his father suggests a familial sentimentality similar to that expressed by Alberti in possessing and keeping the books of one's ancestors.

An insight into the economic value of manuscripts is provided in the *ricordanze* of Francesco Sassetti, general manager of the Medici bank from 1463 until his death in 1490. Begun in 1462, the *ricordanze* consists of a general record of all Sassetti's assets including a list of his books, together with estimates of their value (Illustration 4). Sassetti neatly divides the inventory into a list of his Latin and *volgare* texts. The list of Latin manuscripts predominates, totalling 54 texts with values ranging from 1 florin to the substantial amount of 40 florins estimated for a copy of Saint Augustine's *De civitate dei*, described as 'of antique letters, very beautiful, covered in blue leather.'[97] Other notable texts included a copy of Vitruvius' *De Architectura libri decem* valued at 10 florins, and Cicero's *De Officiis* valued at 5 florins.[98] Just seven vernacular books are listed, each with generally lower estimated values than the Latin texts.[99] The highest value of 10 florins is given for a work by Dante described as 'beautiful, covered in red'. Presumably the 'beauty' of this work, as well as its size, merited a higher estimation than the other Dante listed in the collection that was described simply as very small (*piccholino*) and valued at 1 florin.

As Sassetti's collection demonstrates, the cost of manuscripts could vary greatly. The subject, content and length of the text were potential factors, but so too were more practical issues related to the quality and appearance of the book itself. These included the choice of material used, ranging from expensive vellum to cheaper grades of paper; whether the work was bound or loose-leafed; the degree of decoration; and the skill of the scribe and

4. Account book of Francesco Sassetti, 1462–1472. One folio detailing part of Sassetti's book collection, together with their estimated values

illuminator. Also relevant was whether the book was new or used. As with other decorative goods, the demand for books led to a buoyant second-hand trade in manuscripts. Several inventories from the *Pupilli* registers record booksellers/stationers (*cartolai*) and second-hand dealers (*rigattieri*) acquiring used books from the estates of families. For example, in 1430 the *cartolaio* Francesco di Neri is recorded as purchasing all but two copies from the contents of Giovanni di ser Piero Ciantelini's extensive collection of at least 67 manuscripts for the nominal sum of 72 *lire*.[100]

The decision by Francesco di Neri not to buy the books on the 'Rules of Grammar' and 'Epistles of the Holy Fathers of the Church' is interesting. It would seem to suggest the purchases were made with clearly defined commercial objectives, such as the need to replenish depleted stock, as well as with an appreciation of the texts that would appeal to his customers. The 1426 inventory of the workshop contents of Giovanni di Michele Baldini provides an indication of the books available in one *cartolaio* shop during the first quarter of the century.[101] The range of texts was somewhat limited with a strong focus on school books, including Psalters (*salteri*) and grammars (*alfabeti, donadelli*), as well as popular vernacular texts such as the lives of saints, the travels of Marco Polo and works by Boccaccio. In addition to stocking a number of second-hand books, the workshop functioned as stationers selling different types of notebooks (*quaderni, scartabelli*). The inventory is also instructive for demonstrating the various types of parchment and paper, as well as the different sizes in which books were presented or the quantities in which they were made.[102]

The later inventory of the *cartolaio* Salvestro di Zanobi di Mariano provides a useful comparison with the Baldini workshop. Appraised by the *Magistrato dei Pupilli* in 1496, this inventory records the household contents together with the possessions of the workshop that were apparently stored at the same location.[103] Salvestro died in November 1495, just one month after his father Zanobi di Mariano. A declaration from the 1480 *catasto* confirms that Salvestro assisted in his father's important shop.[104] Since the late 1440s Zanobi had successfully run his *cartolaio* business from different shops rented out by the Badia Fiorentina and located close to the abbey church.[105] The *Pupilli* inventory lists over 290 volumes, of which 80 were recorded as manuscripts and 141 as printed books.

The large number of texts cited, highlights the success of the Mariano shop, as well as the increased importance of printed books. Particularly notable was the potential offered through printing to sell multiple copies of the same work. In the Mariano workshop this resulted in up to 30 copies of the same printed text being listed as stock, while there are never more than two copies cited in manuscript. Like the Baldini inventory the Mariano workshop included a number of popular and devotional texts, but to these were added a range of

classical texts including two manuscripts of Cicero's *De Officiis*, one of which may have been in vernacular translation.[106]

Printing had been introduced to the Italian peninsula from Germany in the years after 1465. Established initially at Subiaco and then in Rome itself, printing presses were also founded in Venice, Foligno and Trevi by 1470. This was followed in 1471 by a marked expansion of presses across Italy in cities such as Florence, Bologna, Ferrara, Milan, Naples, Perugia and Treviso. By the end of the century, printing presses had been established in over 80 cities.[107] While it would be a mistake to interpret the years immediately after the introduction of printing to Italy as stimulating a sudden and dramatic change to the established practices in the book trade, its effect in the middle term was marked. Thirty years after the introduction of printing to the peninsula, the Mariano inventory underlines its impact on the dissemination of the written word.

Analysis of the inventories of both buyers and sellers during the *quattrocento* is informative. If the lists of *cartolai* workshops demonstrate the types of texts that were available for purchase at the time they were compiled, the inventories of private individuals underlines the success of these texts in reaching their audience. Research of the *Magistrato dei Pupilli* registers reflects a diverse ownership of the key texts on magnificence discussed earlier in this chapter. Numerous inventories demonstrate the popularity of the works by Aristotle and Cicero.[108] Although a large number of these fail to specify which text or texts the volume comprised, a range of entries record the presence of Aristotle's *Ethica* and Cicero's *De Officiis*. An early identifiable record of a copy of Aristotle's *Ethica* occurs in an anonymous inventory from 1414 and includes three copies, each of which are described as written in *volgare*.[109] Assuming the date of the inventory is accurate this would predate the 1416 Latin translation by Leonardo Bruni, a copy of which was so highly prized by Giovanni Chellini in 1430.

Further examples of the *Ethica* are found in the inventories of Piero da Filichaia (1439), Antonio di Bartolomeo Corbinelli (1446), Spinello d'Allamanno di Francesco Castellani (1478), and Filippo d'Antonio di Scharlatto Scharllatti (1486).[110] Similarly, in addition to a range of references to Cicero's works, specific copies of *De Officiis* are found in the inventories of Girolamo d'Antonio di Michele Paschualini (1479) and Gismondo di Messer Agniolo della Stufa (1495).[111] The extensive collection of Gismondo della Stufa contained a number of important books, including four additional texts by Cicero, three works by Leonardo Bruni and a copy of Alberti's *De re aedificatoria*.[112]

Inventories from the first half of the fifteenth century suggest that wealth did not automatically lead to the large possession of manuscripts. Notwithstanding its emphasis on medical texts, Maestro Ugolino da Montecatini's collection represented a significant number during this period. Even more substantial,

both in the quantity of texts and their range of subjects, was the extensive book collection of Palla di Nofri Strozzi (1372–1462). According to the 1427 *catasto*, Palla was rated as the wealthiest citizen in Florence by a considerable margin, with a total assessment of 162,906 florins.[113] An inventory from 1431 of his book collection records an incredible 277 texts.[114] The inventory neatly divides the collection up into Latin, Greek and vernacular texts. The great majority of books (242 works) were in Latin, and here the inventory's compiler even went as far as to divide the texts up by author.[115] Works by Cicero numbered 21, including two copies of *De Officiis*, while there were 15 texts of Saint Thomas Aquinas including three different manuscripts of the *Summa Theologiae*.

Also listed were three Latin translations of works by Aristotle including the *Ethica*, as well as two further copies of this text within the works by Leonardo Bruni and Frate Egidius de Roma.[116] The presence of 27 Greek texts is also notable and may be explained by the fact that Palla had studied the language earlier in the century under the Byzantine scholar Manual Chysoloras (1350–1415). The collection contained just seven texts in the *volgare*, including two works by Dante, a book of Sonnets by Petrarch, a book of Morals and Giovanni Villani's *Cronica*.[117]

Palla Strozzi's book collection can be contrasted with that of Gabriello di Messer Bartolomeo Panciatichi (1429).[118] According to the 1427 *catasto*, Gabriello was rated as the fourth richest citizen in Florence with a total assessment of 80,994 florins.[119] Within his study (*scrittoio*) there were just 19 manuscripts. These included classical texts in Latin and *volgare*, popular and devotional texts, a work by Dante, and three books on grammar. Along with Gabriello Panciatichi, other affluent figures from this period, such as Messer Matteo degli Scolari and Salvestro di Simone Gondi, had few or no books listed within their household possessions.[120]

Inventories from the last third of the fifteenth century reflect something of a change in the pattern of book ownership and acquisition. While the *Pupilli* registers do not demonstrate a dynamic general increase in the number of Florentines owning large book collections, they do suggest a closer correlation between wealth, status and books. The inventories of affluent merchants such as Francesco Inghirrami (1471), Gismondo della Stufa (1495) and Lorenzo di Giovanni Tornabuoni (1497), each contained significant numbers of books.[121] Furthermore, these inventories record the presence of a number of printed texts. This would seem to substantiate the ratio of printed texts to manuscripts found in the 1496 Mariano shop inventory, and suggests the marked impact of the printed word on the collections of private individuals.

Additional evidence of the dissemination of the theory of magnificence is strengthened by the incredible success of the writings of Aristotle and Cicero in reaching the printing presses. Analyses of the incunable editions of both authors are particularly illustrative, demonstrating that each achieved an

extensive number of printings within Italy and across Europe in the years to 1501.[122] *De Officiis* was among the first texts to be printed in Mainz in 1465, and of the 66 printed editions, 39 were produced in Italy. The first printed edition of Aristotle's *Ethica Nicomachea* appeared in Straßburg in 1469 according to the Latin translation of Leonardo Bruni. Bruni's translation remained the most popular incunabula version appearing in nine editions, while Janos Argyropoulos' (1415–87) translation was produced six times, including the sole edition printed in Florence around 1480. Of the 26 editions of the *Ethica*, four were printed in Italy.

Examination of inventories, *ricordanze* and *quattrocento* texts, together with incunabula editions that discuss magnificence and splendour, present a persuasive argument for the impact of the written word. The manuscript seller Vespasiano da Bisticci's (1421–98) account of the life of Federico Montefeltro (1422–82), Duke of Urbino, further substantiates this point. Arguing that Federico was 'well versed' in history, the Holy Scriptures and philosophy, he asserts how the Duke studied editions of Aristotle's *Ethica*, and 'would also dispute over the difficult passages.'[123] Bisticci continues, 'after he had heard the Ethics many times, comprehending them so thoroughly that his teachers found him hard to cope with in disputation', he requested during his stay in Florence that the humanist Donato Acciaiuoli (1429–78) comment not only on the *Ethica* but also Aristotle's *Politica*. Notably the account concludes with Bisticci's claim that the Duke 'was ever careful to keep intellect (*ingegno*) and virtue (*virtù*) to the fore, and to learn some new thing everyday'.[124]

Notes

1. Aristotle *Nicomachean Ethics* IV, ii, 1 trans J.A.K. Thomson. London (1953) revised edition (1976): p. 149.

2. Ibid., IV, ii, 1; p.149.

3. Ibid., II, vii, 4–6; p.104. Liberality (*eleutheriotēs*) is the mean between prodigality (*asōtia*) and meanness or illiberality (*aneleutheria*), magnificence (*megaloprepeia*) lies between tastelessness or vulgarity (*apeirokalia, banausia*) and pettiness (*mikroprepeia*).

4. Ibid., II, vi; pp.100–10.

5. Ibid., IV, ii, 3–4; p.149.

6. Ibid., IV, ii, 12–13; p.151.

7. Ibid., IV, ii, 5–6; p.149–50.

8. Ibid., IV, ii, 15–16; p.151.

9. Ibid., IV, ii, 16–17; p.151.

10. *The Illustrated Incunabula Short-Title Catalogue* (1998), lists 26 Latin incunabula editions of Aristotle's *Ethica Nicomachea*, of which 22 were standalone texts. The first printed edition appeared in Straßburg in 1469 according to the 1416 Latin translation by the humanist and chancellor Leonardo Bruni.

11. Cicero's popularity is reflected in the number of incunabula editions recorded in
 The Illustrated Incunabula Short-Title Catalogue (1998). *De Officiis* was one of the first
 texts to be printed in Mainz and Cologne in 1465 and Rome in 1469. Within the
 catalogue are 66 editions of *De Officiis* of which 14 were standalone texts.

12. 'Ataque etiam illae impensae meliores, muri, navalia, portus, aquarum ductus omniaque,
 quae ad usum rei publicae pertinent… tamen haec in posterum gratoria.' Marcus Tullius
 Cicero *De Officiis*, Book II, xvii, 60; trans W. Miller. Cambridge, Mass. (1913): p. 232.

13. 'Habenda autem ratio est familiaris, quam quidem dilabi sinere flagitiosum
 est, sed ita, ut illiberalitatis avaritiaeque absit suspicio; posse enim liberalitate
 uti non spoliantem se patrimonio nimirum est pecuniae fructus maximus.'
 Ibid., Book II, xviii, 64, p. 236. See also Book I, viii, 25, p. 26

14. '…nihil honestius magnificentiusque quam pecuniam contemnere, si non habeas, si
 habeas, ad beneficentiam liberalitatemque conferre.' Ibid., Book I, xx, 68, p. 70

15. 'Et quoniam omnia persequimur, volumus quidem certe, dicendum est etiam, qualem
 hominis honorati et principis domum placeat esse, cuius finis est usus, ad quem
 accommodanda est aedificandi descriptio et tamen adhibenda commoditatis dignitatisque
 diligentia. Cn. Octavio, qui primus ex illa familia consul factus est, honori fuisse accepimus,
 quod praeclaram aedificasset in Palatio et plenam dignitatis domum; quae cum vulgo
 viseretur, suffragata domino, novo homini, ad consulatum putabatur; hanc Scaurus
 demolitus accessionem adiunxit aedibus. Itaque ille in suam domum consulatum primus
 attulit, hic, summi et clarissimi viri filius, in domum multiplicatam non repulsam solum
 rettulit, sed ignominiam etiam et calamitatem.' Ibid., Book I, xxxix, 138, p. 140.

16. Aristotle *Nicomachean Ethics* IV, ii, 12–13; cited above at note 6.

17. The currency of Cicero's text and its importance to fifteenth-century Florentine
 patrons is seen in Giovanni Rucellai's *Zibaldone* (*c.* 1464), fol.63v, where an abridged
 version of Cicero's account of Gnaeus Octavius's palace is provided. Rucellai is
 discussed in greater detail in Chapter 2. See F.W. Kent et al., *Giovanni Rucellai e il
 suo Zibaldone: A Florentine Patrician and his Palace*. Vol. II. London (1981): p. 55.

18. 'Ornanda enim est dignitas domo, non ex domo tota quaerenda, nec domo
 dominus, sed domino domus honestanda est, et, ut in ceteris habenda ratio
 non sua solum…' Book I, xxxix, 139; Miller (1913): pp. 140–2.

19. 'Cavendum autem est, praesertim si ipse aedifices, ne extra modum sumptu et
 magnificentia prodeas; quo in genere multum mali etiam in exemplo est. Studiose enim
 plerique praesertim in hanc partem facta principum imitantur, ut L. Lucilli, summi viri,
 virtutem quis? at quam multi villarum magnificentiam imitati! quarum quidem certe
 est adhibendus modus ad mediocritatemque revocandus. Eademque mediocritas ad
 omnem usum cultumque vitae transferenda est.' Ibid., Book I, xxxix, 140, p. 142.

20. '…ad magnificentiam pertinet ad personam uniuscuiusque, est aliquid parvum in
 comparatione ad id quod convenit rebus divinis vel rebus communibus. Et ideo magnificus
 non principaliter intendit sumptus facere in his quae pertinent ad personam propriam: non
 quia bonum suum non quaerat, sed quia non est magnum – si quid tamen in his quae ad
 ipsum pertinent magnitudinem habeat, hoc etiam magnifice magnificus prosequitur: sicut
 ea quae semel fiunt, ut nuptiae vel aliquid aliud huiusmodi; vel etiam ea quae permanentia sunt,
 sicut ad magnificum pertinent *praeparare convenientem habitationem,* ut dicitur in IV *Ethic.'*
 Saint Thomas Aquinas, *Summa Theologiae* 2a2ae, question 134, article 1, reply to objection 3.
 ed. P. Caramello. Vol. I. Torino (1952): p. 596. See also question 134, article 2; Ibid., p. 597.

21. '…Philosophus dicit, in IV *Ethic*, quod *magnificentia non extenditur circa omnes operationes
 quae sunt in pecuniis, sicut liberalitas: sed circa sumptuosas solum, in quibus excellit liberalitatem
 magnitudine.* Ergo est solum circa magnos sumptus.' Ibid., 2a2ae, question 134, article 3, p. 598.

22. '…Philosophus dicit, in IV *Ethic*, quod *magnificus ab aequali,* idest proportionsto,
 sumptu, opus faciet magis magnificum.' Ibid., 2a2ae, question 134, article 3, p. 598.

23. '…magnos sumptus non possunt facere nisi divites. Sed omnes virtutes possunt
 habere, etiam pauperes…' Ibid., 2a2ae, question 134, article 3, objection 4, p. 598.

24. '…a qua non deficit nec eam exedit…' Ibid., 2a2ae, question
 134, article 1, reply to objection 2, p. 596.

25. '...ad magnificentiam ...pertinet intendere ad aliquod magnum opus faciendum.
 Ad hoc autem quod aliquod magnum opus convenienter fiat, requiruntur
 proportionati sumptus: non enim possunt magna opera fieri nisi cum magnis
 expensis. Unde ad magnificentiam pertinet magnos sumptus facere ad hoc quod
 opus magnum convenienter fiat.' Ibid., 2a2ae, question 134, article 3, p. 598.

26. *The Illustrated Incunabula Short-Title Catalogue* (1998), records 33 separate
 incunabula editions of the *Summa Theologiae* of which 22 were printed in Italy.
 The earliest edition appeared in Straßburg and is dateable to *c.* 1463.

27. On Fiamma see: 'Gualvanei de la Fiamma, "Opusculum de rebus gestis ab Azone,
 Luchino et Johanne Vicecomitibus ab anno MCCCXXVIII usque ad annum MCCCXLII"',
 in *Rerum Italicarum Scriptores*, ed. C. Castiglioni. Vol. XII, part IV. Bologna, 1938; and L.
 Green, 'Galvano Fiamma, Azzone Visconti and the Revival of the Classical Theory of
 Magnificence', *Journal of the Courtauld and Warburg Institutes*, 53 (1990): pp. 100–1.

28. 'Azo Vicecomes considerans se cum ecclexia fore pacificatum, et ab universis hostibus esse
 liberatum, disposuit cor suum, ut domum sibi faceret gloriosam, nam *dixit phylosophus in quarto
 ethicorum*, quod opus magnific est preparare domum decentem.' Castiglioni (1938): pp.15–16.

29. Ibid., p. 16.

30. 'Erunt autem diutiae nobis ornamento: & honori. Id enim est quod Aristhoteles inquit ornate
 per illas sciat. Si sumptus opportune cum decore faciamus, huis partes sunt aedes parare
 diuitiis congruentes: familiam honestam habere, suppellectilem abundantem: equorum
 & uestium decentem apparatum.' Leonardo Bruni's translation of the pseudo-Aristotle
 Economica; modified from G. Griffiths, J. Hankins, and D. Thompson, *The Humanism of
 Leonardo Bruni: Selected Texts*. Binghampton NY (1987): p. 317. The popularity of Bruni's
 version of the *Economica* is demonstrated by the particulary large number of manuscripts
 (at least 245) that survive or are known to be lost. See J. Soudek, 'A Fifteenth Century
 Humanist Bestseller: The Manuscript Diffusion of Leonardo Bruni's Annotated Version
 of the pseudo-Aristotelian Economics', in E.P. Mahoney ed., *Philosophy and Humanism:
 Renaissance Essays in Honour of Paul Oskar Kristeller*. Leiden (1976): pp. 129–43.

31. Leonardo Bruni, *Panegirico della città di Firenze*, ed. G. de Toffol. Florence (1974): pp. 10–14.

32. See B.G. Kohl and R.G. Witt, *The Earthly Republic*. Manchester (1978): p. 123.

33. 'Sive novitatem queris, nichil novis exedificationibus magnificentius
 aut splendidus est.' Toffol (1974): p. 18.

34. 'Quid est in toto orbe tam splendidum aut tam magnificum quod
 cum edificiis huius sit comparandum?' Ibid., p. 20.

35. For Giovanni Pontano's *De liberalitate, De beneficentia, De magnificentia, De splendore,
 De conviventia* (1498) see F. Tateo ed., *I Libri Delle Virtù Sociali*. Rome (1999).

36. '...i casamenti bellissimi, pieni di molte bisognevoli arti, oltre all'altre città
 d'Italia. Per la quale cosa molti di lontani paesi la vengono ad vedere, non per
 necessità, ma per bontà de' mestieri e arti, e per belleza e ornamento della città.'
 La Cronica di Dino Compagni, ed. I. del Lungo. Florence (1924): p. 8.

37. 'Ell' era dentro bene situata e alobergata di molte belle case, e al continovo in questi tempi
 s'edificava, migliorando i lavori di farli agiati e ricchi, recando di fuori belli esempli d'ogni
 miglioramento... e oltre a ciò non v'era cittadino popolano o grande che non avesse edificato
 o che non edificasse in contado grande e ricca possessione, e abitura molto ricca, e con begli
 edificii, e molto meglio che in città... E sì magnifica cosa era a vedere, che i forestieri non usati
 a Firenze venendo di fuore, i più credevano per li ricchi edificii e belli palagi ch'erano di fuori
 alla città d'intorno a tre miglia, che tutti fossono della città a modo di Roma...' Giovanni Villani
 Croniche Book XI Chapter XCIV, ed. I. Moutier and F.G. Dragomanni. Vol.III. Milan (1848): p. 326.

38. 'Non credam Antonium Luschum meum, qui Florentiam vidit, nec aliquem alium,
 quisquis fuerit, si florentinam viderit urbam istam, esse vere florem et electissimam Italiae
 portionem, nisi prorsus desipiat, negaturum. Quaenam urbs, non in Italia solum, sed in
 universo terrarum orbe, est moenibus tutior, superbior palatiis, ornatior temples, formosior
 aedificiis, quae porticu clarior, platea speciosior, viarum amplitudine laetior, quae populo
 maior, gloriosior civibus, inexhaustior divitiis, cultior agris?' *Prosatori Latini del Quattrocento*,
 ed. E. Garin. Milan (1965): p. 34; trans adapted from C. Smith, *Architecture in the Culture of
 Early Humanism: Ethics, Aesthetics and Eloquence 1400–1470*. Oxford (1992): pp. 180–1.

39. '…e simile i palagi de' cittadini che non ha il mondo palagi reali che il vantaggino, e tutta la città è piena di belle e ornate abitazioni.' Dati was a leading figure in the Florentine society of the 1420s. In 1425 he served as *priore*, and in 1428–9 he was elected as *gonfaloniere*. C. Gilbert, 'The Earliest Guide to Florentine Architecture, 1423', *Mitteilungen des Kunsthistorichen Institutes in Florenz*, 14 (1969): p. 46.

40. The principal interlocutors in *De avaritia* are: Cencio Romano dei Rusticci, Bartolomeo da Montepulciano, Andrea of Constantinople and Andrea Loschi. Bracciolini produced a second version of *De avaritia* following advice from his friend Niccolò Niccoli. Both versions obtained wide approval with 12 copies of each version still existing in European libraries, and at least three early sixteenth-century printed editions. See Kohl and Witt (1978): p. 236.

41. 'Nullus enim sere, nisi quantum sibi & familiae suae fuerit satis futurum… Quid enim dabit alteri, cui nihil ad dandum superest. Quomodo munificus esse poterit qui tantum possidet, quantum sibi soli sufficit. Auferetur magnificentia omnis ciuitatum, tolletur cultus atque ornatus, nulla aedificabuntur templa, nulli porticus, artes omnes cessabunt, perturbatio uitae nostrae & rerum publicarum sequetur, si quilibet eo quod sibi satis erit acquiescet.' Poggio Bracciolini *De Avaritia* in R. Fubini ed., *Opera Omnia*. Vol.I . Torino (1964): p. 13; modified from Kohl and Witt (1978): p. 260.

42. 'His enim adeò inoleuit pecuniae cupiditas, ut non vitium, sed virtus putetur auaritia, & quo quis ditior fit, honoretur magis.' Fubini (1964): p. 14; Kohl and Witt (1978), p. 261.

43. 'Nulla in re nocuit auaritia. Adde quod afferunt persaepe magnum ornamentum & decorem suit ciuitatibus. Quot enim (ut vetera omittam) nostris diebus fuerunt magnidicae domus, egregiae uillae, templa, porticus, hospitalia auarorum pecunijs constructa, ut nisi hi fuissent carerent omnino urbes maximis ac pulcherrimis ornamentis.' Fubini (1964): p. 15; Kohl and Witt (1978), p. 263.

44. 'Ben confesso quella antiqua latina lingua essere copiosa molto e ornatissima, ma non però veggo in che sia la nostra oggi toscana tanto d'averla in odio, che in essa qualunque benchè ottima cosa scritta ci dispiaccia… Né posso io patire che a molti dispiaccia quello che per usano…' L.B Alberti *I libri della famiglia* in *Opere Volgari*, ed., C. Grayson. Vol. I. Bari (1960): p. 155; trans R.N. Watkins *The Family in Renaissance Florence*. Columbia (1969): pp. 152–3. Thirteen fifteenth-century manuscripts of *I libri della famiglia*, including a complete copy with the author's revisions in his own hand, survive today.

45. De officio senum erga iuvenes et minorum erga maiores et de educandis liberis; De re uxoria; Economicus; De Amicitia.

46. 'Se l'acquistare ricchezza non è glorioso come gli altri essercizii maggiori… Puossi colle ricchezze conseguire fama e autorità adoperandole in cose amplissime e nobilissime con molta larghezza e magnificenza.' Grayson (1960): p. 141.

47. 'E accade tale ora a fare qualche spesa la quale apartenga allo onore e fama di casa, come alla famiglia nostra delle altre assai e fra molte quella una de'padri nostri in edificare nel tempio di Santa Croce, nel tempio del Carmine, nel tempio degli Agnoli e in molti luoghi dentro e fuori della terra, a Santo Miniato, al Paradiso, a Santa Caterina, e simili nostri publici e privati edificii. Adunque a queste spese che regola o che modo daresti voi?' Grayson (1960): pp. 210–11.

48. '…le spese tutte siano o necessarie o non necessarie, e chiamo io necessarie quelle spese, senza le quali non si può onesto mantenere la famiglia, quali spese chi non le fa nuoce allo onore suo e al commodo de'suoi; e quanto non le faccendo più nuocono, tanto più sono necessarie… Ma le spese non necessarie con qualche ragione fatte piacciono, non fatte non nuocono. E sono queste come dipignere la loggia, comperare gli arienti, volersi magnificare con pompa, con vestire e con liberalità. Sono anche poco necessarie, ma non senza qualche ragione, le spese fatte per asseguire piaceri, sollazzi civili, senza quali ancora potevi onesto e bene viverti.' Grayson (1960): p. 211, modified from Watkins (1969): p. 202.

49. 'Magnificenzia è posta nelle grandi spese dell'opere maravigliose et notabili.' Matteo Palmieri *Della vita civile* ed. G. Belloni. Florence (1982): p. 147.

50. 'non private ma publice, come in edificii et ornamenti di templi, theatri, logge, feste publice, giuochi, conviti.' Ibid., p. 147.

51. 'Le richeze et abondanti facultà sono gli strumenti coi quali i valenti hunomini virtuosamente se exercitono…' Ibid., p. 153.

52. 'Della belleza et ornamento della città.' Ibid., p. 194.

53. '...cose che in nella città sono meno necessarie, ma contengono apparato magiore et amplitudine splendida degli ornamenti civili.' Ibid., p. 194.

54. 'La belleza et singulare ornamento degli edificii prima è posto in ne muramenti publici: contiene la continuata extensione delle alte et fortissime mura della città...gli elevati et superbi palagi, per insigne gloria de' magistrati; contiene la sublimità et notabile magnificentia de' sacrati templi, la conveniente compositione et attissima belleza de' privati habituri...' Ibid., p. 194.

55. 'non il signore per la casa, ma la casa pel signore si vuole et debbe honorare.' Ibid., p. 194.

56. 'Chi seguitasse et volesse assimigliare le magnifiche case de' nobili cittadini merita biasimo se prima non ha agiunte o superate le loro virtù.' Ibid., p. 195.

57. Aristotle *Nicomachean Ethics* IV, ii, 12–13; Thomson (1953): p. 151.

58. Cicero *De Officiis*, Book I, xxxix, 139. See above note 18.

59. 'Troviamo ch'è fanciulli e fanciulle che stanno a leggere, da otto a dieci mila. I fanciulli che stanno ad imparare l'abbaco e algorismo in sei scuole, da mille in milledugento. E quegli che stanno ad apprendere la grammatica e loica in Quattro grandi scuole, di cinquecentocinquanta in seicento.' Book XI, chapter 94, Moutier (1848): p. 324.

60. 'ancora della grandezza e stato e magnificenza del commune di Firenze'. Ibid., p. 323.

61. For a full discussion of schooling in Italy see P.F. Grendler, *Schooling in Renaissance Italy: Literacy and Learning, 1300–1600*. Baltimore (1989). See also R. Black, *Humanism and education in medieval and Renaissance Italy: tradition and innovation in Latin schools from the twelfth to the fifteenth century*. Cambridge (2001).

62. The English 'hornbook' was a first book for children, consisting of a single leaf set in a frame, with a thin plate of semi-transparent horn in front to preserve it. It was known in Italian as: *tavola, carta, quaderno* or *santacroce*.

63. The grammar was not the *Ars minor* of Aelius Donatus, fourth-century Roman grammarian and teacher of Jerome, but a late-medieval Italian compilation known as the *Rudimenta grammatices*, or Rudiments of Grammar. Some editions of the *donato* included vernacular translations after each phrase.

64. On the basis of the 1480 *catasto*, Grendler has estimated an overall male literacy rate for ages 6–14 of 30–33%. See Grendler (1989): pp. 74–8.

65. For a discussion on *ricordanze* and their relationship to other forms of private writings see: A. Cicchetti and R. Mordenti, 'La scrittura dei libri di famiglia', in *Letteratura italiana: Volume terzo La forme del testo; II. La Prosa*. Rome, (1984): pp. 1117–1155.

66. '...ch'egli stava così bene al mercatante sempre avere le mani tinte d'inchiostro.' Grayson (1960): p. 205.

67. '...quasi sempre avere la penna in mano.' Ibid., p. 205.

68. For Venice and the dearth of *ricordanze* see: James Grubb, 'Memory and identity: why Venetians didn't keep ricordanze', *Renaissance Studies*, 8 (1994): pp. 375–387.

69. The *serrata* extended the political class to about 1,100 members, but in so doing created a clearer distinction between the *nobilità* and the *popolo*. Grubb (1994): pp. 375–87.

70. '...iscrivere di nostra nazione e condizione antica e che di noi seguiterà insino potrò e mi ricorderò; ciò per passare tempo e che i nostri cosa ne sappiano, perchè oggiogni catuno si fonda in grande antichità; e però vo' mostrare la verità della nostra.' Giovanni di Pagolo Morelli *Ricordanze*, in V. Branca ed., *Mercanti Scrittori: Ricordi nella Firenze tra Medioevo e Rinascimento*. Milan (1986): p. 103.

71. 'alcune cose apartenente in genere a tutta la casa.' Francesco Guicciardini *Ricordanze* cited in Cicchetti and Mordenti (1984): p. 1138.

72. The relevant passage reads: 'Quando la donna mia fra pochi giorni fu rasicurata in casa mia, e già il desiderio della madre e de' suoi gli cominciava essere meno grave, io la presi per mano e andai monstrandoli tutta la casa, e insegna'li suso alto essere luogo pelle biave, giù a basso essere stanza per vino e legne. Monstra' li ove si serba ciò che bisognasse alla mensa, così per tutta la casa rimase niuna masserizia quale la donna non vedesse ove stesse assettata,

e conoscesse a che utilità s'adoperasse. Poi rivenimmo in camera mia, e ivi serrato l'uscio le monstrai le cose di pregio, gli arienti, gli arazzi, le veste, le gemme, e dove queste tutte s'avessono ne' luoghi loro a riposare.' Grayson (1969): p. 218; trans Watkins (1969): p. 208.

73. 'Solo e' libri e le scritture mie e de' miei passati a me piacque e allora e poi sempre avere in modo rinchiuse che mai la donna le potesse non tanto leggere, ma né vedere. Sempre tenni le scitture non per le maniche de' vestiri, ma serrate e in suo ordine allogate nel mio studio quasi come cosa sacrata e religiosa, in quale luogo mai diedi licenza alla donna mia né sola v'intrasse, e più gli comandai, se mai s'abattesse a mia alcuna scrittura, subito me la consegnasse.' Ibid., p. 219; trans Watkins (1969): p. 209. Later, Alberti reinforces the need to keep papers away from women adding: 'e' secreti e le scritture mie sempre tenni occultissime.' Ibid., (1969): p. 221; trans Watkins (1969): p. 210.

74. 'Et si omnia diligentius exquiras quae ad poliendam rem librariam attinent … His autem rationibus bibliothecam in secretiore domus parte habere par est, cuiusmodi apud Plinium minorem atque cubiculum deprehenditur, qua quidem lectitandos magis libros, ut ipse ait, quam legendos includeret. Caeterum ut non domestici solum, sed ex proximo strepitus arceantur… Igitur omne perpolitum, pavimentum, parietem, contignatione, diligentique ordine locatum intra bibliothecam conspiciatur.' Angelo Decembrio, *De politia litteraria* fols.8v–9r, cited in A. Grafton *Commerce with the Classics: Ancient Books and Renaissance Readers*. Michigan (1997): pp. 29–31.

75. 'In iis Ciceronis omnia volumina, praesertim philosophiae moralis, uno in codice. Et Terentium habeo correctissimum, in locis etiam difficilioribus expositionibus Donati circumscriptum, legoque assidue… Et profecto si mihi quicquam creditis, cum saepe voluminum meorum ordines evolvoque, nam cuiuslibet autoris sui in tegumento nomen apposui, videor tanquam eorum qui scripsere sanctissima quaedam sepulchra contueri…' Ibid., fol.35v, p. 33

76. 'E di poi hai apparato, fa che ogni in dì, un'ora il meno, tu istudi Vergilio, Boezio, Senaca o altri autori, come si legge in iscuola.' Branca (1986): p. 199.

77. '… tuo intelletto cominci a gustare la ragione delle cose e la dolcezza della iscienza, tu n'arai tanto piacere, tanto diletto, tanta consolazione quanto di cosa che tu abbia.' Ibid., pp. 199–200.

78. 'Di questo ti seguirà gran virtù nel tuo intelletto: conoscerai, ispeculando gli ammaestramenti degli autori, quello hai a seguire nella presente vita e sì in salute dell'anima e sì in utilità e onore del corpo… Tu aria in tua libertà tutti i valentri uomini: tu potrai istarti nel tuo istudio con Vergilio… con Boezio, con Dante e cogli altri poeti, con Tulio che t'insegnerà parlare perfettamente, con Aristotile che ti insegnerà filosofia: conoscerai la ragione delle cose, e, se none in tutto, ogni piccola parte ti darà sommo piacere. Istara' ti co' santi profeti nella Santa Iscrittura, leggerai e studerai la Bibbia… e da questa virtù della scienza tu sarai tanto bene ammaestrato e 'nsegnato che non bisognerebbe dire più avanti, chè tutto è di soperchio.' Ibid., pp. 199–200.

79. 'La scienza fia quella che ti farà venire a' sommi e onorati gradi'. Ibid., p. 200.

80. Kent (1981): p. 55 (fol.63v). The significance of this entry is discussed in greater detail in Chapter 2.

81. See for example Charlo di Matteo de lo Scelto (1425) MPAP 158 fol.75v, cited in C. Bec *Les livres des Florentins, 1413–1608*. Florence (1984): p. 158: 1° Dante scritto in charta banbagina di mano di Charlo, fl.3; Ghabriello di Messer Bartolomeo Panciatichi (1430) MPAP 165 fol.436r: iiii° libri grandi in volghare in fogli reali di banbagia iscritti di mano di Ghabriello choverti d'asse cioè la Bibia e la Vita di Giobo e fatti di Troia e altre cose; Giovaniello di Giovanello Adimari (1430) MPAP 165 fol.464r: 1° libro titolato Boezio chon due opere di Salustio in charta banbagina di buona lettera chovertato d'assi chon chuoio rosso imbullettato chon afibiatoi titolato nella choverta di Giovanniello Adimari; Francesco Chambioni (1448) MPAP 169 fol.168r, Bec (1984): p. 182: uno libro con coverte d'ase bianche scritto di mano di Francesco che parla di storie antiche.

82. D.V. Kent, *Cosimo de' Medici and the Florentine Renaissance: the patron's oeuvre*. New Haven (2000): pp. 43–6.

83. For examples of Giovanni Villani see: Messer Matteo degli Scholari (1431) MPAP 165 fol.606v: 1° libro grande choperchiato di chuoio rosso e biancho chiamasi la Chronicha di Giovan[n]i Villani in charta banbagina a quarto serrami; Simone di Matteo di Piero Cini (1485) MPAP 179 fol.93v: 1° libro cioè la Chronacha Fiorentina in charta banbagina. For Marco Polo see: Maestro Ugholino di Giovanni da Montecatini (1429) MPAP 165 fols.192r: 1° libro titolato Marcho Polo. Gregorio Dati's *La Sfera* had 17 incunabula editions, nine of which were printed in Florence (between 1472 and 1500) and Burchiello's *Sonetti* 11 editions, with three printed in Florence (1481, c. 1490, 1495). See *The Illustrated Incunabula Short-Title Catalogue* (1998).

84. Cosimo de' Medici's study is included in the inventory made for the contents of the house of his father Giovanni di Bicci in March 1417 (Florentine style). A total of 63 books are listed in Cosimo's study, although some presumably belonged to his brother Lorenzo (d.1440). Fol.61r–v: *Nello scriptoio di Cosimo*: 'i mappamundi bello'. Dati's *La Sfera* was known as 'il mappamundo' because of the number of maps detailing the known world. For the inventory see: M. Spallanzani ed., *Inventari Medicei 1417–1465 (Giovanni di Bicci, Cosimo e Lorenzo di Giovanni, Piero di Cosimo)*. Florence (1996): pp. 20–21

85. Gismondo di Messer Agniolo della Stufa (1495) MPAP 179 fol.366v: '1° libro di Ghiribizzi di Giovanni Betti choverta rossa'. Gismondo's book collection comprised 58 named texts located in his study (*schrittoio*).

86. Gismondo di Messer Agniolo della Stufa (1495) MPAP 179 fol.367r: '2 quadernucci di mano di m[on]ª Chaterina segnato A uno dare e avere e l'altro di richordi'.

87. Although limited numbers of books can be found in other spaces especially in inventories where no study is listed, the greatest concentration of texts occurs within the *scrittoio* or *studio*.

88. The duality of functions served by the study is discussed in greater detail in Chapter 4.

89. Maestro Ugholino di Giovanni da Montecatini (1429) MPAP 165 fols.191v–192r.

90. Maestro Jacopo di Maestro Antonio da Montecatini (1430) MPAP 165 fol.544r–v.

91. On the career of Maestro Ugolino da Montecatini see K. Park, *Doctors and Medicine in early Renaissance Florence*. Princeton, N.J. (1985): p. 213. For his friendship with Coluccio Salutati see: R.G. Witt, *Hercules at the crossroads: the life, works, and thought of Coluccio Salutati*. Durham, N.C. (1983): pp. 106, 293–4.

92. See: M.G. Nardi, ed. Ugolino da Montecatini: *'Tractatus de balneis'*. Florence (1950).

93. See Park (1985): pp. 191–8.

94. 'Ricordo che a dì [] di gennaio 1430 io prestai la mia eticha bella e nuova di cuoio rosso stampato secondo la traslatatione di Messer Lionardo d'Arezzo a Monovello di Dattaro da Saminiato per due mesi portoglila a Saminiato Abrano suo padre dieglile in casa mia. Rendemela per Dattaro suo fratello a dì [] di giungo 1431.' *Le ricordanze di Giovanni Chellini da San Miniato*, ed M.T. Sillano. Milan (1984): p. 95. It is interesting that Manovello kept the Ethics somewhat longer than the two months Chellini stipulated as the terms for the original loan.

95. On Chellini's loans involving Maestro Girolamo see Sillano (1984): pp. 157, 166, 168, 173, 182, 186, 189, 196, 200, 203, 217.

96. 'Ricordo che a dì 3 d'agosto 1456 io prestai al maestro Girolamo de Broccardi da Imola medico il terzo e 4° d'Avicenna che fu di mio padre legato in asse coverto di cuoio quasi stracciato, il quale altre volte li prestai e rendemelo ch'ora di nuovo me lo domandò in prestanza per parecchi dì perché dice l'à trovato molto corretto e lo suo non è corretto. Portoglilo uno garzone che lui mandò e alora cum esso li mandai il trattato de pestilentia fece maestro Piero da Tosignano acciò che me lo copiazze in carte di cavretto, le quali carte esso comperò per me e io gli rendetti i denari de costo cioè s.24. Di poi gli le donai per medicatura e servigi fece a Tommaso mio.' Sillano (1984): pp. 217–8. Avicenna was a Persian philospher and doctor. Pietro da Tosignano taught medicine in Padua and Bologna during the 1280s, and like Maestro Girolamo was born in Imola.

97. '1° Agostino de civitate dei di lett. anticha bellissimo coperto di chuoio azurro. fl.40'. Libro di inventari e di creditori e debitori di banco di Francesco Sassetti (1462–1472), Archivio di Stato, Florence, Carte Strozziana II, 20, fol.3v. See also A. de la Mare, 'The library of Francesco Sassetti (1421–90)', in C.H. Clough ed., *Cultural Aspects of the Italian Renaissance*. Manchester (1976): pp. 160–201, esp. pp. 172–3.

98. '1° Vetruvio et Chato de Re Rusticha et Marco Varro de agricoltura coperto di rosso. fl.10'; '1 Tulio de offitiis coperto di rosso. fl.5'. Carte Strozziana II, 20, fol.3v.

99. Headed 'libri di volgare', the entries read: '1° Dante bello coperto di rosso. fl.10; 1 Petrarcha coperto di rosso. fl.4; 1 de trionphi coperto di paonazzo. fl.1; 1 de primo bello punico in papiero. fl.1; 1 libro di Tristano in francioxo. fl.1; 1 libro della phisicha d'Aristotele in francioso. fl.3; 1 Dante picccholino. fl.1.' Carte Strozziana II, 20, fol.4v.

100. Giovanni di ser Piero Ciantelini (1430) MPAP 165 fols.389r–92v. Each purchase made by Francesco di Neri is marked with the letter 'C' in the left marginalia, with the following clarification at the bottom of fol.388r: 'Nota che tutti e libri di detta redita

che sono in questo inventario di legiende segnato C sono venduti a Franc[esc]° di Neri chartolaio apare a libro del atore segnato A charte 89, fl – lr.72.' The two manuscripts not purchased by Francesco di Neri were: (fol.389v) 'Reghole di gramaticha del m[aestr]°' and (fol.390r) '1° libro di Pistole di Santi Padri in volghare in charta banbagina in assi'.

101. On the Baldini inventory see A. de la Mare, 'The shop of a Florentine "Cartolaio" in 1426', in B.M. Biagiarelli and D.E. Rhodes, eds., *Studi offerti a Roberto Ridolfi direttore de 'La Bibliofilia'.* Florence (1973): pp. 237–48.

102. The best parchment for books was the skins of young goats (*cavretti*), the finest being from unborn goats (*cavretti non nati*). Also listed in the inventory was '*carte da messali*' or sheepskin. The paper was either '*reali*' and '*mezani*', which unfolded measured 615 × 445 mm and 515 × 345 mm respectively. Mare (1973): pp. 237–48. See also the later *cartolai* inventories of Gherardo and Monte di Giovanni (1476) in G.S. Martini, 'La bottega di un cartolaio fiorentino della seconda metà del quattrocento: Nuovi contributi biografici intorno a Gherardo e Monte di Giovanni', *La Bibliofilia: Supplemento* (1956): pp. 6–82; and Salvestro di Zanobi di Mariano (1496) MPAP 181 fol.34r, also cited in C. Bec, 'Une librarie Florentine de la fin du XVe siècle', *Bibliothèque d'Humanisme et Renaissance*, 31 (1969): pp. 321–332.

103. The contents of the workshop are listed after the household possessions on fol.34r under the heading: 'Nota di chose apartenente a la botegha del chartolaio, che sono al presente in deta chasa'.

104. See *Catasto* (1480), Quartiere di San Giovanni, Gonfalone Vaio, Camioni, vol.1024, fol.347r; cited in M.L. D'Ancona, *Miniatura e miniatori a Firenze dal XIV al XVI secolo: Documenti per la storia della miniatura.* Florence (1962): p. 271.

105. Ibid., p. 270.

106. The differentiation of the two entries for Cicero's *De Officiis* suggests Latin and vernacular manuscripts (fol.34v): 'uno Ttulio, d'Ufiziis, in pena e in banbagina, ¼ foglio, choperto paghonazo' and 'uno Ttulio, De hofizis, in charta buonna e in pena, ¼ choperto mezo'.

107. See B. Richardson, *Printing, Writers and Readers in Renaissance Italy.* Cambridge, (1999): pp. 3–48.

108. Examples include: Tomaso di Bartolo di ser Tino (1425) MPAP 159 fol.60r: 1° libro delle Pistole di Tulio; and fol.60v: 1° libro di Tulio'; Francesco di ser Benozzo (1439) MPAP 171 fol.11r: opere di Tulio; Domenicho d'Antonio Burini (1472) MPAP 173 fol.314r: 1° [] Della virtù e de' vizi sechondo Aristotile in charte banbagine secondo Aristotile.

109. 'ii libri de l'Ethica, in volgare; i libro, Etica e Rettoricha, in volghare.' Anonymous inventory, MPAP 151 fol.134r cited in Bec (1984): p. 150

110. Piero da Filichaia (1439) MPAP 168 fol.518v, Bec (1984): p. 181: i libro detto Eticha d'Aristotile; Antonio di Bartolomeo Corbinelli (1446) MPAP 169 fol.134v, Bec (1984): p. 181: i libro dell' Etica d'Aristotile, in charta di pechora, leghato in asse; Spinello d'Allamanno di Francesco Castellani (1478) MPAP 174 fol.282v, Bec (1984): p. 192: i libro titolato d'Etica d'Aristotile e altro; i libro titolato l'Etica d'Aristotele; Filippo d'Antonio di Scharlato Scharlati (1486) MPAP 180 fol.27v, Bec (1984): p. 205: uno libro di ½ foglio, in pena, dell'Etica d'Aristotile, choperto tutto di panno.

111. Girolamo d'Antonio di Michele Paschualini (1479) MPAP 177 fol.106r: Tulio, De Oficii isiolto, in forma, in [c]harta banbagina; Gismondo di Messer Agniolo della Stufa (1495) MPAP 179 fol.367r: 1° libro leghato in charta pechora, in forma, chiamato De uficis…

112. Gismondo di Messer Agniolo della Stufa (1495) MPAP 179 fol.366v: 1° libro di Messer Glionardo d'Arezzo e titolato Bellu ghattioli; 1° libro in charta banbagina choverta paghonazza chiamato Liorido Aretino a Ant° de gli Albizi; 1° libro leghato in charta pechora in forma chiamato a x Batista Alberti edifichatorio; 1° libro choverta paghonazze in charta pechorina chiamato le Pistole di Tulio; 1° libro leghato pechora in forma chiamato l'Orazione di Cecerone; fol.367r: 1° libro choverte rosse in charta banbagina inpone chiamato le Pistole di Rezente overo di Cecerone; 1° libro choverte paghonazze in charta banbagina titolato Lionardo Aretino; 1° libro avere di charta pechora in prima in charte banbagina la fiquese de Cecerone. See Appendix 2.

113. The second highest assessment was that of Francesco di Simone Tornabuoni with a total of 109,333 florins. On the *catasto* data see the Online *catasto* at www.stg.brown.edu/projects/catasto.

114. For the inventory see: Fiocco, G, 'La biblioteca di Palla Strozzi', in *Studi di bibliografia e di storia in onore di Tammaro de Marinis.* II Vols. Verona (1964): pp. 289–310.

115. The Latin texts numbered as follows: 'Opera M.T. Ciceronis' (21 texts); 'Opera Titi Livii' (6 texts); 'Opera Senece Moralis' (4 texts); 'Opera Leonardi Aretini' (24 texts); 'Opera Virgilii' (8 texts); 'Opera Ovidi' (28 texts); 'Opera Oratii' (7 texts); 'Opera Statii' (7 texts); 'Opera Lucani' (4 texts); 'Opera Iuvenalis (4 texts); 'Opera Persii' (3 texts); 'Opera Francisci Petrarce' (5 texts); 'Opera Sancti Tomme de Aquino' (15 texts); 'Aristotelis' (3 texts); Sanctus Ambrosius (4 texts); Gregorius Papa (2 texts); Albertus Magnus (3 texts); Frater Albertus de Sassonia (2 texts); Frater Egidius de Roma (93 texts). Ibid., pp. 306–309.

116. Ibid., pp. 306–09.

117. The entries for the 'libri volghari' are: 'Uno Centonovelle di Messer G[iovanni] B[occacci]; Una Cronica di Giovanni Villani; Uno Boetio; Uno Ovidio, di Pistole; Uno libro di sonnetti di Messer F[rancesco] P[etrarca]; Dua Danti; Uno libretto di Morali'. Ibid., p. 309.

118. Ghabriello di Messer Bartolomeo Panciatichi (1430) MPAP 165 fols.436r–v. See Appendix 1.

119. Ghabriello's brother, Giovanni appears as the fifth richest citizen with a total assessment of 70,548 florins. Collectively the two brothers accounted for an impressive 1.7% of Florence's total wealth in 1427. See the Online *catasto* at www.stg.brown.edu/projects/catasto; D. Herlihy and C. Klapisch-Zuber, *Tuscans and their Families: A Study of the Florentine Catasto of 1427*. New Haven, 1985.

120. Messer Matteo degli Scholari (1429) MPAP 165 fol.606v had just seven manuscripts located in the space called *Nella detta chamera*, including Giovanni Villani's *Chronica* and a *Fioretto della Bibbia*, tracts of the life of Saint Francis, *De viris illustribus* and one Cicero. Salvestro di Simone Ghondi (1429) MPAP 165 fol.243r–60v had no books listed in the inventory.

121. Franciescho di Baldino Inghirrami (1471) MPAP 173 fols.265r–73v: at least 39 texts; Gismondo di Messer Agniolo della Stufa (1495) MPAP 179 fol.366r–73r: at least 125 texts; Lorenzo di Giovanni Tornabuoni (1497) MPAP 181 fols.146v–150r: at least 90 texts.

122. See *The Illustrated Incunabula Short-Title Catalogue* (1998).

123. Vespasiano da Bisticci ran a highly successful manuscript copying business in Florence whose clients included the Duke of Urbino and Cosimo de' Medici. Upon retirement in 1482 he produced his *Vite*, covering the careers of a number of his patrons and leading contemporaries. The relevant passage reads: 'Ritornando alle lettere, il duca d'Urbino n'ebbe grandissima cognitione, non solo delle istorie et de' libri della Iscrittura sancta, ma egli ebe grandissima notitia di filosofia... Udì da maestro Lazero l'Etica d'Aristotile con comenti et sanza comenti, et non solo l'udì, ma tutti quegli passi difficili gli disputava... Avendo udita l'Etica più volte tutta, intendendola maravigliosamente, in modo che dava fatica al precetore nelle disputationi, udita l'Etica, e non solo intendendola ma sapiendola quasi a mente, si fece legere la Pulitica, et quella vide con grandissima diligentia. Sendo venuto a Firenze nell'aquisto di Volterra, priegò Donato Aciaiuoli che gli piacessi durare fatica, avendo comentata l'Etica, di comentare la Pulitica...' Vespasiano da Bisticci *Le Vite*, A. Greco, ed. Vol. I. Florence (1970): pp. 379–80

124. Attendeva del continovo a fare che lo'ngegno suo et la sua virtù andassi sempre inanzi a imparare ogni dì cose nuove.' Ibid., p. 380

2

Magnificent Architecture

1. The motivation to build: for God, for the city and for oneself

The wealthy Florentine merchant Giovanni Rucellai, writing in 1473 about his vast expenditure on public and private building projects, stated that 'they gave the greatest contentment and greatest satisfaction, since they served in part the honour of God, the honour of the city and the memory of me'.[1] This section discusses the complex motivations that encouraged patrons to build major houses and palaces in Florence, thereby bestowing honour on the city.

As early as 1404 Leonardo Bruni had ascribed the magnificence of the city in his *Laudatio florentinae urbis* (*c.* 1403–4) to its civic, religious and private buildings. As with the classical and medieval *laudes* tradition of which it was a part, Bruni's panegyric elevated the city to be praised above all others: 'Just as these citizens [of Florence] surpass all other men by a great deal in their natural genius, prudence, elegance, and magnificence (*magnificentia*), so the city of Florence has surpassed all other cities in its prudent site and its splendour (*splendore*), architecture (*ornatu*), and cleanliness (*munditia superat*).[2] Although Bruni extols a range of virtues that contribute to Florence's magnificence, a clear emphasis is placed on its 'splendid and magnificent' architecture:

What in the whole world is more splendid (*splendidum*) or magnificent (*magnificum*) as the architecture of Florence? Indeed, I feel sorry for other cities when a comparison is made with Florence. In other places perhaps one or at the most two streets in the entire city are filled with important buildings, while the rest of the town is so devoid of architectural distinction that the townsmen are ashamed to have visitors see these parts. But in our city there is really no street, no quarter that does not possess spacious and ornate buildings. Almighty God, what wealth of buildings, what distinguished architecture there is in Florence![3]

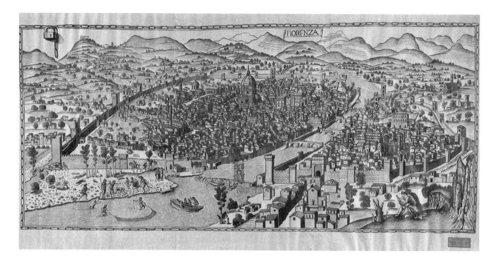

5. Copy of the map known as the *Carta della Catena*,
attributed to Francesco di Lorenzo Rosselli, c. 1480

The chronicler Benedetto Dei reinforced Bruni's description of the magnificence
of Florence's buildings spread throughout the whole city. Writing somewhat
later during the 1470s, Dei composed a list of what he considered to be the
most distinguished buildings in the city. Under the heading 'Fiorenza bella',
Dei wrote: 'Beautiful Florence has built at the time of Cosimo de' Medici and
of Messer Lucca Pitti and of Neri di Capponi and of Messer Giannozo Manetti
33 very grand structures (*muraglie*) of great fame and of very great expense.'[4]
The list that follows mixes religious institutions and private structures from
across Florence in a seemingly random way.[5] Thus the first 'famous structure'
recorded by Dei is the 'cupola of Santa Maria del Fiore' followed by that
made by the '*gran chasa*' of the Pitti family.[6] Despite being mentioned first
under Dei's heading of 'beautiful Florence' the building activity of the Medici
family is listed fourth after the entry citing Santo Spirito, San Lorenzo and
San Marco. Although churches intersperse Dei's list, the overriding emphasis
and focus is placed on the buildings 'made' by its private citizens. Indeed, this
is further emphasized by Dei when he states – after singling out the Medici,
Pitti, Capponi and Manetti – that he was recording the structures for 'their
glory and honour and that of the people of Florence.'[7]

 Bruni and Dei's literary evocation of the diffusion across the city of civic,
religious and private structures is visually reinforced in the topographical
maps produced by Florentine workshops during the period (Illustration 5).
Benedetto Dei was writing at a time when Florence was experiencing a veritable
'building boom' that lasted through to the second half of the sixteenth century.[8]

Around 1545 Benedetto Varchi referred directly to Benedetto Dei's earlier chronicle, which he found provided useful 'details concerning the grandeur and magnificence (*magnificenza*) of the city of Florence.'[9] Based on Dei's writings, Varchi observed that between 1450 and 1478 there were 30 palaces built in Florence 'although today some of them would be better described as large and comfortable houses rather than *palazzi*',[10] together with another 35 older (*più antici*) palaces. To this Varchi added his own list of a further 18 palaces also worthy of mention, 'that have all possible ornamentation (*ornamenti*) and conveniences (*comodità*)',[11] and concluded that 'he who would wish to describe all this…would have too much to do'.[12]

Varchi's comment that the new structures completed between 1450 and 1478 would by his day have been more suitably termed 'large and comfortable houses' is interesting. As early as 1381 Coluccio Salutati had referred to the 'vast palaces' (*immensa palatia*) of Florence,[13] while Gregorio Dati had termed the palaces of the 1420s as royal (*reali*).[14] In fact Benedetto Dei only connects the Pazzi building activity with the word '*palazi*'.[15] The specific reference to *palazi* in the Pazzi entry and its absence elsewhere is perhaps surprising.[16] Constructed in the years immediately preceding the Pazzi Conspiracy of 1478, the Pazzi palace may owe its singular reference to the fact that it represented the most recent palace construction at the time Dei was compiling his list[17] (Illustration 6). In light of the other leading families listed, not least that of the Medici, a wider explanation however appears more probable. It would seem that Dei is not merely referring to the *casa* or house of the leading families of Florence in the literal sense of a familial residence, but also in the wider genealogical sense of a family house or clan (*consorteria*), each with a concentrated presence of properties within their respective *quartiere*.[18] Within many of the entries Dei applies clear distinctions between each family. Thus the Gianfigliazzi are referred to as '*la magnia casa*', while other families including the Medici, Salviati and Rucellai are each referred to as '*la gran casa*'. For the Gianfigliazzi the distinction may rest in a combination of the antiquity of its lineage and the long-standing association the *consorteria* held within its administrative district (*gonfalone*) near the church of Santa Trinità where, since the thirteenth century, members of the clan had resided.

The wider expression of *casa* is important. Across Florence the *consorti* of leading families became inextricably associated with the neighbourhood in which they collectively resided.[19] Again and again the new palaces constructed during the fifteenth century were built within areas already dominated by the family clan. Palaces were often constructed upon sites owned or previously occupied by descendants. While this clearly had a degree of practicality in the sense that its new occupant or occupants would have often inherited the existing property from their forebears, the importance of literally building upon ancestral foundations should not be

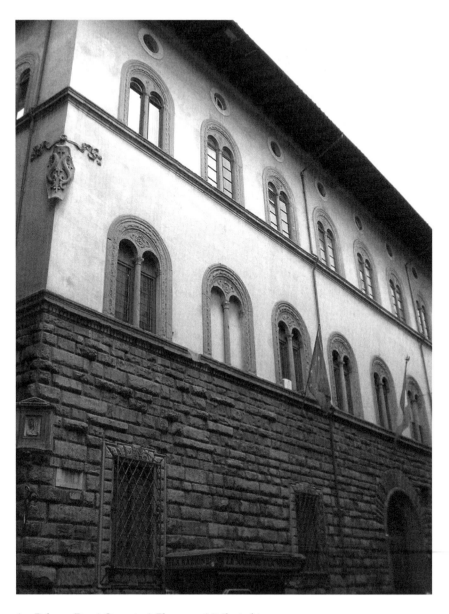

6. Palazzo Pazzi-Quaratesi, Florence. Attributed to
Giuliano da Maiano. Built c. 1458–69

underestimated. Ties with kinsmen or friendship networks could also assist
in acquiring additional sites connected to the ancestral home. Frequently,
palace builders attempted to acquire several further plots or existing

7. Detail of Palazzo Rucellai, Florence, showing the incomplete
eighth bay abutting onto the adjacent property

structures in order to create a larger, more impressive palace. Giovanni
Rucellai's palace united behind one façade eight separate houses,[20] while
the imposing palace built by Filippo Strozzi required the demolition of a

vast site comprising over a dozen properties. Property acquisitions did not, however, always run smoothly. This was true even with sites in the possession of the builder's own *consorteria*, which could sometimes prove problematic and provoke frictions within family networks, as was demonstrated with Giovanni Rucellai's unsuccessful attempt to acquire the property of a certain Giovanni d'Antonio Rucellai that was essential for the completion of a symmetrical eight-bay façade[21] (Illustration 7).

The impact achieved by an imposing corner position that provided an unrestricted view of the façade, was recognized by contemporaries as one of the desirable qualities of the magnificent palace. In Filarete's (*c.* 1400–69) *Trattato di Architectura* (1461–4) it is the position of the recently completed Palazzo Medici at the 'head' of Via Larga which is one of the palace's most notable features: 'First, as you know, it is at the head of the Via Larga. The nobility of this site we shall leave aside. The main street on the other side is most notable. On another side there is another noble street so that streets run on three sides of it'[22] (Illustration 8).

The desire to build exactly upon the ancestral plot could, however, lead its builder to relegate something of the palace's visual impact for the greater significance of its ancestral location. Giovanni Rucellai clearly expressed his desire to live amongst his 'paternal kin (*consorti*), relations (*parenti*) and neighbours (*vicini*) and the rest of the men of the district (*gonfalone*)',[23] despite the full effect of the palace's distinctive *all'antica* façade being restricted by its position along the narrow Via della Vigna Nuova.

In a mercantile society where precise accounting was considered a necessity, the testaments, tax reports and inventories of fifteenth-century Florentines frequently detail the specific fractional amounts by which property and chattels were to be divided among heirs. The principle of birthright in Renaissance Florence was that of partible inheritance, generally through the male line. In contrast to the divisive law of primogeniture practised in much of northern Europe, partible inheritance created a sense of unity by providing a common interest among all the sons, with the shared aim of maintaining the patrimony of the inheritance.

The standard formula in testaments was to bequeath the palace to the owner's direct descendants in the first instance and thereafter to other branches prioritized by closeness to the deceased's own line. Giovanni Rucellai's will of 1465 devoted by far the greatest amount of space to the future ownership of his palace. The *palazzo* was never to leave Rucellai's paternal lineage.[24] In the event that the Rucellai clan became extinct, the palace was to be passed on to the Florentine *commune* though the property was never to be inhabited by anyone of Florentine birth. This last clause suggests that family palaces were perceived as possessing an almost sacred quality analogous to the family chapels patronized across the mendicant churches of Florence.[25] In this sense,

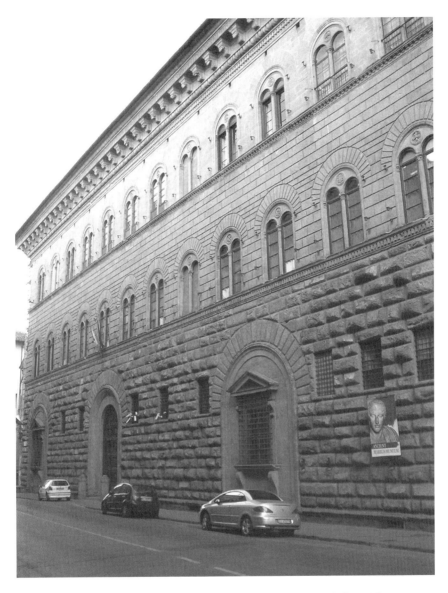

8. Palazzo Medici, Florence, 1444–62. Architect Michelozzo Michelozzi. The original ten bay façade was lengthened to 17 in the early eighteenth century.

the inter-relationship between sacred and religious structures detailed in Benedetto Dei's list of Florence's most notable buildings, may be instructive. Palaces could provide a lasting memory of their patron and his lineage. This was reflected in the 1501 testament of Giuliano Gondi, who insisted that his

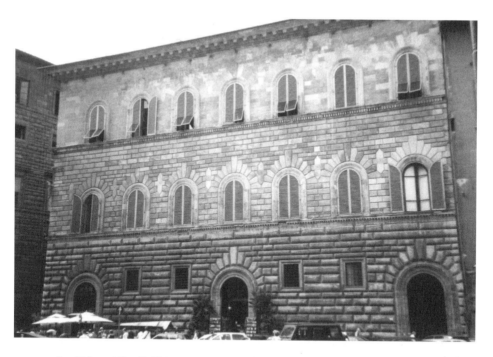

9. Palazzo Gondi, Florence *c.* 1489. Architect Giuliano da Sangallo. The axis and façade on Via de Gondi were added by the family in the late nineteenth century.

palace be completed 'to preserve his memory and for the honour of his sons and the house and family of the Gondi'[26] (Illustration 9). Similar sentiments were expressed by Cosimo de' Medici, who according to Vespasiano de Bisticci was concerned that 'in the lapse of 50 years no memory would remain of his personality or of his house save the few fabrics he might have built.'[27] Giovanni Rucellai's testament expresses the same concern that the occupation of the family palace by anyone outside the wider *consorteria* could erase its builder's reputation.

An attribute of Aristotelian magnificence was to spend money with a 'preference upon results that are long-lasting because they are the finest'.[28] As the testaments of Rucellai and Gondi demonstrate, constructing a family palace could provide a means of leaving its builder an enduring memory. Leon Battista Alberti had acknowledged this attribute of building when he wrote in Book IX of *Decem libri de re aedificatoria* (*c.* 1443–52): 'the need to hand down to posterity a reputation for both wisdom and power is universally accepted (for that reason, as Thucydides said, we build great works so as to appear great in the eyes of our descendants)'.[29] Beyond Alberti's learned reference to the ancient historian Thucydides, the enduring quality of architecture was also

recognized by Florentines of more modest birth, as in the *diario* of the pharmacist Luca Landucci who commented that the grand palace currently being constructed by Filippo Strozzi would, once complete, 'last almost eternally.'[30]

For Florentines, the palace demonstrated a family's history in a concrete form. In this sense, the family palace was closely connected to the specifically Florentine desire to record or appropriate a heritage. The palace, like the *ricordanze* meticulously maintained by so many Florentines during the fifteenth century, recorded the family's current status and social position as well as serving as an exemplar to future generations. Within the pages of *ricordanze* personal and wider family memoirs were inter-connected. Information on matters such as births, marriages and deaths, or appointments to public offices, were included alongside information on property transactions, construction costs and decoration expenses for the palace. The *ricordanze* often included a genealogy of the family, sometimes with biographies of its notable members, with the clear intention of demonstrating the family's honourable, prominent, and, if possible, antique origins.[31] An appropriately constructed palace could reinforce a family's origins and enhance its status within its ancestral neighbourhood, *quartiere* and the whole city.

Few palaces constructed in Florence during the fifteenth century were actually built anew. In Vespasiano da Bisticci's brief reference to the palace constructed by Cosimo de' Medici, it is the fact that the palace was built 'from the foundations' which warranted comment as much as the phenomenal cost of '60,000 ducats'.[32] Clearly the huge expense involved in constructing a new palace left this as a viable option for only the very richest members of Florentine society. Less of a financial burden was to build upon the same foundations as the previous ancestral home or to 're-use' and integrate where possible the existing structure's walls. Financial concerns, however, were not the sole determining factors. To destroy a house that had close connections with its builder's family or *consorteria* was not undertaken lightly. Alberti states in *De re aedificatoria* that 'it is not proper to show disrespect to the work of our ancestors or to fail to consider the comfort citizens draw from their settled ancestral hearths'; adding that he therefore favoured leaving 'all old buildings intact, until such time as it becomes impossible to construct anything without demolishing them.'[33] This view was given further credence by the Medici who elected to keep their existing palace intact and build on a more prestigious site nearby.

The well-known *palazzi* of the Medici, Strozzi and the Pitti are notable examples of palaces built anew from the foundations, but remaining in the *gonfalone* within which the *consorteria* had historical predominance. The palaces of Giovanni Rucellai and Tommaso Spinelli provide examples of the more typical Florentine method of palaces built re-utilizing the existing

walls of several properties, including ancestral sites, united behind a unified façade. The palace acquired by Francesco Nori in 1469 introduces a further example of the way a palace could take on new meanings and histories. Nori represented the class of *gente nuova* in Florence who rose to social and political prominence, to a large extent through their close connection with Lorenzo de' Medici. Although Nori had connections with *via de' Neri* and had acquired a site suitable for a palace on this street, he instead chose to purchase an existing palace a short distance away on *via de' Benci*. The palace Nori purchased was originally built in around 1400 for Alberto di Zanobi and represented the largest structure in the neighbourhood. As has been suggested, Nori's acquisition of an old palace must have been intended to bestow a sense of antiquity and therefore validity upon his own lineage.[34]

A magnificent palace went further than merely distinguishing its builder, family or wider *consorteria*. The Strozzi palace, like the other major palaces constructed during the fifteenth century, embellished, beautified and enhanced the city[35] (Illustration 10). The wide interest generated by the construction of the Strozzi palace is documented in contemporary accounts that refer to the ritual surrounding the laying of the foundation stone on 6 August 1489. The astrologer Benedetto Biliotti, in consultation with, among others, the neo-Platonist Marsilio Ficino, had determined the actual date for the ceremony, while a special medal was cast to commemorate the occasion.[36] The raising of this event to one of almost religious sanctity was reinforced by the fact that during the foundation ceremony, masses were said in several places across the city.[37] Alberti himself cites how the ancients had used astrology and placed great significance on the exact time and moment to commence construction, stating: 'Some advise that construction should not commence until an auspicious occasion, since great importance is attached to the moment in time when anything enters existence.'[38] The diarist Luca Landucci recorded that: 'They began to fill in the foundations, at ten in the morning, here and there; and Filippo Strozzi was the first who began to throw down the gravel and chalk, on this side, together with certain medals.'[39] Another account in the *ricordanze* of Tribaldo de' Rossi describes how Filippo Strozzi allowed him to throw a stone and a coin into the foundations. Rossi was so excited that he went and collected his young son and daughter to witness the event. With Strozzi's permission Rossi made his son also throw in a coin and flowers, while stressing to him the importance of remembering this moment.[40]

Ceremonies such as these allowed citizens to be part of a palace's history. Two weeks after the foundation ceremony for Palazzo Strozzi, Luca Landucci vividly captured the hive of activity around the Piazza Tornaquinci as construction continued. Landucci ran an apothecary shop in the Canto de' Tornaquinci a short distance from the site of the Palazzo Strozzi. His

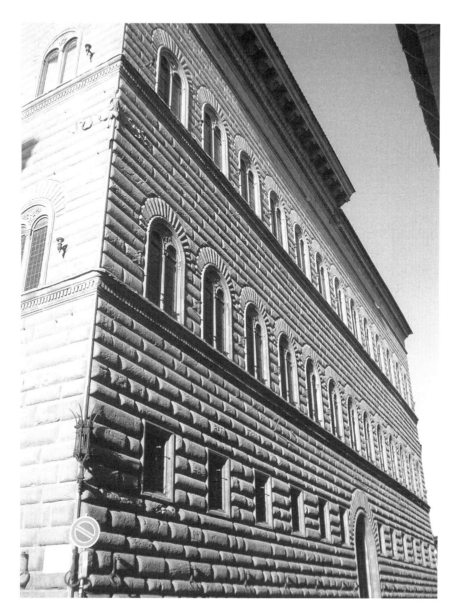

10. Palazzo Strozzi, Florence. Begun 1489, largely complete
by 1523. Architect Benedetto da Maiano

eyewitness account records the 'crowds of people' who continued to come
and see the building work progress, as well as the significant disruption
caused to the area:

And all this time they were demolishing the houses, a great number of overseers and workmen being employed, so that all the streets were filled with heaps of stones and rubbish, with mules and donkeys who were carrying away the rubbish and bringing gravel; making it difficult for anyone to pass along. We shopkeepers were continually annoyed by the dust and the crowds of people who collected to look on and those who could not pass by with their beasts of burden.[41]

During the fifteenth century these scenes must have become a familiar sight to Florentines. Among his references to the construction of the Strozzi palace, Landucci cited a range of on-going building works both within and outside the city. The list included religious sites, the Medici villa at Poggio a Caiano, and the Gondi palace, as well as 'many other houses' currently being built across Florence. All this construction activity led Landucci to comment: 'Men were crazy about building at this time, so that there was a scarcity of master-builders and of materials.'[42] As Iodoco del Badia was the first to point out, this impressive urban development was specifically stimulated by the Florentine *signoria*.[43]

The increase in population stimulated the need for new properties within the city walls. Since religious institutions owned most of the available empty sites within the city, properties were increasingly being constructed outside the city walls, thereby resulting in lost revenue to the *signoria* in gate taxes. In April 1489, legislation was passed which offered tax exemption from the *catasto* for 40 years for any new house built or begun within five years 'in places where there was no house or any beginning of one.'[44] In addition a Papal bull was obtained which aimed to simplify the procedure for selling ecclesiastically owned land for building houses.

Since the *catasto* did not apply to the property the owner lived in, and houses under construction were unable to be taxed as they brought in no revenue, Caroline Elam has argued that the primary aim of the legislation was to increase the construction of new houses intended for rent, not private palaces.[45] Nevertheless, the intent of the 1489 legislation to beautify and enhance the city through the construction of new housing should not be overlooked. As the preamble to the legislation stated, the *signoria* wanted to bring 'much honour to the city making it more beautiful with new buildings.'[46] Certainly the streets singled out by Landucci as areas where numerous new houses were constructed brought significant urban renewal. In this sense the Florentine legislation can be seen to relate to laws passed in other cities that intended to enhance the urban fabric through new construction, and thereby increase its collective magnificence.

In Siena during the fifteenth century the *commune* consistently pursued a policy of urban renewal.[47] Unlike Florence, this programme centred on a specific location: the city's principal street the *Strada Romana*. The importance of the *Strada Romana* to Siena's civic magnificence was demonstrated as early

as 1241 when it was the city's first street to be paved in brick. By the fifteenth century the *Strada* served as the major thoroughfare through the city and into the *Piazza del Campo*. As the major route through which foreigners, visiting dignitaries and pilgrims passed, the street's beauty enhanced the status of the entire city and its citizens. Part of the *commune* programme of urban renewal saw the creation of a new office, the *Ufficiali sopra all'Ornato*, whose purpose was to enforce policies for the enhancement of the city and to stimulate private owners to renew their property.

In 1423 a law was passed that attempted to force owners of derelict houses to restore their properties 'for the honour and order of the city' within six months or face the threat of confiscation.[48] Fuelled by the increase in the population and the resultant need for more housing, a further law was passed in 1471 that provided public subsidies for the restoration of derelict properties that brought 'great dishonour' to the city.[49] Under the common purpose of the 'beautification of the city' (*ornamento della città*), the *Ufficiali sopra all'Ornato* introduced a wide range of provisions. These included zoning regulations that encouraged bankers, goldsmiths, and cloth merchants to concentrate along the *Strada Romana* to increase the sale of Sienese goods, particularly to visitors;[50] and the removal of projecting balconies (*ballatoi*) from buildings that reduced both movement and light along the street.[51] Like the zoning, this latter provision also had the visual impact of visitors to the city in mind in its desire to 'improve the civic image and renew the city's appearance by appropriate and beautiful works' since those entering the city saw this street 'more than any other.'[52]

During the 1480s and 1490s Bologna also experienced a period of urban renewal under the auspices of its political figurehead Giovanni II Bentivoglio 'for the adornment, beauty and honour of the citizens'.[53] Although sporadic plans for renewing the city had been attempted by the Bologna senate in the decades after 1460, it was under Bentivoglio that the programme received its greatest impetus.[54] In a scheme similar to that introduced in Siena, the principal focus were the streets and piazzas that served as ceremonial routes for processions, visiting dignitaries and ambassadors; the Piazza Maggiore and the communal palace, together with the main streets leading from the city gates to Piazza Maggiore.

The programme ranged from the removal of projecting overhangs and wooden stalls to the straightening and rebuilding of streets. Even in a quasi-princely state like Bologna the programme was clearly presented as being initiated for the benefit of the city through the magnificence of its first citizen. Similar messages were presented during the 1490s under Ercole d'Este in Ferrara and Ludovico il Moro in Milan. The underlying intent of the programmes for urban renewal remained consistent within princely and republican cities alike. As Ludovico il Moro's remodelling of the town

of Vigevano was presented, everything was undertaken specifically 'for the city's magnificence and splendour (*magnificentiam splendoremque*).'[55]

In *De re aedificatoria* Alberti eloquently recounts the 'honour' that architecture brings to family and citizens alike. To the reward of the 'honour' gained through building, Alberti also introduces the notion of the 'satisfaction' and 'delight' that architecture bestows upon both the builder and spectator. This was taken up in typically exuberant style by Filarete who described building in the *Trattato di architectura* as 'nothing more than a voluptuous pleasure, like that of a man in love'.[56] For Alberti when building private houses, one can be proud if they have been 'constructed with a little more care and attention than usual.' Here architectural style, through a suitably adorned wall or portico, provides the tangible evidence that personal wealth has been spent appropriately. The decorum of spending was appreciated by Giovanni Rucellai who, referring specifically to his building projects, wrote in his *zibaldone quaresimale*: 'I believe I have given myself more honour and my soul more satisfaction by having spent well than by having earned.'[57] The same point had been made by Alberti that through 'spending well' on architectural projects, its builder enhances his own 'honour and glory', as well as that of his family and descendants and the wider city at large:

> Need I mention here not only the satisfaction, the delight, but even the honour that architecture has brought to citizens at home and abroad? Who would not boast of having built something? We even pride ourselves if the houses we live in have been constructed with a little more care and attention than usual. When you erect a wall or portico of great elegance and adorn it with a door, columns, or roof, good citizens approve and express joy for their own sake, as well as for yours, because they realize that you have used your wealth to increase greatly not only your own honour and glory, but also that of your family, your descendants, and the whole city.[58]

2. Exemplary magnificence: building anew in the antique style

This section discusses how a range of fifteenth and early sixteenth-century theorists praised the building projects of Cosimo de' Medici. A common theme in the acclaim levelled at Cosimo was the appropriate construction of the new Medici palace. Here the Pater Patriae truly served as a worthy successor to the achievements of the builders of the classical past. Central to such claims was the oft-cited connection between the antique magnificence demonstrated by Cosimo and the classical architectural style of the Medici palace.

Tulio in the first [book] called *De Officiis* says that he understands that Gnaeus Octavius, a Roman citizen, obtained the greatest honour by building a most beautiful palace in Rome on the Palatine Hill. And the said Tulio, having to write to his son, who was studying in Athens, in order to inspire him to every

virtue with the examples of the magnanimous and most virtuous men, said this to him, that is: we have heard of the very great honour given to Gnaeus Octavius, Roman citizen, who was made consul of Rome the first one of his family on account of his building of a very beautiful palace made for him on the Palatine Hill; a palace that was imbued with renown and great dignity because it embodied good order and measure, and he understood that this was the reason he acquired very great benevolence and gratitude from the people.[59]

Giovanni Rucellai *Zibaldone quaresimale*

In the above entry dateable to around 1464, Giovanni Rucellai refers at length to Cicero's account in *De Officiis* of the palace constructed by the Roman consul Gnaeus Octavius (see Illustration 1). Rucellai's familiarity with this passage from the classical text went beyond mere transcription. In his interpretation of Cicero's account, Rucellai expands the 'rewards' gained through the construction of Octavius' palace away from that of simply securing votes, to the broader acknowledgement of gaining 'great benevolence and gratitude from the people.' That Rucellai chose to single out these benefits as the results of appropriate palace construction fits in well with the theoretical discussion of magnificence during the fifteenth century. Most explicitly extolled by Leonardo Bruni in his *Laudatio florentinae urbis* (1403–4), the connection between the physical appearance of the city and the virtues of its citizens had become familiar to Florentine readers. As Bruni makes clear, beautiful architecture reflects the magnificence of the city and its citizens, as well as those who build.

The elements from Cicero's account that Rucellai chose to ignore or adapt are as significant as the parts he chose to follow. Rucellai underlines that it is the decorum of the building embodied in its 'good order and measure', which specifically imbued Octavius' palace with 'renown and great dignity'. Not present in Cicero's text, it seems likely that here Rucellai is in fact expanding the classical account to apply to his own palace. Certainly Rucellai was familiar with, and sensitive enough to, Cicero's text to take what was appropriate to his needs and ignore others. This is most readily demonstrated in the absence from Rucellai's entry of any reference to the subsequent demolition of Octavius' palace by Scaurus. A reality of Florentine fifteenth-century palace construction, Cicero's condemnation of Scaurus who destroyed Octavius' palace merely to enlarge his own, must have proved problematic to Rucellai and his contemporary palace builders.

Alberti, the architect of Rucellai's own palace, had warned of over-extravagant building. In Book IX of *De re aedificatoria*, he wrote: 'I notice that the most prudent and modest of our ancestors much preferred frugality and parsimony in building as in any other matter, public or private, judging that all extravagance on the part of the citizen ought to be prevented and checked.'[60] To reinforce his argument, Alberti cited the exemplary actions of emperor

Octavian. In a veritable inversion of Cicero's account of the indecorous and destructive behaviour of Scaurus, Alberti describes how Octavian 'was so upset by over-extravagance in building, that he demolished a villa which was too lavish.'[61]

In the *Trattato di architectura* (1461–4) by contrast, Filarete provides a significant justification for the destruction of existing properties. Book XXV describes in some detail a palace which Francesco Sforza, Duke of Milan, gave 'through his goodwill' to Cosimo de' Medici 'as a sign of the gratitude and friendship' that existed between them.[62] Referred to today as the *Banco Mediceo*, because it housed the Milan branch of the Medici bank, Filarete recounts how Cosimo 'restored and refurnished it and almost built it anew and not at small expense.'[63] In the final remarks on the palace, considered to be 'the most noble in Milan',[64] Filarete suggests that the destruction of the houses opposite is appropriate to the situation and will make the façade appear 'more magnificent':

Also, as I understand, they wish to improve it somewhat more because there are houses opposite the façade that take up much space. For this reason they have bought them in order to raze them, so it will be lighter and more beautiful. This is because they are very close. I do not think that the street is more than 8 *braccia* wide. There is no doubt that as soon as these houses are torn down, the façade [will appear] more magnificent (*più magnifica*) and much more beautiful.[65]

The decorum shown in Rucellai's *palazzo* through its 'good order and measure' acknowledges Cicero's call that 'careful attention' should be paid to a palace's 'convenience and distinction.' For Rucellai and his contemporaries, where Octavius provided an exemplary model, Scaurus provided a check on the aspirations of those who ignored the rules of decorum and built beyond their means. Order and measure underline Rucellai's considered response to Cicero's warning that 'one must be careful, too, not to go beyond proper bounds in expense and magnificence (*magnificentia*), especially if one is building for oneself.'[66]

The Rucellai palace was understood by contemporaries to be inextricably connected with its antique style of architecture (see Illustration 2). Filarete briefly referred to the palace in his *Trattato di architectura* when he wrote of 'the remodelled house in the Via Contrada that is called Via della Vigna' stating that 'the entire façade [is] composed of dressed stone and all built in the antique style (*modo antico*).'[67] Elsewhere in his *zibaldone*, Rucellai demonstrates an awareness of the classical revival that was taking place in the architecture of Florence. In a section headed '*Ricordi e ritratti storici*', Rucellai proudly extols the artistic achievements of his city: 'The city and surrounding area [has] many beautiful churches, hospitals, houses and palaces both within and outside, adorned with very beautiful stones of the Roman manner (*alla*

romanesca), that is they build in the fashion of the ancient Romans (*antichi romani*).'[68] Significantly, it is the architect Filippo Brunelleschi (1377–1446) that Rucellai specifically praises for 'rediscovering' the 'Roman manner of ancient building':

> Filippo di ser Brunellescho, of whom it is said that, since the time the Romans
> ruled the world, there has never been a man so singular in architecture,
> eminent in geometry and perfect master of sculpture; in similar things
> he has the greatest intellect (*ingiengnio*) and imagination (*fantasia*), and
> the Roman manner of ancient building was rediscovered by him.[69]

Filarete further reinforced Rucellai's delight in the achievements of his fellow Florentines in the *Trattato di architectura*, stating: 'I freely praise anyone who follows the antique practice and style. I bless the soul of Filippo di ser Brunellesco, a Florentine citizen, a famous and most worthy architect, a subtle follower of Dedalus, who revived in our city of Florence the antique way of building.'[70] As a fellow architect, Filarete's praise of Brunelleschi is understandable. Indeed, some years earlier in 1436, Alberti had also singled out Brunelleschi by dedicating the *volgare* edition of *De Pictura* (1435) to the master.[71]

Rucellai's praise for Brunelleschi is more surprising. Written by a wealthy patrician, the commendation of the architect rather than the patron who commissioned the building project is unusual. In the later texts written by Paolo Cortesi and Giovanni Pontano, it is the patron, or specifically Cosimo de' Medici, who is personally credited with the revival of a classical style. In his *De Cardinalatu* (1510) Paolo Cortesi wrote: 'in our father's time, Cosimo de' Medici, who initiated the revival of the manner of the ancients in Florence, first used the example of Trajan's forum in planning the decorations of the walls'.[72] In *De magnificentia*, Giovanni Pontano notably considered that Cosimo de' Medici's building projects demonstrated 'antique magnificence' (*priscam magnificentiam*).[73] To qualify this term, Pontano later specifically connected Cicero's account of Gnaeus Octavius to the palaces constructed by Cosimo:

> Cicero writes that Gnaeus Octavius was given much prestige and obtained
> much gratitude from the people for having built a magnificent palace (*domum
> magnificam*). The villas that Cosimo built in many diverse places with extraordinary
> magnificence (*magnificentia*) and the palace, whose construction renewed a most
> antique and nearly forgotten architectural style, greatly enhanced his prestige.[74]

Pontano goes further than Rucellai by specifically delineating the connection between the magnificence of the builders of ancient Rome and those of fifteenth-century Florence. The 'antique magnificence' displayed by Octavius had been revived in Pontano's own day by Cosimo. Like Octavius, Cosimo demonstrated 'extraordinary magnificence' and 'greatly enhanced his prestige' through building. In a similar fashion to Cortesi, Pontano specifically credits

Cosimo with reviving classical architecture. The qualities of this 'most antique' style were cited as virtuous elements of the Medici palace by Flavio Biondo (1392–1463) who wrote in *Italia illustrata* (begun 1447) (see Illustration 8):

Whatever private houses [by Cosimo] which recently had been built on Via [Larga] must be compared to the work of former Roman princes and, certainly, to distinguished ones; indeed I myself, who have achieved some measure of fame from my writings, do not hesitate to state that there are no remains of private princely residences in Rome which display any greater magnificence (*magnificentiam*) than those [of Cosimo].[75]

Through building in the antique style Cosimo added lustre to his reputation and increased his magnificence. Nevertheless architectural style was, as with other areas of magnificence, also subject to the rules of decorum. The later well-known account by Vasari in the *Le Vite* (1550) describes how Cosimo had approached Brunelleschi to obtain a design for the Medici palace. According to Vasari, Brunelleschi made 'a great and very beautiful model'[76] for the project but 'broke the design into a thousand pieces' when he learnt that Cosimo had rejected his plan.[77] The reason Vasari provides for Cosimo's decision is instructive: 'Cosimo, thinking it too sumptuous and great a fabric, refrained from putting it into execution, more to avoid envy than by reason of the cost.'[78] Vasari repeats this account almost verbatim in the Life of Michelozzo, stating that Brunelleschi's design was considered: 'too sumptuous and magnificent (*magnifico*), and more likely to stir up envy among his fellow citizens than to confer grandeur or adornment on the city, or bring comfort to himself.'[79] In the politically sensitive climate of the 1440s, Vasari's claim that Cosimo rejected the design to avoid 'envy among his fellow citizens' seems plausible.

Despite Vasari's assertion that the primary objective of Cosimo's palace was to confer grandeur on the city, the rejection of Brunelleschi's design suggests that private building could also attract criticism. Although the panegyrics and eulogies praising Cosimo and his magnificent building projects predominate, examples of the censure such activities aroused can be glimpsed in a few sources. As Vasari intimates, envy and resentment were common themes of the invectives against Cosimo. In the *Commentarii* of Pope Pius II (completed in 1463) one entry recounts how the 'magnificent' and 'noble' building projects undertaken by Cosimo fell just short of overcoming envy since ultimately 'the people always hate superior worth':

Cosimo, having thus disposed of his rivals, proceeded to administer the state at his pleasure and amassed such wealth that I should think even Croesus could hardly have possessed. In Florence he built a palace fit for a king; he restored some churches and erected others; he founded the wonderful monastery of San Marco and stocked its library with Greek and Latin manuscripts; he decorated his villas magnificently (*magnifice*). It was beginning to look as if by these noble works he had overcome

envy, but the people always hate superior worth and there were some who asserted that Cosimo's power was intolerable and tried in every way to thwart his projects.[80]

Significantly in the uncensored version of Pius' text the entry concludes: 'some also hurled insults at him'.[81] The chronicler Giovanni Cavalcanti (1381– c. 1451) further recorded how verbal insults could develop into more sinister threats. In his *Seconda storia* (1441–7), he recounts how during the construction of Cosimo's new palace, the household awoke one morning to find blood strewn across the front entrance, 'the grievous significance of which there was the greatest murmuring across the city'.[82] Notably, Cavalcanti attributes this action to the wider envy felt towards Cosimo's 'infinite wealth'.[83]

Cavalcanti's *Seconda storia* followed on from his *Istorie fiorentine* that had described the Florentine political climate during the years 1420–41.[84] Though this earlier work is critical of the increase in Medicean ascendancy, it is in the *Seconda storia* that Cavalcanti more explicitly demonstrates wider popular condemnation for Cosimo's political and economic rule. It is significant that Cavalcanti is careful not to implicate himself personally as an active participant in such censure, but rather chooses to portray himself as an interested observer fully aware of the arguments and ill feeling presented against Cosimo:

> The multitude of citizens, no less than the plebeians, directed their anger full of evil and bitterness against the more distinguished citizens… and united by abominable envy of the infinite wealth of Cosimo: for which unjust reasons many complained of his magnificent buildings (*magnifici muramenti*)… He has put his coats-of-arms (*palle*) in monasteries, and now that he has finished building for the friars he has started a palace, by comparison with which the Coliseum of Rome would seem worthless. And others say: Who would not build magnificently (*magnificamente*) with the money of other people? And so all over the city there were many critical sermons and everything was directed angrily towards Cosimo.[85]

Central to Cavalcanti's account of the people's criticism of Cosimo was not only his unparalleled wealth, but also the perception that it was not his to spend. Cosimo was building magnificently with the money of others. Later in the same chapter, Cavalcanti repeats this point when he records that among the grievances of the people was the fact that the 'coffers of the taxes collected at the gates were being emptied to build Cosimo's house'.[86] In Republican Florence, Cosimo's behaviour risked being seen as imitating the actions of princely oligarchs. In this sense it is surely not coincidental that Pius II also chose to challenge Cosimo's unchecked wealth through his building activities, by referring to his palace as being 'fit for a king'.

If assuming the trappings of a modern ruler were considered unacceptable in Republican Florence, emulating the magnificence of ancient leaders proved a useful defence against such criticisms. In several of the eulogies praising Cosimo's magnificence, the humanists used his achievements as

an exemplar to equal or even surpass those of the classical past. In a 1462 letter, Donato Acciaiuoli wrote a eulogy of Florence, praising the wider impact achieved by the beautiful buildings constructed by the citizens. Once again Cosimo's building is specifically mentioned, though here as a worthy successor to the 'kings or emperors' of antiquity: 'Cosimo himself, a most famous man, builds now private homes, now sacred buildings, now monasteries, inside and outside the city, at such expense that they seem to equal the magnificence (*magnificentiam*) of ancient kings or emperors'.[87]

The extent of the potential censure of Cosimo is further suggested in the tract composed between 1454 and 1456 by Timotei Maffei, rector of the Badia at Fiesole. Though written as a defence of Cosimo's architectural patronage its title alone, *In magnificentiae Cosmi Medicei Florentini detractores libellus*, suggests that it was drafted as a retort to existing criticism. In his introduction Maffei acknowledges the existence of critics of magnificence. The text itself is composed in the form of a dialogue between Maffei and an unidentified detractor of magnificence. By taking Saint Thomas Aquinas' *Summa Theologiae* (written before 1273) as his model, Maffei confidently asserts how his carefully constructed defence eventually convinced his accuser of the overriding virtue of Cosimo's magnificence:

The man did not allow me to praise your works for long, or to speak admiringly of you and your magnificent (*magnificis*) achievements, but answered back quite sharply and violently. I realized then that what is always said is actually true, that virtue inevitably brings with it envy, and has always found detractors; but I finally brought him around to your side, as I was hoping, after a long argument.[88]

As with the accounts of Pius II and Cavalcanti, envy is again cited as a common sentiment felt by others towards magnificence. To this Maffei also raises further potential areas of censure. Similarly with Aquinas' *Summa Theologiae*, these are presented as a series of arguments against magnificence that are then followed by a number of replies intended to counter such criticisms. Thus some people, Maffei writes, will condemn Cosimo for excess when they see the scale and expense of the monastery of San Marco. Others will criticize the building that he undertook at San Lorenzo with 'such expense and ornament that no contemporary work of anyone, even a king, should be compared with it.'[89] Others still will attack Cosimo's private palace:

Someone else will perhaps blame him if he goes into his house which has recently been built and sees in this marvellous stone construction the highest and widest walls, tall and sturdy columns, marble statues and wonderful pictures which you would say were by Apelles or Lysippus, the most ornate rooms of his sons Piero and Giovanni, the gilt *solaria* executed with marvellous variety, the cypress benches and other things which seem to suit a Prince rather than a private citizen.[90]

Notwithstanding such criticism Maffei concludes: 'But all these things deserve extraordinary praise and should be recommended to posterity with the utmost enthusiasm.'[91] Even the common practice adopted by many leading *quattrocento* Florentine patrons of placing their coats-of-arms on sacred, as well as private, buildings is turned into a virtuous pursuit when in the hands of Cosimo. Maffei argues that Cosimo's coats-of-arms have been added to ensure that prayers are offered to him by his descendants and to encourage others to undertake similar exemplary building projects.[92] Absent in the *Summa Theologiae*, the reference to the display of coats-of-arms highlights the contemporary relevance of Maffei's text.

Cosimo's palace provided contemporaries with ammunition for both censure and commemoration. To the detractors, of whom Cavalcanti writes, it served as a symbol of anti-republican values constructed with the money of others. To the eulogists, it beautified the city and enhanced Florence's magnificence. Its size and scale were seen as criteria with which to praise the structure, as with Maffei's commemoration of the palace's 'marvellous stone construction the highest and widest walls', but here too precedents for censure could also be found in classical texts. In Cicero's *De Officiis* for example, it was the enlarged and therefore inappropriate size of Scaurus' palace that brought him disgrace and ruin.

If the appropriate construction of the 'highest and widest walls' bestowed magnificence on the city and the builder, it also served as a fortress to resist outsiders. In the 1330s Galvano Fiamma, citing Aristotle as precedent, had demonstrated how a 'dignified house' could counter the very real threat of attack from citizens: 'since the people seeing the marvellous buildings stand thunderstruck in fervent admiration... and from this they judge a prince to be of such power that it is impossible to attack him.[93] Over a century and a half later, Paolo Cortesi evoked Fiamma's words when he wrote in *De Cardinalatu*:

Such [external] decorations of palaces which make them appear attractively designed and sumptuously executed are also to be recommended for reasons of prudence. Thus the ignorant mob will be deterred from threatening the cardinals with harm and from plundering their goods by the mightiness of the building and through admiration for its opulence... On the other hand, when men see cardinals housed modestly, they immediately believe that the palaces are vulnerable to attack and so they think readily of overturning and destroying the cardinal's position in the hope of loot and from [the desire] for perverse liberty...[94]

As an example of the very real threat posed by the populace, Cortesi cites the forced removal of Pope Eugenius IV in 1434 who was 'thrown out of his house by the people because of their contempt for him.'[95] This historically inaccurate account of events is used by Cortesi to underline his general point about the

power of the 'ignorant mob'. Cortesi concludes that: 'in choosing the manner of exterior decoration of the cardinals' palaces, that type should be chosen which will dazzle the eyes of the people by its dignified grandeur, rather than one which will tend to inspire contempt by its modest appearance.'[96]

Renaissance palace building was a delicate balancing act. A palace's façade should be 'attractively designed and sumptuously executed' to avert attack but dignified enough to avoid inciting the envy of the citizens. The significant number of weapons and arms that are listed in several of the extant Medici inventories from the fifteenth century go beyond mere usage for ceremonial or jousting events and reinforce both the potential for attack and the need for defence.[97] For Vasari it is the 'graceful ornaments' of the Medici façade 'which have majesty and grandeur in their simplicity' that distinguishes the palace.[98] If Cortesi's concept of 'opulence' was appropriately restrained in the Medici palace, that of its 'mightiness' or scale was unequivocal and must have overwhelmed contemporaries in a way reminiscent of Fiamma's account. In the fifteenth century the palace dominated the other structures along Via Larga and even today its position on the curve of the road demands attention.

Within the 'Ricordi e ritratti storici' section of his zibaldone, Giovanni Rucellai provides short 'historical portraits' of four Florentine citizens: Filippo Brunelleschi, Leonardo Bruni, Palla Strozzi and Cosimo de' Medici. Rucellai singles out these four figures as citizens who have achieved 'great and dignified fame' in Florence.[99] Leonardo Bruni is described as being so learned in theory (iscienzia) that no one in the whole world was his peer. The longest account is given to Rucellai's father-in-law Palla Strozzi. He is described as of noble blood, learned in all theories and the languages of Latin, Greek and Hebrew, as well as possessing a courteous manner (un'aria gientile). Rucellai also states that he was wealthy, so that no one of this time was his equal, not only in Florence but also in all of Christendom. This wealth – Rucellai is quick to point out – was well acquired. Cosimo de' Medici is also described as extremely wealthy and affluent. A very skilful man (valentissimo huomo) of notable intellect (ingiengnio) the like of which there has never been a higher example in Florence, Cosimo is described as controlling the city and government at his pleasure.

Rucellai's use of the word ingiengnio to describe one of Cosimo's virtues is significant. This term was also repeated in Rucellai's description of Brunelleschi, and its re-use here must have been deliberate. Ingenium was taken up from classical sources in the fourteenth century and was often connected with the related term ars.[100] Where ars was understood as the skill or competence that could be learnt, ingenium was the innate or natural talent that could neither be taught nor trained. By providing both the leading patron and foremost architect of the first half of the fifteenth century with this shared virtue, Rucellai makes an important connection between patron

and architect. For Brunelleschi, however, Rucellai combines his *'grandissimo ingiengnio'* with the term *'fantasia'*.[101] Based on Aristotelian theory, *fantasia* was understood in the fifteenth century to relate to the faculty of imagination. This fundamental distinction is key to Rucellai's artistic theory: where both can possess *ingiengnio*, it is the architect alone who has the capacity to formulate imaginative ideas through his *fantasia* into realizable projects.[102]

It was, however, the *ingenium* of Cosimo de' Medici and his fellow palace patrons, not the architects, who were celebrated as the true builders. The Medici palace and its *quattrocento* successors were understood and interpreted as visual metaphors for the dignity of its owners not the *'ingiengnio e fantasia'* of its architects. Then, as much as today, these great structures were known as the possession of its patron or family. For all the contemporary references to the Medici palace as the *'palazzo di Cosimo'*, the architect Michelozzo Michelozzi (1396–1472) is significantly never mentioned. By the time Vasari composed his *Le Vite* in the mid-sixteenth century, the architect had obtained increased identity. In the Life of the architects Giuliano (*c.* 1443–1516) and Antonio da Sangallo (*c.* 1453–1534), the brothers are credited with bringing honour to themselves and their city. Vasari specifically praises them for advancing the 'Tuscan order of building', embellishing the city and spreading the fame of Florence and its citizens across the peninsular.[103]

The wide recognition of Cosimo de' Medici as the first modern exemplar of magnificence is of fundamental importance. This identification by a range of authors, writing in a range of literary contexts, removes us from mere theoretical discussion. Praise for Cosimo extended beyond his immediate contemporaries to include later writers such as Giovanni Pontano in Naples and Paolo Cortesi in Rome. Cosimo provided a Renaissance model to rival or even surpass the exemplary displays recounted in the classical texts of Cicero and others. Significantly, it is Cosimo's building projects, both public and private, which were frequently portrayed as demonstrative displays of 'modern' magnificence. The ultimate success of the eulogists is emphasized by the fact that even the detractors made the connection between Cosimo and the magnificence of his buildings, the focus of their censure and envy.

3. The principle of decorum in the architectural treatises of Alberti and Filarete

This section concludes with the architectural treatises of Leon Battista Alberti (1404–72) and Antonio Averlino, known as Filarete (c. 1400–69), which demonstrate the importance to the magnificence debate of the concept of decorum in private building.

Leon Battista Alberti's *Decem libri de re aedificatoria* (c. 1443–52) was the first Renaissance text on the art of architecture. Indeed, it was the first text to address architecture as its sole subject since Vitruvius' *De architectura libri decem* (first century BC), rediscovered in manuscript form by Poggio Bracciolini in 1415. As the similarity between the two titles suggest, Alberti made extensive reference to Vitruvius' text, dividing his treatise into ten books and using direct quotations or paraphrases. Notwithstanding the similarities, there are also significant differences and on occasion Alberti is highly critical of Vitruvius' text.[104] Alberti's intention was not merely to quote verbatim, but rather to take it as a model to be both surpassed and re-applied to the concerns of his contemporary audience.

Although Alberti's treatise was not printed until 1486, some 14 years after his death, an original draft was completed by 1452 when a version was presented to Pope Nicholas V. Alberti's contemporaries seem to have readily accepted *De re aedificatoria*, and even before its publication many of his ideas were circulating in Florence and other city-states across the Italian peninsula.[105] Alberti was writing for both patrons and architects alike, and the choice of Latin text over *volgare*, which he had so pointedly used in *I libri della famiglia*, underlines his intention that both the audience and architects should be educated. In *De Officiis*, Cicero had ranked architecture as a discipline equal to medicine or teaching, and therefore a profession 'becoming to a gentleman'.[106] Alberti builds upon Cicero's notion of required intelligence to address the range of skills needed 'if the architect is to succeed in planning, preparing, and executing the work properly and professionally'.[107] Not everyone can undertake architecture. The architect must be 'of the greatest ability, the keenest enthusiasm, the highest learning, the widest experience, and, above all, serious, of sound judgment and counsel'.[108] Alberti states:

> The greatest glory in the art of building is to have a good sense of what
> is appropriate. For to build is a matter of necessity; to build conveniently
> is the product of both necessity and utility; but to build something
> praised by the great, yet not rejected by the frugal, is the province only
> of an artist of experience, wisdom and thorough deliberation.[109]

This principle of appropriateness is a fundamental attribute of magnificent expenditure. For Alberti, 'what is appropriate', or '*quid deceat*', is the underlying theory of building. Vitruvius described *decor* as 'the correct appearance of a work using approved elements and backed by authority'.[110] Known more recognizably as *decorum* to the ancient Romans, the term therefore was understood as the principle of appropriate appearance. Both *decor* and *decorum* share the same root as the verb *decet*, 'it is fitting'.[111] In Book II on 'Materials', Alberti had argued, 'the work should be not only feasible but also appropriate.'[112] Later he states: 'Although modesty (*modestiam*) is generally

expected in private monuments, and magnificence (*magnificentiam*) in public ones, occasionally the latter may also be praised for exhibiting the modesty expected of the former.'[113] Concluding this section, Alberti insists that his reader should consider his 'own social standing as the one who commissions the building' since 'it is the sign of a well-informed and judicious mind to plan the whole undertaking in accordance with one's position in society and the requirements of use.'[114]

In Book IX on 'Ornament to Private Buildings', Alberti argues 'the severest restraint is called for in the ornament to private buildings', although a 'certain license is often possible', which is not permitted in public works.[115] For Alberti 'everything is best when it is tempered to its own importance'.[116] It was preferable that the 'houses of the wealthy were wanting in things that might contribute to their ornament, than have the more modest and thrifty accuse them of luxury (*luxuriem*) in any way.'[117] Alberti acknowledges the desire to decorate private property 'as much to distinguish family and country as for any personal display', arguing further 'who would deny this to be the responsibility of a good citizen?'[118] Nevertheless, 'any person of sense would not want to design his private house very differently from others, and would be careful not to incite envy through extravagance or ostentation.'[119] Here Alberti is arguing for a house to be fitting to the status and class of its builder, recalling Cicero's earlier warning to remain within appropriate levels of expense and display when building for oneself.[120]

The *Trattato di architectura* of Antonio Averlino (*c.* 1400–1469), known as Filarete, was composed between 1461 and 1464. The text was written in Milan and dedicated to the city's leader Duke Francesco Sforza. Filarete was, however, a Florentine by birth, and many of the themes he extols in the *Trattato* reinforce his firmly Florentine outlook. Indeed, Filarete sent another manuscript to Piero de' Medici in Florence. Significantly, this Florentine version had an additional book appended to the end of the original text praising the building projects of Piero's father, Cosimo de' Medici.

The original *Trattato* consisted of 24 books, written in *volgare*, and structured in the form of a dialogue. The major purpose of Filarete's treatise was to instruct, but also to amuse and entertain. As such it served a different function and ambition to the Latin text of Alberti's *De re aedificatoria*. This is reinforced in the preface dedication of the Medici manuscript. Filarete acknowledges that such a work 'ought to be in Latin and not the vulgar'.[121] By not doing so, he argues that his text will be more widely understood,[122] whilst noting there are 'already enough works to be found in Latin by most worthy men'.[123] Filarete therefore requests: 'Such as it is take it not as written by Vitruvius nor by other worthy architects, but by your Filareto architect, Antonio Averlino, the Florentine.'[124]

The dialogue commences at a dining table with Filarete defending the art of building. On the basis of the eloquence of his argument, Francesco Sforza

employs Filarete to construct an ideal city, to be called Sforzinda, and a port known as Plusiapolis. The text is frequently interspersed with anecdotal detail and elaborate digressions, which suggest its intention may have been to be read aloud to the Duke and his court as intellectual entertainment.

In Books XI and XII, Filarete outlines his attempt to design a 'house for each class of persons.'[125] Filarete breaks these classes down to: a gentleman's palace, and the houses of a merchant, an artisan and the poor.[126] Each class of building, Filarete states, 'ought to be in harmony with the inhabitant'.[127] Therefore the ground plan for the gentleman's palace is to be 200 *braccia* in length and 100 in width with 'the qualities and proportions of the Doric, that is large'.[128] Earlier in Book VIII, Filarete had compared the orders of columns to the different classes of society, arguing that the Doric proportions of 2:1 was most suited to the gentleman.[129] For the merchant, representative of Filarete's second class in society, the house should have Corinthian proportions of 3:1 and a plan of 150 × 50 *braccia*. The artisan's house is to be 30 × 50 *braccia*, and have Ionic proportions of 3:5.[130] Just as 'the other houses had their comforts' so too will the house of the artisan 'in its own degree'. Once completed 'it will be beautiful enough for an artisan or other modest person.'[131] Lastly, Filarete discusses the house of the poor, which is to be in a square of 10 or 12 *braccia*: 'A poor man cannot make his house very attractive by himself. He will build in any way he can in order to have shelter.'[132]

Filarete's range of ideal building types takes classical theories of decorum to a new practical level. Though theoretical, the architectural drawings that accompany Filarete's text visually reinforce the concept of building according to one's status.[133] Measurements are precisely related to the type of decoration, while the criteria for these distinguishing factors is inextricably tied to the class of the inhabitant.

During the fifteenth century, both literary and architectural theorists adopted the application and meaning of the principle of decorum. A particularly eloquent definition of the term, together with its intrinsic relationship to *decor*, was provided in Lorenzo Valla's (1407–57) philological treatise *Elegantiarum Libri*:

Decor is a kind of beauty (*pulchritudo*) derived from the suitability (*decentia*) of things and persons to both place and time, whether in action or speech. It also applies to virtues when it is called *decorum*: this refers not so much to virtue itself as to what common opinion considers to be virtuous, beautiful and fitting...[134]

As will be demonstrated in the next chapters, the principles of decorum, magnificence and splendour extended not only to the construction of an appropriate palace, but also the interior decoration and the hospitality to be displayed 'behind the walls of the buildings of Florence'.[135]

Notes

1. '…danno grandissimo chontentamento e grandissima dolcezza, perchè raghuardano in parte all'onore di Dio e all'onore della città e a memoria di me.' A. Perosa ed., *Giovanni Rucellai ed il suo Zibaldone: 'Il Zibaldone Quaresimale'*. Vol.I. London (1960): p. 121.

2. 'Nam quemadmodum ipsi cives naturali quodam ingenio, prudentia, lautitia et magnificentia ceteris hominibus plurimum prestant, sic et urbs prudentissime sita ceteres omnes urbes splendore et ornatu et munditia superat.' Leonardo Bruni, *Panegirico della città di Firenze*, ed. G. de Toffol. Florence (1974): p. 12; trans B.G. Kohl and R.G. Witt, *The Earthly Republic*. Manchester (1978): p. 136.

3. 'Quid est in toto orbe tam splendidum aut tam magnificum quod cum edificiis huius sit comparandum? Pudet me profecto ceterarum urbium, quotiens huius rei comparatio michi venit in mentem. Ille enim, una aut summum duabus viis in tota urbe ornatis, in ceteris omnibus ita ornamentorum vacue sunt ut ab advenis conspici magnopere erubescant. In hac vero nostra nulla est via, nulla urbis regio, que non amplissimis atque ornatissimis edificiis sit referta. Que enim, deus immortalis domorum instructiones, que ornamenta!' Ibid., p. 139.

4. Florentie bella à ffato al tenpo di Chosimo de' Medici e di Messer Lucha Pitti e di Neri di Gino Chapponi e di Messer Giannozo Manetti 33 muraglie grandissime e di gran fama e di grandissima ispesa.' Benedetto Dei La *Cronica dall'anno 1400 all'anno 1500*, ed. R Barducci. Florence (1984): p. 86

5. In the 1540s Benedetto Varchi utilised Dei's chronicle and stated: 'ed anco nel raccontargli poteva tener miglior'ordine di quello che fece.' B. Varchi *Storia Fiorentina*, c. 260, printed in L.G. Lisci, *I Palazzi di Firenze*. II Vols. Florence (1972): p. 803.

6. The first four entries read: 'la famosa muraglia della chupola di Santa Maria del Fiore cho lla palla; la famosa muraglia che ànno fatto la gran chasa de'Pitti in Firenze; la famosa muraglia di Santo Spirito e quella di San Lorenzo e Sa' Marcho; la famosa muraglia che ànno fatto la gran chasa de' Medici in Firenze…' Barducci (1984): p. 86.

7. 'E per gloria e onore di loro e del popolo fiorentino…' Ibid., p. 86.

8. See R. Goldthwaite *The Building of Renaissance Florence*. Baltimore, 1980.

9. 'nel qual sunto egli notò alcune particolarità della grandezza, e magnificenza della città di Firenze'. B. Varchi *Storia Fiorentina*, c. 260, printed in Lisci (1972): p. 803.

10. 'che alcuni di quegli, ch'egli mette per Palazzi, sarebbono tenuti oggi più tosto grandi, ed agiati Casoni, che Palazzi…' Ibid., c. 260, p. 803.

11. The 'ornamentation and conveniences' Varchi singled out were terraces, loggias, stables, courtyards, passages and walls, and wells of fresh water. Ibid., c. 260, p. 803.

12. 'E chi volesse raccontare tutto quello…sarebbe troppo che fare.' Ibid., c. 260, p. 803.

13. Coluccio Salutati *De seculo et religione*, cited in M. Baxandall *Giotto and the Orators*. Oxford (1971): p. 144.

14. C. Gilbert, 'The Earliest Guide to Florentine Architecture, 1423', *Mitteilungen des Kunsthistorichen Institutes in Florenz*, 14 (1969): p. 46.

15. In addition to specifying the Pazzi palace, Dei singled out the family chapel at Santa Croce. The entry reads: 'la famosa muraglia che ànno fatto e Pazzi, e palazi loro, e a Santa Croce el Capitolo;' Barducci (1984): p. 86.

16. In an earlier entry to his chronicle Dei had specifically referred to civic *palazzi* writing 'Florentie bella à 23 palazzi drento alla città, là dove sono e signori e ufiziali e chancellieri e chamarlinghi e provdeitori e notai…' Ibid., p. 79.

17. On the problematic dating of the Pazzi palace see H. Saalman, 'The authorship of the Pazzi Palace', *The Art Bulletin*, 46 (1964): pp. 388–94.

18. Unity within *consorti* is underlined by Dei's use of the plural verb '*ànno fatto*'.

19. Florence was divided into four quarters (Santo Spirito, Santa Croce, Santa Maria Novella, and San Giovanni) each of which was further divided into four administrative districts or *gonfalone*. The city was also divided by parish.

20. Rucellai acquired the first of the properties on the site of his palace in 1428 and the last in 1467. See B. Preyer, 'The Rucellai Palace', in F.W Kent et al. *Giovanni Rucellai ed il suo Zibaldone: A Florentine Patrician and his Palace.* Vol. II. London (1981): pp. 156–7

21. The failure to acquire this site left the palace incomplete with seven bays. The property eventually passed to Giovanni Rucellai's descendants in 1654. Ibid., pp. 159–60, 183–4, 205–6

22. 'Prima, come è noto, egli è in capo della Via Larga, la quale quanto ella sia degnissima lascerò; e dell'altre parti la strada maestra e degnissima, e dalla testa un'altra degna via ancora, sì che dai tre canti la strada corre.' Filarete *Trattato di Architettura* Book XXV, Fol. 190r; A.M Finoli and L. Grassi eds. Vol. I. Milan (1972): p. 696. Today Via Larga is known as Via Cavour.

23. '...de' consorti et de' parenti et de' vicini et del resto degli'uomini del gonfalone.' See F.W. Kent, 'The Making of a Renaissance Patron of the Arts', in F.W. Kent (1981): p. 28.

24. For Rucellai's will see Archivio di Stato, Florence, Notarile Antecosimiano, L 130 (Ser Leonardo di Giovanni da Colle), Testamenti, no.31, fol.3r and 4r. An excerpt from the will is published in Kent (1981): Document XVII p.216. Filippo Strozzi's will provides extensive details for the completion of his palace and its future occupation by his heirs. See R. G. Goldthwaite, 'The Building of the Strozzi Palace: The Construction Industry in Renaissance Florence', *Studies in Medieval and Renaissance History*, X (1973): p. 115.

25. The lavish fresco cycle commissioned by Giovanni Tornabuoni and decorated by Domenico Ghirlandaio in the 1480s provides a notable example. Tornabuoni dedicated his chapel 'to the exaltation of his house and family', cited in F.W. Kent *Household and lineage in Renaissance Florence: the family life of the Capponi, Ginori and Rucellai.* Princeton (1977): p. 252.

26. '...ad preservandum memorium suam et pro honore suorum filiorum et domus et familiare de Ghondis' cited in F.W Kent 'Palaces, Politics and Society' *I Tatti Studies*, 2 (1987): p. 46.

27. 'non aveva perchè, conosciuta la natura della sua città, egli non sarebono anni cinquanta, che del suo né della casa sua non si truoverebbe nulla, se non quelle poche reliquie ch'egli aveva murate...' Vespasiano da Bisticci *Le Vite*, A. Greco, ed. Vol. II. Florence (1976): p. 191.

28. Aristotle *Nicomachean Ethics*, IV, ii, 16–17; trans J.A.K. Thomson. London (1976): p. 151.

29. '...quando posteritati famam cum sapientiae tum etiam potentiae relinquendum omnes assentiamur – eaque re, uti aiebat Tuchidides, magna struimus, ut posteris magni fuisse videamur.' Alberti *De re aedificatoria* Book IX, 1, ed. G. Orlandi. Vol. II. Milan (1966): pp. 781–3; trans J. Rykwert, N. Leach and R. Tavernor, *On the Art of Building in Ten Books.* Cambridge, Mass. (1988): p. 292.

30. A. de Rosen Jervis, trans, *A Florentine Diary from 1450–1516.* London (1927): p. 52.

31. See Giovanni Rucellai who provided in the opening folios of his *Zibaldone* 'notizia della discendenzia della nostra famiglia de' Rucellai' with extensive genealogical information. Cited in Kent (1977): p. 274; Fols.1r–2v. See also the *ricordanze* of Bartolomeo di Tommaso Sassetti. Carte Strozziane V, 1751, fol.185v, which covers the period 1419–33, including on the last folio a detailed account of the deaths of his 'antique' forebears since 1348.

32. 'Fece murare il palagio di Firenze da' fondamenti che montò tra le case comperate, dove lo fondò, et la muraglia, ducati sesanta mila'. Greco (1976): vol. II, p. 189.

33. '...interea dedecet profecto non parcere veterum laboribus et consulere civium commodes his, quae assuetis maiorum suorum laribus capiant; quando et perdere et prosternere et funditus convellere quaeque ubique sunt, ex arbitrio semper relictum sit. Itaque pristina velim serves integra, quoad nova illis non demollitis attolli nequeant.' Book III, 1, Orlandi (1966): pp. 175–7; trans Rykwert (1988): p. 62.

34. Nori was killed in the Pazzi Conspiracy of 1478. For a more detailed discussion of Francesco Nori's acquisition and alterations to Alberto di Zanobi's palace see: B. Preyer, 'Florentine Palaces and Memories of the Past', in G. Ciappelli and P.L. Rubin, eds., *Art, Memory and Family in Renaissance Florence.* Cambridge (2000): pp. 185–6.

35. Palace construction also brought significant economic benefits to the city, stimulating and sustaining the labour market during this period. See Goldthwaite (1980): esp Part II: The Construction Industry.

36. Goldthwaite (1973): p. 113. A similar medal ceremony took place during the construction of the Gondi palace in 1490.

37. Ibid., p. 114.

38. 'At sunt qui admonent bonis initiis inchoandum esse aedificationem: permaximi quidem interesse, quo temporis momento in rerum praesentium numero esse occeperit.' Orlandi (1966): p.167; trans Rykwert (1988): p. 59.

39. Rosen Jervis (1927): p. 48.

40. Translated in R. Trexler *Public Life in Renaissance Florence*. New York (1980): p. 447. The importance of foundation ceremonies is also demonstrated in Rossi's *ricordanze* celebrating the construction of the Palazzo Gondi, where he threw a coin into the foundations.

41. Rosen Jervis (1927): p. 48.

42. Ibid., p. 49.

43. I. Del Badia ed., L. Landucci *Diario fiorentino*. Florence (1883): p. 59.

44. Ibid., p. 59. For the legislation see: Archivio di Stato, Firenze Consigli Maggiori Provvisioni Reg.180, fols.26r–27r, 26 April 1489.

45. See C. Elam, 'Lorenzo de Medici and the Urban Development of Renaissance Florence', *Art History*, 1 (1978): pp. 43–66; and 'Lorenzo's architectural and urban policies' in G.C. Garfagnini, *Lorenzo il Magnifico e il suo mondo: convegno internazionale di studi (Firenze, 9–13 giugno 1992)*. Florence (1994): pp. 357–84. In 1495 the *catasto* was replaced by the *decima*. The *catasto* was levied at 0.5% on the total value of property while the *decima* was at 10% of the income from property.

46. 'volendo procedere in questo caso molto honorevole alla citta faciendola piu bella con nuovi edificii…' Cited Elam (1978): p. 61, note 34.

47. On Siena's programme of renewal see: F. Nevola, *Urbanism in Siena (c. 1450–1512): Policy and Patrons: Interactions between Public and Private*, PhD Thesis, Courtauld Institute of Art, University of London, 1998; and his article, '"Per Ornato Della Città': Siena's Strada Romana and Fifteenth Century Urban Renewal', *The Art Bulletin*, 132 (2000): pp. 26–50.

48. The law appears to have been ultimately unsuccessful, although its reissue in 1444 led to over 200 properties earmarked for restoration being successfully repaired. See Nevola (2000): p. 30.

49. Ibid., p. 30.

50. 12 May, 1452; Ibid., p. 31.

51. 18 December, 1465; Ibid., p. 33.

52. Ibid., p. 33.

53. 'pro ornamento Civitatis Domos…honorifice et laudabiliter reedificent;' cited in G. Clarke, 'Magnificence and the city: Giovanni II Bentivoglio and architecture in fifteenth-century Bologna', *Renaissance Studies*, 13 (1999): p. 406.

54. In 1462 the Bologna senate undertook a programme of major street and piazza paving together with sewer construction that continued in 1470 and 1476. See Ibid., pp. 404–5.

55. 'ad urbanam magnificentiam splendoremque;' cited in R. Schofield, 'Ludovico il Moro and Vigevano', *Arte Lombarda*, 62 (1982): p. 117.

56. 'Non è altro lo edificare se none un piacere voluntary, come quando l'uomo è innamorato…' Book XXV, Fol.192r; Finoli and Grassi (1972): p. 41.

57. The entry appears in the section entitled 'Ricordo del 1464' as follows: 'Et credo che m'abbi facto più honore l'averli bene spesi ch'averli guadagnati et più chontentamento nel mio animo.' Perosa (1960): p. 118.

58. 'Iam vero quantum cives domi forisque non iuverit modo atque delectarit architectura, sed multo quidem honestarit, quid est quod referam? Quis non sibi laudi ascribat, quod aedificarit? Privatis etiam quod habitemus aedibus paulo accuratius constructis, gloriamur. Boni viri, quod parietem aut porticum duxeris lautissimam, quod ornamenta postium columnarum tectique imposueris, et tuam et suam vicem comprobant et congratulantur vel ea re maxime, quod intelligunt quidem te fructu hoc divitiarum tibi familiae posteris urbique plurimum decoris ac dignitatis adauxisse.' Orlandi (1966): p. 13; trans Rykwert (1988): p. 4.

59. 'Tulio nel primo chiamato *De Officiis* dice lui avere inteso essere stato honore grandissimo a Gneo Ottavio cittadino romano per la edificazione d'uno bellissimo palazzo edificato a Roma nel Monte Palatino. E avendo detto Tulio a scrivere al figliuolo, ch'era in istudio atene per inanimarlo alle virtudi con esempli de' magnanimi e virtuosissimi huomini, gli si dice chosi, cioè: Noi avemo inteso essere stato a honore grandissimo a Gneo Octavio ciptadino romano, il quale fu facto consolo di Roma il primo che fossi mai della famiglia sua per chagione della edificazione d'uno bellissimo palazzo facto per lui nel Monte Palatino, lo quale palazzo era pieno di riputazione e di dignità per avere in sè buono ordine e chosa misurata, e intesa che fu chagione di farli aquistare nel populo grandissima benivolenza e grazia.' Kent (1981): p. 55 (fol.63v).

60. 'Apud maiores nostros video pridentissimis et modestissimis quibusque viris vehementer placuisse cum in caeteris rebus et publicis et privatis tum hac una in re aedificatoria frugalitatem atque parsimoniam, omnemque luxuriem in civibus tollendam cohercendamque putasse;' Book IX, 1 Orlandi (1966): p. 779; trans Rykwert (1988): p. 291.

61. 'Postea vero aucto imperio tantum in plerisque omnibus crevit luxuries, praeterquam in Octaviano – nam is quidem sumptuosiore aedificatione gravabatur; quin et villam quoque nimium profuse extructam diruit...' Ibid., Book IX, 1; Orlandi (1966): p. 781; trans Rykwert (1988): pp. 291–2. The classical source for this account is Suetonius' Augustus 72.3, who describes the villa belonging to Octavian's grand-daughter Julia. Alberti also cites the example of Valerius: 'Valerius Romae cum in Esquiliis domum haberet altissimam, invidiae vitandae causa diruit et in plano aedificavit.' Ibid., Book IX, 1 (1966): p. 781.

62. '...donò per la benevolenza e segno di gratitudine e anche per l'amicizia che era tra lui.' Book XXV, Fol.190v; Finoli and Grassi (1972): p. 698.

63. '...l'ha ristaurata e riallustrata e quasi come di nuovo fatta. E non con piccola spesa...' Ibid., Book XXV, Fol.190v; p.699. The *Banco Mediceo* was given to Cosimo de' Medici on 20 August, 1445 and stood in the Via dei Bossi. The structure has been so radically altered since the *quattrocento* that Filarete's drawing on fol.192r provides the most complete evidence of its appearance.

64. '...la detta casa è degnissima a Milano;' Ibid., XXV, Fol.192r; p.703.

65. '...la detta casa è degnissima a Milano; e ancora, secondo intendo, la vogliono migliorare, e ancora assai più, perchè vi sono case al dirimpetto della facciata, le quali molto l'occupano. E per questo l'hanno comprate, per gittarle in terra, acciò che sia più bella, perchè gli sono molto propinque, chè non credo che sia la strada larga oltr'a otto braccia. Sì che non è dubbio che ogni volta che le dette case saranno in terra, quella mosterrà più magnifica e molto più bella la detta facciata.' Ibid., XXV, Fol.190v; p.703; trans J.R. Spencer *Filarete's Treatise on Architecture*. Vol. II. New Haven (1965): p. 328.

66. 'Cavendum autem est, praesertim si ipse aedifices, ne extra modum sumptu et magnificentia prodeas.' Cicero *De Officiis*, Book I, xxxix, 140; trans W. Miller. Cambridge, Mass. (1913): p. 143. See also Chapter 1, section 1.

67. The entry reads: '...intra gli altri una casa fatta in via contrada nuovamente, le qual via si chaima la Vigna, tutta la facciata dinanzi composta di pietre lavorate, e tutta fatta al modo antico.' Book VIII, fol.59r; Finoli and Grassi (1972): pp. 227–228.

68. 'La cipttà e contado molto più bello chiese, spedali, chase e palazi dentro e di fuori con bellissimi addornamenti di conci alla romanesca, cioè al modo facievano gli antichi romani.' Perosa (1960): p. 69.

69. 'Filippo di ser Brunellescho, che si dicieva dal tenpo ch'è Romani signioreggiorono il mondo in qua non fu mai più sì singhulare huomo d'architettura di lui e sommo in gieometria e perfetto maestro di scoltura; e in simile chose aveva grandissimo ingiengnio e fantasia, e lle muraglie antiche alla romanescha furono ritrovate da llui.' Ibid., p. 55.

70. 'Lodo ben quegli che seguitano la practica e maniera antica, e benedico l'anima di Filippo di ser Brunellesco, cittadino fiorentino, famoso e degnissimo architetto e sottilissimo imitatore di Dedalo, il quale risuscitò nella città nostra di Firenze questo modo antico dello edificare...' Book VIII, Fol.59r; Finoli and Grassi (1972): p. 227.

71. In the dedication to Brunelleschi, Alberti writes: 'mi piacerà rivegga questa mia opera 'de pictura' quale a tuo nome feci in lingue Toscana.' The other artists Alberti mentions are Donatello, Ghiberti, Luca della Robbia and Masaccio. Alberti *De pictura*, trans C. Grayson. London (1972, repr 1991): pp. 34–5 and 97.

72. 'Siquidem patrum memoria Cosmus Medices, qui auctor Florentiae priscorum symmetriae renouandae fuit, primus Traiani fori modulo est in ornandorum parietum descriptione usus.' K. Weil-Garris and J.F. D'Amico *The Renaissance Cardinals Ideal Palace: A Chapter from Cortesi's 'De Cardinalatu'* Rome (1980): p. 86.

73. 'Aetate nostra Cosmus Florentinus imitatus est priscam magnificentiam tum in condendis templis ac villis, tum in bybliothecis faciendis.' *Giovanni Pontano I libri delle virtù sociali* ed F. Tateo. Rome (1999): p. 188.

74. 'Refert Cicero multum contulisse auctoritatis et gratiae inter cives C. Octavio, quod domum magnificam aedificasset. Ad Cosmi auctoritatem addidere plurimum tum villae diversis in locis ab ipso aedificatae singulari cum magnificentia, tum domus, in qua condenda pervetustum atque obliteratum iam structurae morem modumque revocavit...' Ibid., p. 190.

75. 'Quid quod privatae aedes suae [Cosimo's] recens in via lata extructae, Romanorum olim principum et quidem primariorum operibus comparandae sunt: quin ego ipse, qui Roman meis instauravi scriptis, affirmare non dubito nullius extare privatia edificii principum in urbe Romana reliquias, quae maiorem illis aedibus prae se ferent operas magnificentiam.' H. Burns, 'Quattrocento Architecture and the Antique: Some Problems,' in R.R. Bolgar ed., *Classical Influences on European Culture, A.D. 500–1500.* Cambridge (1971): p. 273. Two incunabula editions including *Italia illustra* exist: one printed in Rome *c.* 1474 and another in Verona 1481–2. See *The Illustrated Incunabula Short-Title Catalogue.* Second edition (1998).

76. '...gli fece un bellissimo e gran modello per detto palazzo;' Giorgio Vasari, Vita di Filippo Brunelleschi in *Le Vite de' più eccellenti pittori scultori e architettori*, ed. P.D. Pergola et al. Vol. II Milan (1962): p. 281.

77. 'Ma intendendo poi la resoluzione di Cosimo, che non voleva tal cosa mettere in opera, con isdegno in mille pezzi ruppe il disegno.' Ibid., p. 281.

78. 'parendo a Cosimo troppo suntuosa e gran fabbrica, piú per fuggire l'invidia che la spesa, lasciò di metterla in opera.' Ibid., p. 281.

79. '...troppo suntuoso e magnifico e da recargli fra i suoi cittadini piutosto invidia che grandezza o ornamento alla città o comodo a sé;' Giorgio Vasari 'Vita di Michelozzo Michelozzi'. Ibid., p. 332.

80. 'Cosmas deinde sublatis emulis pro suo arbitrio rem publicam administravit, easque opes accumulavit, quales vix Croesum possedisse putaverim. Aedificavit in urbe palacium rege dignum, ecclesias alias instauravit, alias a fundamentis erexit; monasterium Sancti Marci miro construxit opere, in quo bibliothecam Gręcis ac Latinis voluminibus refersit; villas magnifice adornavit. Videbatur iam praeclaris operibus invidiam superasse, sed populi excellentem virtutem oderunt: inventi sunt, qui Cosme ferendam negarent, eiusque conatibus multis modis obviam irent.' *PII Secundi Pontificis Maximi Commentarii*, I. Bellus and I. Boronkai eds. Budapest (1993): p. 119; trans in *The Commentaries of Pius II*, ed. F.A. Gragg. London (1960): p. 162.

81. 'et quidam probra in eum iacerent'. Ibid., p. 119; trans Gragg (1960): p. 162.

82. 'Onde, di notte tempo, gli fu tutto l'uscio avviluppato di sangue: della quale così dolorosa stificanza ne fu grandissimo mormorío per la Città.' Giovanni Cavalcanti *Istorie fiorentine* Book II, chapter XXXIII; in F. Polidori ed., *Istorie fiorentine scritte da Giovanni Cavalcanti*. Vol.II. Florence (1838–9): p. 211 and also pp.111–12.

83. '...maledetta invidia delle infinite ricchezze di Cosimo.' Ibid., p. 210.

84. A member of the magnate class, Cavalcanti was forced into debt because of what he considered unjust taxes, spending over a decade from 1429 in Le Stinche prison, where he composed much of the *Istorie fiorentine*. On Cavalcanti see: M.T. Grendler, ed., *The 'Trattato politico–morale' of Giovanni Cavalcanti (1381–1451): A critical edition and interpretation.* Geneva, 1973; and D.V. Kent, 'The Importance of Being Eccentric: Giovanni Cavalcanti's View of Cosimo de' Medici's Florence', *Journal of Medieval and Renaissance Studies*, 20 (1979): pp. 101–32.

85. 'Avendo la moltitudine de' cittadini, non meno che la plebe, le loro ire, piene di fellonesche amaritudini, verso i maggiorenti addirizzate; ... congiungnendole colla maledetta invidia delle infinite ricchezze di Cosimo: dalle quali così inique cagioni da molti erano compianti i sì magnifici muramenti; ...Egli ha pieno per insino i privati de' frati delle sue palle; ed ora che non c'è più da murare fratesamente, ha cominciato un palagio, al quale sarebbe a lato il Culiseo di Roma disutile. Ed altri dicevano: Chi non murerebbe magnificamente, avendo a spendere di que' danari che non sono suoi? E così per tutta le cose erano rivolte iratamente verso Cosimo.' Polidori (1838–9): p. 210.

86. 'E con questi cotali rimbrottamenti, aggiungevano, come le casse delle Porte s'andavano a votare a casa di Cosimo'. Ibid., p. 211.

87. 'Cosmus ipse clarissimus vir, nunc privatas domos, nuc sacras edes, nuc monasteria, tum in urbe tum extra urbem tot tantisque sumptibus condit, ut antiquorum vel imperatorum vel regum magnificentiam equare videantur.' Florence, Biblioteque Nazionale, MS Magl. VIII, 1390, fol.48; cited in A. Brown, 'The humanist portrait of Cosimo de' Medici, pater patriae', *Journal of the Warburg and Courtauld Institutes,* 24 (1961): p. 193. The letter was written on behalf of the successful manuscript seller, Vespasiano da Bisticci, to Alsonso da Palencia.

88. 'Non est diu passus homo ille me tua opera commendantem: et de magnificis rebus tuis magna cum tui laude loquentem. Caeterum cum stomacho et acutule quidem ad multa respondit. Tum verum esser novi quod in sapientissimorum hominum ore versatur: virtutis scilicet comitem semper invidiam extitisse: et multas eam continue obtrectatores habuisse. Tandem post multos congressus eum, uti optabam, tibi amicum feci.' A.D. Fraser Jenkins, *Timoteo Maffei's 'In Magnificentiae Cosmi Medicei detractors' and the problem of patronage in mid-fifteenth century Florence.* MPhil Thesis, Warburg Institute, University of London (1969): p. 12 and p.30.

89. 'Condemnabunt alii forte Laurentii Martyris templum: quod illud tot impensis, tot ornamentis inceperit: ut nullius etiam Regis opus hoc nostro tempore cum illo sit conferendum.' Ibid., p. 17 and pp. 33–4.

90. The relevant section reads: 'Obiurgabit eum fortassis et alius: cum domum illius nuper extructam ingredietur: videritque in eo miro ordine lapideo et altissimos et latissimos muros, crassiores procerasque cloumnas, marmoreas statuas, pictures egregias quas Appellis dicers seu Lysippi, ornatissima Petri et Ioannis filiorum cubicula, solaria inaureata, miraque excisa varietate, scamna cypressina, et reliqua, quae Principi magis quam privato civi convenire videantur.' Ibid., pp. 16–17 and p. 33.

91. 'Haec omnia tamen incredibili sunt laude digna: et quae posteritati summo studio commendari mereantur.' Ibid., p. 17 and p. 34.

92. 'Porro cum haec ita se habeant: existimandum est eum sua signia suis structis infixisse: vel ut posteri memores eius inter orandum pro eo deo preces effundant: vel ut ea visuris, ad aedificia huiusce modi extruenda incitamento sint.' Ibid., p. 20 and p.36.

93. C. Castiglioni ed., *Rerum Italicarum Scriptores.* Vol. XII, part IV. Bologna, 1938, trans. L. Green, 'Galvano Fiamma, Azzone Visconti and the Revival of the Classical Theory of Magnificence', *Journal of the Courtauld and Warburg Institutes,* 53 (1990): p. 101.

94. Weil-Garris and D'Amico (1980): pp. 86–7. A similar argument regarding the potential of beautiful buildings to prevent attack was also promoted by Alberti who wrote: 'At pulchritudo etiam ab infestis hostibus impetrabit, ut iras temperent atque inviolatam se esse patiantur.' Book VI, 2; Orlandi (1966): p. 447; trans Rykwert (1988): p. 156

95. 'cum in domo transtyberina habitaret.' This historically inaccurate account of events is used by Cortesi to underline his general point about the power of the 'ignorant mob'. Weil-Garris and D'Amico (1980): pp. 86–7.

96. 'in alterutrum incidendum est, dubitari nullo modo debet quin magis sit optanda in senatoria domo ornanda ratio, quae dignitate sit oculos praestrinctura plebes quam quae contemptum mediocritate paritura uideatur.' Ibid., pp. 86–7.

97. See for example the weapons listed in the space termed 'Nello armario d'arme e sopra lo scriptoio di Cosimo' (fol.61r) of the March 1417 inventory of Giovanni di Bicci de' Medici, in M Spallanzani ed., *Inventari Medicei 1417–1465 (Giovanni di Bicci, Cosimo e Lorenzo di Giovanni, Piero di Cosimo)* Florence (1996): pp. 19–20.

98. '...con tante utili e belle commodità e graziosi ornamenti, quanti si vede; i quali hanno maestà e grandezza nella simplicità loro,' Giorgio Vasari, 'Vita di Michelozzo Michelozzi'; Pergola (1962): vol. II, p. 332.

99. The sentence reads: 'Sono stati in questa età nella nostra città di Firenze quatro cipttadini grandi e dengni di fama da farne memoria di loro, chome al diripetto diremo.' Ibid., p. 54.

100. Baxandall (1971): pp. 15–16.

101. See note 69 above.

102. For *fantasia* see M. Kemp, *Behind the Picture. Art and Evidence in the Italian Renaissance.* New Haven (1997) and D. Summers, *Michelangelo and the Language of Art.* New Jersey (1981).

103. See Vasari's 'Vita di Giuliano e Antonio da Sangallo in Pergola' (1963): vol. III, p. 52.

104. See Book VI *On Ornament*, where Alberti objects to Vitruvius' style of writing, especially his interspersing Latin text with Greek terms. Orlandi (1966): p. 441; trans Rykwert (1988): p. 154.

105. Filarete refers to Alberti's treatise in his *Trattato de architectura* and in 1484 Lorenzo de'Medici agreed to lend a copy to Duke Borso d'Este of Ferrara providing it was returned promptly 'because he is very fond of it and reads it often.' Ibid., p. xix.

106. 'Quibus autem artibus aut prudentia maior inest aut non mediocris utilitas quaeritur ut medicina, ut architectura, ut doctrina rerum honestarum, eae sunt iis, quorum ordini conveniunt, honestae.' Book I, xlii, 151, Miller (1913): p. 154.

107. 'Sed quo in his rebus curandis parandis exequendis sese recte atque ex officio architectus possit…' Book IX, 10, Orlandi (1966): p. 853; trans Rykwert (1988): p. 315

108. 'Summo sit ingenio, acerrimo studio, optima doctrina maximoque usu praeditus necesse est, atque in primis gravi sinceroque iudicio et consilio…' Ibid., Book IX, 10, p. 855; trans Rykwert (1988): p. 315.

109. 'De re enim aedificatoria laus omnium prima est iudicare bene quid deceat. Nam aedificasse quidem necessitatis est; commode aedificasse, cum a necessitate id quidem, tum et ab utilitate ductum est; verum ita aedificasse, ut lauti approbent, frugi non respuant, nonnisi a peritia docti et bene consulti et valde considerati artificis proficiscetur.' Ibid., Book IX, 10, p. 855; modified from Rykwert (1988): p. 315.

110. 'Decor autem est emendatus operis aspectus probatis rebus conpositi cum auctoritate'. Vitruvius *De architectura* Book I, 2, 5; F. Granger, *On Architecture.* Vol. I. London and Cambridge Mass. (1931): p. 26; trans. J. Onians, *Bearers of Meaning: The Classical Orders in Antiquity, the Middle Ages, and the Renaissance.* Princeton N.J. (1988): pp. 36–7.

111. Onians (1988): pp. 36–7.

112. 'Accedit quod non modo quid queas, verum et quid deceat, non in postremis considerandum est.' Book II, 2, Orlandi (1966): p. 103; trans Rykwert (1988): p. 36.

113. 'Quod etsi in privatis monumentis modestiam, in publicis magnificentiam exigunt, publica etiam interdum privatorum modestia col laudantur.' Ibid., p. 103.

114. 'Quae cum sint, officii erit ea spectasse, quae recensuimus, hoc est, quid sit, quod agas, et quid quo agas loco, et qui sis, qui id agas. Et pro eius dignitate et usu rem totam constituere nimirum hominis erit bene consulti et considerati.' Ibid., p. 105.

115. 'Itaque in privatis ornamentis severissime continebit sese; tamen in plerisque liberiore utetur via.' Ibid., Book IX, 1, p. 785.

116. '…placere quae pro cuiusque dignitate moderentur.' Ibid., p. 781.

117. '…malim quidem in privatis lautissimi aliquid desiderent, quod ipsum ad ornamentum faciat, quam ut modestissimi et parcissimi ulla ex parte luxuriem repraehendant.' Ibid., p. 781.

118. '…quando item patriae familiaeque condecorandae non minus quam lautitiae gratia nostra ornamus – quod esse boni viri officium quis neget?' Ibid., p. 783.

119. '…qui sapiat, in suis privatis aedibus parandis egregie differre ab aliis; cavebitque, nequid sumptu et ostentatione contrahat invidiae.' Ibid., p. 783.

120. Cicero *De Officiis*, Book I, xxxix, 140; see Chapter 1, section 1.

121. 'che meriterebbe essere in latino e none in volgare.' Fol.1r; Finoli and Grassi (1972): p. 4.

122. A similar argument was more extensively developed in Alberti's *I libri della famiglia.*

123. Fol. 1r; Finoli and Grassi (1972): p. 4.

124. 'Come si sia, pigliala, non come da Vetruvio, né dalli altri degni architetti, ma come dal tuo filareto architetto Antonio Averlino fiorentino.' Ibid., p. 5.

125. '…farò una abitazione a ciascheduna facultà di persone.' Ibid., Book XI, Fol. 84r, p. 323.

126. Filarete also discusses the palaces of the Duke and Bishop. The Duke's palace (Book VIII, fol. 58v) has a ground plan of 160 × 330 *braccia*. The Bishop's palace (Book IX, fol. 66v) has a plan of 160 × 320 *braccia*, similar to the gentleman's palace reflecting Filarete's Doric ratio of 2:1.

127. '...sì che così debbono conseguire li edifizii [da loro] abitati.' Book XI, Fol. 84r; Finoli and Grassi (1972): p. 323.

128. '...saranno della qualità e misura dorica, cioè grande.' Ibid., p. 323.

129. Book VIII esp. fol 56v. Filarete's column proportions are not in line with those accepted by tradition, but are his concept of both a literary and visual theory for appropriate building. For traditional measurements of columns including comparisons with Alberti and Vitruvius, see Spencer (1965): p. 96.

130. Filarete stated that he considered the Ionic order to be the 'lowest class, that is for bearing weight'. Ibid., p. 96.

131. 'Delle altre commodità che bisognano nella casa, come nelle altre sono fatti e ordinati, così nel grado suo arà questa... quando sarà fatta, secondo da artigiano e persona mediocre sarà belle assai.' Ibid., Book XII, Fol. 86v, p. 331.

132. 'Per uno povero uomo, il quale per lui non possa fare così acconciamente, egli farà come potrà, pure che possa stare al coperto.' Ibid., p. 331.

133. Without illustrations Filarete's description would be extremely difficult to visualise. The use of architectural drawings provides another marked contrast to their absence in Alberti's *De re aedificatoria*.

134. 'Decor est quasi pulchritudo quaedam ex decentia rerum personarumque, in locis, temporibus, sive in agendo, sive in loquendo. Transfertur quoque ad virtutes: appellaturque decorum, non tam ipsum honestum, quam quod hominibus et communi opinioni honestum videtur et pulchrum, et probabile.' Lorenzo Valla *Elegantiarum Libri* Book IV, 15; cited in Baxandall (1971): pp. 10 and 172.

135. Toffol (1974): p. 23. This quote is discussed in greater detail in Chapter 3.

Going beyond the palace façade

1. Connecting the interior and exterior

This section highlights the theoretical and visual connections between the interior and exterior of the palace. The messages conveyed by these two distinct but intrinsically related areas are too often overlooked. This requires an approach that is unfamiliar to modern studies of Renaissance architecture. Relationships between the interior and exterior can greatly enhance our understanding of the impact of palaces on contemporary visitors. Indeed, only when these two areas are collectively considered can a more complete picture be created of the fifteenth-century Florentine palace.

In short, everything should be measured, bonded, and composed by lines and angles, connected linked and combined… so that one's gaze might flow freely and gently along the cornices, through the recessions, and over the entire interior and exterior face of the work, its every delight heightened by both similarity and contrast.[1]

Leon Battista Alberti *De re aedificatoria* (1485)

The above words by Alberti encourage us to consider both the exterior and interior together. The contemporary relevance of this approach is suggested in a range of *quattrocento* literary sources. One of the earliest accounts is found in Leonardo Bruni's *Laudatio florentinae urbis* (*c.* 1403–4). In the panegyric, Bruni devotes a significant amount of space to the 'homes of private citizens' which he states, 'were designed, built and decorated for delight, size, respectability, and especially for magnificence (*magnificentiam*).'[2] For Bruni, both the interior and exterior of the palaces are magnificent. Unlike other cities whose beauty is 'publicly displayed' and restricted to the exterior or 'outward bark', with Florence 'fine architecture and decoration are diffused throughout the whole city.' Bruni beseeches people to 'come here and walk through the city' in order to experience the delights of Florence for themselves, since words fail to adequately describe the beauty of the city's homes. They should not

'pass through like a temporary guest or a hurrying tourist', but 'pause, poke around, and try to understand' what they are seeing.

In stark contrast to Florence, in other cities 'if tourists leave the well-frequented places and try to examine the interiors as well as the exteriors of the buildings, there will be nothing to confirm their first impressions. Indeed, instead of houses they will find only small huts, and behind the exterior decorations only filth.' Bruni notes that 'the beauty of Florence cannot be appreciated unless seen from the inside,' where 'the sort of careful scrutiny that brings shame to other cities only serves to raise the esteem of Florence'. Uniquely 'behind the walls of the buildings of Florence there are no fewer ornaments and no less magnificence (*magnificentie*) than there is outside'. He concludes that there is no 'one street that is better decorated or more handsome than another, but every quarter shares in the beauty of the city. Hence just as blood is spread throughout the entire body, so fine architecture and decoration are diffused throughout the whole city.'³

The notion of magnificent private structures diffused throughout the city, like 'blood throughout the entire body', was well suited to the broader discussion of the virtues of Republican Florence. Commending Florence's 'outstanding civil institutions and laws', Bruni states: 'nowhere else do you find such internal order, such neatness, and such harmonious co-operation.'⁴ In the immediate aftermath of the aggression posed by the Milanese despot Giangaleazzo Visconti, the praise for the laws and political structure of Republican Florence was especially pertinent. Bruni unites Florence's numerous virtues so that the city is 'harmonized in all its parts' and 'pleases both the eyes and minds of men.'⁵ Similarly, a well-ordered dwelling – both within and without – accorded closely to Bruni's consistent premise that Florence contains nothing that is 'ill proportioned, improper, incongruous, or vague; everything occupies its proper place, which is not only clearly defined but also in appropriate relationship to all the other elements.'⁶

Whilst written early in his career, Bruni was ready to acknowledge that some people – especially outside Florence – might consider that he had been driven to compose the *Laudatio* in order to receive 'flattery and gain influence'.⁷ He pre-empts such criticism, however, by insisting: 'I would have been naive if I thought I would be able to purchase the favours of a large citizen body with this literary work', and stating 'once I had seen this beautiful city, once I had come to admire its fine site, architecture, nobility, comforts, and great glory, I wanted more than I can tell to try and describe its great beauty and magnificence (*magnificentiam*).'⁸

The relationship between the exterior and interior of buildings was also discussed in some detail by the Neapolitan court theorist Giovanni Pontano (1428–1503), who provided the most developed account of magnificence, splendour and its related virtues in his *De liberalitate, De beneficentia, De*

magnificentia, De splendore, De conviventia (1498). Pontano's categorizations of *magnificentia* and *splendore* provide a neat division between the virtuous acts of building and furnishing of palaces. Where magnificence applies to the 'concept of grandeur and concerns building', splendour relates to the 'ornament of the household' and comprises furniture and domestic display.[9]

In the first chapter of *De splendore*, Pontano defines the intrinsic connection between magnificence and splendour, asserting that: 'they both consist of great expense and have a common matter, that is money.'[10] However, where 'magnificence (*magnificentia*) reveals itself more in public works (*publicis operibus*) and in those which are destined for longer life', splendour (*splendor*) 'is more concerned with private matters (*privata potius*) and does not despise something for being of short duration or small.'[11]

De liberalitate, the first and longest book on the social virtues, is composed upon familiar Aristotelian lines: liberality is a virtue connected with the spending of money;[12] it is the appropriate measure between avarice (*avarus*) and prodigality (*prodigus*);[13] the liberal man does not think only of himself, but takes pleasure in bestowing gifts.[14] This establishes the premise for Pontano's discussion of magnificence in the third book. Again evoking Aristotle, Pontano cites magnificence as the mean between miserliness and vulgarity. Magnificence consists of expense applied on a great scale but always within an appropriate measure of decorum. Indeed, the concept of decorum is a fundamental theme throughout each of Pontano's texts on the social virtues.

In Chapter XI, Pontano describes 'the works of the magnificent man', making a clear distinction between the public (*publica*) and private (*privata*) character of building projects. To the former, Pontano ascribes 'porticoes, temples, quays, streets, theatres, bridges'; while the latter includes 'magnificent palaces (*aedes magnificae*), sumptuous villas, towers, sepulchres.'[15] Uniting both public and private projects: 'It follows that those who are magnificent (*magnifici*), are especially interested in works that are destined to remain for a long time. In fact, the longer they last, the more they are excellent, and the longer is their use, so much greater is the praise that the work and its author receive.'[16]

The distinction between public and private magnificence is clear, as is the Aristotelian example that works should be long lasting. Pontano continues his passage by delineating the exemplary works of figures from the classical past. Within the list of public works Pontano makes a rare contemporary digression to refer to the recent achievements of Cosimo de' Medici, who had demonstrated 'antique magnificence' through building, thereby being 'the first to recreate the custom of divulging private money to the public good and to the ornament of the fatherland.'[17]

Having discussed public monuments, Pontano turns his attention to private building, since 'it holds that the magnificent man ought to have both town houses and villas constructed magnificently and according to his dignity.'[18]

Magnificent palaces, if constructed appropriately, 'constitute an ornament to the city and give prestige to the owner.'[19] Those who do not build magnificently, or neglect to observe the principle of decorum, bring dishonour not only to themselves but to the well-born, and therefore by extension, magnificent citizen: 'he who makes a house squalid and sparse brings dishonour to those who abound in wealth, to those aristocratic citizens, because it seems an indication of a mean and wretched mind.'[20]

When describing the category of magnificent private building in *De magnificentia*, Pontano elects to focus on the impact of the structure itself. By contrast, in *De splendore* he focuses on the interior of the private house and its furnishings as a virtue related to, but separate from, magnificence. For Pontano, splendour is an entirely appropriate extension of magnificence into the domestic interior. Earlier theorists had, as we have seen, discussed the interior as an attribute of magnificent expenditure. Indeed, Aristotle had provided an exemplar for the inclusion of magnificent display extending to the interior.[21] Pontano expands this concept further, developing an extensive consideration of this attribute of magnificence, defining splendour as the mean between luxury (*luxus*) and baseness (*sordes*).

In *De Cardinalatu* (1510) Paolo Cortesi also refers to the interior and exterior of palaces. Although written as a manual for the conduct of the ideal cardinal, Cortesi saw no inappropriateness in the relationship between religious duties and the display of wealth. In Book II, Cortesi argues that money is necessary for a cardinal to undertake charitable deeds and live in a manner suitable to his dignified position, and discusses 'how the cardinal should be housed'.[22] This included references to the palace's location, plan and interior and exterior decoration. Under the heading, 'On the ornament of the palace',[23] Cortesi states that there should be two types of decoration: 'one which ennobles the exterior, the other which embellishes the interior of the palace'.[24] These distinctions are, like those of Pontano, important. The acts of decorating the interior and exterior are both considered positive uses of wealth. It is, however, the results that each achieve that are different.

In *De re aedificatoria* (1485), Alberti had recommended the use of scale models to ensure that the required effects of both the interior and exterior of a palace were appropriately considered. Alberti states that 'these models should be employed not only at the outset but also during construction, so that on their advice we may determine in advance what is necessary and make preparations in order to avoid any hesitation, change or revision after the commencement of the work, and so that we may form a concise overall picture of the whole.'[25]

An indication that this was considered good practice is found in Vasari's *Le Vite* (1550) where, in the lives of Filippo Brunelleschi and Michelozzo

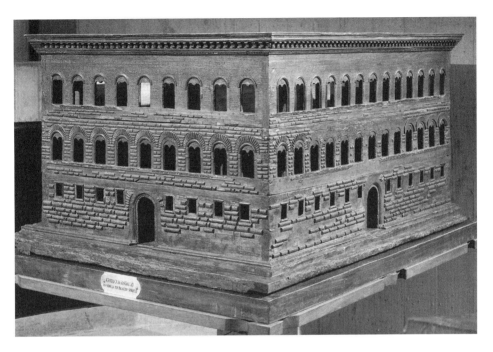

11. Giuliano da Sangallo, *Model of the Palazzo Strozzi*, Florence.
147.5 (length) × 117 (width) × 73.7 (height) cm. Made of wood and constructed in
three detachable storeys with some sketches of architectural details on interior walls

Michelozzi, he refers to the use of presentation models for the Medici palace
project. Vasari records how Cosimo de' Medici 'determined to have a palace
made for himself, and therefore revealed his intention to Filippo, who,
putting aside every other care, made him a great and very beautiful model
for the said palace.' Brunelleschi's model was ultimately rejected by Cosimo
as being 'too sumptuous and magnificent (*magnifico*)',[26] in favour of the design
by Michelozzo who 'was so intimate with Cosimo de' Medici that the latter,
recognizing his genius, caused him to make the model for the house and
palace at the corner of the Via Larga, beside San Giovannino'.[27]

 Despite their apparent usage on important palace projects, only one
intact scale model has survived. This represents an early design for the
Palazzo Strozzi by Giuliano da Sangallo (Illustration 11). Constructed in
wood, each of the three storeys are detachable to allow the interior room
divisions to be spatially assessed for each floor, and appears to be made
from the inside out.[28] This is particularly significant, as this indicates
that the plan for the palace must have been established before the façade
design was applied to it – a point further emphasized by the inclusion
of architectural details on the interior walls. The construction of a model

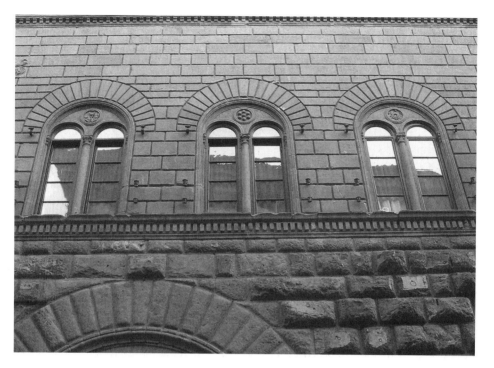

12. Palazzo Medici, Florence. Detail of biforate windows on façade with Medici *palle, imprese* and rose designs

therefore enabled the relationship between the façade and the interior plan to be considered together in visual form. As such, the model satisfies Alberti's requirement that one's gaze should pass simultaneously over the 'entire exterior and interior face of the work.'

The employment of certain architectural details within palaces reinforces the desire to create a relationship between the exterior and interior. One example of this is found in the replication of the family's coats-of-arms (*arme, stemmi*) or personal devices (*imprese*). These emblems were prominently displayed on a number of *quattrocento* palace façades, many of which are still visible today. The re-use of these motifs is also duplicated within a number of courtyards and loggias, as at the palaces of Tommaso di Federigho Federighi (1489) and Bartolomeo di Mariotto di Giovanni dello Stecchuto (1496), as well as other interior spaces.[29]

On the Medici palace façade, for example, the family coat-of-arms together with other familial devices are proudly displayed at both corners, while the biforate windows bear alternating decorations of the *palle*, the *imprese* of the diamond ring with three feathers, and roses (Illustration

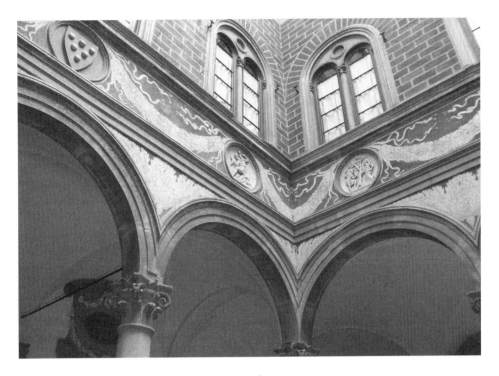

13. Palazzo Medici, Florence. Detail of courtyard

12).[30] In the courtyard, there are a series of carved marble medallions, several of which depict reliefs that imitate antique gems in the Medici collection, while others display the family's coats-of-arms (Illustration 13). Within the chapel – the only room to survive from the fifteenth century – coats-of-arms, personal devices and mottos (such as *semper*) are intricately interwoven into the fabric of the panelling, floor and fresco designs, thereby creating both an integrated and unified interior design (Plate 2 and Illustration 14).

In addition, furnishings and domestic goods could also contain familial coats-of-arms or personal devices. One well-known example of a domestic object containing Medici arms and *imprese* can be found on the *Medici-Tornabuoni Birth Tray* (*c.* 1448–9) the front of which depicts the *Triumph of Fame*, largely based on Petrarch's *Trionfi* (1354–74). On the reverse of this tray, placed prominently in the centre, are the diamond ring, three feathers and a scroll inscribed with the motto *semper* – all of which were the devices closely connected with Piero de' Medici. On either side are the arms of both the Medici and Tornabuoni families, represented respectively by eight red

14. Palazzo Medici, Florence. Detail of the decoration of the lower part of
the wall beside the altar, with Medici *palle, imprese* and motto *semper*

palle on the left and a rampant lion on the right (Illustrations 15 and 16). It
seems likely that this tray was made to celebrate the birth of Lorenzo de'
Medici in 1449, and was given by Piero de' Medici to his wife Lucrezia di
Giovanni Tornabuoni. The symbolic and sentimental importance of this
object is underlined by its probable appearance in Lorenzo's *camera* at his
death in 1492 where an entry in the inventory refers to: *Uno descho tondo da
parto, dipintovi il Trionfo della Fama. f.10.* [31]

While the *Medici-Tornabuoni Birth Tray* provides a rare example of an
extant object traceable to an entry in an inventory, one would be mistaken
to assume that coats-of-arms were not frequently found on goods in the
Renaissance interior. Indeed, as the registers of the *Magistrato dei Pupilli*
confirm, throughout the fifteenth century an extraordinary variety of
domestic furnishings and decorative objects included familial or related
coats-of-arms – ranging from large-scale furniture forms, such as *cassone*
and *forziere* to smaller scale, less durable decorative wares. A 1430s
example can be found in the inventory of Messer Matteo degli Scolari,

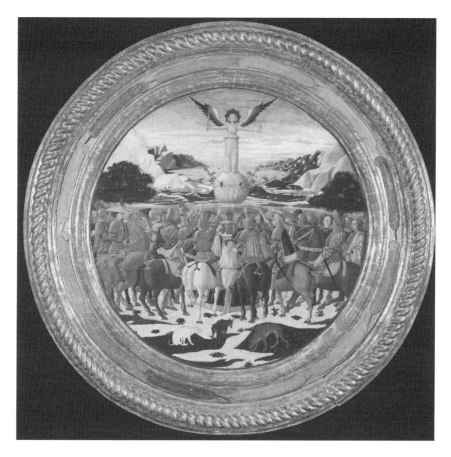

15. Giovanni di Ser Giovanni, called Lo Scheggia, *The Medici-Tornabuoni tray*, 1448–9. Obverse: *The Triumph of Fame*. Tempera, silver and gold on wood

which included two intarsiated *cassoni* with the 'arms of the house', together with two smaller *forziere* detailed as 'to go in the office (*uficio*).³² In the 1495 inventory of Gismondo della Stufa, smaller wares – such as a leather book and a brass ewer with damascene work – are described as bearing coats-of-arms.³³

The central role domestic objects could serve as tangible symbols of social networks or familial alliances can also be suggested through the inventories. Included in the della Stufa inventory, there are four different brass basins stored within the *lettucio* of Gismondo's principal *camera*. Interestingly, only one of these basins displays solely his own coat-of-arms, while the others combine the della Stufa *arme* with those of the Paghanelli, Spini and Ridolfi families respectively.³⁴ Similarly, the 1497 inventory of Lorenzo di

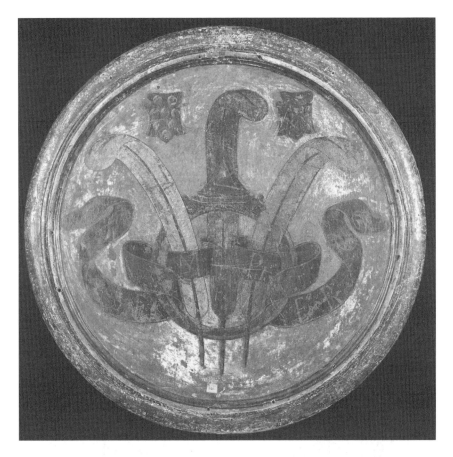

16. Giovanni di Ser Giovanni, *The Medici-Tornabuoni tray*, 1448–9. Reverse: *Imprese* of the Medici family with coats-of-arms of the Medici and Tornabuoni families

Giovanni Tornabuoni includes one entry that records two highly decorated brass basins with enamelled work bearing the arms of the Albizzi and Gianfigliazzi families.[35] A further entry in the *camera* of Lorenzo's deceased father Giovanni, also notes the presence of two chests specifically identified as being connected to marriage. These chests were presumably lavish pieces and are recorded as displaying the Tornabuoni *arme* together with those of the Pitti family.[36]

The complexities of fifteenth-century Florentine marital alliances are revealed in the Tornabuoni inventory. Lorenzo's father Giovanni Tornabuoni served as the General Manager of the Medici bank in Rome between 1464 and 1494, and married Francesca Pitti in 1467. Lorenzo was betrothed to Giovanna degli Albizzi in 1486, and following her death during

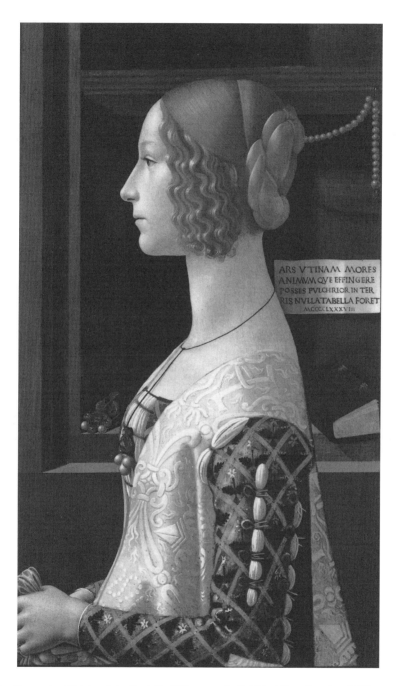

17. Domenico Ghirlandaio, *Portait of Giovanna degli Albizzi Tornabuoni, c.* 1488

childbirth he took Ginevra Gianfigliazzi as his second wife in 1491. The inventory demonstrates the significance and sentimentality attached to both furnishings and decorative goods. This is particularly noticeable by the surprising linkage of the *arme* of Lorenzo's first and second wives together on the brass basins, without any reference to the Tornabuoni family arms. This visible demonstration of loyalty by Lorenzo to his first wife is further underlined by the inclusion in the inventory of a portrait of Giovanna degli Albizzi. Located in the highly important *camera del palcho d'oro*, the painting (*quadro*) is recorded as depicting both the head and bust of Giovanna, within a gilded frame – an entry which surely refers to the portrait by Domenico Ghirlandaio, dateable to *c.* 1488, and now housed in the Thyssen-Bornemisza Collection in Madrid (Illustration 17).[37]

Though particularly refined, the intellectual games and conceits employed on the Medici palace façade and interior, should be seen within the wider context of other fifteenth-century palaces, not least those of the Rucellai, Strozzi and Pazzi. At the Strozzi palace, the desire to continue the visual interplays between the architectural details and familial motifs is demonstrated by the family *arme* of three crescents carved into numerous areas on the façade, as well as on the beautifully rendered iron lanterns and torch holders (Illustrations 18 and 19). The architectonic appearance of the lanterns, whose classical form seems to replicate the palace's biforate windows, further emphasizes the conscious efforts made to establish a unified structure. Though the use of lanterns and torches served to benefit the city, illuminating the street by night, their significance is heightened since only a select group of citizens had the right to display these on their façades.

The use of benches was also a feature common to both the exterior and interior of palaces. Built into the façades of palaces such as the Medici, Strozzi, Rucellai and others, these stone benches provided an important seating area for visitors waiting to enter the palace, or for others who simply wanted to rest and discuss matters close to such socially and politically significant buildings. At the Rucellai palace an *opus reticulatum* pattern is carved into the stone along the palace façade, as well as in the *loggia* opposite (Illustration 20). Of classical derivation, both Vitruvius and Alberti discussed the *opus reticulatum* pattern of wall construction in their books on architecture.[38] Unique to the Rucellai façade, it would seem to represent an attempt to simulate *spalliere* or backrests commonly found on benches within palace interiors. Here, this architectural technique appears to have been used in order to visually extend the interior space to the exterior of the building.

Inventories further confirm the frequent existence of extensive benches within the court *loggia*.[39] These may well have represented the second stage in the long waiting process endured by those seeking an audience with

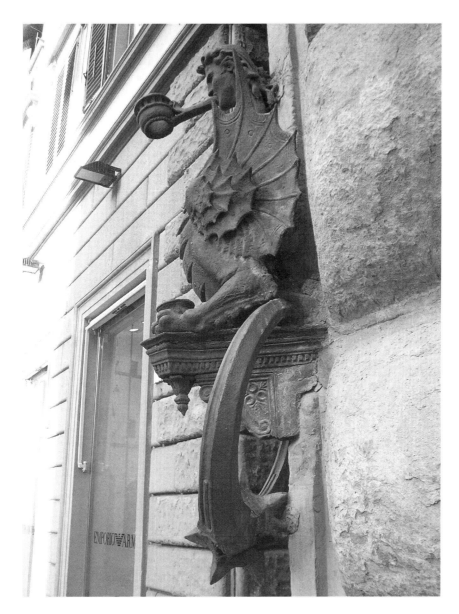

18. Palazzo Strozzi, Florence. Torch holder with coat-
of-arms on ground floor corner of façade

the owner of the palace. The memoirs of Tribaldo de' Rossi provide a rare
insight into this process. Rossi describes his attempt to gain a meeting with
Lorenzo de' Medici, which lasted a week. On the seventh day Rossi relates

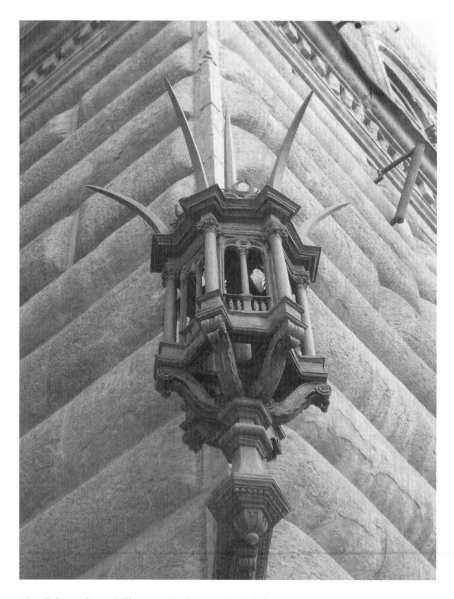

19. Palazzo Strozzi, Florence. Architectonic-style lantern
crowned with coat-of-arms, ground floor corner of façade

how: 'Lorenzo put on his coat and came down to the courtyard and gave
audience. Ser Piero told me repeatedly to stay close to him, and that he would
tell him that I was there, [we] being at the gate of the courtyard leading out
[into the street].' No sooner had Rossi begun his petition, walking together

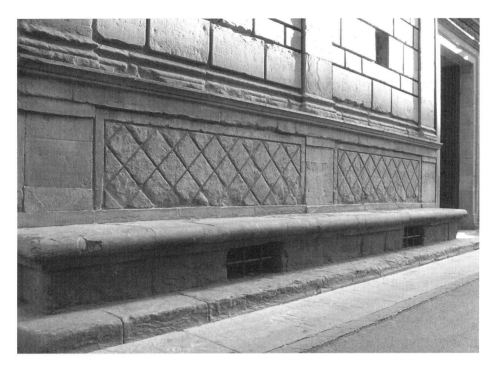

20. Palazzo Rucellai, Florence. Detail of façade showing
benches with *opus reticulatum* pattern above

'up to the gate of the palace on the street side', than Lorenzo was forced to 'give audience to' the 40 or more citizens who also demanded his attention, and Rossi was forced to remove himself 'down the street a few steps'.[40]

An additional use to which courtyards and their benches were put is suggested in the account of Lorenzo de' Medici's wedding, where tables are described as being set up for use by the older men.[41] Benches are also listed in other spaces within the palace, including the hallway (*androne*) or hall (*sala*). In these domestic spaces, the benches were again attached to the wall and often included backrests (*spalliere*). For example, in the *sala grande* of the 1492 Medici palace inventory, benches (*panche*) with *spalliere* are recorded as running around the room. Measuring over a staggering 46 metres (80 *braccia*) in length, these benches incorporated an architectonic cornice with inlaid work together with matching carved walnut feet.[42]

Select late *quattrocento* inventories also record that *spalliere* or wainscoting, could be conceived in an elaborate architectural style. The effect achieved by *spalliere* panels is demonstrated in the *camera* of Giovanni di Lorenzo

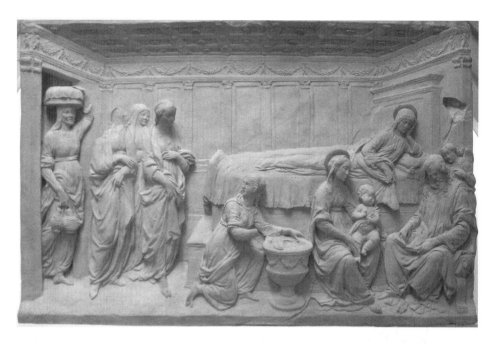

21. Benedetto da Maiano, *The Birth and Naming of Saint John the Baptist, c.* 1477. Terracotta

de' Medici. Almost 7 metres (12 *braccia*) in length, this vast *spalliera* panel was divided into three sections complete with a cornice and small gilded columns.[43] A sense of the clear architectonic appearance of such spaces is suggested in Benedetto da Maiano's (1442–97) terracotta panel depicting the *Birth and Naming of Saint John the Baptist* (*c.* 1477) where the *spalliere* panels are divided by a row of columns complete with capitals that strikingly recalls that of the Rucellai palace façade (Illustrations 21 and 22).

A further area where the exterior and interior coincide is in the architectonic form and appearance of the major pieces of furniture used in the domestic interior. These range from the bed (*letto, lettiera*) and day bed (*lettuccio*), often complete with hat-rack (*cappellinaio*), to various types of large chest, such as *cassapancha, cassone* and *forziere*. In addition to the massive scale of these pieces of furniture, many also incorporate architectural features such as pilasters, mouldings, or entablatures, and are frequently described in the inventories as being '*all'antica*'. Numerous references to an *all'antica* style occur in inventories throughout the fifteenth century. *Cassone* and *forziere* chests for example, are frequently described in the *Pupilli* registers as being variously painted, decorated with inlaid work, with historical subjects or perspective scenes '*all'antica*'. Although

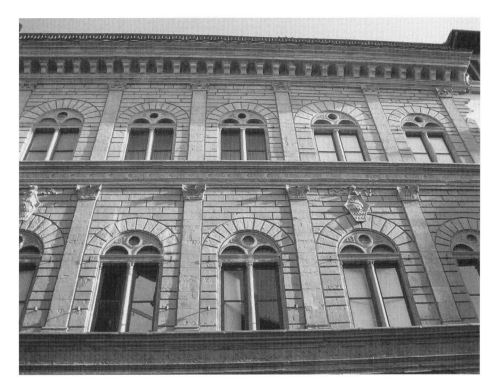

22. Detail of Palazzo Rucellai façade

it is possible that the assessors' references to an 'antique style' may refer to the decoration, it seems likely that this term was used to apply to the architectural form and ornament of these storage chests[44] (Plate 3). Similarly, beds (*lettiere*) and day beds (*lettucci*) are often described within inventories as *all'antica*, and on several occasions they are further detailed as having a prominently featured cornice (*cornicione*) that would have emphasized their architectonic appearance (see Illustration 34).[45]

The close examination of the relationship between the exterior and interior of the Renaissance palace can greatly enhance our understanding of the desire by patron and builder alike to produce a coherent whole, whether construed from the outside-in or the inside-out. The massive cornices on the upper storeys of palaces are replicated on beds, day beds and chests. The pilasters and columns with their classical orders adorning buildings are integrated within major furniture forms. Benches that were integral to palace façades, are found within courtyards and interior spaces. Classical swags decorating palace courtyards are duplicated on internal doorframes, wainscoting and furniture. Coats-of-arms are displayed on the smallest

decorative wares as well as the massive palace façades. By appropriating a classical architectural style, the interior and its furnishings truly laid claim to accepted notions of magnificent display applicable to the palace façade.

2. The accessibility of the palace and its spaces

This section examines the correlation between Vitruvius' account of the 'domus' of antiquity and Alberti's fifteenth-century prescription for the layout of the private palace. Central to both authors' discussions was the desire to use the architectural plan to channel the flow of visitors around defined areas of the house. The interior is not merely viewed in terms of public and private areas, but rather as a series of spaces accessible to the invited and uninvited visitor.

In his treatise on architecture, known today as *Trattato I* (*c.* 1475–80), the Sienese architect Francesco di Giorgio Martini (1439–1502) wrote in some detail on the appropriate 'distribution of rooms' (*le stribuizioni delle stanza*) in the 'houses of princes and great men' (*le case de' principi e gran signori*).[46] The house is to be provided with a large and beautiful aspect and should be situated before a spacious *piazza*. Location is also important and the residence should be positioned close to the cathedral, public places and areas where the city's commerce is conducted.[47]

Turning to the interior, many of the rooms and spaces cited by Francesco di Giorgio are familiar from *quattrocento* inventories and contemporary plans. Below ground are to be located various storage areas appropriate to the service of the house such as cellars and storerooms. Above these there should be a courtyard and loggia, together with large and small reception halls, dining rooms, chambers, and studies as well as 'other things appropriate to the type of building and owner, and according to the invention of the architect'.[48]

Francesco di Giorgio's reference to the distribution of rooms suggests a refined consciousness of the appropriate use and function of domestic space. This emphasis on the nomenclature of rooms, however, can be seen to have had an important classical precedent in the first century BC architectural treatise of Vitruvius, and further suggests Francesco's careful study of this text. The only full treatise on architecture and its related arts to survive from antiquity, Vitruvius' *De Architectura libri decem* had been known and copied throughout the Middle Ages. The discovery of a manuscript in 1415 by the Florentine humanist and book collector, Poggio Bracciolini, stimulated renewed interest in this work. Found in the monastery library of St Gall near Lake Constance, the manuscript generated particular excitement because the Carolingian script was incorrectly thought to be the Roman original.[49]

Although the first printed edition of Vitruvius' *De Architectura* did not appear until 1486, manuscripts of the text were copied throughout the century. Carol Krinsky has established that there were 17 Vitruvius manuscripts known to Italians during the fifteenth century. Three of these were certainly in Florence during the 1460s, two being in the possession of the Medici family and the other belonging to Francesco Sassetti. The Sassetti manuscript is listed in a 1462 inventory of his assets, where it is recorded as being bound together with Cato's *De Agricultura* and Varro's *De re rustica* (see Illustration 4). While the inclusion of Vitruvius' text with other works is interesting, it was not in fact unusual: of the 78 extant fifteenth-century Vitruvius manuscripts, 27 were copied and bound with other texts or excerpts of texts in one volume.[50]

As both Poggio's discovery at St Gall and Sassetti's manuscript suggest, the geographical interest in Vitruvius transcended the Italian peninsula. Copies of Vitruvius existed in a range of medieval libraries across France, Germany and the Low Countries, and by the mid-fifteenth century the treatise was available not only in Italy but also England, Spain and Poland. Francesco Sassetti's manuscript, presumably acquired during his period as manager of the Geneva branch of the Medici bank, can be shown to have an early fifteenth-century French provenance being originally copied for a friend of the humanist Jean de Montreuil.[51]

For both patrons and architects, Vitruvius' text served as the principal source of information on the architecture of antiquity. In Book VI on private architecture, Vitruvius defines the parties involved from the conception to the completion of a building. The success of all building rests on the quality of the craftsmanship, magnificence (*magnificentia*) and architectural composition.[52] Vitruvius continues: 'When a building has a magnificent (*magnificenter*) appearance, the expenditure of those who control it is praised. When the craftsmanship is good, the supervision of the works is approved. But when it has a graceful effect due to the symmetry of its proportions, the site is the glory of the architect.'[53]

Vitruvius places the credit for a building's 'magnificent appearance' firmly in the hands of the patron. As with Aristotle, Vitruvius reinforces the connection between magnificence, expenditure and building. The architect remains at the centre of this tripartite division accepting advice from both craftsman and patron, 'for all men and not only architects can approve what is good.' The difference between the architect and layman is, however, marked: only the architect has a definite idea how the finished work will turn out with respect to beauty (*venustate*), convenience (*usu*) and decorum (*decore*).[54]

In Book VI Vitruvius devotes a significant part of his text to the interior form and function of the ancient house or *domus*. Particularly relevant to our discussion is the clear distinction made between 'public' and 'private' space within the *domus*. It is the architect's role to plan how rooms defined

as 'belonging to the family' should be distinguished from those to be 'shared with visitors'. Significantly, Vitruvius explains this distinction in terms of social convention. Central to the interior plan is the visitor. The crucial division rests between 'invited' and 'uninvited' visitors and the appropriate levels of accessibility to be offered to each. Vitruvius defines private rooms as including chambers (*cubicula*), dining rooms (*triclinia*) and baths (*balneae*). These spaces are only accessible to invited visitors. Public areas, notably vestibules (*vestibula*), courtyards (*cava aedium*) and peristyles (*peristylia*), are open to visitors whether invited or not:

> When we have arranged our plan with a view to aspect, we must go on to consider how, in private buildings, the rooms belonging to the family, and how those which are shared with visitors, should be planned. For in the private rooms no one can come uninvited, such as chambers, dining rooms, baths and other apartments which have similar purposes. The common rooms are those into which, though uninvited, persons of the people can come by right, such as vestibules, courtyards, peristyles and other apartments of similar uses.[55]

Accessibility depended on the social status of both the owner and the visitor. Vitruvius underlines that the common man has no need for public areas, since he does not receive visitors but rather carries out the required social obligation by visiting others: 'Therefore magnificent vestibules (*magnifica vestibula*) and alcoves (*tabulina*) and courtyards (*atria*)[56] are not necessary to persons of a common fortune, because they pay their respects by visiting among others, and are not visited by others.'[57] The houses of bankers and tax collectors on the other hand, should be 'more spacious, imposing and well secured', while for lawyers and orators they should be more elegant as well as spacious enough to accommodate meetings. The most prominent citizens are those who hold public office, and it is they who require lofty and princely vestibules (*vestibula regalia alta*) and the most spacious courtyards and peristyles (*atria et peristylia amplissima*). In addition, these citizens will also have libraries (*byblithecas*) and basilicas (*basilicas*), arranged with the magnificence of public structures (*publicorum operum magnificentia*), since it is here that both public deliberations and private judgments are often carried out.[58]

Vitruvius' text shows a desire to control, or at least channel, the flow of visitors around defined areas of the *domus*. To modern sensibilities, the apparent lack of privacy offered in the houses of the richest citizens is surprising. The degree of openness or accessibility within the Roman house denoted status, which was in turn reflected in the number of visitors received. Cicero had discussed the house in similar terms in *De Officiis* stating how in the homes of the wealthy, the owner gains credit when 'numerous guests' are entertained and 'crowds of every sort of people received.'[59] At issue for Vitruvius is the differing degree of internal access offered to outsiders, with

admission or restriction dependent upon whether they were friends, guests, visitors or the wider general public.

Here our understanding of the differentiation between 'public' and 'private' domestic areas is not helpful. Distinctions between work and leisure became blurred in the ancient home and business was regularly conducted within the *domus*. This activity could have a more 'public', less controlled dimension when conducted on a wider scale in the larger spaces grouped around the entrance, such as vestibules or courtyards; but could also occur in a more restricted capacity within *cubicula* or chambers.

An insight into the multifunctional role served by the *cubiculum* is provided in Suetonius' *De vita Caesarum*. In the account of Vespasian he describes the daily ritual conducted by the emperor within his chamber: 'While emperor, he always rose very early, in fact before daylight; then after reading his letters and the reports of all the officials, he admitted his friends, and while he was receiving their greetings, he put on his own shoes and dressed himself.'[60] Suetonius uses this account to demonstrate both the diligent and thrifty character of Vespasian in conducting his official duties before daylight and dressing himself unaided. It also suggests the range of social and business activities that could take place within the *cubiculum*. Clearly these went beyond the basic function of a room for sleeping and were far from simply acting as 'private' retreats.

Despite Vitruvius' importance to Renaissance readers and writers as a tool for comprehending classical building, it remained an extremely difficult text to recreate in visual form. As Alberti bluntly underlined in his own treatise that emulated Vitruvius, *Decem libri de re aedificatoria* (c. 1443–52), the 'impure' classical style with which the text was written was littered with terms whether Greek or Latin whose precise meaning and application were at best unclear. In the opening chapter of Book VI, Alberti comments that in Vitruvius' 'very text is evidence that he wrote neither Latin nor Greek, so that as far as we are concerned he might just as well not have written at all, rather than write something that we cannot understand'.[61]

In 1511 Fra Giocondo published the first illustrated edition of Vitruvius. Although this publication provided further assistance with the visual understanding of the ancient author's text, the obscurity of Vitruvius' language continued to be misunderstood by a succession of Renaissance theorists.[62] In its discussion of broader issues, however, particularly with respect to the relationships between social function and the accessibility of space within the domestic interior, Vitruvius' impact was marked.

Alberti's *Decem libri de re aedificatoria* is interesting for its application of Vitruvius' discussion of private building. In Book IX on 'Ornament to private building', Alberti refers to the houses of the wealthy stating: 'the royal palace and, in a free city, the house of anyone of senatorial rank, be he *praetor* or consul, should be the first one that you will want to make the most handsome.'[63]

Continuing along distinct Vitruvian lines he writes: 'it is preferable to make the parts that are particularly public or are intended principally to welcome guests, such as the façade (*frons aedis*), vestibule, and so on, as handsome as possible.'[64] Having discussed public areas Alberti turns to describe how to adorn the areas restricted to 'private' use:

I would give each house a most dignified (*honestissimum*) and splendid (*splendidissimum*) vestibule, according to its importance. Beyond this should be a well-lit portico; there should be no shortage of magnificent (*magnifica*) open spaces. As far as possible, in short, every element that contributes to appropriateness and dignity should follow the example of public works; yet they should be handled with such restraint as to appear to seek delight rather than any form of pomp.[65]

Alberti's language again recalls that of Vitruvius. The divisions between 'public' and 'private' remain focused around the visitor. Like Vitruvius, Alberti has the most prominent citizens command the 'most handsome' properties. In contrast to the classical writer, Alberti specifically refers to the façade as a public area. The façade was the most highly visible, and therefore the most public, aspect of the house. Displayed to all, the messages it delivered could be highly distinct from internal areas, where accessibility could be more controlled. Alberti seems to implicitly recognize this in his inclusion of the '*frons aedis*', which welcomes visitors but is also 'particularly public'.

Also distinct is Alberti's definition of the vestibule serving both a public and private role. Later, this duality of spatial function is extended to other rooms within the house. In an expansion of Vitruvius, Alberti underlines how certain rooms and spaces, defined as dining rooms (*tricliniorum*), corridors (*itionum*), and chambers (*conceptaculorum*): 'may be either public or enclosed and thoroughly private, the former should combine the splendour (*splendori*) of the forum with civic pomp, provided it is not too offensive, but in more private examples a degree of license may be taken according to taste.'[66]

Alberti acknowledged that the parts of a private building differed greatly from one another, 'in their nature as well as their appearance.'[67] Size and position are inextricably connected to the social function or functions served by each space. As Alberti wrote: 'Some must be large, such as the bosom (*sinus*) of the house, while others require a smaller floor plan (*area*), such as the closet (*conclave*) and all the inner rooms (*penetralia*); yet others are of an intermediate size such as the dining room (*coenacula*) and the vestibule (*vestibulum*).'[68] In Book V on the 'Works of individuals', Alberti had written in greater detail on the *sinus*, which he saw as an essential part of the house:

The most important part is that which we call the *sinus* of the house, although you might refer to it as the *cavum aedium* or *atrium*; next in importance comes the *coenacula*, followed by the *cubicula*, and finally *conclavia*. Then come the remainder, according to their use. The *sinus* is therefore the main part of the house, acting

like a public forum, toward which all other lesser members converge; it should incorporate a comfortable entrance, and also openings for light, as appropriate.[69]

Alberti's realization that *cavum aedium* and *atrium* denoted the same space underlines his close reading of Vitruvius' text.[70] The public function of this area is reinforced by its close proximity to the entrance, as well as by its analogous role in 'acting like a public forum'. The distribution of further spaces beyond the *cavum aedium / atrium* is distinguished by a decrease in public or an increase in private function as appropriate. Here we are close to Vitruvius' distinction between the accessibility offered to the invited and uninvited visitor. As Alberti had discussed earlier in Book V, the private house should contain areas divided into public, semi-public and more private zones: 'As we have said, there are parts of the house pertinent to all, others to a good number, others to the single person.'[71]

3. Magnificent hospitality in the splendid interior

This section addresses the roles the palace interior could serve in enhancing the magnificence and splendour of its owner. Particular focus is given to the civic function served by a number of Florence's palaces as appropriate locations for the official visits of dignitaries and eminent visitors to the city.

Therefore the splendid man (*splendidi hominis*) should not only ensure that he has worthy and elegant furnishings and that his home has abundant ornaments, but as it is even more shameful if he is unprepared for either private (*privata*) or public (*publica*) service, he will have very many things in the house for these occasions when he needs to demonstrate his polish (*luculentiam*). Thus, if a guest should arrive, he will be ready to receive him in a manner that is not only welcoming but also magnificent (*magnifice*).[72]

Giovanni Pontano *De splendore* (1498)

As Giovanni Pontano underlines, hospitality provided occasions when splendid and magnificent behaviour could be readily displayed (Illustration 23). The domestic interior was a logical area in which this virtue could be demonstrated since, at its most basic level, the majority of occasions connected with this act involved the provision of food, drink and accommodation. The Christian virtue of hospitality was familiar to Renaissance audiences through biblical passages such as that in Hebrews 13:2 which stated: 'Do not neglect to show hospitality; by doing this some have entertained angels unawares.' Where these entries inevitably tended to reinforce the charitable notion of Christian hospitality towards one's neighbours, the classical texts extolled the merits of magnificent displays on a lavish scale. Underpinned by a clear sense of decorum, Cicero

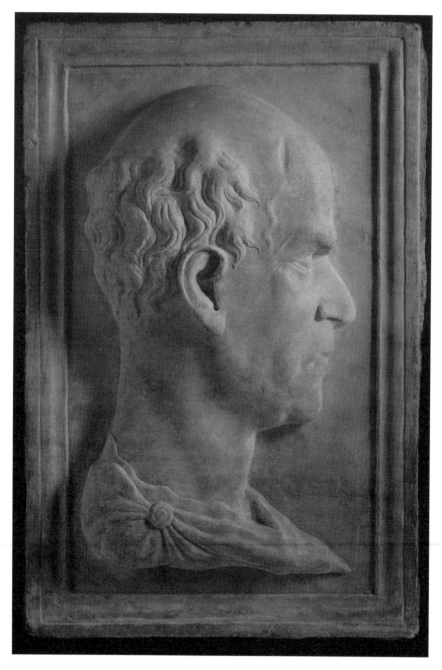

23. Marble relief of Giovanni Gioviano Pontano (1426–1503)
by Adriano Fiorentino, c. 1490. 50.5 × 33.5 cm

stated in *De Officiis*: 'And as in everything else a man must have regard not for himself alone but for others also, so in the home of a distinguished man, in which numerous guests must be entertained and crowds of every sort of people received, care must be taken to have it spacious.'[73]

The application of Cicero's words can be seen in Filippo Beroaldo's text on the ideal state, *De optimo statu* (1497). Although dedicated to the *de facto* ruler of Bologna, Giovanni II Bentivoglio, Beroaldo elects to focus on the public virtue of hospitality as an 'ornament for the community'. Using Cicero as his source, he cites hospitality as the 'sister of liberality', declaring it is desirable that 'the homes of illustrious men lie open to illustrious guests.' Beroaldo praises Bentivoglio as a contemporary example of a prince 'whose very beautiful house most magnificently (*magnificentissime*) lies open to guests of the most illustrious sort', and who are 'received in a hospitable and courteous way.'

To further reinforce the significance attached to hospitality, Beroaldo refers to Cimon the Athenian who was 'very hospitable to the Spartan ambassadors' received at his house, despite the fact that Athens was at war with Sparta. Recounting how this narrative was recorded in the classical writings of Theophrastus, Plutarch and Emilius Probus, Beroaldo states how Cimon had 'ordered his household that everything should be provided whoever had turned aside from their travels into his house.' Significantly, Beroaldo elects to conclude his discussion by underlining the parallels between Cimon's exemplary pagan conduct and the Christian duty of hospitality, adding that such charitable conduct is 'recorded very widely in the canonical decrees'.[74]

For Cicero, like Beroaldo, hospitality and entertainment are duties. In *De Officiis*, should the home of a 'distinguished man' not be filled with 'numerous guests', the end result is clear: 'But if it is not frequented by visitors, if it has an air of lonesomeness, a spacious palace often becomes a discredit to its owner.'[75] Cicero further qualified his statement that a vacant palace brought 'discredit' to its owner by adding that 'this is sure to be the case if at some other time, when it had a different owner, it used to be thronged. For it is unpleasant, when passers-by remark: "O good old house alas! How different the owner who now owneth thee!" And in these times that may be said of many a house!'[76]

In the turbulent political climate of fifteenth-century Florence, Cicero's words must have had particular resonance. This is underlined in the memoir of Marco Parenti which graphically details the events surrounding the patrician revolt against the Medici regime following the death of Cosimo de' Medici in 1464. The attempted *coup d'etat* centred on Cosimo's son Piero di Cosimo de' Medici and Luca Pitti. In illustrating the circumstances surrounding the reduced political power of Piero, Parenti uses a distinctly Ciceronian style. Where Piero's political standing had been reduced to

such a degree 'that few frequented his house and they were men of little consequence,' that of his rival Luca Pitti had increased so that he 'held court at his house, where a large part of the citizens went to consult on matters of government'.[77] This power change, however, proved short-lived and some folios later Parenti describes the reversal in Pitti's fortunes remarking how, despite his position as an electoral official, no one went to see him in order to be elected. Instead Pitti 'remained cold and alone at home, and no one visited him to talk about political affairs – he who used to have his house full of every kind of person.'[78]

Giovanni Rucellai also showed his familiarity with Cicero's discussion of hospitality in his *Zibaldone*, writing: 'In the house of a rich man numerous guests should be received and they should be honoured with generosity (*largità*) for if one did otherwise the great house would be a dishonour to the owner.'[79] The reference by Cicero to the duty of receiving and entertaining guests and 'crowds of every sort of people' followed on directly from the classical writer's account of the virtuous palace constructed by Gnaeus Octavius. As discussed above, Rucellai had demonstrated his fluency with this passage from *De Officiis* in a *Zibaldone* entry from 1464.[80] Here Rucellai's entry, dateable to around 1457, shows an earlier additional usage of this source. In Rucellai's account, the dwelling of Cicero's 'distinguished man' is referred to bluntly as the 'house of a rich man'. The underlying premise of Cicero's text, however, is preserved in Rucellai's account, with decorum underpinning the message and suggesting that appropriate hospitality brought honour to its host. This accords well with Marco Parenti's reference that the house of a successful figure in Florentine society was indicated by whether or not it was 'full of every kind of person.'

In fifteenth-century Florence the distinctions between private and public hospitality regularly overlapped. The connection between these notions had been addressed in Book IV of the *Ethica Nicomachea*, where Aristotle had outlined those occasions when public and private magnificence could be suitably demonstrated. Significantly, certain events had the virtue of hospitality at their centre 'such as a wedding or something of that sort, or any event that excites the interest of the whole community; or entertainments to mark the arrival or departure of foreign guests.'[81]

The fusion of public and private events is demonstrated by the manner in which the city and its palaces served an intrinsic role in the ceremony of marriage. The bride's processional journey on horseback through the streets from her parental home to that of the groom or his family's house, was one of the most public and highly visible moments of the marriage ritual. The civic significance of this event is regularly recorded on the panels of *forzieri* chests – which were used to transport the bride's dowry goods to her new husband's house – and were themselves part of the ceremonial occasion.

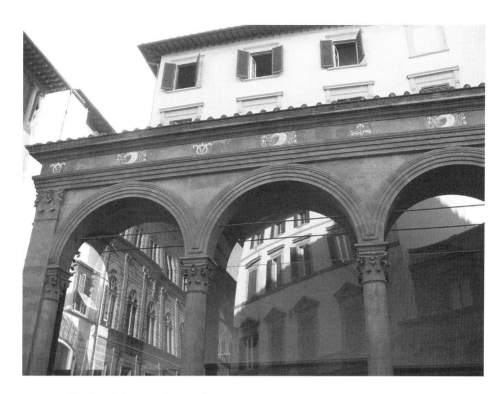

24. Rucellai family loggia, Florence featuring Giovanni Rucellai's
imprese of the billowing sail alongside the Medici diamond ring with two
feathers. The Rucellai palace's close proximity to the loggia is shown
by its reflection in the modern plate glass window on the left

The public dimension of the Florentine marriage ritual is further suggested in the memoranda of Giovanni Rucellai. In the *zibaldone*, Rucellai records in meticulous detail the events surrounding his son Bernardo's marriage to Nannina de' Medici in June 1466. The lavish festivities took place publicly outside the Rucellai palace in front of the family loggia in the square on the Via della Vigna Nuova (Illustration 24). Witnessed by several hundred onlookers including 'kinsmen, friends and neighbours' (*parenti e amici e vicini*), a sense of the sumptuousness of the occasion is demonstrated by the descriptions of the 'very beautiful furnishings' (*bellissimo apparto*) that accompanied the celebrations. These ranged from a credenza richly decorated with silver to various types of tapestries, cloths and wall-hangings displaying the arms of the Medici and Rucellai families.[82]

In Republican Florence, private hospitality was extended to visiting dignitaries. This is vividly demonstrated in an official book of ceremonies

called the *Libro Cerimoniale*, which was commissioned by the Florentine *Signoria* in 1475.[83] This exceptional commission covered the period 1450–1522, and provides detailed information on the diplomatic visits of foreigners to the city. The responsibility for recording events was entrusted in the first instance to the herald Francesco Filarete.[84] The purpose of the *libro* was clearly stated in a decree of 27 December 1475, where the herald was required 'to make and compile a book that is to be kept in the chancery of the *Signoria*. In it [he is to] list all the entries of ecclesiastical and temporal princes at least from 1456 who have come to the city and been honoured, the ceremonies effected, and any costs [incurred].'[85]

The *Libro Cerimoniale* served as more than simply a detailed record of ceremonial visits, and may also have been intended to function as a manual for regulating and improving future visits to the city. The specific content dictated by the *Signoria* accorded well with the typically Florentine tradition of *ricordanze*. Filarete was required to make a memoir of earlier visits as well as keeping a journal of truly contemporary events. By specifying that the *Libro* should commence in 1456, the *Signoria* reflected its desire to assess and document the ceremonial impact of visits conducted a generation earlier. In addition, the historical record made by Filarete must have been seen as providing written evidence that, like the visit itself, enhanced and added lustre to the city's magnificence.

Through the visit of dignitaries and the resultant hospitality this entailed, the connection made by Leonardo Bruni and others between the beauty of the city and the beauty of its architecture took on a practical application. The *Libro Cerimoniale* demonstrates the complex ritualistic processes involved in key ceremonial moments ranging from the official greeting of the dignitary at the city gates, through to the procession of the entourage into the city to the Palazzo della Signoria, and its conclusion on the first day with the visitor being accompanied to his private accommodations.[86]

A fusion of decorum and tradition dictated the major categories of residences used in Florence. For example the apartments attached to the mendicant church of Santa Maria Novella provided accommodation during the fifteenth century for important princes and dignitaries, as well as Pope Pius II (1459 and 1460) and Emperor Frederick III (1452);[87] while the hostels Alla Corona and Alla Campana in Borgo San Lorenzo housed ambassadors and in 1482 the King of Bosnia.[88]

Significantly, private citizens could also accommodate visitors. The folios of the *Libro Cerimoniale* frequently record the key ceremonial role played by the houses and *palazzi* of Florence's leading citizens. Their presence underlines the civic significance of these structures in the ceremonial visit, and read like a 'who's who' of the leading Florentine families and their palaces. Numerous entries in the *Libro* specifically refer to the houses of the Gondi, Lenzi, Medici,

Minerbetti, Nori, Pazzi, Tornabuoni, da Uzzano and Vespucci. The 1482 visit of the papal legate, the Cardinal of Mantua, underlines the intrinsic role urban palaces served in the protocol of official visits:

The Cardinal of Mantua and legate of the supreme Pope came this day 22 October 1482 and was honoured as is the custom of legates with baldachins and processions. The magnificent *Signoria* greeted him at the *ringhiera*. And after the visit he was accompanied to the Tornabuoni, that is the house of Giovanni Tornabuoni, and I debited the expenses to the public account. Our magnificent *Signori* visited him the next day with a good number of the citizens.[89]

One significant omission from the *Libro Cerimoniale* was an account of the visit by the French monarch Charles VIII to Florence in November 1494. Although the king's visit was ostensibly peaceable, it had been greeted with great apprehension by the *signoria* due to the recent expulsion of Piero de' Medici and the humiliating policy of appeasement the new government had been forced to follow with France. As with earlier ceremonial visits and entries, whose central aim was to promote civic pride and present Florence's magnificence to outsiders, the events surrounding Charles' entry do fortunately survive in a number of written accounts.

The route taken by Charles VIII can still be followed on a map of Florence today. Entering beneath the decorated Porta San Frediano, the procession continued to Piazza Frescobaldi, across the Ponte Vecchio to the Piazza della Signoria, which had been adorned with a *Triumph of Peace* by Filippino Lippi (*c.* 1457–1504). Continuing north to the Piazza San Giovanni the entourage travelled up Via Martelli, which was covered with blue canopies, tapestries and other hangings displaying the arms of the *signoria* and the French king. This scheme continued to the entrance of the Medici palace – which had been decorated by Pietro Perugino (*c.* 1450–1523) with a wooden triumphal arch – and was repeated within the interior, the stairs and along the loggia. Notwithstanding Piero's banishment from the city a few days earlier, it was the ostensibly private Palazzo Medici, rather than the Palazzo della Signoria, that the new Republican government elected to appropriate as the residence for the king's visit.[90]

Something of the way in which 'entertainments to mark the arrival or departure of foreign guests', could excite 'the interest of the whole community' is suggested in both Granacci's painting for the entry of Charles VIII into Florence, and a fresco from the 1540s depicting the *Joust of the Saracean in Via Larga* (Plate 4). Painted for the Palazzo della Signoria it depicts the populace thronging Via Larga, lining both sides of the street and standing on the benches outside various palaces including the Palazzo Medici, while other spectators look down from windows on the upper levels with interior hangings adorning the palace façades.

As with all the temporary accommodations provided for official visitors, the *Signoria* covered the costs for the room and board that was to be provided, reimbursing the host directly in the case of private residences. Negating this rule by personally bearing the costs of hospitality and lodging could enable the private host to demonstrate his magnanimity. This had been prominently displayed by Cosimo de' Medici for the visit of the Duke of Milan's eldest son, Galeazzo Maria Sforza, to Florence in 1459. As a letter to Francesco Sforza confirms, Cosimo had determined that in addition to providing accommodations at the Medici palace he personally, rather than the *Signoria*, would meet Galeazzo and his considerable entourage's expenses.[91]

The decision to cover the expenses incurred on Galeazzo Maria Sforza's visit reflected and reinforced the close relationship between Cosimo and the Milanese ruler. On a broader public level the ceremony and ritual provided for the visit bestowed honour on the whole city and displayed on a grand scale the strong diplomatic alliance that existed between Florence and Milan. Among the range of contemporary writers who recorded the importance of the visit, was Benedetto Dei who observed: 'Never in Florence were there such entertainments, such processions, and such performances as were presented to Pope Pius II and Galeazzo Maria, son of the Duke of Milan.'[92] The civic significance of the visit was confirmed by Cosimo himself in a letter written to his nephew Pierfrancesco in which he declared: 'This is a feast of the whole community, put on in honour of the city and not for frivolous reasons as has been done on several other occasions.'[93]

The ostensible motive for Galeazzo Maria's visit to Florence was to meet with Pope Pius II and then escort him to Mantua. Since the young prince was only 15 there were obvious concerns over his safety and well-being and several letters were sent back to Milan detailing his progress. In addition other accounts written from a Florentine perspective also survive and provide further information on the events surrounding the visit. Collectively, these sources provide an incredibly complete picture of the pomp and ceremony surrounding the two-week visit.

The *Libro Cerimoniale* records how Galeazzo was met in the customary fashion outside the city walls by a number of leading Florentine citizens, both parties in full regalia.[94] The large procession then returned through the streets to the Piazza della Signoria where they were greeted with 'the great noise of trumpets and bells.'[95] The Count was then received on the platform in front of the Palazzo Signoria (*ringhiera*). Once the greetings and orations by both parties were complete, the party remounted their horses and continued to the Medici Palace, where the official account of this day concludes. The continuation of events is, however, covered in a letter written to the Duke of Milan by Niccolò de' Carissimi da Parma, a counsellor in Galeazzo Maria's entourage. Niccolò writes:

...I went to and dismounted at the palace of Cosimo. And first I found Piero di Cosimo all in state at the top of the first stair, who embraced and kissed the aforesaid Count with great lovingness, and took the hands of and welcomed the whole entourage as pleasingly as he could. Then the aforesaid Count went immediately into the little chapel of the aforesaid Cosimo. He was waiting for him there, even though suffering all over from the gout. And he threw himself forwards with reverence, and the said magnificent (*magnifico*) Cosimo gathered him to his bosom...[96]

The tenderness and relative intimacy of the greeting between Galeazzo Maria and Cosimo soon had to be curtailed, since as Niccolò remarks: 'we had to go away from there because of the multitude that was arriving that wanted to visit the aforesaid magnificent Cosimo.'[97] The account fuses the dignified protocol expected for such occasions, as characterized in the folios of the *Libro Cerimoniale*, with a sense of the genuine affection that existed between the young Count and Cosimo. The description of Piero de' Medici dressed in state regalia to greet Galeazzo Maria 'at the top of the first stair' compares with the solemn meeting held for official visits at the *ringhiera* outside the Palazzo Signoria. As Trexler has shown, the protocol dictating the actions of the *Signoria* on the *ringhiera* and the exact position at which the exchange of greetings should occur was both minutely planned and strictly enforced.[98]

The symbolic messages sent by the domestic setting chosen to greet Galeazzo Maria must also be interpreted within these terms. Located on the *piano nobile* at the end of the hallway, the chapel provided a suitably dignified space within which to receive the young Count and his extensive entourage. Despite its small size and the fact that Benozzo Gozzoli's decorations for the walls were not yet in place, the chapel still made a distinct impact on its visitors (see Plate 2). In the lengthy narrative poem known as the *Terze Rime* the chapel is described by its anonymous author as follows:

And there is a chapel so ornate/ that it has no like in all the universe,/ so well prepared is it for the worship of God. And whoever looks at it well on every side/ will say that it is the tabernacle of the divine Three,/ for it is lovely and elegant throughout.[99]

The chapel was an entirely appropriate space for Cosimo to demonstrate his Christian hospitality. Described in the *Terze Rime* as 'ornate' and 'elegant throughout', its very existence reinforced Cosimo's importance. In Florence during the 1450s, the Palazzo Medici was somewhat exceptional in containing a 'private' chapel.[100] This privilege was granted in 1422 to Cosimo and his wife, Contessina de' Bardi, through specific papal dispensation from Martin V, which permitted the right to use a portable household altar in the old Medici palace or *casa vecchia*.[101] In the chapel of the new palace, the religious and diplomatic functions performed by this space did not appear to be at odds with expected notions of decorum. The chapel connected directly with Piero de' Medici's suite of rooms, which were to be Galeazzo Maria's

accommodation during his stay. In preparation for the Count's arrival the *Terze Rime* describes how Piero himself oversaw the appropriate display of his chamber and *anticamera*:

And Piero's chamber, cheerful and genteel,/ was prepared in a manner worthy of emperors and queens/ for the great unconquered fighter,/ With a canopy of silk with fringed curtains,/ and on the bed a cover of Alexandrian velvet,/ embroidered with silver and fine gold./ All around on every side/ it shone more brightly than the midday sun/ with the scent of cypress, incense and pine. His *anticamera* no less richly/ was prepared with bed and canopy,/ and with curtain and ornament around.[102]

The range of silk and velvet embroidered with silver and fine gold collectively made the chamber shine 'more brightly than the midday sun'. The allusion to the gleam or shine created by the costly materials, interior decorations and furniture forms is repeated in Niccolò de' Carissimi's letter to Francesco Sforza. Niccolò describes how after dinner Galeazzo Maria and his entourage went on a tour of the noblest parts of the palace including 'the studies, chapels, halls, chambers, and garden all of which are constructed and decorated with admirable mastery, decorated on every side with gold and fine marbles, with carvings and sculptures in relief, with pictures and inlays done in perspective by the most accomplished and perfect masters even to the very benches and floors of the house.'

Carissimi continued to describe 'tapestries and household ornaments of gold and silk; silverware and bookcases that are endless and without number; then the vaults or rather the ceilings of the chambers or halls, which are for the most part done in fine gold with diverse and various forms; then a garden done in the finest of polished marbles with diverse plants, which seems a thing not natural but painted'. He concludes by stating that 'whoever sees them judges that they are celestial rather than earthly things, and everyone is agreed that this house is the most finished and ornate that the world had ever had or may have now, and that it is without comparison. In sum, it is believed by all that there is no other earthly paradise in the world than this'.[103]

Niccolò's enthusiastic response goes beyond mere eulogy and seems to be based on genuine amazement at the delights of the palace interior. Niccolò later states in his letter that he believes he 'shall never see anything worthier than this', and is quick to add that he is not alone in holding this opinion, stating that all the entourage 'do nothing else but discuss it.'[104] Here then is Galvano Fiamma and Paolo Cortesi's prescription, that palace architecture should leave onlookers 'thunderstruck', applied to the interior.[105]

The conceit that a palace could become an 'earthly paradise' was repeated in Giovanni Sabadino degli Arienti's 1497 account of the interior features of the Ferrarese palace of Belfiore: 'All the rooms of this palace take light from glassed windows. The joy of seeing the ornaments of the delicate and

splendid (*splendidi*) beds, and coverings, makes this habitation appear like an earthly paradise.'[106] As with that of Belfiore, it is the luminosity and shine created by the play of light against the fineness of the materials that stood out in the Medici palace interior. Where Niccolò saw the interior as an 'earthly paradise', the author of the *Terze Rime* interpreted the palace as somehow otherworldly.[107] The palace contains such delights that each person can take 'his pleasure as he sees fit' and pause to 'admire the great elegance of the palace', the 'appointments of the chapel' or the chambers and the study. Some though pause to admire particular details contained within the palace interior, such as the gilt ceiling: 'Which brings forth marvel in every face, / for when in the evening the torches are lit, / it represents a sun of paradise.'[108] Elsewhere in the narrative, another ceiling is also singled out for particular attention:

There's a ceiling such that to me it seems a sky of stars,/ so decorated
with blue, silver and gold/ that I could not tell of it with these verses./ I
do not believe that the choir of the seraphim/ in the heavens shines more
brightly/ than do these carvings ornamented with such work.[109]

The use of ornate and in particular gold ceilings was referred to in classical literature. In the *Naturalis Historia*, Pliny records how in his day it was common to find 'ceilings covered with gold even in private houses, but they were first gilded in the Capitol during the censorship of Lucius Mammius after the fall of Carthage [146 B.C].'[110] Used appropriately, golden decorations became associated with great wealth and status. Livy referred to Antiochus Epiphanes who 'built a magnificent temple (*magnficum templum*) to Jupiter Capitolinus, which had not merely its ceilings panelled with gold, but also its walls wholly covered with gilded plates.'[111] When used with undue excess and without regard to rules of decorum golden ceilings were to be condemned. This is shown in Suetonius' account of Nero's palace in which 'all parts were overlaid with gold and adorned with gems and mother-of-pearl. There were dining-rooms with fretted ceilings of ivory, whose parts could turn and shower down flowers and were fitted with pipes for sprinkling the guests with perfumes.'[112] Funded by ruinous taxes and built by forced labour, the immense palace that stretched from the Palatine to the Esquiline was the ultimate riposte to earlier notions of republican restraint.

Notorious throughout antiquity, the *Domus Aurea* or 'Golden House' was also cited during the Renaissance as a metaphor of the vice of unfettered extravagance. In Giovanni Pontano's discussion of splendour, Nero is specifically used as an example of excessive behaviour unbecoming of the splendid man. Recalling Suetonius' account of the *Domus Aurea* he commented that, despite his position as emperor, Nero 'was unrestrained without limits' and therefore outside the acceptable measure of decorum.[113] In another example, Pontano refers to Pope Paul II who he states 'wished to imitate the

glory' of the great gem and pearl collections of the Duke de Berry and King Alfonso of Naples. Where the fame of the Duke de Berry's splendour had 'spread across the land',[114] Paul II's attempt to 'join splendour to the pomp of the pontificate and to the ornament of the church' was seen 'as going beyond the dignity of a Pope.'[115]

Unlike Nero's *Domus Aurea*, in Cosimo's palace nothing was considered 'superfluous or lacking'.[116] The collective virtue of the Medici palace rooms that shone 'more brightly than the midday sun' and created an 'earthly paradise' accords closely with Pontano's description of splendour. References to 'polish' are interspersed throughout Pontano's text and are fundamental to the attainment of splendour. Thus in the section 'On Ornament' he writes: 'Above all it seems to me that one should have care for cleanliness and polish which is the companion of splendour';[117] and 'the homes of those who are splendid should have many things, well cared for and polished.'[118] Similarly in the section discussing the 'furnishings that are appropriate to the splendid man',[119] Pontano states: 'The goods of the splendid man should therefore be both polished and abundant. Not only should they correspond to his wealth but also to the expectations of others and to his dignity'.[120]

In *De splendore*, Pontano directly links the acquisition of goods with the benefit they accord to others. For Pontano, the appropriate purchase of furnishings and decorative goods is intrinsically related to the virtue of hospitality and has become the 'obligation of the splendid man'. Domestic objects are not to be acquired merely for personal 'use and comfort' but also for the intellectual reward of visitors and friends: 'Although men buy these things for use and comfort, it is the obligation of the splendid man to regard not only use and comfort, but to acquire as many of these objects as possible in such a way that friends and the knowledgeable, when it is necessary, can easily avail themselves of them...'[121]

Pontano further expands the benefits and application of domestic goods when he states: 'The splendid man must ensure that it is clear from his deeds that he has not purchased the goods for himself, but for his household, his friends and his family and when the public good requires it, for the use and the comfort of the people as a whole.'[122] The role served by splendid furnishings and decorative goods 'brings pleasure and prestige to the owner of the house, when they are seen by the many whom frequent his house.'[123]

The notions of the wider public benefits of hospitality were familiar themes repeated in fifteenth-century theoretical texts. In Beroaldo's *De optimo statu* (1497), the section on hospitality directly recalled Cicero's statement that 'the homes of illustrious men lie open to illustrious guests'. Through being 'thronged with guests and a crowd of people of every kind' these homes, Beroaldo argued, served as 'an ornament for the community'.[124] In a similar way, in *De optimo cive*, the Lombard humanist Platina also cited Cicero's

praise of hospitality. Dedicated to Lorenzo de' Medici in 1474, the text praised Lorenzo's grandfather Cosimo for having achieved in his palace the objective that a house 'should be open and spacious so that private and public guests can be received magnificently and very honourably.'[125] For Pontano too, hospitality was also a public and private duty: the splendid man should be ready to receive guests 'in a manner which is not only welcoming but also magnificent' while ensuring that 'he has worthy and elegant furnishings and that his home has abundant ornaments.'[126]

Notes

1. 'Erunt denique omnia demensa, et nexa et compacta lineis angulis ductu cohesione comprehensione… praebebuntque se, ut per coronas per intercapedines omnemque per intimam extimamque faciem operas quasi fluens libere et suave decurrat intuitus, voluptatem augendo ex voluptate similium dissimiliumque rerum.' Alberti *De re aedificatoria* Book IX, 9, ed. G. Orlandi. Milan (1966): p. 851; trans J. Rykwert, N. Leach and R. Tavernor, *On the Art of Building in Ten Books.* Cambridge, Mass. (1988): p. 314.

2. 'Sed redeo ad privatorum domos, que ad delitias, ad amplitudinem, ad honestatem maximeque ad magnificentiam instructe, excogitate, edificate sunt.' Leonardo Bruni, *Panegirico della città di Firenze*, ed. G. de Toffol. Florence (1974): pp. 20–22.

3. The relevant passage reads: 'Sed si quis ea nosse cupit, huc accedat, urbem peragret; nec velut festinus hospes aut citatus viator petranset, sed insistat, inquirat, contempletur. Nam ceterarum quidem urbium valde interest ne quis in ea peregrinus trahat moram diutius. Nam si quid ornamenti habent, id quidem omne in propatulo est atque in primo (ut ita dicam) cortice, quod simul atque urbem ingressi sunt advene homines intueantur. At si celebriora loca relinquant, si non domorum cortices sed medullas perscrutentur, nichil erit quod ei quam ante conceperant opinioni respondeat: pro domibus enim edicule sunt, proque externo decore interne sordes. Florentia vero nisi intus inspiciatur, omnis eius pulcritudo cognosci non potest. Itaque quod aliis damnum existimationis affert, huic summe auget existimationem. Non enim intra parietes minus ornamenti aut magnificentie habet quam extra; nec una aut altera via decora aut nitidia est, sed universe totius urbis partes. Nam velut sanguis per universum corpus, sic ornamenta delitieque per universam urbem diffuse sunt.' Ibid., p. 23; trans B.G. Kohl and R.G. Witt, *The Earthly Republic.* Manchester (1978): pp. 140–1.

4. 'Sed cum foris hec civitas admirabilis est, tum vero disciplina institutisque domesticis. Nusquam tantus ordo rerum, nusquam tanta elegantia, nusquam tanta concinnitas.' Ibid., p. 82.

5. 'eodem modo hec prudentissima civitas ita omnes sui partes moderata est ut inde summa quedam rei publice sibi ipsi consentanea resultet, que mentes atque oculos hominum sua convenientia delectet.' Ibid., p. 82.

6. 'Nichil est in ea preposterum, nichil inconveniens, nichil absurdum, nichil vagum; suum queque locum tenent, non modo certum, sed etiam congruentem.' Ibid., p. 82.

7. 'non tamen unquam adductus sum ut blanditiis atque assentando id consequi vellem.' Ibid., p. 58.

8. 'Perstultus quipped essem, si ex ac tantula re numerosissimi populi gratiam comparare mihi posse existimarem. Sed ego, cum hanc pulcerrimam urbem viderem, cum eius prestantiam, ornatum, nobilitatem, delitias, gloriam magnopere admirarer, tentare volui possemne dicendo tantam pulcritudinem ac magnificentiam explicare.' Ibid., p. 58; trans Kohl and Witt (1978): p. 156.

9. For Pontano's quote on the relationship between magnificence and splendour see the Introduction.

10. 'quod et ipse in magnis versatur sumptibus et habet pecuniam communem quidem cum illa materiam…' F. Tateo ed., *Giovanni Pontano I libri delle virtù sociali.* Rome (1999): p. 224.

11. 'Quin etiam magnificentia in publicis operibus et iis, quae diutius permansura sint, magis versatur, cum splendor privata potius curet, nec momentanea quaedam ac minore negligat.' Ibid., p. 224.

12. Ibid., p. 44. Aristotle *Nicomachean Ethics* IV, i, trans J.A.K. Thomson. London (1976): p. 142.

13. Ibid., p. 60. Aristotle had considered liberality (*eleutheriotēs*) as the mean between the excess of prodigality (*asōtia*) and the deficiency of illiberality (*aneleutheria*). Aristotle *Nicomachean Ethics* II, vii, 4 and IV, i; Thomson (1976): p. 104 and p. 142.

14. Ibid., pp. 88 and 100–5. Aristotle had stated 'it is the nature of the liberal man not to regard his own interest'. The art of giving appropriately is a central attribute of the liberal man. Aristotle *Nicomachean Ethics* IV, i; Thomson (1976): p. 144.

15. XI. Quae sint magnifici viri opera. The relevant passage reads: 'Quae autem opera magnificorum sint propria, distinctibus dicenda sunt; quorum alia publica sunt, alia privata: publica, ut porticus, templa, moles in mare iactae, viae stratae, theatra, pontes et eiusmodi alia; privata, ut aedes magnificae, ut villae sumptuosae, turres, sepulcra.' Ibid., p. 184.

16. 'Quo fit ut, qui magnifici sunt, in illis praecipue versentur operibus, quae diutius sint permansura. Quo enim diuturniora, eo praeclariora sunt, et eorum quidem usus quo diuturnior, eo magis et opera et auctores ipsos commendat.' Ibid., p. 186.

17. 'Aetate nostra Cosmus Florentinus imitatus est priscam magnificentiam tum in condendis templis ac villis, tum in bybliothecis faciendis; nec solum imitatus, sed, ut mihi videtur, is primus revocavit morem convertendi privatas divitias ad publicum bonum atque ad patriae ornamentum…' Ibid., p. 188.

18. 'Nam, etsi magnificentia in publicis maxime operibus enitescit, tamen tum urbanas aedes, tum villas magnifice ac pro dignitate structas exornatasque habere magnificum volumus…' Ibid., p. 190.

19. 'quae et urbi sunt ornamento et domino pariunt auctoritatem.' Ibid., p. 190.

20. 'Ad haec qui divitiis affluat, qui sit e principibus civitatis, huic sordida et angusta domus dehonestamento est; videtur enim indicium esse tum avari, tum abiecti animi.' Ibid., p. 190.

21. Aristotle *Nicomachean Ethics* IV, ii; Thomson (1976): p. 151; see also Chapter 1, section 1.

22. 'Qualis esse debeat domus cardinalis.' K. Weil-Garris and J.F. D'Amico *The Renaissance Cardinal's Ideal Palace: A Chapter from Cortesi's 'De Cardinalatu'*. Rome (1980): pp. 70–1.

23. 'De ornamento domus.' Ibid., pp. 86–7.

24. 'Ornamentorum autem genus duplex esse potest: unam quod extrinsecus in excolendorum ratione uersatur, alterum quod in interiori ornandi descriptione consistit.' Ibid., pp. 86–7.

25. 'neque solum quae incohes, sed etiam quae inter efficiendum usui futura sunt, ex ipsis exemplaribus admonti praecogitemus necesse est atque etiam paremus, ne, coepto opere, non hesitandum non variandum non supersedendum, sed tota re brevi et circumscripta quadam explicatione percepta…' Book IX, 9, Orlandi (1966): p. 851; trans Rykwert (1988): p. 314.

26. For a discussion of the motivations for Cosimo de' Medici's rejection of the Brunelleschi design, see Chapter 2, section 2.

27. Giorgio Vasari 'Vita di Filippo Brunelleschi': 'Cosimo de' Medici voleva far fare il suo palazzo, e così ne disse l'animo suo a Filippo; che posto ogni altra cura da canto, gli fece un bellissimo e gran modello per detto palazzo…' The passage in the *Vita di Michelozzo Michelozzi* reads: 'Fu Michelozzo tanto familiare di Cosimo de' Medici, che conosciuto l'ingegno suo, gli fece fare il modello della casa e palazzo che è sul canto via Larga, di costa a S. Giovannino…' in *Le Vite de' più eccellenti pittori scultori e architettori*, ed. A. Rossi. Vol. II. Milan (1962): p. 281 and p. 332.

28. A. Lillie, 'The Palazzo Strozzi and Private Patronage in Fifteenth Century Florence', in H.A. Millon ed., *The Renaissance from Brunelleschi to Michelangelo: The representation of architecture*. London (1994): p. 519.

29. Tommaso di Federigho Federighi (1489) MPAP 179 fol.189r. *Nel logia*: 1° schudo dell'arme loro; Bartolomeo di Mariotto di Giovanni dello Stecchuto (1496) MPAP 181 fol.44v. *Nella logia*: uno palvese e 1ª ttargha chol'arme.

30. The diamond ring with three feathers together with the motto *semper*, were adopted by Piero di Cosimo de' Medici. Roses are also used elsewhere in Medicean imagery. See F. Ames-Lewis, 'Early Medicean Devices', *Journal of the Warburg and Courtauld Institutes*, 42 (1979): pp. 122–43.

31. M. Spallanzani and G.C. Bertelà, eds., *Libro d'inventario dei beni di Lorenzo il Magnifico*. Florence (1992): p. 27. On the birth tray see: J.M. Musacchio, 'The Medici-Tornabuoni Desco da Parto in Context', *Metropolitan Museum Journal*, 33 (1998): pp. 137–51; and *The Art and Ritual of Childbirth in Renaissance Italy*. New Haven (1998): pp. 73–5.

32. Messer Matteo degli Scholari (1430) MPAP 165 fol.606r: 2 forzeretti d'andare in uficio choll'arme della chasa; 2 chassoni tarsiati cho' arme della chasa.

33. Gismondo di Messer Agniolo della Stufa (1495) MPAP 179 fol.367r: 1° libretto in charta pechora chiamato chol'arme in sulla choverta; fol.368r: 1ª misciroba d'ottone alla domaschina chol'arme di…

34. Gismondo di Messer Agniolo della Stufa (1495) MPAP 179 fol.368v. The consecutive entries read: 1° bacino d'ottone chol'arme di chasa e degli Spini; 1° bacino d'ariento chon più lavori e chol'arme di chasa; 1° bacino d'ottone chon l'arme di chaxa e de' Paghanelli; 1° bacino d'ottone usato chol'arme di chaxa e de Ridolfi.

35. Lorenzo di Giovanni Tornabuoni (1497) MPAP 181 fol.141v: 2 bacini d'ottone con più lavori chon ismalto e con l'arme di chase Albizi e Gianfigliazi.

36. Ibid., fol.149v: 2 chassoni a sepoltura da spose chon l'arme di chasa e de' Pitti di braccia 4 l'uno chon serami choperti di tela verde.

37. Ibid., fol.148r: 1° quadro chon chornicione messo d'oro chon testa e busto della Giovanna degli Albizi.

38. The *opus reticulatum* pattern was discussed in Vitruvius, Book II, 7 and Alberti, Book II, 2 and VIII, 3.

39. For example in the *loggia terrena* of the Medici palace: 'Quattro panche di pino corniciate di nocie e pettorali et intarisiate intorno a detta loggia, di br. 80, tutte di stima. f.20.' 1492 inventory, fol.3r. See Spallanzani and Bertelà (1992): pp. 6–7.

40. For this account see R. Trexler, *Public Life in Renaissance Florence*. New York (1980): pp. 447–8.

41. J. Ross, *Lives of the Early Medici as Told in Their Correspondence*. London (1910): pp. 129–54.

42. 'Panche e spalliere atorno che ricinghono detta sala, di braccia 80 incircha, di pino corniciate di nocie e tarsie, e piedi di dette panche intagliati pure di nocie. f. 20.' 1492 inventory, fol.13v. See Spallanzani and Bertelà (1992): p. 25.

43. The three consecutive entries read as follows: 'Dua forzieri a sepultura, richi, con console e architrave, messe d'oro fine tutto e storiato della storia della vittoria di Marcho Mar[c]ello della Sicilia. f.50; Uno chassone di pino da br. 4, cornicie e squarciato di nocie con tarsie e più lavori di silio e una predella di nocie con tarsie sotto a' detti forzieri et chassone. f.12; Una spalliera di br. xii lunga e alta br. una e ½ sopra a' detti forzieri e chassone, dipintovi drento la storia della giostra di Lorenzo con cornicie e colonnette messe d'oro, divisa in 3 parte, di mano dello Scheggia. f.60.' Spallanzani and Bertelà (1992): p. 73 (fol.39r).

44. For example Matteo di Guiliano Ghottoli (1439) MPAP 171 fol.1r: 1 paio di forzieri storiati all'anticha; and Salvestro di Zanobi di Mariano chartolaio (1496) MPAP 181 fol.31v: Un chassone a selpolttura chon tarsia al'anticha di br.4 incircha.

45. For *lettiere* see: Gismondo di Messer Agniolo all Stufa (1495) MPAP 179 fol.364r: 1ª lettiera di braccia 5 incircha chon chornicione di noce con tarsie a pie. For *lettucci* see: Alberto d'Avirado Castiglionchi (1495) MPAP 178 fol.352r: 1° letto cho lettiere al'anticha; 1° lettuccio al'anticha; Lorenzo di Giovanni Tornabuoni (1497) MPAP 181 fol.141r: 1° lettuccio di braccia 5 in circha chol chornicione di nocie e chassone.

46. See C. Maltese and L. Degrassi Maltese in *Trattati di architettura ingegneria e arte militaria* Vol.I. Milan (1967): p. 72. For a discussion of Francesco di Giorgio's manuscripts and other related issues see pp. xi–lxviii.

47. 'Le case de' principi e gran signori vogliano essare in nella prima fronte di bello e grato aspetto. Situate con espaziose piazze dinanzi da esso. Presso al cattedral e luoghi pubrichi come se d'uffizi e altri luoghi mercantili della città…' Ibid., p. 72.

48. 'E che in nella parte sotterranea sia canove, cellai, legnai, pistrini e molte altre cose opportune al servizio d'essa. In nel sicondo pavimento e al piano della prima entrata sieno sale, salotti, camare, anticamare, tinelli, di spense, studi, udienze, cancellarie,

destri e altre cose appartenenti a tali edifizi e signori, e sicondo la invenzione
dell'architetto o opportunità d'esso, tutti dupricati e conferenti.' Ibid., pp. 72–3.

49. P.W.G. Gordon, *Two Renaissance Book Hunters: The letters of Poggius
Bracciolini to Nicolaus de Niccolis* New York (1974): p. 188.

50. See C.H. Krinsky, 'Seventy-eight Vitruvius Manuscripts', *Journal of the Warburg and
Courtauld Institutes*, 30 (1967): pp. 36–70. Sassetti's manuscript is listed in a 1462
inventory of his assets as: '1 Vetruvio et Chato de Re Rusticha et Marco Varro de
agricoltura coperto di ross. fl.10.' Archivio di Stato, Florence, Carte Strozziane, ser. 2,
20, Ricordanze di Francesco Sassetti fol.3v. See the fifth entry in Illustration 4.

51. A. de la Mare, 'The library of Francesco Sassetti (1421–90)', in C.H. Clough ed.,
Cultural Aspects of the Italian Renaissance. Manchester (1976): p. 162. The Sassetti
manuscript is now in the Biblioteca Medicea-Laurenziana, Florence Plut. xxx, 10.

52. 'Itaque omnium operum probationes tripertito considerantur, id est fabrili
subtilitate et magnificentia et dispositione.' Vitruvius *De Architectura
libri decem* ed F. Granger. Vol.II. London (1931): p. 56.

53. 'Cum magnificenter opus perfectum aspicietur, ad omini potestate inpensae laudabuntur;
cum subtiliter officinatoris probabitur exactio; cum vero venuste proportionibus et
symmetriis habuerit auctoritatem, tunc fuerit gloria area architecti.' Ibid., pp. 56–58.

54. The relevant section reads: 'Namque omnes homines, non solum architecti,
quod est bonum, possunt probare, sed inter idiotas et eos hoc est discrimen,
quod idiota, nisi factum viderit, non potest scire, quid sit futurum,
architectus autem, simul animo constituerit, antequam inceperit, et venustate
et usu et decore quale sit futurum, habet definitum.' Ibid., p. 58.

55. 'Cum ad regiones caeli ita ea fuerint disposita, tunc etiam animadvertendum est,
quibus rationibus privatis aedificiis propria loca partibus familiarum et quemadmodum
communia cum extraneis aedificari debeant. Namque ex his quae propria sunt, in ea
non est potestas omnibus intro eundi nisi invitatis, quemadmodum sunt cubicula,
triclinia, balneae, ceteraque, quae easdem habent usus rationes. Communia autem
sunt, quibus etiam invocati suo iure de populo possunt venire, id est vestibula,
cava aedium, peristylia, quaeque eundem habere possunt usum.' Ibid., p. 36.

56. As Linda Pellecchia has demonstrated *cavum aedium* and *atria* were used
interchangeably by Vitruvius to denote the same space. For the sake of clarity I
have used the word 'courtyard' to denote these terms. L. Pellecchia, 'Architects
read Vitruvius: Renaissance Interpretations of the Atrium of the Ancient House',
Journal of the Society of Architectural Historians, 51 (1992): pp. 377–416.

57. 'Igitur is, qui communi sunt fortuna, non necessaria magnifica
vestibula nec tabulina neque atria, quod in aliis officia praestant
ambiundo neque ab aliis ambiuntur.' Granger (1931): p. 36.

58. Ibid., p. 38.

59. '…sed etiam aliorum, sic in domo clari hominis, in quam et hospites multi
recipendi et admittenda hominum cuiusque modi multitudo…' Cicero *De Officiis*
Book I, xxxix, 139; trans W. Miller. Cambridge Mass. (1913): p. 143.

60. 'In principatu maturius semper ac de nocte vigilabat; dein perlectis epistulis
officiorumque omnium breviariis, amicos admittebat, ac dum salutabatur, et
calciabat ipse se et amiciebat;' Suetonius *De vita Caesarum: Vespasian* Book VIII,
trans J.C. Rolfe Vol.II London and Cambridge Mass. (1914): p. 314

61. 'Accedebat quod ista tradidisset non culta: sic enim loquebatur, ut Latini Graecum
videri voluisse, Graeci locutum Latine vaticinentur; res autem ipsa in sese porrigenda
neque Graecum fuisse testetur, ut par sit non scripsisse hunc nobis, qui ita scripserit, ut
non intelligamus.' Book VI, 1, Orlandi (1966): p. 441; trans Rykwert (1988): p. 154.

62. Pellecchia (1992): pp. 377–416.

63. 'Domus regia et illius, qui libera in urbe senator praetorius consularisive
sit, prima erit omnium, quam esse decentissimam desideres.' Book
IX, 1, Orlandi (1966): p. 783; trans Rykwert (1988): p. 292.

64. 'placebit nimirum, qui partes eas, quae maxime publicae, quaeve in primis hospiti gratificaturae sint, uti est frons aedis, vestibulum et eiusmodi, admodum esse decentissima voluerit.' Ibid., trans Rykwert (1988): p. 292.

65. 'Vestibulum quidem velim pro cuiusque dignitate sese praestet honestissimum atque splendidissimum. Succedat et porticus clarissima; neque desint spatia magnifica. Demum et caetera deinceps omnia ex publicorum imitatione sibi, quantum res ipsa permittat, quod faciat ad decus dignitatemque desument; hac rerum moderatione adhibita, ut prae se ferat longe venustates maluisse captare quam ullos fastus sequi.' Ibid., pp. 783–5; modified from Rykwert (1988): pp. 292–3.

66. 'Cumque tricliniorum et itionum et conceptaculorum alia popularia sint, alia obclusiora et prorsus intima, in illis serviet splendori forensi cum publica urbis […] pompa nequicquam odiosa, in his autem reconditioribus paulo sublascivire ad arbitrium licebat.' Ibid., p. 787; Rykwert (1988): p. 294.

67. 'Sed cum partes aedificiorum inter se multum different, natura scilicet et specie…' Ibid., Book IX, 3 (1966): p. 795; trans Rykwert (1988): p. 296.

68. 'Et earum aliae maiores fiant necesse est, uti sunt aedium sinus; aliae minore indigent area, uti est conclave penetraliaque omnia; aliae sunt mediae, uti coenacula atque etiam vestibulum.' Ibid., p. 795; Rykwert (1988): p. 296.

69. 'Omnium pars primaria ea est, quam, seu cavam aedium seu atrium putes dici, nos sinum appellabimus; proxima veniunt coenacula; subinde habentur, quae singulorum sunt, cubicula; postrema existant conclavia; reliqua ipsis ex rebus notescunt. Itaque sinus pars erit primaria, in quam caetera omnia minora membra veluti in publicum aedis forum confluant, ex quave non aditus modo commodissimus verum et luminum etiam commoditates aptissime importentur.' Ibid., Book V, 17 (1966): pp. 417–19; modified from Rykwert (1988): p. 146.

70. As Pellecchia points out Alberti was the only *quattrocento* writer to realize that the two words were synonymous. Pellecchia (1992): pp. 377–416.

71. 'Quomque, uti diximus, aedium partes aliae universorum aliae plurimorum aliae singulorum sint…' Book V, 17, Orlandi (1966): pp. 415–17; Rykwert (1988): p. 145.

72. 'Est igitur splendidi hominis non solum curare ut dignam atque elegantem supelectilem habeat domesticisque ornamentis abundet, sed, quod turpe sit imparatum offendi, sive ad privata, sive ad publica munera, habebit quidem domi apparatum rerum plurimarum, quae ipsius luculentiam declarent, ut, si hospes, advenerit, praesto sint ea, quibus opus fuerit ad illum non comiter tantum, verum etiam magnifice accipiendum.' Tateo (1999): p. 234; trans adapted from E. Welch, 'Public Magnificence and Private Display: Giovanni Pontano's "De Splendore" (1498) and the Domestic Arts', *Journal of Design History*, 15 (2002): p. 225.

73. '…sed etiam aliorum, sic in domo clari hominis, in quam et hospites multi recipendi et admittenda hominum cuiusque modi multitudo, adhibenda cura est laxitatis…' Book I, xxxix, 139; Miller (1913): p. 143.

74. Filippo Beroaldo, *De optimo statu*. Bologna, 1497 fol.D iiii v. British Library, London IA.29076.

75. '…aliter ampla domus dedecori saepe domino fit, si est in ea solitudo, et maxime…' Book I, xxxix, 139; Miller (1913): p. 143.

76. '…si aliquando alio domino solita est frequentari. Odiosum est enim, cum a praetereuntibus dicitur: "o domus ántiqua, heu quam díspari domináre domino!" quod quidem his temporibus in multis licet dicere.' Ibid., p. 143.

77. Quoted in M. Phillips, *The Memoir of Marco Parenti: A Life in Medici Florence*. Broadview Press (2000): p. 190. Cicero also discusses hospitality in Book II, where he specifically refers to the 'very great advantage' of appropriate hospitality 'for those who wish to obtain a powerful political influence'. Book II, xviii, 64; Miller (1913): p. 237.

78. Phillips (1987): p. 208.

79. 'Nella casa d'un uomo richo sono da essere ricevuti molti forestieri e debbono essere honorati con largità imperochè altrimenti faccendo l'ampla casa sarebbe a disonore del Signore.' F.W. Kent et al *Giovanni Rucellai ed il suo Zibaldone: A Florentine Patrician and his Palace*. Vol. II (1981): p. 84.

80. For Rucellai's reference to the palace of Gnaeus Octavius in Rome see Chapter 2, section 2.

81. Aristotle IV, ii, 15–16; Thomson (1976): p. 151.

82. For Giovanni Rucellai's account of the marriage festivities see: A. Perosa ed., *Giovanni Rucellai ed il suo Zibaldone: 'Il Zibaldone Quaresimale'*. Vol.I. London (1960): p. 28.

83. For a full discussion of the *Libro Cerimoniale* see R. Trexler, *The Libro Cerimoniale of the Florentine Republic by Franceso Filarete and Angelo Manfridi*. Geneva (1978).

84. Filarete recorded entries in the *Libro* from 1456 until 1499 when old age led to the position passing to his son-in-law Angelo di Lorenzo Manfridi di Poppi. Manfridi's first ceremonial report was not until 1515 and the book ends with a final entry in September 1522. See Trexler (1978): pp. 47–52.

85. 'Ma lui sia obligato fare et a ordinare uno libro el quale si tenga in cancellaria de' signori, et in su quello riduca almeno dal 1456 in qua tucte le venute di principi ecclesiastici et temporali venuti nella città et stuti honorati, et le ceremonie facte et spese in modo se n'abbia.' Ibid., p. 54.

86. Trexler (1980): pp. 279–330.

87. For the visits of Pius II and Frederick III see Trexler (1978): pp. 71–5 and 78.

88. 'Re di Bossina tornò Alla Corona…' fol.17r. Ibid., p. 95.

89. 'El cardinale di Mantova e legato del sommo pontefice vene a dì 22 dì d'octobre 1482 e fu honorato come di costume de' legati col baldacchino e lle processioni. Fu aspettato dalla nostra magnifica Signoria alla ringhiera. E dopo la visitatione fu acompagnato a' Tornabuoni, cioè in casa di Giovanni Tornabuoni, e fattogli le spese del publico. Fu l'altro dì visitato da nostri magnifici Signori con buono numero di cittadini.' Ibid., p. 95.

90. E. Borsook, 'Decor in Florence for the Entry of Charles VIII of France', *Mitteilungen des Kunstistorichen Institutes in Florenz*, 12 (1961–2): pp. 106–22; and B. Mitchell, *Italian Civic Pageantry in the High Renaissance. A descriptive bibliography of Triumphal Entries and selected other Festivals for State occasions.* Florence (1979): pp. 35–37.

91. R. Hatfield, 'Cosimo de' Medici and the Chapel of his Palace' in F. Ames-Lewis ed., *Cosimo 'Il vecchio' de' Medici (1389–1464)*. Oxford (1992): p. 223.

92. 'Ma tanto e in Firenze non si fe' mai simile feste, nè simile prociessioni, nè simile rapresentazioni quanto fu questa, la qual si fe' al papa Pio e Ghaliazo Maria figl[i]o del ducha di Milano.' Benedetto Dei, *La cronica dall'anno 1400 all'anno 1500*. R. Barducci ed. Florence (1984): p. 68.

93. 'Questa è festa della chomunità et fassi per honore della ciptà e non per altre leggieri chagioni come s'è chostumato più volte.' Letter dated 17 April 1459 cited in A. Rochon, *La Jeunesse de Laurent de Médicis (1449–1478)*. Paris (1963): p. 100, n. 8.

94. Trexler (1978): pp. 74–5.

95. '…con questo expectaculo bellissimo si pervene con grande strepito di trombe e campagne alla piazza.' Ibid., p. 75.

96. 'andò ad smontare nel palazzo de Cosmo. Et primo trovò Petro de Cosmo tuto in ystato in sula cima dela prima scala, quale abrazò et basciò el prefato conte molto amorevelemente, et a tuta la brigata tocò la mano et fece queste più grate acoglienze gli foi possibile. Poi immediate andò el prefato conte nela capelleta del predecto Cosmo. Lo aspectava lì, pur tuto ingotato. Et reverentemente se gli butò inanzi, et lo decto magnifico Cosmo lo reclose sul pecto…' April 17, 1459. See Hatfield (1992): p. 225.

97. '…se bisognò partire da lì per la multitudine che sopragiungeva che voleva visitare el prefato magnifico Cosmo.' Ibid., p. 225.

98. Trexler (1980): esp. pp. 315–323.

99. 'Et è vvi una chappella tanto ornata / che nonn 'a pari in tutto l'universo, / tanto al chulto di Dio è preparata. / Et chi la guarda ben per ongni verso che 'l tabernachul sia dell' almo Trino / dirà, perché per tutto è pulcro et terso.' *Terze Rime*, fol.22r; R. Hatfield, 'Some Unknown Descriptions of the Medici Palace', *Art Bulletin*, 52 (1970): pp. 234 and 247.

100. For a discussion of chapels in Florentine palaces see: P. Mattox, *The Domestic Chapel in Florence 1440–1550*. PhD Thesis, Yale University, 1996.

101. H. Saalman and P. Mattox, 'The First Medici Palace', *Journal of the Society of Architectural Historians*, 44 (1985): pp. 344–5.

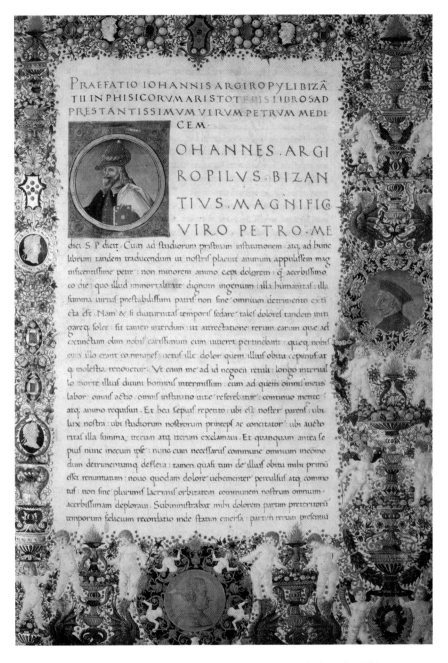

PRAEFATIO IOHANNIS ARGIROPYLI BIZĀ
TII IN PHISICORVM ARISTOTELIS LIBROS AD
PRESTANTISSIMVM VIRVM PETRVM MEDI
CEM·

OHANNES·ARGI
ROPILVS·BIZAN
TIVS·MAGNIFIC
VIRO·PETRO·ME

dici. S. P. dicit· Cum ad studiorum pristinam institutionem: atq. ad hunc
librum tandem traducendum ut nostris placuit animum appulissem mag
nificentissime petre: non minorem animo cepi dolorem: q. acerbissimo
eo die: quo illud immortalitate dignum ingenium: illa humanitas: illa
summa uirtus prestabilissum patris non sine omnium detrimento exti
cta est. Nam & si diuturnitas temporis sedare tales dolores tandem miti
gareq. solet: sit tamen interdum: ut attrectatione rerum earum que ad
extinctum olim nobis carissimum cum uiuerit pertinebant: quicq. nobis
cum illo erant communes: uetus ille dolor quem illius obitu cepimus at
q. molestia renouetur. Vt enim me ad id negoci retuli: longo interual
lo morte illius diuini hominis intermissum: cum ad quem omnis meus
labor omnis actio omnis institutio uite referebatur: continuo mente
atq. animo requisiui. Et heu sepuls repento: ubi est noster parens: ubi
lux nostra: ubi studiorum nostrorum princeps ac concitator: ubi aucto
ritas illa summa: iterum atq. iterum exclamaui. Et quanquam antea se
pius nunc mecum ipse: nunc cum necessariis commune omnium incomo
dum detrimentumq. deflera: tamen quasi tum de illius obitu mihi primū
esset renuntiatum: nouo quodam dolore uehementer perculsus atq. commo
tus: non sine plurimis lacrimis orbitatem communem nostrum omnium·
acerbissimam deploraui. Subministrabat mihi dolorem partim preteritorū
temporum felicium recordatio inde statim emersa: partim rerum presentiū

Plate 1 Janos Argyropoulos' Aristotle, Latin translation including the *Ethica
Nicomachea, c.* 1473–8, fol. 2r. On parchment, 380 × 268mm

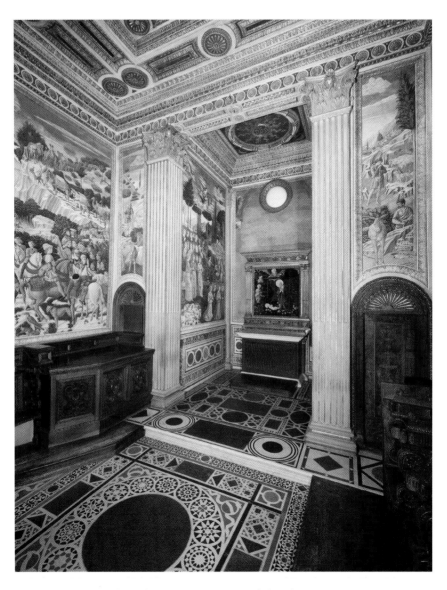

Plate 2 Palazzo Medici, Florence. Interior view of chapel

Plate 3 Workshop of Apollonio di Giovanni, *forziere*, *c*. 1475. The gilding, lid and feet of a later date. Carved and gilt walnut, painted in tempera

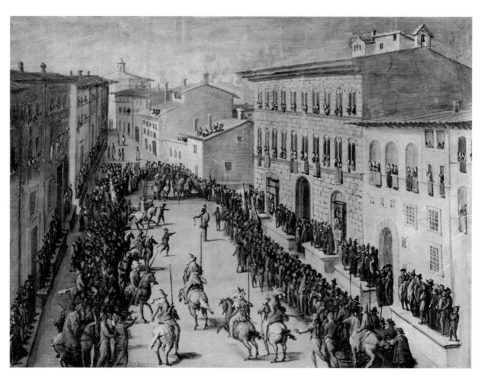

Plate 4 Giovanni Stradano, *Joust of the Saracen in Via Larga*, 1540s

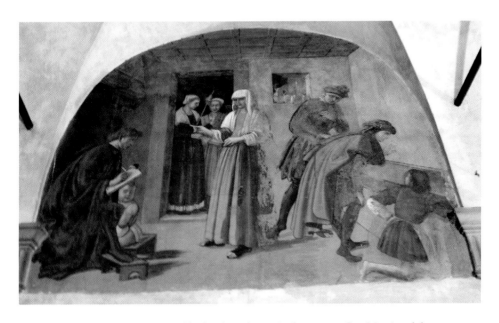

Plate 5 Workshop of Domenico Ghirlandaio, fresco in the oratory San Martino del Vescovo, Florence. Late fifteenth century

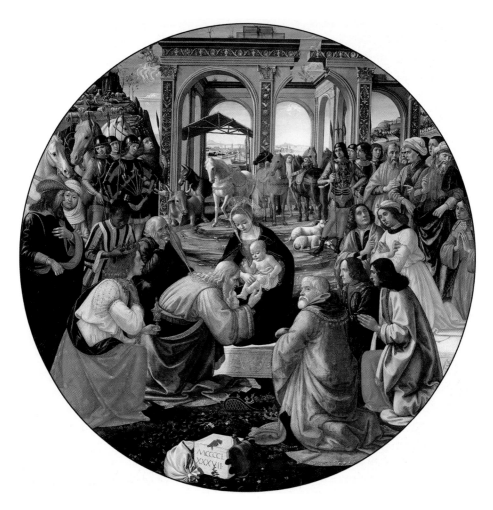

Plate 6 Domenico Ghirlandaio, *Adoration of the Magi*, 1487. Tempera on panel, diameter 171.5 cm

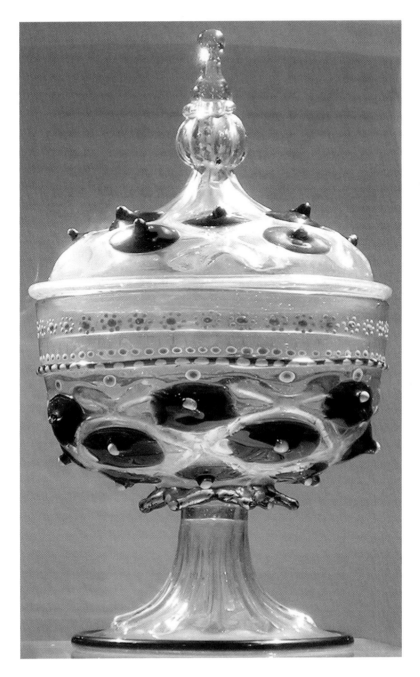

Plate 7 Standing cup and cover with applied red, blue and green glass, enamelled and gilt decoration. Height: 24.5 cm. Venice, late fifteenth century

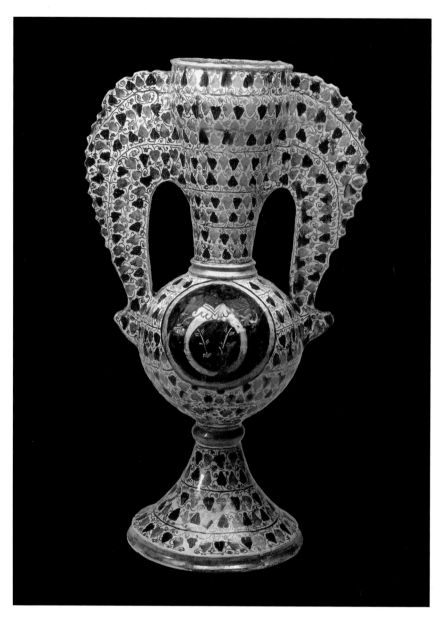

Plate 8 Two-handled maiolica vase with the *imprese* of Piero or Lorenzo de' Medici.
Leaf design in lustre and cobalt blue. Valencia, Spain, *c.* 1465–92. Height: 57 cm

102. 'Et la zanbra di Pier, gientile et leta, / si preparò da 'nperio et da reine / per lo invitto
et mangnio aghoniteta,/ Di seta un ciel chon frangiate chortine, / sul letto un vellutato
alessandrino, / richamati d'argiento et d'oro fine./ Et tutta intorno per ongni chonfino
/ lustrava più che 'l sol di mezzo giorno / chon odor d'arcipresso, incienso et pino,
/ L'antichamera sua non chon meno orno / parata fu di letto et sopra cielo, / et di
chortina et d'ornamento intorno;' fol.29v; Hatfield (1970): pp. 235 and 247–8.

103. 'In questo mezo el prefato conte insieme con la compagnia andò visitando questo palazo, et
in specialità le parte più digne; como sonno alcuni studioli, capellete, sale, camere et zardino,
quali tutti sonno fabricati et ornati con mirabile maystero, ornati da ogni canto d'oro et marmori
fini, a intaly et sculture relevate, de pincture et tarsiature facte in perspectiva da solennissimi
et perfectissimi maistri fino ale banche et le tere tute de casa; dele tapazarie et ornamenti de
casa d'oro et de sette; dele arzentarie et librarie che sonno infiniti et senza numero; poi dele
celi o vero solari dele camere et dele sale, che sono la più parte posti ad oro fine cum diverse
et varie forme; poy uno zardino facto tutto de bellissimi marmori politi cum diverse piante,
che no pare cosa naturale ma dipincta… Et ogniuno iudica che questa casa sia la più compita
et ornata che havesse may né habia el mondo, et senza alcuna comparatione. In somma, per
tutti se crede che al mondo non sia paradixo terrestro che questo.' April 17, 1459. Ibid., p. 246.

104. 'ho opinione che ali dì mei non vederò may cosa più digna de questo [che]
ho veduto et vedo de prima. Et io non solo ho questa opinione, ma tutta
la brigata qui, che non hanno altro che rasonare…' Ibid., p. 246.

105. See Chapter 2, section 2.

106. '…e tutte le stantie de questo palacio prendeno lume per vitruate finestre presso la felicita del
vedere li loro ornamenti de li dilicati e splendidi lecti & Tapezarie che pare una Abitatione
de uno terestre paradiso…' W.L. Gundersheimer ed., *Art and Life at the Court of Ercole I
d'Este: the 'De Triumphis religionis' of Giovanni Sabadino degli Arienti.* Geneva (1972): p. 72.

107. Hatfield (1970): p. 246.

108. The relevant lines read: 'Ciaschun chome gli par piglia piaciere; / chi mira del palazzo il mangnio
ornato, / chi del giardino et chi si dà 'l ghodere; / Et chi della chappella l'apparato, / chi chamera
et scrittoio rimira fiso, / chi le sale et chi 'l palcho aureato, / Che fa la maraviglia in ciaschun viso, /
ché quando sono la sera i torchi acciesi / e' rappresenta un sol di paradiso.' Ibid., pp. 236 and 248.

109. 'Tal palcho v'è ch' un cielo di stelle parmi, / ornato si d'azzuro, argiento et oro / ch' i'
no' l' potrei ridire chon questi charmi. / Non credo che più splenda in cielo il choro / de'
serafini che si facciano quellj / intagli ornatj di tanto lavoro.' Ibid., pp. 234 and 247.

110. 'Lacquearia, quae nunc et in privatis domibus auro teguntur, post Carthaginem eversam
primo in Capitolio inaurata sunt censura L. Mummi,' Pliny *Naturalis Historia*, Book
33, xviii, 57; trans H. Rackham. Cambridge Mass. Vol. IX (1958–67): pp. 46–7.

111. '…et Antioche Iovis Capitolini magnficum templum, non laqueatum auro tantum, sed
parietibus totis lammina inauratum…' Livy *Historiae Romanae* Book 41, xx. 9; trans E.T.
Sage and A.C. Schlesinger. London and Cambridge, Mass. Vol. XII (1938): p. 249.

112. 'In ceteris partibus cuncta auro lita, distincta gemmis unionumque conchis erant;
cenationes laqueatae tabulis eburneis versatilibus, ut flores, fistulatis, ut ungenenta desuper
spargerentur;' Suetonius, *De vita Caesarum: Nero.* Book VI, xxxi, 2; Rolfe (1914): p. 130.

113. 'Fuit domus eius non solum auro perlita, sed gemmis atque unionum conchis distincta,
cuius coenacula tabulis eburnei iisque versatilibus laqueata fuerint, quo tum flores
per fistulas spargi, tum unguenta desuper defluerew possent. An hic tibi ex omni
parte diffluxisse videtur…' Tateo (1999): p. 226; trans Welch (2002): p. 223.

114. 'Fama splendoris eius per orbem terrarum erat divulgata.' Ibid., p. 238.

115. 'Paulus secundus, Pontifex Maximus, visus est hac in parte gloriae horum
invidisse et, quanvis id agere se ostenderet, ut in pontificios ornatus ac templorum
ornamenta splendorem hunc suum conferret, iudicatum tamen est supra pontificis
gravitatem huic rei indulisse.' Ibid., p. 238; trans Welch (2002): p. 226.

116. '…nulla v'è soperchio o mancho.' This observation comes from the *Terze Rime* (fol.29v), where
the author is describing the splendour of Piero's *antichamera*. Hatfield (1970): pp. 235 and 248.

117. 'Munditiarium quoque ac nitelea, quae splendoris comes est,
cura imprimis videtur habenda.' Tateo (1999): p. 232.

118. 'Est etiam splendidorum habere domi permulta, et quidem nitida et culta…' Ibid., p. 232.

119. 'III. Qualem esse deceat viri splendidi supelectilem.' Ibid., p. 228.

120. 'Erit igitur splendidi supelex nitida et multa, ac non solum pro facultibus,
 verum etiam pro expectatione atque auctoritate…' Ibid., p. 228.

121. 'Haec quandam homines usus et commoditatis gratia sibi comparant, splendidorum tamen
 officium est non usum aut commoditatem solam respicere, sed ut ea tum multa domi
 habeant, quibus etiam, cum opus fuerit, amici notique commode uti possint...' Ibid., p. 223.

122. 'Illud etiam praestandum est a splendidis, ut re ipsa appareat non sibi soli, sed
 familiae quoque et amicis cognatisque et, cum publicus etiam usus vocaverit,
 populi usui atque commodes comparasse supelectilem.' Ibid., p. 230.

123. 'delectat autem eorum aspectus, ac domino pariunt auctoritatem, dum
 multi, ut ea videant, domos ipsas frequentant.' Ibid., p. 232.

124. 'Recte etiam in principe laudatur hospitalitas : ut pote, Germana liberalitatis. Est enim valde
 decorum : ut inquit Arpinas orator : patere domos hominum illustrium illustribus hospitibus.
 Idque etiam rei publicae est ornamento. Ideoque domus principum amplae esse debent, &
 laxitate conspicuae : cum hospitibus & hominum cuiusque generis multitudine frequententur.'
 Filippo Beroaldo, *De optimo statu*. Bologna, 1497 fol.D iiii v. British Library, London IA.29076.

125. Cosimo de' Medici: 'Sit laxa et ampla, ut privati ac publici hospites magnifice et
 honorificentissime suscipi possint.' Platina *De optimo cive*, ed. F. Battaglia. Bologna (1944): p. 207.

126. See note 72.

4

The Splendid Interior

1. Rooms and their functions

This section addresses the interior of the fifteenth-century Florentine palace. Through extensive analysis of unpublished inventories contained in the Magistrato dei Pupilli registers, these records enable us to examine the accessibility and nomenclature of interior space.

Established in 1388, the *Magistrato dei Pupilli* or Office of Wards functioned as a civic agency for Florentines who died intestate leaving dependent minors. If the deceased's family were unable or unwilling to take over the estate, the *Ufficio* acted in the interests of the heirs (*rede*) during the years of their minority. Elected officials from the four quarters of Florence (Santa Maria Novella, San Giovanni, Santa Croce and Santo Spirito) governed the *Magistrato dei Pupilli*. Customarily leading figures within the social and political sphere, their contribution is often proudly displayed in the invocation at the start of each register.[1]

As the statutes of the *Ufficio* confirm, the agency was subject to rigorous rules and procedures, which were strictly enforced.[2] Once the Office was requested to take over an estate, an administrator (*actore*) was appointed. The *actore* had full legal and financial responsibility. This power could regularly extend to settling or reconciling any debts;[3] securing property and chattels for the heirs;[4] or dividing the estate once the heirs came of age.[5] The administrator was required to annually review the ledgers of his case, and to balance any losses that had occurred during the year.[6] Within 15 days of his initial appointment, the *actore* was obliged to compile an inventory of the estate.[7]

Of particular significance was the stipulation in the *Pupilli* statutes that an Office employee compiled the inventory in the presence of a relative from the deceased's family. This requirement greatly enhances the value of these documents to the modern historian. By requiring a family relative or member

of the household to be present, the inventory achieved greater integrity and accuracy. In addition, it provided more personal information about both domestic objects and interior spaces than would otherwise have been stated or known had the assessors been working independently.

The *Pupilli* inventory assessed the house owner's entire assets. With regard to personal property this was divided distinctly between immoveable (*immobili, posessioni*) and moveable (*mobili*) goods. The range of *immobili* depended on the wealth of the deceased and could be broad. Such possessions might include the house or palace itself; a villa or other property in the *contado*;[8] property owned and rented out; workshops or warehouses; as well as areas of land. *Immobili* were usually cursorily defined, detailing only in general terms the salient characteristics of the property and its location.[9] *Mobili* consisted of any household goods or possessions not built in or permanently fixed to the walls of the house.

Like *immobili*, moveable possessions were rarely given a financial valuation. Though frustrating to the modern historian, the absence of estimates or valuations is explained by the inventory's primary function. The principal purpose for conducting the inventory was to safeguard and preserve the heirs' property. The assessors were only required to attach values to chattels when income had to be raised for the heirs through private sale or auction, or outstanding debts had to be settled.

The preamble to the inventory provides general information on the deceased. In addition to detailing the deceased's name and the date of the inventory, it also records the names and ages of the heirs, as well as the name of the acting *attore* or notary (*notaio*). Occasionally the occupation of the house owner is also described, as is the name of his wife or other family members assisting with the inventory or the general well being of the heirs. The location of the property to be appraised was also occasionally specified here, although this could also appear at the end of the inventory along with any other *immobili* and *posessioni*. The inventory proper usually commences with the ground or underground storage areas, such as the *ciella*, *volta* or *stalla*, before progressing room by room, floor by floor up to the attic level. The general sequence of rooms as detailed in the inventories suggests a rational linear progression throughout the house, although without extant architectural plans for the property this cannot be unequivocally confirmed.

Archival analysis from inventories in the *Magistrato dei Pupilli* registers confirms the frequent presence of a courtyard (*corte*) or *loggia*, particularly in the palaces of wealthy Florentine families (Illustration 25). Almost invariably these spaces are characterized by few objects or limited furniture forms, often consisting of benches and tables. Generally, the impression given from inventories is that these areas served as deliberately open spaces suitable for the meeting and greeting of visitors. A more formalized seating area is

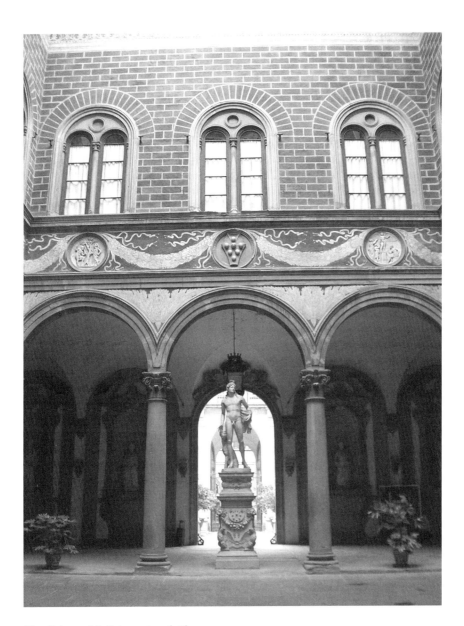

25. Palazzo Medici courtyard, Florence

cited in the 1492 inventory of the Medici palace where an incredible 80 *braccia* (over 46 metres) of benches were placed around the *loggia terrena*. Made in four sections, these benches or *panche* were decorative pieces, constructed in pinewood with intarsia work and walnut mouldings.[10]

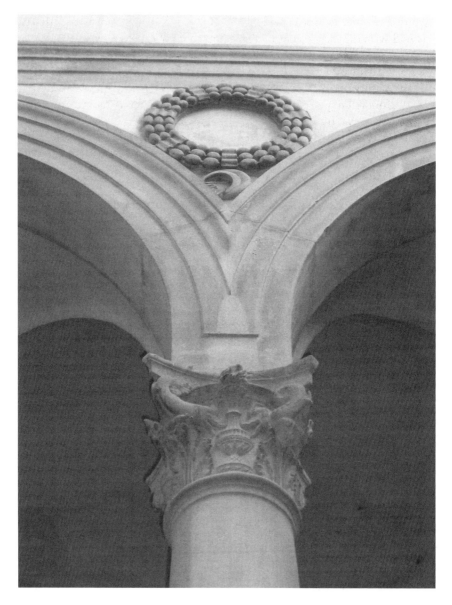

26. Palazzo Pazzi-Quaratesi, Florence, *c*. 1458–69. Detail of courtyard showing one of the capitals incorporating the Pazzi coat-of-arms and roundels which originally contained *all'antica* medallions

The use of benches, though on a smaller scale, is found in the 1489 inventory of Tommaso di Federigho Federighi. Here the items listed in the *loggia*

included two desks, one of which was of 2½ *braccia* and used as a credenza, a shield with the family coat-of-arms, and three worn wooden benches of 18 *braccia*.[11] Similarly, the *loggia* of Bartolomeo di Mariotto dello Stecchuto (1496) included a walnut table of 6 *braccia*, a small old table and chair, two shields, one with coats-of-arms, and old benches of unspecified length described as placed around the space.[12] The presence here and in other inventories of *targhe*, *palvesi*, and *schudi* displaying the owner's, or those connected to the family's, coats-of-arms further reinforces the impression of the public function of the *loggia* or *corte*. Indeed these shields would have complemented the permanent *stemmi* or *imprese* built into the fabric of the *corte* or *loggia*, examples of which can still be seen today in Florentine palaces (Illustration 26).

Another extremely important ground floor space was the *camera terrena*. Situated in close proximity to the main entrance, this room is frequently mentioned in inventories throughout the fifteenth century. Analysis from the *Pupilli* registers confirms that the *camera terrena* consistently served as the principal chamber on the ground floor. The significance of this room is suggested by its prominent location off the *corte / loggia* or entrance hallway (*androne*), as well as the range and quality of the domestic objects and furnishings frequently found within this space.

The functions performed by the *camera terrena* seem to have been varied. First, its conspicuous position lent itself well to public functions, though on a reduced scale to that offered in the *corte / loggia* areas. As the initial major space within the house, the *camera terrena* would have provided a convenient area in which to discuss matters with those visitors deemed worthy of progression beyond the more overtly accessible *corte* or *loggia*.

Second, the *camera terrena* could also serve as a 'guest room' for important visitors or guests. In Book V of *De re aedificatoria* (1485), Alberti had referred to the need to provide accommodation for guests directly off the 'public' vestibule: 'guests should be accommodated in a section of the house adjoining the vestibule, where they are more accessible to visitors and less of a disturbance for the rest of the family.'[13] An indication that the *camera terrena* could serve this purpose is demonstrated in the *palazzo* of the wealthy Prato merchant Francesco Datini. In November 1409 Louis of Anjou, King of Sicily and Jerusalem, visited Prato and resided for several days in the *camera terrena* of the *palazzo*, the walls of which Datini had specifically redecorated with the crown and lilies of the house of Anjou.[14] The 1492 inventory for the Villa Medici at Fiesole provides a further example of a ground floor chamber used for guests. Here the room is referred to as the '*camera* of the two beds, or rather of the guests'.[15]

Third, the *camera terrena* could be used as a summer chamber for the owner. Alberti had recommended that the houses of the wealthy should have separate chambers for summer and winter.[16] Load bearing and outer

ground floor walls tended to have greater thickness thereby helping ground floor chambers to remain cooler during the summer months.[17] Further, these spaces often had small windows placed high in the walls of the room that, in addition to providing greater security and privacy at street level, also served to keep out direct sunlight.

The next major room within the house was the *sala*. Broadly translated as a hall, the *sala* too served various functions: a formal living room, a room for dining and a space for entertaining. Alberti referred distinctly to dining rooms (*coenacula* or *triclinium*) in his treatise, although a vernacular equivalent for this is rarely specifically defined in inventories. More frequent is the reference to dining tables (such as *tavola da mangiare* or *descho da mangiare*) to reflect this function.[18] Larger palaces could have more than one *sala* with the major distinction resting on location and scale.[19] Referring to *coenacula*, Alberti stated: 'The dining rooms should be entered off the bosom of the house. As use demands, there should be one for summer, one for winter and one for the middling seasons'.[20] Vitruvius had also referred to seasonal dining rooms,[21] while his recommendation that their length should be twice their width also suggested their public function.[22]

Though references can be found in inventories relating to ground floor *sale*, the main hall or *sala principale* was invariably located on the first floor.[23] Location on the *piano nobile* was important and the *sala* was frequently positioned prominently at, or close to, the top of the stairs. The position of the *sala* close to the main staircase is suggested by its being frequently referred to as the first room listed in inventories after the ground floor spaces and before other rooms on the *piano nobile*. Most familiar from the Medici palace, this convention is further confirmed in several prominent *quattrocento* inventories. On the *piano nobile* at Palazzo Medici the visitor was confronted with a long corridor or hallway (*androne*) at the head of the staircase, with immediately to the right the *sala grande* and opposite on the other side the smaller *saletta* (Illustration 27).

A similar scheme was devised at Palazzo Piccolomini (1458–62) in Pienza built for Pope Pius II. Here too the 'hallway' at the top of the staircase leads to a large *sala* on the left and a smaller *sala* to the right. A more modest example of the location of the *sala* on the *piano nobile* is also found in the Palazzo Pazzi (see Illustration 6), where the large *sala* was prominently located at the top of the staircase to the right of the *androne*, and positioned along the principal façade facing the main street, in a manner similar to that of the Medici palace.[24]

As a major reception space, the *sala* made an important statement about its owner's status and pretensions. The impact of this room on visitors as they approached from the top of the staircase must have been one of immense space and scale. The *sala* tended to have a limited range of furnishings and was frequently characterized by few entries in inventories. Even in the Medici

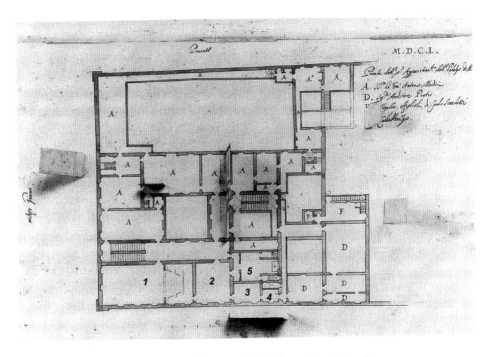

27. Palazzo Medici, Florence. Plan of *piano nobile*, 1650, north at right. The
sequence of rooms shown are: 1 *sala*, 2 *camera*, 3 *anticamera*, 4 *scrittoio*, 5 *cappella*

palace, the major furniture simply comprised the 80 *braccia* of decorative
benches with backrests that ran around the room.[25] This suggests *sale* were
not used on a daily basis but rather on specific occasions, such as receptions
or banquets, when the required temporary furniture could be brought into
the space. A more intimate and therefore perhaps more frequently used space
is suggested by the diminutive form of the term *sala*, described variously as
saletta, *salotto*, or *salettina* in several inventories.[26]

Common to all *sale* was the presence of at least one fireplace. Alberti
discussed at some length the importance of the fireplace (*focus*), referring to
both its location and function, stating that 'it should be prominent', as well
as having 'sufficient light but no draft'. The fireplace 'must not be confined
to some corner or recessed deep within the wall' nor should it 'occupy the
most important position in the room where the guests' table should be.'[27]
Since inventories only listed moveable goods, the inclusion of fixed goods is
harder to assess. For example, objects associated with a fireplace indicate its
existence, if not exact location in a room.[28]

As with other major furnishings, the scale of Renaissance fireplaces was
vast, commanding attention as well as making a major impression on the

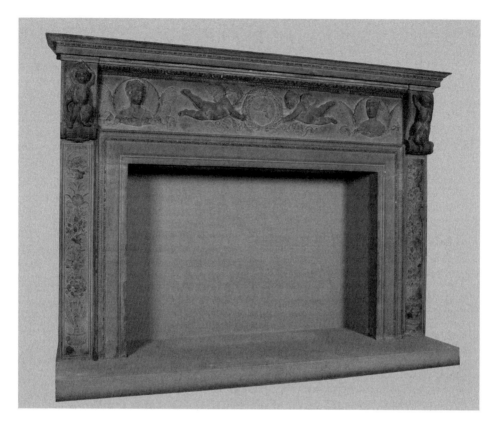

28. Workshop of Desiderio da Sangallo, Chimneypiece, *c.* 1458. Possibly from Palazzo Boni, Florence. Pietra serena, 259.5 × 365.8 cm

room's appearance (Illustration 28). In the *sala* of Piero di Messer Andrea Buondelmonti (1497) two pairs of fire irons (2 *alari da fuoco*) are listed together with other associated utilitarian domestic objects: a brass dish for keeping food warm (*schalda vivande*), three buckets (*secchione*), two of brass and one of copper, two ewers (*misciroba*) one of silver with coats-of-arms and another of brass without, and a large deep-sided brass dish (*rinfreschatoio*). The social function served by this room is demonstrated in the seating and tables: two inlaid tables (*tavole*) of 9 *braccia*, two pairs of trestles (*trespoli*), four small desks or tables and seven chairs (4 *deschette e 7 seggiole*) as well as benches around the room (*panche intorno*). The importance of natural light in *sale* is reflected in their position along the main windowed façade of palaces such as the Medici, Pazzi and Piccolomini. At the Buondelmonti palace, the 14 brass candlestick holders (*candellieri*) and the brass lamp in a holder (*lucierna nel chandelliere*) would have provided much needed artificial evening light.[29]

The kitchen (*chucina*) was often positioned close to the *sala*.[30] The number of *chucine* could be dependent on the number of *sale* or other rooms that required servicing in the house.[31] At Palazzo Piccolomini, Pope Pius II's residence had three kitchens built in a separate three-storey wing. The kitchens, with their various offices, were connected to the palace by porticoes, 'thereby making it possible to serve the three floors with the greatest convenience.'[32]

A major consideration in the architectural planning was to prevent smoke, wind or other fumes affecting the palace proper. The problem of locating a kitchen was of special concern: too close to major rooms and noise or noxious smells prevailed, too far away and food would reach the *sala* cold and in a poor state. Alberti addressed these issues in Book V, in which he notes that: 'The dining rooms (*coenaculis*) require a kitchen (*coquina*) and a storeroom (*cella*) for the leftovers of meals, along with vessels and tablecloths.' For convenience, 'the kitchens should be neither right in the lap of guests, nor so far off that dishes intended to be served hot become cold in transit; those dining need only be out of earshot of the irksome din of scullery maids, plates and pans.' On a practical note, care should be taken to ensure that 'the trays of food are carried along a route that is protected from the rain, has no tortuous corners, and does not pass through any dingy place, all of which may compromise the standard of the cuisine.'[33]

The *sala* has been interpreted as the first space in an apartment or series of rooms that also comprised the *camera*, *anticamera* and study (*scrittoio*, *studio*, *studiolo*).[34] Although this general sequence of rooms is often found in inventories and can be seen in the 1650 Medici palace plan, its application was by no means entirely standard. Social convention and tradition may well have characterized the arrangement of rooms. In addition, the wealth of the house owner was also clearly an important factor dictating the range and type of rooms in a given dwelling. In particular the number and variety of *camere* specified in Florentine interiors could vary greatly. The houses of the wealthy could include chambers identified with the head of the household or other family members, such as children or parents, as well as domestic maids and servants.

An example of this is demonstrated in the 1497 inventory of the extremely wealthy banker Lorenzo di Giovanni Tornabuoni. The town palace contained a *camera* and *anticamera* associated with Lorenzo, a small hall (*saletta*) and *camera* used by his eldest son Giovanni, as well as a room still connected with his deceased father. In addition there was also a *camera* for the domestic maids, and a chamber described as used by the *maestro*.[35] Here, as in other inventories the *camere* for servants and domestic staff were positioned in less visible areas of the house. Alberti had recommended this practice in Book V, stating: 'the butlers, domestics, and servants should be segregated from the gentry, and allocated accommodation decorated and furnished in keeping with their

positions'; whereas 'the maids and valets should be stationed close enough to their areas of responsibility to enable them to hear commands immediately and be at hand to carry them out.'[36]

Alberti's premise of accommodation appropriate to the status of its occupant is demonstrated in the *camera della fante* of the Tornabuoni inventory. There, the maids' limited possessions included a rustic or simple bed (*lettiera salvaticha*) with an old (*vecchia*) mattress and a sad (*triste*) pillow; as well as an old box (*chassetta*) and two small sad and old chests (*forzeretti*).[37] Removed from the view of visitors and guests, such spaces were frequently positioned, as Alberti advised, close to the principal service areas of the kitchen or hall. Indeed, in the inventory of Bartolomeo dello Stecchuto (1496) the *chamera dela serva* was even located within the same space as the kitchen.[38]

Analysis from the *Pupilli* registers confirms that houses contained at least one principal *camera* that was the locus for domestic objects and goods. Consistently throughout the *quattrocento* this chamber served as the space where the greatest concentration of domestic objects and furnishings were to be found. In several examples the main *camera* was the room used by, or at least identified with, the house or palace owner. This association is frequently made clear in the inventory through specific reference.[39] An early fifteenth-century inventory from the estate of Matteo de Ricci (1420) provides one example. The room described as *letto fu di Matteo de Ricci* contained 59 separate entries for domestic goods, as compared with the *camera terrena* that included 34 and the *sala terrena* with just two (*iii paia di trespoli da tavole; 1ª tavola da mangiare di braccia 5½*). Within Matteo's *camera* was a wide range of notable domestic and decorative goods. These included his bed (*lettiera*) of 5½ *braccia* described as good (*buona*); a panel of the Virgin with shutters; a birth tray (*descho da parto*); two beautiful chests (*ii forzieri begli*) and a large *cassone* with a lock and inlaid woodwork; a day bed (*lettuccio*) with beautiful work on it (*lavorato bello*); various cloth and covers (*coltricie, copertoio, panno*) including on the bed a large and beautiful piece of vermilion cloth (*1° panno vermiglio grande e bello al deto letto*).[40]

A familiar passage from Alberti's *I libri della famiglia* (1430s) suggests the importance of the house owner's *camera*. In Book III, the leading interlocutor Giannozzo describes taking his new wife on her first tour of the entire house. The last room to be shown is Giannozzo's main chamber. It is here that the precious goods, silver, tapestries, garments and jewels are safely kept behind a locked door, each within their own designated space.[41]

In isolation the description of Giannozzo locking the door to the *camera* before showing his wife his most prized possessions suggests a strictly segregated space withdrawn from the rest of the house. Alberti's account should not, however, be seen as reflecting solely a private use or function for the *camera*, but rather one of restricted or controlled access. This is

demonstrated in Giannozzo's later qualification of the motives for keeping his precious goods in his *camera*, since he always felt his treasures 'should be kept where they are safe from fire and other natural disaster, and where I can frequently, whether for my pleasure or to check them over, shut myself up alone or with whomever I choose while giving no cause for undue curiosity to those outside. No place seemed more suited for this purpose than the room where I slept.'[42]

Here, the important characteristic of the *camera* rests with Giannozzo's control over whom he chooses to allow into this space. This division is important and recalls Vitruvius' distinction between invited and uninvited visitors, and the areas accessible to each within the interior. As with the ancient *cubiculum*, the *camera* was a more controlled, less public room that was only within the reach of admitted visitors. In a similar way to the ancient *domus*, the distinctions between public and private areas were less defined in the *quattrocento* house. Although controlled by a code of decorum and social convention, domestic space still retained a degree of fluidity. As Alberti had underlined in *De re aedificatoria*, chambers, like dining rooms and corridors, could be 'either public or enclosed and thoroughly private'.[43] Indeed, in a number of inventories the principal *camera* is listed immediately after the *sala*, suggesting a direct sequential relationship between the two spaces.[44]

Along with other key interior spaces the *camera* served a range of social roles. This multi-functionality is glimpsed in a small number of written accounts, some of which predictably revolve around the Medici. In his *Vite*, Vespasiano da Bisticci describes having a meeting with Cosimo de' Medici in his *camera* when they were interrupted by two citizens seeking a resolution from a dispute; while in a *notarile* record Lorenzo de' Medici is similarly described as arbitrating over a dispute in his chamber.[45] Letters of the wealthy silk merchant Marco Parenti provide a fascinating insight into just how the potential privacy offered by the *camera* could quickly take on more public status. As the brother-in-law through marriage to Filippo Strozzi, Parenti carried some standing in Florentine society which he used effectively to gain urgent and unexpected access to Piero de' Medici's *camera*: 'And I went with them right to Piero's chambers; and because he was sleeping, they were on the point of leaving him, since no one dared to disturb him. But I was so insistent that in the end the servant was sent back in and woke him.'[46] This intimate account is nicely contrasted by a passing reference in the *ricordanze* of Carlo di Silvestro Gondi who noted on a separate visit to Piero's quarters 'finding many people in his *camera*.'[47]

In a different capacity an entry in the *Libro Cerimoniale* records the official role the *camera* could serve in a private palace. This is detailed in the account of the papal legate Cardinal Borges' visit to Florence in 1499. After the usual ceremony on the *ringhiera*, the Cardinal was escorted the following day to the

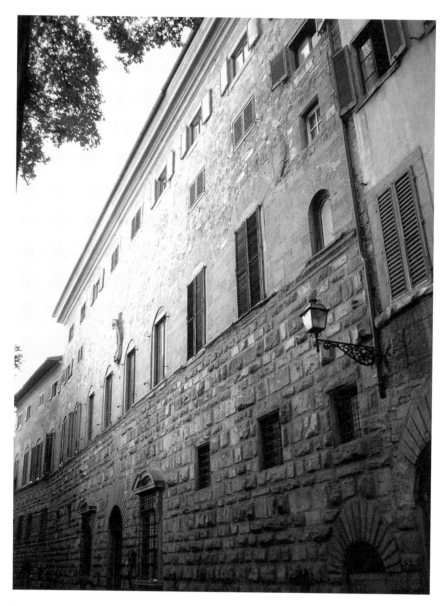

29. Palazzo Uzzano-Capponi, Florence. Early fifteenth century. Built
for Niccolò da Uzzano with later additions by the Capponi family

Uzzano palace 'accompanied by a great number of citizens, about 100', who
went with him inside the *palazzo* 'as far as the threshold of the entrance of the
camera' (Illustration 29). The *Signoria* held a separate more private audience

with the Cardinal in the adjoining *anticamera*, kneeling before him 'as was the custom when arriving in the presence of a legate.'[48]

The reference in the *Libro Ceremoniale* to the use of an *anticamera* in the Uzzano palace as a separate audience chamber is interesting. *Anticamere* are referred to in numerous inventories accompanying the principal *camera*. As with other areas the functions performed by the *anticamera* could be varied. In the 1469 inventory of Piero and Ghugliemo Cionni for example, the *anticamera* served as a study – as confirmed by the scribe's qualification of the room as *nel antichamera overo iscrittoio*.[49] Invariably spelt '*anti*', denoting next to or against, this room is generally listed after the *camera* in inventories. This relationship is important and suggests a more intimate space leading from or connected to the *camera*. In Francesco di Giorgio da Pescia's inventory (1476) this relationship is qualified by the description as *nel antichamera da lato*, or by the side of the main chamber.[50] In several examples the *anticamera* is as lavishly furnished as the *camera* with which it is connected, though on a diminished scale, suggesting a subordinate relationship to the main chamber.[51] Common to most *anticamere* is the presence of a bed (*lettiera*) indicating that the basic function of sleeping took place here. *Lettiere* were of course inherent in principal *camere* as well, although given the quasi-public functions served by this chamber, it is tempting to interpret the *anticamera* as a more private space where the owner slept on a daily basis.

The principal *camera* may also have served as a suitable area to conduct business. In certain inventories the presence of various types of writing desk, seating and storage chests containing books and papers suggest a distinct area within the *camera*. In other examples, a study (*scrittoio, scriptoio* or *studio*) is cited as a separate room often located off the *camera* or *anticamera*. The presence of account books and other business related material, suggests the apparatus required for consulting financial documents and concluding formal agreements. Such work-related pursuits conducted both alone or with clients, were in turn facilitated through convenient access close to or within the *camera*.

The impressively furnished *chamera di sala* of the wealthy banker Francesco di Romolo Ducci (1478) provides one example. This room contained a range of furnishings and objects including: a writing desk; a portable writing table covered in green cloth; various books and writings including an annotated copy of Dante and a book on philosophy; eight books and day-books relating to the bank stored in a chest; an old journal; a notebook and a pair of scales.[52] A visual sense of such a chamber is provided in Carpaccio's *Dream of Saint Ursula* (1495) where in the corner of the room is placed a writing desk and stool with a quill and inkstand, an hour glass and two books, one of which is left open ready for use. To the side is a bench-chest while behind is shown an open cupboard containing further books and a candleholder (Illustration 30).

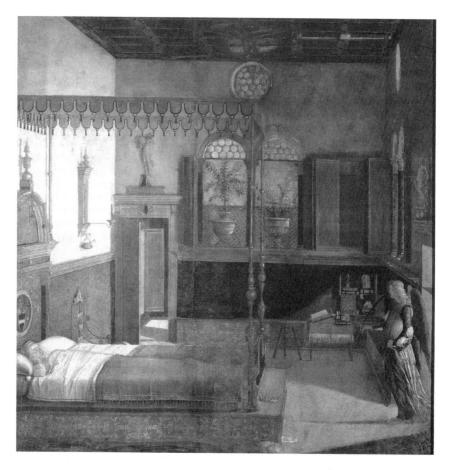

30. Vittore Carpaccio, *Dream of Saint Ursula*, 1495. Oil on canvas, 274 × 267 cm

The study has traditionally been interpreted as a closed private space suitable for intellectual pursuits and quiet contemplative learning, but it is equally possible that this room functioned as a convenient office space. This duality of function led the theorist Benedetto Cotrugli to recommend in *Della mercatura e del mercante perfetto* having two *scrittoi* each with a distinct role:

You ought to have a *scrittoio* in the *solar* on the first floor, suitable for your needs …which should be separate [from the rest of the house] without causing disturbance to your family on account of the strangers who come to the house to contract business with you. He who delights in letters should not keep his books in the common *scrittoio*, but should have a *studiolo*, set apart in the most remote part of the house. Should it be close to the room in which one sleeps, it is an excellent and most salubrious thing, for it allows one to study with greater ease whenever time allows.[53]

Cotrugli's treatise on the ideal business and conduct of merchants again demonstrates the importance of visitors in the layout of the interior. It suggests that business was so regularly conducted within the house that a clear distinction should be made between an area for work (*scrittoio*) and one for leisure (*studiolo*). Lorenzo di Giovanni Tornabuoni's palace contained two *scrittoi* that reflect something of Cotrugli's prescription. One study was conveniently and prominently located at the head of the staircase and included a wardrobe with two locks, containing various writings and books relating to Lorenzo's accounts.[54] The other study, by contrast, was located at the end of the apartment off an *anticamera*. Here, the emphasis was on the quality rather than quantity of decorative objects within the room including: a small box made of cypress wood containing medals depicting heads in relief and a purse of rich brocade; a small tabernacle of the Virgin, Saint Jerome and Saint Francis; as well as further writings and a small book shut away in a protective box.[55]

The *Pupilli* registers from the fifteenth century do not make clear distinctions in terminology between *scrittoio* and *studiolo*. In Florence at least, the term *scrittoio* was used in inventories to denote a study/office or study/office area, as well as a form of writing desk. The dual application of the term is reflected in John Florio's *Queen Anna's New World of Words* (1611) Italian dictionary, where *scrittoio* is defined in exactly these terms as an office as well as a writing desk.[56] A clear understanding of the application of *scrittoio* in a given inventory can therefore prove problematic, with the modern reader left to infer its application through careful consideration of the nomenclature, its location and the number or type of objects it contained.[57]

Archival analysis indicates that the Tornabuoni were unusual, but not exceptional, in possessing two *scrittoi*. The inventory of Bartolomeo di Mariotto dello Stecchuto (1496) also contains two studies. A range of *quaderni, richordi, schritti* and other account books dominated the first study, while the second – located on the floor above – included a portable and lockable writing desk (*schanelo*) with six small compartments to hold money, containing various account books, writings and receipts (*quadernuci e schriti e polize*). Also detailed within the room were two inkstands (*chalamai*), a gesso head (*testa di gieso*), a small brass candlestick holder (*chandelieruzo d'otone*) and lamp (*luciernieruzo*).[58] The 1492 Medici inventory also records two *scrittoi*. The first, located on the half-landing of the staircase (*a meza schala*), was dominated by an elaborate desk ensemble; while the second study was positioned off an *anticamera* on the *piano nobile*. Originally used by Piero de' Medici, the room contained an astonishing range of decorative objects, books, jewels and gems including the cameo bowl today known as the *Tazza Farnese* with an incredible estimated value of 10,000 florins, and now housed in the Museo Archeologico Nazionale in Naples.[59]

Locating a *scrittoio* on the ground floor provided a particularly convenient office space. Here, clients and business contacts could be easily escorted from the main entrance *androne* or *corte* to the office/study, without the inconvenience or disruption of progressing up to the *piano nobile*. This solution provided ease of access and must have facilitated the efficient and frequent turnover of meetings. Several examples of *scrittoi* on the ground floor indicate their application.[60] Ser Bonachorso Bonachorsi's (1431) *scrittoio di terreno* contained 13 separate entries and was prominently located off the *loggia*. Listed were: an account book for the years 1422 to 1430; two books covering the statutes of the *Podestà* and the *Misericordia*; and a map for navigating (*1ª carta da navichare*). Notable domestic objects comprised a bed (*lettiera*) with a cover and a bench (*pancha*) both of 3 *braccia*; an intarsia game board (*tavoliere intarsiato*); and a small lamp and mirror (*lucierniero e specchio*).[61]

The 1496 inventory of the successful *cartolaio* or bookseller, Salvestro di Zanobi Mariano is interesting since this records both a ground floor *scrittoio* and a separate workshop (*bottegha*) located within his house in the San Giovanni *quartiere* of the city. In the *scrittoio* there are just two entries: a painted panel on the wall and two old portable writing desks. The *bottegha* contents, on the other hand, record an incredible range of stock. Over 290 volumes are listed of which 80 are referred to as manuscripts. The majority of volumes relate to scholastic and popular devotional texts, although there is also a wide range of classical and patristic works.[62] The presence of such extensive workshop stock in the house denotes business use. Such a commercial application of domestic space is suggested in other inventories. On occasion, the *Pupilli* registers detail the deceased house owner's profession as well as the location and contents of the workshop. As with Salvestro's inventory, this provides an insight into the relationship between commercial and domestic areas within the property.[63]

In the later inventory of Piero di Jacopo Puccio (1517) the space for commercial activity is underlined by the specific reference to an *uficio* or office. Listed immediately before the *loggia* in the inventory, the *uficio* was distinct from the *scrittoio* located off the principal *camera/anticamera* on the *piano nobile*.[64] The clear linguistic contrast between *uficio* as an office and *scrittoio* as a study, suggests a developed awareness by the inventory assessor of the need to distinguish commercial and contemplative space.

As with the *domus* of antiquity, in the *quattrocento* palace the dichotomy between 'public' and 'private' space was less defined. Business was regularly conducted within the Florentine house, and consequently clear divisions between work and leisure did not exist. Rather than notions of public and private space, at issue was the concept of openness and closure. At the centre of this – or as Alberti would have it the *sinus* – was the Vitruvian division between the invited and uninvited visitor.

2. Furniture and display in the splendid interior

This section focuses on the principal camere detailed in a range of unpublished inventories relating to predominantly wealthy Florentines. These chambers are analyzed in detail through the furniture forms listed – ranging from beds and their hangings to various forms of chests. Collectively they enable us to visually recreate the linguistic definition of splendour.

As consultation from the *Magistrato dei Pupilli* archive confirms, the Office's services were by no means used exclusively by the lower classes of society. Time and again names of small or no importance mix with the same folios as leading figures of Florentine society. For example, on 25 September 1497 the *Pupilli* conducted the inventory of the important banker Lorenzo di Giovanni Tornabuoni.[65] Lorenzo was executed outside the Bargello in August of that year, for his part in the failed attempt to restore the Medici to power. The inventory, which covers the town house (*casa grande*) and two properties (*case da signiore*) in the *contado*, extends for 19 sides and details a staggering range and quality of domestic goods (Illustration 31).

The next inventory to be entered into the register is dated two days later and covers the sparse possessions of Ser Andrea Machallo. The contrast between the two inventories could hardly be more profound. Machallo lived in the *popolo* or district of *San Felice in Piazza* and left two dependents, Pier Giovanni and Spinetta aged 'about' nine and seven respectively. The chattels left to these heirs make depressing reading. Covering less than one side, the goods and household possessions comprised just ten entries, together with a small amount of funds deposited in the *Monte*.[66]

The assessors of the estate were salaried officials of the *Magistrato dei Pupilli*. Employed for their familiarity or even expertise with domestic goods, they appear to have worked by calling objects out loud to a notary who recorded the descriptions. Once the inventory was complete, it was indexed and cross-referenced with other official records before being copied into one of the large registers of inventories which contained other recently conducted appraisals.[67] A late fifteenth-century fresco from the Buonomini oratory of San Martino del Vescovo in Florence visually recreates the appraisal process. A widow stands in the middle of the room providing information to a notary seated on the left, while three men inspect the contents of a chest on the right (Plate 5).[68]

Despite the wide benefits of inventories to the historian, by their nature they can only demonstrate the possessions of a household at a specific time. Objects in particular appear frozen in time, suspended in a given internal space at the moment when they were appraised. Interiors were far from static, and goods – like people – had the ability to move around these spaces in a

31. First page from the inventory of Lorenzo di Giovanni Tornabuoni, 1497

constant state of flux. There was also the potential for the interior to change after the death of the head of the household. Goods could be sequestered or appropriated by family members and removed from their original location

before the inventory was able to be made. Relevant here is the degree of elapsed time between the house owner's death and the completion of the inventory, as well as the possible impact of seasonal goods and the time of year that the appraisal was conducted. Further, the assessors themselves could move the goods to different areas or accumulate furnishings together in a given space to assist in appraising the property, and thereby alter the original interior display.

Lastly, there is the question of the method adopted by the assessors themselves as they progressed through the interior. Although the appraisers appear to have worked sequentially floor by floor, there remains the criterion that governed their selection of one room over another; and once within a given space the approach taken to record the domestic goods. It is not possible to determine what happened when the assessors reached a staircase, or had a choice to enter spaces to the left or right. Nor once in a particular room, what was the decisive factor for commencing with one object over and above another. Also relevant, but unclear, is whether the assessors worked logically around the space or selected items by a diminishing or increasing sense of scale or value.

Notwithstanding these constraints, specific issues applicable to the *Magistrato dei Pupilli* registers can be addressed and hypotheses suggested supporting their usage. The stipulations in the *Pupilli* statutes, including the prompt appraisal of the deceased's assets in the presence of family members, provides a major counter to the traditional criticisms levelled against such documents. The estate's appraisal by independent assessors also challenges concerns over the issue of bias or objectivity. The fact that the inventories were conducted through the auspices of one institution brings a consistency of approach that cannot be replicated in private inventories. Collectively, this permits issues regarding the form and function of the interior to be more confidently assessed. Governed by *Ufficio* regulations and working within notarial conventions, the inventories provide an insight into the lexicological development of domestic goods and furnishings.

Analyzed over an extended period the *Pupilli* registers chart the evolution of new goods as well as the refinement or development of existing ones. Further, they also allow conclusions to be drawn over the 'value' of objects. Clearly, the absence of economic values in the inventories does not permit this in pure monetary terms, but an impression can be gauged of an object's ritualistic, sentimental, social or aesthetic worth. Like all inventories, the *Pupilli* registers present a 'snap shot' of the interior at a given moment in time. Nevertheless they can also indicate what may be termed the 'afterlife' of both the interior and its possessions. Despite the turmoil of losing their father, the heirs to an estate were not necessarily forced to leave their family home. Frequently, the children resided in the same location and life continued within the walls of

the house. This is important to stress, since there has been a tendency not to view post-mortem inventories in these terms.

Careful analysis of the *Pupilli* registers indicates that where the mother of the heirs survived, she could appropriate her dead husband's principal *camera*. As discussed above, the house owner's *camera* was a key space in the Renaissance home. Consequently the appropriation by the wife must have had an important symbolic meaning to both the surviving family members and subsequent visitors to the house. An example of this is found in the 1429 inventory of Salvestro di Simone Gondi. Here, Salvestro's wife Alesandra, is recorded as occupying both the principal *camera* and *anticamera* (*chamera di mona Alesandra, antichamera di mona Alesandra*). Within the *camera* a range of clothing and jewellery items are not only specifically identified with Alesandra and her children, but also with her deceased husband.[69] The impression of a shared space – now associated directly with Salvestro's wife – is confirmed by the concentration of goods in this room and the absence of any other *camera* identified with either of them elsewhere in the inventory.

The later 1485 inventory of Simone di Matteo Cini is also instructive. The procurement by Simone's wife, also called Alesandra, of the *camera* is qualified by the appraiser's reference to her claim over specific domestic goods in the room's heading as: '*in chamera di mona Alesandra sechonda che dice apertenesi a lei.*'[70] The relative infrequency of examples of a wife's appropriation of her husband's *camera* suggests this was unusual enough to warrant specific reference by the assessors. Analysis of inventories across the *quattrocento* is generally conspicuous for the absence of *camere* occupied by or identified with the wife. This implies that – except in the instances when the *Magistrato dei Pupilli* had confirmed guardianship with the heirs' mother – women did not have separate quarters, but rather shared the principal *camera* with their husband.

In *De re aedificatoria*, Alberti was somewhat equivocal in his discussion of women's chambers. In Book V, he recommended separate rooms for both the husband and wife. Though distinct spaces each with their own doors, they were to be situated next to each other and inter-connected by a side door 'to enable them to seek each other's company unnoticed.' Off the wife's chamber, Alberti recommended a dressing room, while the husband's was to lead to a study.[71] The major benefit of the division was to ensure that the husband was not disturbed by his wife, when giving birth or during illness, and to allow even in summer uninterrupted sleep. In Book IX, however, where Alberti discusses appropriate room decoration he appears to contradict his earlier recommendation by suggesting a shared space for both husband and wife.[72] The contradictory nature of Alberti's view on distinct or shared quarters is also seen in *I libri della famiglia*. In Book III Giannozzo describes how the family treasures are kept in his chamber, while a few pages later reference

is made to him and his wife returning to their own locked chamber to pray together to God.[73]

The issue of gendered space is also addressed in Vitruvius' *De Architectura libri decem*. This occurs in the discussion of private architecture in Book IX and provides one of the most important contrasts between the Greek and Roman house. In his description of the Greek house, Vitruvius constantly draws attention to the divisions between male and female space. He refers specifically to women's quarters or *gynaeconitis* on the one hand,[74] and residential quarters (*andronitides*) and banqueting halls (*oeci*), accessible only to men, on the other.[75] In the Roman house such distinctions did not exist. This is underlined by Vitruvius' analysis of the term *andrones*. While the Greeks apply this term to the '*oeci* where men's banquets usually take place because women are excluded', the Romans refer to *andrones* as corridors.[76] Vitruvius' account of this term highlights the considerable difficulties he faced with developing Latin equivalents for Greek terms. It also reinforces the 'de-gendered' nature of the Roman house: *andrones* are taken to denote corridors in Latin, exactly because there were no exclusive male or female domestic spaces in the *domus* of antiquity.

At the end of the fifteenth century, Giovanni Pontano also referred to women's apartments in his discussion of the social virtue of splendour. This occurs in chapter four 'On ornament' (*De ornamentis*), where Pontano discusses what he terms 'ornamental objects' (*ornamenta*). Here, *gynaeceum* are contrasted with halls (*aulam*) to demonstrate the appropriateness of particular ornamental objects in particular interior spaces: 'But the ornamental objects, which should be as magnificent (*magnifica*) and various as possible, should each be arranged in their own place. Thus one is fitting for the hall, another for the women's apartments.'[77] Pontano stops tantalizingly short of detailing which objects were appropriate to these or other domestic areas. This was not, however, his primary objective. Rather than creating a prescriptive manual to be slavishly imitated, *De splendore* (1498) provided its reader with the tools necessary to emulate the social virtue in more general terms. As Pontano stated: 'We are not describing the house of the splendid man but describing him according to our opinion.'[78]

At issue was the desire to demonstrate the role served by ornamental objects in domestic display. As elsewhere in his text decorum underpinned this premise. Defined as goods acquired 'not so much for use as for embellishment and polish (*nitorem*)', appropriately displayed ornamental objects could 'adorn' domestic space or 'decorate sideboards and tables'. Ornamental objects are characterized broadly as 'seals, paintings, tapestries, divans, ivory seats, cloth woven with gems, cases and caskets variously painted in the Arabic manner, little vases of crystal and other things of this type'.[79] Acquired for the pleasure and prestige they bring their owner rather than merely for function or use,

this status is directly dependent on the number of visitors to the house. The degree of visibility and public display of these objects could vary since some ornaments were designed for 'daily use' while others were 'kept for feast days and for ceremonies'.[80]

Pontano's section on ornamental objects follows on directly from his discussion of the 'furnishings (*supelectilem*) that are appropriate to the splendid man.'[81] Pontano defines furnishings as 'all domestic objects, such as vases, plates, linen, beds and other objects of this category without which it would not be possible to live comfortably'.[82] Though furnishings were, unlike ornamental objects, acquired for 'use and comfort' (*usus et commoditatis*), both serve for the benefit of outsiders. Where *ornamenta* were dependent upon the number of visitors to the house, *supelectilem* were to be as numerous and as varied as possible for the benefit of 'friends and the knowledgeable'. The acquisition of furnishings is the 'duty of the splendid man' (*splendidorum tamen officium est*). To the attributes of domestic furnishings, Pontano adds the virtue of quality or excellence (*egregia*) 'that is due either to the artistry, or to the material, or to both.'[83] Though not specifically mentioned, *egregia* was also inherent in Pontano's characterization of *ornamenta*, whose qualities resided in the relationship between the preciousness of the material with which it was made and the skill taken in its creation.

Decorum is again important and governs both the level of furnishings acquired and their display. Regarding the former Pontano states: 'The furnishings should be those which will not be inappropriate to those who possess them.'[84] To reinforce his point he asks: 'Can there be anything more inappropriate than watching a peasant drink from a goblet ornamented with gems?'[85] For display, decorum is shown 'if along with the quantity and excellence of the furnishings there is a variety in the work, the artistry and the material of a series of objects of the same category.'[86] Again artistry and the material are singled out, though to this is added a further distinguishing virtue: the display of a range of objects of the same type. Here the variety is achieved through distinctions by function, shape or material: 'It is not necessary indeed, that there should be many cups resplendent on the sideboard, but that these should be of various types. Some should be in gold, silver and porcelain; and they should be of different forms, some as chalices, bowls for mixing wine, or in the form of a jug, others as shallow dishes or goblets with handles or without handles.'[87]

Though Pontano creates distinctions between *supelectilem* and *ornamenta*, he also allows his reader to comprehend their shared attributes. Thus on the one hand the 'use and comfort' of furnishings is contrasted with the 'embellishment and polish' of ornamental objects; while on the other, notions of 'excellence' inherent in the 'material' or 'artistry' is common to each, rendering both worthy of display. This is demonstrated by Pontano's reference to the *abaco*

which can be taken to denote either a sideboard, dresser or *credenza*. Whilst intrinsically furniture forms, *abaci* were considered suitable apparatus for the display of ornamental objects. The potential display function of the *credenza* is demonstrated in Giovanni Rucellai's *zibaldone* where he provides a detailed account of the celebrations of his son Bernardo's marriage in 1466. The banquet took place outside the palace in front of the family loggia, and among the adornments embellishing the feast, Rucellai singled out 'above all a credenza (*credenziera*) furnished with works of silver, very rich'.[88]

Occasional references to *credenze* can be also found in inventories. These date from the last quarter of the fifteenth century onwards and tend to be listed in the *sala*. In its simplest form, the credenza was a table, to which could be fitted at the back, staged levels designed to facilitate the display of additional objects. The *sala prima* of Piero di Jacopo Puccio (1517) for example, contained a small wooden *credenziera* of 2 *braccia* with two stages or platforms (*palchetti*) above and below.[89] Some *credenze* included lockable cupboards below the table surface for additional more secure storage.[90] A drawing by Maso Finiguerra of *Susanna and the Elders* (*c.* 1460) shows the simple wooden structure formed by the stages placed on the tabletop (Illustration 32). On the three levels various plates, bowls and ewers are displayed in an ordered fashion. The basic wooden stages could be covered with cloth or offset against a costly tapestry or a fabric *spalliere*, which served to disguise the frame and enhance the objects displayed on the *credenza*. A fresco in the *sala* of Palazzo Altemps in Rome (*c.* 1470–80) shows a credenza displaying, in symmetrical arrangement, a lavish range of silver plate set against an *alla verdura* tapestry. The range and different forms of the vessels conforms well to Pontano's advice, as does the decorum of their arrangement, though it lacks his suggestion for a use of different materials.

The examples listed in inventories do not describe the *credenza* with any accompanying objects on display. Given that *credenze* are usually cited in the *sala*, this is not perhaps surprising since this space tended to have a limited range of furnishings and was often characterized by few entries in inventories. As the major reception area, the *sala* could have furniture or objects brought into the space for important occasions such as receptions or banquets. This may well have occurred in the case of the goods associated with the credenza whose functional purpose is suggested in the Rucellai wedding entry and the Maso Finiguerra drawing.

The absence of listed objects in the *sala* is interesting and brings us to the wider issue of domestic display beyond the *credenza* or *abaco*. Pontano acknowledged the portable nature of domestic goods in his discussion of *ornamenta* when he commented that some objects were designed for daily use, while others were reserved for feast days and ceremonies. This suggests a more public and more visible display for certain objects, against a less public and less visible display for others. Though Pontano is equivocal over

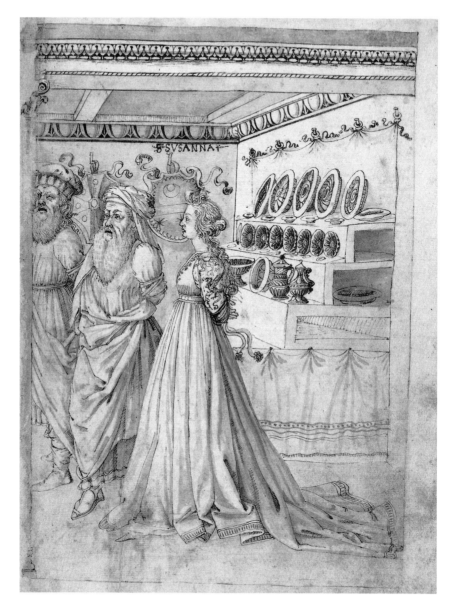

32. Maso Fineguerra, Drawing of *Susanna and the Elders*, *c.* 1460

the precise details of which objects serve for habitual or ritualistic use, his general premise of a greater or lesser degree of visibility for domestic goods is suggestive. Analysis of the *Pupilli* registers confirms that there was a wide range of furniture forms designed for storage. These included diverse

storage chests (such as the *arca, cassapancha, cassa, cassone, forziere*) as well as different types of wardrobes or cupboards (*armario, credenza*).

If the storage forms were diverse, then so too were the range and type of domestic goods that were placed inside. Across the period, the *Pupilli* registers demonstrate in particular the practical role served by the different types of chests used within the interior. Their importance – both as storage pieces and major furniture forms – is underlined by the way the chests and their contents are carefully singled out within the room in which they were located. The sheer quantity of objects placed within many of these chests is staggering. By the end of the fifteenth century it was not unusual to find inventories detailing in excess of 50 separate entries for one chest. With the large number of domestic goods also came a striking variety. In this sense, the contents of chests recall Pontano's recommendation for diversity of objects both across classes of goods and within goods of the same type or category. As well as different types of domestic objects, chests could also contain diverse goods ranging from shoes and clothing, or handkerchiefs and towels, to jewellery, textiles, fabrics or other materials.

The inventory of the wealthy Florentine banker Francesco Inghirrami provides a notable example, both for the diversity of types of chests and their contents. Appraised by the *Magistrato dei Pupilli* in 1471, the inventory included Inghirrami's principal residence with a smaller house connected at the side. Both properties were located on Canto de Lana della Stufa by the side of the church of San Lorenzo.[91] Analysis of the contents of these connected properties in the Canto de Lana details an impressive range of storage chests. Those specifically singled out with their contents as distinct entities comprised: one *archetta*, two *chassapanche*, 33 *chasse*, two *chassette*, one *chassettina*, seven *chassoni*, seven *forzieri*, and one *forzerino*.[92]

As the nomenclature of both the domestic spaces and the types of chests demonstrate, certain broad conclusions can be drawn from the example of the Inghirrami inventory. Perhaps most striking is the quantity of *chasse* detailed in the properties. In a significant number of cases these are described as being placed around the bed. In the majority of *quattrocento* inventories the *lettiera* was placed against the wall with chests placed around the three exposed sides. On occasion, however, the bed could protrude more prominently into the *camera*, with chests also placed behind or at the head of the bed, or less obtrusively by being situated in the corner thereby leaving only two exposed sides. The 'Davanzati bed' in the Metropolitan Museum (Illustration 33) – though now considered to date from the late nineteenth century – recreates the simple box-like structure of the *cassa*, familiar from depictions of religious birth scenes.[93] As Benedetto da Maiano's terracotta *Birth and Naming of Saint John the Baptist* (c. 1477) shows, *casse* are positioned against the bed creating a raised platform around the two exposed sides,

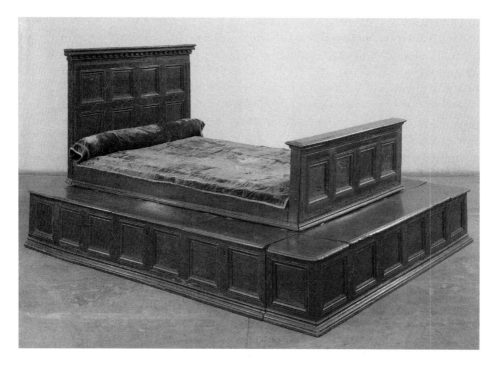

33. 'The Davanzati bed'. Various woods, probably Florentine
workshop. Previously considered to be fifteenth century but now re-
attributed to the late nineteenth or early twentieth century

while the flat lids could also serve as additional seating space (see Illustration
21).[94]

Elsewhere in the Inghirammi inventory *casse* are located in domestic spaces
clearly distinct from the *lettiera*. Where *casse* are cited within the same domestic
space as other major storage forms such as *cassoni* or *forzieri*, this suggests
that the distinctions between each type of chest were particularly marked.
Though the inventories demonstrate the particular visual skills and aptitudes
of the *Pupilli* officials, the assessors must nevertheless have been working
within conventions of linguistic usage and terminology that would also have
been generally familiar to contemporaries. In fact, they show a remarkable
decisiveness over the precise terms used to describe these chests: indecision
over a chest's identity or the desire to qualify its appearance is found in the
inventories only on rare occasions.[95] This contrasts with today's confusion
over *quattrocento* terms, compounded in modern times by the generic use of
the term '*cassone*' to describe any of the large painted and gilded chests that
now grace many of the world's leading museums.[96]

The extensive focus on *cassone* is perhaps explained by Giorgio Vasari's exclusive reference to this class of chest in his *Vite* (1550 and 1568). Writing in the mid-sixteenth century and referring back to the then outmoded traditions of the *quattrocento*, Vasari cited the *'grandi cassoni'* that citizens had in their *camere* at that time.[97] As the Inghirrami and other inventories confirm, both *cassoni* and *forzieri* were significant pieces of furniture in terms of their numbers and their size. Close reading of inventories and private account books, however, suggests that the more ornate chests tended to be referred to as *forzieri*. This is confirmed in the extant account book from the *bottegha* of Apollonio di Giovanni and Marco del Buono whose workshop specialized in the output of these highly decorated chests, and whose surviving accounts only use the term *forziere* to describe them.[98] As the Victoria & Albert Museum example demonstrates, these chests were designed to stand against a wall, since the painted decoration extends to the front, sides and occasionally the underside of the lid – but not to the back (see Plate 3).

As a range of entries confirm, *forzieri* could be extremely costly pieces and were frequently connected with marriage. The importance of the *forziere* within Florentine marriage customs is indicated in the *Pupilli* registers, where several references can be found to 'betrothal' chests or *forzieri da sposa*.[99] In the 1476 inventory of Francesco di Giorgio da Pescia the room listed as *chamera di sopra* included a pair of painted chests described as: *1° paio di forzieri dipinti da sposa*.[100] Demonstrating again the clear distinctions drawn by the assessors between storage forms, these *forzieri* – and another painted *forziere* in the antique style – were listed among other chests in the same room, specified as a bench chest (*chasapancha*) in the antique style with two locks and a platform at its base; a large intarsia *chasone* of 3½ *braccia* covered in walnut; and a chest (*chasa*) described as 2 *braccia* high with a lock.[101]

Often purchased or commissioned in pairs, the value of *forzieri* appears to have rested on their associations with Florentine marriage rituals, which was in turn reflected in the quality of the chests' craftsmanship, materials and appropriate choice and display of pictorial scenes. The symbolic and ritualistic role of *forzieri* lay in their application as containers used to transport the bride's dowry goods to her new husband's house.[102] Chabot has suggested that *forzieri* were commissioned in pairs to facilitate a clear distinction between the gifts the bride received from her father and those given by the groom.[103] Recent studies by social historians have indicated that a change in the customs connected with *forzieri* occurred during the second half of the fifteenth century.[104] Previously the bride's family, or more specifically her father, had provided marriage chests in Florence. In the decades after 1440 a change in the negotiations and scale of the dowry seems to have led to an increase in the bride's *trousseau*, which was reciprocated by a significant counter dowry from the groom's family. As part

of this new obligation, the groom appears to have personally taken over the responsibility for acquiring the *forzieri*.

The importance of this general shift in consumer power from the bride's father to her prospective husband should not be underestimated. The desire to control the purchase of the marriage chests has been interpreted by Lydecker as indicative of a wider interest in decorative goods at this key moment in a Florentine's life.[105] Lydecker views the time of marriage as the most important occasion when a Florentine entered the art market and acquired a significant number of domestic furnishings. Though persuasive, it seems problematic and over simplistic to suggest that this was the only time when Florentines acquired major domestic goods. Whilst account books devote extensive folios to the expenses involved in furnishing the *camera*, often described as *la mia camera*, at the time of marriage, close analysis of inventories suggests that furnishings and objects continued to be acquired throughout a Florentine's life. This is indicated by the frequent references across the period to a wide range of objects as new (*nuovo*). This could relate to goods ranging from beds or benches to carpets or candlestick holders found throughout the domestic interior.[106]

On occasion rooms themselves are specifically referred to as 'nuovo', further suggesting a desire on the part of at least some Florentines to update or refurbish domestic space as and when required or deemed necessary. For example, the 1496 inventory of the highly successful bookseller (*cartolaio*) Salvestro di Zanobi di Mariano includes a *camera* specifically described as new and positioned at the head of the hallway (*in chamera nuova in chapo al'androne*).[107] From the description of the preceding rooms it is evident that this *camera* was located on the *piano nobile*. This, together with its prominent location on the hallway, suggests the importance of the space. It is not clear from the inventory what elements of the room constituted its attribution as 'new'. None of the domestic objects detailed in the room are described in this way and it is tempting to infer that the reference alludes to the decoration or permanent fixtures that would not have been recorded in an inventory of *mobili*.

The general impression of newness is suggested by the number and type of objects listed in the room. With just 29 separate entries the *chamera nuova* contains fewer objects than the room that follows. Referred to as 'in chamera che da in su la androne' this space included 137 entries, a significant number of which are kept in two *chasse* and two *chassoni*. The *chamera nuova* by contrast contained one *chassone* described as full of books and two *chassapanche* that were presumably waiting to be filled with goods since they were not accompanied by any additional entries. The room also contained a bed (*lettiera*) and a *lettuccio* or 'day bed' complete with a 'hat-rack' (*chapelinaio*). In addition the *chamera* included several notable art objects – a painted gesso

bust of Christ, three small tabernacles of the Virgin and Saints, and an intarsia birth tray in the antique style.[108] Without the discovery of Salvestro's account book the attributes of this room, like the motivations for its redecoration, can never be completely ascertained. Nevertheless, the evidence provided in the inventory demonstrates the potential for significant financial outlays on domestic space and objects outside of the rituals associated with marriage or emancipation.[109]

If *forzieri* were often lavish pieces of furniture, so too were *cassoni*. Several examples can be found in inventories of *cassoni* listed together or described as pairs complete with painted, perspective or historical scenes as well as inlaid work.[110] Indeed *cassoni* could themselves be directly connected to marriage rituals, as references in the inventories of Gismondo della Stufa (1495) and Lorenzo di Giovanni Tornabuoni (1496) demonstrate.[111] Though unusual, both entries occur in principal *camere* along with *forzieri* or other chests, which suggests that the identification with the *cassoni* form is quite deliberate. Vasari's reference to the type of chests used in the fifteenth century specifically relates to large wooden *cassoni* in the form of a sarcophagus.[112] This seems to have become an important sub-category of chest type, particularly in the last decades of the fifteenth century – as is reflected in several entries from the *Pupilli* registers, as well as the della Stufa and Tornabuoni 'betrothal' *cassoni* which were both described as '*chassoni a sepoltura*'.

The application of such 'sarcophagus-type' chests appears to have been wide. Significantly, this type of chest transcended *cassoni* and numerous examples can also be found in late *quattrocento* inventories that refer to *forzieri a sepolture*.[113] This suggests the major distinguishing factor between these and other storage chests rested in their form and appearance rather than merely function.[114]

Though inherently functional, these storage forms were by no means perceived as of little worth. As massive pieces of furniture, the larger chests made a major impact on the visual space in which they were displayed. 'Use' may have been the principal purpose of this furniture, but their 'value' went beyond merely their functional role. This additional value attributed to a *forziere* or betrothal chest – in both a financial and ritualistic sense – is the most familiar example of a storage form that extended beyond its intrinsically functional purpose. These lavishly decorated chests symbolized the social and economic worth of the new marital alliance – a point visibly underlined through the frequent inclusion of both families' coats-of-arms. Transported locked and closed through the city, the opulence of these chests hinted at the wealth of goods that lay hidden from general view. Once within the home these chests continued to serve as emblematic reminders of this alliance, gaining over time a strong sentimental value.

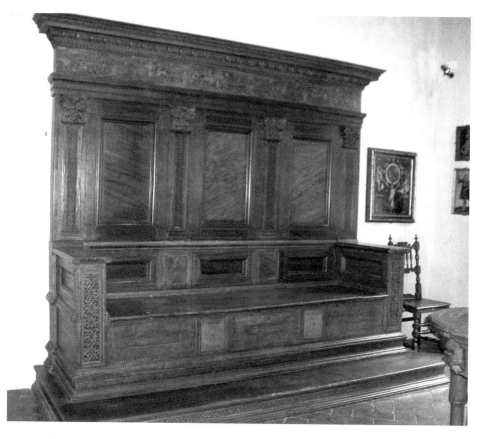

34. *Lettuccio*. Inlaid and carved walnut. Late fifteenth century. 250 (length) × 85 (width) × 290 (height) cm

A furniture form that satisfied Pontano's joint requirements for *supelectilem* of 'use and comfort' was the *lettuccio*. Inventories throughout the *quattrocento* confirm that *lettucci* were used for storage as well as sleeping or seating. Essentially the *lettuccio* consisted of a large chest (*cassa* or *cassone*) to which were attached armrests and a backrest or *spalliera* complete with cornice (*cornicione*). An exquisite late fifteenth-century carved and inlaid walnut *lettuccio*, measuring 2.5 × 2.86 metres, at the Museo Horne in Florence, demonstrates the display quality of such pieces (Illustration 34).[115]

Numerous entries in inventories confirm this general appearance. A particularly lavish example was displayed in the *chamera de sala* of Lorenzo di Domenicho Francheschi (1499) where it is recorded as: '*1° letuccio di chasone con chornicioni tutto di nocie intarsiato bello.*'[116] Collectively the ensemble's form, with its use of inlaid walnut, moved the assessor to describe the *lettuccio* as

beautiful. Variations in the general form of the *lettuccio* can be traced in the *Pupilli* registers, with the inclusion of additional elements that further embellished their appearance, as in the day bed of Piero del Rosso Buondelmonti which was specifically described as containing perspective work.[117]

The large size of *lettucci*, which often exceeded 5 *braccia* (approximately three metres) in width, made them particularly useful for storage.[118] This practical function is illustrated by the *lettuccio* kept in the principal *camera* of Gismondo della Stufa (1495). Detailed in the inventory as covered in walnut and intarsia with two locks, the *chassone* of the *lettuccio* contained in excess of 50 separate entries. The range and type of objects were diverse and included: various types of brass and silver basins with coats-of-arms of the della Stufa and other families; a gilded mirror; diverse types of tin ware dishes and plates; a small book of Psalms and other Orations; and an unusual birthing stool 'of painted porphyry'.[119]

The desire to achieve relative comfort is reinforced by entries that accompany the *lettuccio* in inventories. These refer to various types of mattress, covers, sheets and pillows and collectively indicate the role of the *lettuccio* as a 'day bed' suitable for either sitting or sleeping. The *lettuccio* listed in the *chamera di detta sala* of Lorenzo di Giovanni Tornabuoni's palace provides one example. Described as a *lettuccio* with a *chappellinaio* covered in walnut of 5 *braccia*, this entry is followed by: a small mattress filled with wool, a cotton bed cover, and four pillows, two described with ordinary pillow cases and two covered with rich work in silk.[120] A late *quattrocento* woodcut from Savonarola's *Predica dell'arte del ben morire*, visually replicates the accoutrements recorded in inventories and the comfort they provided (Illustration 35).

Although *lettucci* were often luxurious display pieces, they can be found detailed in houses across a wide section of society – from wealthy merchants to craftsmen and artisans. The currency for *lettucci* among lower sections of society may have influenced John Florio's definition of the term as 'a sillie poore bed or couch' in his Italian dictionary of 1611.[121] Thus the engraver or sculptor Taddeo di Stefano possessed a *lettuccio* in the *camera* of his house in 1430, as did the hosier or shoemaker Francesco di Giano in 1497.[122] In this sense the presence of Lorenzo di Domenicho Francheschi's 'beautiful' *lettuccio* discussed above is interesting since he too was not a member of the elite but rather from the middling ranks of Florentine society. Though the inventory suggests a degree of comfort for himself, his wife and his five children, his possessions in terms of their numbers were limited. There were just seven separate entries in the room that contained the *lettuccio*. Despite their restricted quantity, these objects appear to have been of significant quality. The room comprised a painted tabernacle with the Nativity; a small painting (*quadretto*) of Saint Sebastian; two heads of white gesso; as well as six clay putti (*banbocci*) and two clay heads. The major furniture in the *camera* consisted of the *lettuccio*

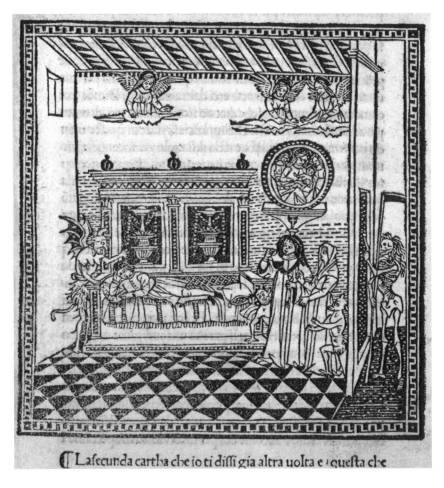

C Lafecunda cartha che io ti diffi gia altra uolta e / quefta che

35. Antonio Tubini and workshop, woodcut from Savonarola's *Predica dell'arte del ben morire, il 2 novembre 1496*. Florence, *c.* 1496

together with a walnut intarsia *cassone* in the *sepoltura* form; and a walnut bed of 4 *braccia* with walnut bench chests (*chassapanche*) around it and mattresses and covers on top (*cho' sachone e materasa e choltricie*).[123]

Significantly the *Pupilli* assessor also described the bed ensemble in Francheschi's *camera* as *bello*. This reference underlines how beds too, like chests and *lettucci*, could be functional, imposing and beautiful. Pontano specifically cited beds (*lectos*) as illustrative of the type of *supelectilem* 'without which it would not be possible to live comfortably.' Numerous references confirm the close relationship of the bed to the chests that were often placed around it. In some references the bed and chests are specifically described as fitted together

or attached (*commesse, appicchate*).[124] Inventories also suggest that the bed and the *lettuccio* were often positioned close or next to each other, as in Andrea del Sarto's fresco at Santissima Annunziata of the *Birth of the Virgin* (1513).

As with other major furniture forms, beds varied in form and size. More basic beds were often described bluntly as simple (*semplice*) and rustic (*salvatico*) or by reference to their rudimentary lattice base (*canaio*) and its trestle support (*trespolo*). Examples of these can be found in inventories, especially from the lower sections of Florentine society, as well as in the chambers of servants or maids of the wealthy.[125] Larger beds seem to have been distinguished as a *lettiera* instead of *letto* and often contained a large headboard (*testiera, capoletto*) that could project forward to provide useful shelving suitable for the display of various objects. This would have provided a pleasing vertical emphasis to complement the *lettuccio* that was often accompanied by a 'hat-rack' or *chapellinaio*. Though beds could be painted, as the 'relic' now in the church of Santa Maria delle Grazie in Pistoia (1460s) demonstrates, archival references indicate that *lettiere* with intarsia work remained more common during the fifteenth century.[126]

During the *quattrocento*, the form of beds seems to have developed, becoming more architectural in appearance.[127] As beds became more massive and structurally secure, new modes of accompanying bed hangings evolved. Towards the last decades of the century beds with posts began to appear, which offered still greater potential for hangings to be directly attached to the main bed structure. The different terms applied for bed hangings reflect evolving changes in fashion. One such term is *sopracielo*, that literally formed a 'sky' or 'heaven' above the bed and could be attached to either the ceiling or – once posted-beds had developed – the *lettiera* itself. A *sopracielo* specified as of French style with a fringe (*1° sopracielo Franzese chon frangie*) is described in connection with a *lettiera* in the room of Jachopo di Cino's mother.[128] In another example a cloth *sopracielo* complete with a curtain that presumably enclosed the *lettiera* is also identified in the principal *camera* of Piero del Rosso Buondelmonti (*1° sopracielo da letto di panno lino cholla chortina*).[129]

Another type of covering above the bed was the *padiglione*, so termed because of its dome or cone-shaped form. The *padiglione* could also be attached to the bed or hung from the ceiling as depicted in a panel by Francesco Granacci from the *Life of Saint John the Baptist* (Illustration 36).[130] Unlike the *sopracielo* the *padiglione* hung down as one piece and enclosed the whole bed. A variation of these hangings was the shorter and more curved *sparviero* (also spelt *sparbiero*) whose name derived from its apparent resemblance to a hovering sparrow-hawk. The potential permanence of the *sparviero* is suggested in the inventory of Gismondo della Stufa (1495), where a room is specified as: *in chamera degli sparbieri di sopra*. Although the first entry given is for a *lettiera*, there are no further references to the *sparbieri* within the room, which would seem to indicate that this covering was a permanent fixture and therefore not subject to further appraisal.[131]

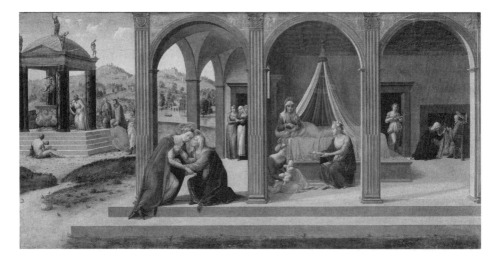

36. Francesco Granacci, *Scenes from the Life of Saint John the Baptist*,
c. 1510. Oil tempera and gold on wood. 80 × 152.4 cm

A further variant bed hanging was the *cortinagio*, which could also be
suspended from the ceiling or attached to the bedposts. The *cortinagio*
consisted of a box-like frame structure, often fitted with rings that facilitated
the opening or closure of curtains around the *lettiera*. If attached to the actual
bed frame, the curtains could be tied up against the posts when not in use,
thereby enabling the bed covers and quilts to be visibly displayed. The doctor
Maestro Mario di Brocardi da Imola had a *cortinagio* in his principal *camera*.
Here the *Pupilli* assessor confirms that the *cortinagio* covers all four sides of
the bed while also stressing its horizontal emphasis with the use of the term
sopracielo. Collectively this ensemble must have created an impressive display.
Made of 'foreign' cloth with a fringe, the bed hangings were also accompanied
by two painted gesso putti.[132]

A wide range of accoutrements including mattresses, sheets, pillows and
bed covers are frequently listed in conjunction with the *lettiera*. Though similar
to those found on the *lettuccio*, they were often more extensive in their quantity.
An example of these related accessories can be found in the 1496 inventory
of the extremely wealthy banker Lorenzo di Giovanni Tornabuoni. Within
Lorenzo's principal *camera* was a massive piece of furniture consisting of a
lettiera together with a *lettuccio* and *chappellinaio* attached to a *chassone*.[133] It is
not entirely clear from the entry whether this comprised one complete suite of
furniture or if they were simply closely situated to each other within the *camera*.
What is not in doubt is the lavishness of the ensemble, which is described as
made of walnut together with decorative work in gold and silver. In addition,

a later entry contains a *chortinagio a padiglione* with two valances.[134] The list that follows includes various types of mattress distinguished as *choltricie, choltricina, materassa, materassina, sacchone*; a pair of 'foreign' linen sheets (*lenzuola*); a white bed cover (*choltre biancha da letto*) with work on it; five pillows with pillowcases (*ghuanciali chon federe*), three for the bed and two for the *lettuccio*; together with another cover with work and a fringe for the *lettuccio*.[135]

Though the *Magistrato dei Pupilli* inventories can only provide a snapshot of possessions as recorded at the time of death, conclusions can be drawn from the descriptions regarding the life of domestic goods. As these documents confirm, the major furniture forms were not only functional pieces for storage and use, but were also often lavishly decorated and would have commanded attention in the spaces which they occupied, thereby reinforcing Pontano's criteria for both the '*usus et commoditatis*' of splendid furnishings and the *egregia* of their workmanship. In the concluding section of this chapter, the information acquired from the *Pupilli* inventories will be expanded to encompass Pontano's discussion of *ornamenta* – the smaller decorative wares that could be stored within furniture forms, as well as prominently displayed in key spaces within the interior.

3. *La camera bella*: the room made beautiful through domestic display

Using unpublished inventories, this section explores the range of luxury domestic goods – from maiolica and glass to metallic wares – that were found in the homes of fifteenth-century Florentines. As well as fulfilling practical functions, these smaller more fragile wares also found a purpose and prestige that warranted display. Often inherently associated with the functions of dining or entertainment, such goods transcended these basic roles and collectively enhanced the aesthetic of the domestic interior. Displayed together with the larger furniture forms whose spaces they shared, these goods collectively recreated the shine and polish required of the furnishings of the 'splendid man'.

Throughout the fifteenth century, specific references to domestic objects and furnishings as 'beautiful' were surprisingly rare. Indeed, whilst the inventory of Lorenzo di Giovanni Tornabuoni (1497) distinctly refers to his principal *camera* as *bella*, the word itself appears on only two other occasions throughout the entire document.[136] This pattern of selective usage is replicated in the *Pupilli* registers across the *quattrocento* and suggests a conscious appreciation or awareness by the assessors of the importance of the term. Such careful treatment of the word '*bello*' is at odds with other value judgements or descriptive terms applied to objects and domestic goods. Indeed, terms such as new (*nuovo*), good (*buono*), used (*usato*), old (*vecchio*), or sad (*tristo*) which

ostensibly serve the same expressive function, were used far more liberally by the *Pupilli* assessors. In the Tornabuoni inventory, for example, there are 32 separate references to 'new' objects, though none coincide as one might have expected with *bello* or *buono*. The appearance of other value judgements in the Tornabuoni inventory further illustrates this point: *buono* appears 85 times, *tristo* 17, *usato* 173, and *vecchio* 47.

The connection between 'new' and 'beautiful' occurred only exceptionally in other inventories. The inventory of the prominent banker Francesco Inghirrami (1479) contained 11 separate references to '*bello*' of which two entries were also described as new (*nuovo*): 24 beautiful new spoons and 12 beautiful new forks with a figure of Hercules in silver on each handle.[137] The remaining objects described as beautiful in the inventory were diverse and included: two painted *forzieri* with coats-of-arms; a *lettuccio* and *chapellinaio* of walnut with intarsia; and a small leather book in French for women with gilded silver studs and a buckle.[138] Other inventories from earlier in the century also record objects as 'beautiful'. For example Matteo degli Scolari (1430) possessed two beautifully enamelled basins; two linen cloths with beautiful decoration; and a clock with a beautiful little bell,[139] while the extensive inventory of Gabriello Panciatichi (1430) contained seven separate references to *bella* including two beautiful missals; a sapphire; eight brass candlestick holders; and two tabernacles of the Virgin each with shutters.[140]

At the end of the fifteenth century the application of the term '*bella*' to Lorenzo di Giovanni Tornabuoni's *camera* is of fundamental importance, suggesting an evolved decorum of domestic display that could extend to an entire interior space. Such a concept was implicit in Pontano's discussion of splendour. There, reference had been made to different levels of appropriateness for furnishings and goods within the domestic space. This decorum extended from the type of objects that were considered suitable for certain rooms to the way these objects were displayed within these spaces. In the Tornabuoni inventory none of the entries detailed within the *camera* are specifically described as 'beautiful'. Rather it would appear that it was the range, type and quality of the goods located in this space that merited the collective association with the word *bella*.

The issue of quality or excellence (*egregia*) was, as we have seen, an integral concept in Pontano's discussion of the splendour of both ornamental objects and domestic furnishings. In Lorenzo's 'beautiful room' the '*egregiousness*' of the objects is suggested by their descriptions. Common in eight of the entries is the use of gold or gilded decoration described variously as *d'oro*, *dorato* or *messo d'oro*. The application of such decoration was wide and appears on a range of furniture pieces and decorative objects. For example the massive furniture ensemble described above comprising the *lettiera*, *lettuccio*, *chappellinaio* and *cassone* had gold and silver gilding applied to the expensive walnut woodwork, while two marriage chests with *spalliere* were painted and

gilded.[141] Work in gold is also detailed on the frames of a *tondo* depicting the *Adoration of the Magi* (Plate 6), two maps of the world and a circular mirror.[142] In addition, one entry records 'two gilded infants, embracing together', while another suggests a more restricted use of gilding applied to the brass balls of a chair with fringes and covered in velvet.[143]

Both the individual and the collective effects achieved by these objects accorded closely with the definition of splendour. The shine, polish and luminosity of such furnishings and domestic goods were intended to appear as solid gold. Though difficult to appreciate today, with the majority of damaged and tarnished pieces displayed in museums, the lustre found in such objects when new must have created a lavish display. In addition to the general effect achieved, the notion of masking or concealing the real material with which the objects were actually constructed must have appealed to Renaissance tastes. Other materials were also replicated to take on the appearance of gold, silver or other precious materials. Possessing similar prerequisites of malleability and elasticity common to precious metals, copper (*rame*), brass (*ottone*) or bronze (*bronzo*) could be gilded or enamelled to achieve a more polished effect. Elsewhere in the Tornabuoni inventory, one entry records two copper jars with silvered enamel,[144] while that of Gismondo della Stufa (1495) included a small figure in gilded bronze, a pair of women's spurs in gilded brass, and three knives with silvered brass handles.[145]

A lavish style adopted for a range of wares and vessels was damascene work. Referred to in inventories as *domaschina* or *damaschina* because of its perceived origins in Damascus or traditional export from that city, this technique involved the intricate application of inlaid silver on brass or bronze. The popularity of such luxury objects is confirmed by their presence in the inventories of wealthy Florentines during the fifteenth century. The 1463 inventory of Piero de' Medici lists 36 damascene objects ranging from basins, ewers and buckets to candlestick holders, lamps and incense burners.[146] By the time of the 1492 inventory, compiled at the death of Piero's son Lorenzo de' Medici, the number of objects had risen to 50, while a further 54 were detailed as *alla domaschina*.[147] The taxonomic usage of '*alla*' suggests a clear distinction between damascene objects or goods from Damascus and those of a different origin or even style. Though one should be cautious in relying too heavily on such written sources for an interpretation of stylistic differences, the clear dichotomy between *domaschina* and *alla domaschina*, particularly within the same inventory, is persuasive. In the 1492 inventory, the *domaschina* objects are generally given higher estimations, suggesting that the stylistic distinctions also conditioned value. Nevertheless, although the highest estimate of 200 florins was reserved for a jug described as 'without a spout', several of the *alla domaschina* goods were also highly valued, as one basin estimated at 60 florins demonstrates.[148]

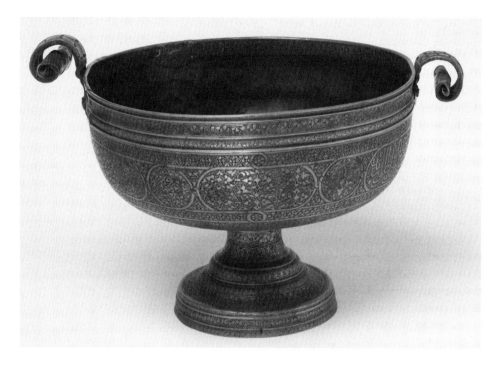

37. Circular footed brass bowl engraved and damascene with silver.
Damascus, Syria, second half of the fifteenth century. Foot possibly shaped
and decorated in Venice, with the coat-of-arms of the Priuli family inside. The
handles are a nineteenth-century addition. Height: 22 cm Diameter: 30.7 cm

It is unclear from inventories precisely where pieces recorded as *alla
domaschina* would have originated. By the fifteenth century a number of
Islamic centres were producing damascene wares as was Venice, which had
developed extensive trade networks with the Orient. The 1424 inventory
of Angelo da Uzzano provides an early reference to eight *alla domaschina*
candlestick holders among his extensive possessions.[149] Notably, these are
recorded as having been personalized with the Monaldi family coats-of-
arms – an embellishment that became popular later in the century, as the
application of *arme* individualized objects, rendering them suitable either for
private ownership or public gifts.

Extant examples of Islamic exports and indigenous Italian products suggest
the popularity of such luxury goods. A large brass bowl from the second half
of the century marks a transitional phase in the development of damascene
ware and demonstrates the assimilation of Islamic designs to contemporary
Italian tastes (Illustration 37). While the shape and Arabic inscription on the
bowl is traditional, the turned foot is distinctly Italian in its ornament and

form. Like the coats-of-arms added to other Islamic pieces this bowl, which includes the coats-of-arms of the Venetian Priuli family inside, must reflect either a compromise to the demands of the European export market, or their subsequent addition in Venice.

It was not just metallic goods that were described in inventories as *domaschina*. Other furnishings, especially fabrics and textiles were also listed in this way. This suggests that in Florence at least, Damascus – or the styles originating from that city – was considered broadly indicative of wider Islamic production. Occasional references can also be found for objects from Alexandria or in the Moorish style. In the 1495 inventory of Gismondo della Stufa, entries in the principal *camera* record the presence of a small painted box with Moorish designs, and a cloth with Moorish work on it, together with a gown of Alexandrian satin and velvet.[150]

Fabrics and textiles of European origin are also recorded in inventories and were used variously for covers, upholstery and clothing. As with Islamic styles, these too could derive from the location in which they were made or relate to the designs appropriated locally by indigenous craftsmen. Inventories during the fifteenth century record a striking range of not only Italian materials, but also silks from Spain, cloth from Flanders, and linens from Rheims and Paris. Styles were apparently so familiar to the *Pupilli* appraisers that the colour or pattern of the material was often deemed unnecessary or incidental to the need to simply register its geographical origin. An indication of the quality of the fabrics could be suggested by adjectives such as good (*buona*) or fine (*fine, sottile*), which suggests the material's tactile quality was considered an important attribute along with its colour and visual appearance. In Lorenzo Tornabuoni's 'beautiful *camera*', a linen cover with embroidered edges is referred to as *buona* while a pair of linen sheets is specifically described as foreign. The usage of such a geographically indistinct term is unusual but not exceptional in *quattrocento* inventories, and suggests that new or unusual styles were continually being introduced in Florence during the period.[151]

Also on display in the Tornabuoni *camera bella* were two vases of colourless glass (*cristallino*) from the island of Murano, just north of Venice.[152] The perfection of *cristallo* glass in Venice during the second half of the fifteenth century represented an important technological development, achieving unprecedented transparency and surface shine, while remaining remarkably light when held. The glass itself took its name from the close resemblance it bore to rock crystal, a natural material that was highly valued during the Renaissance and allowed glassworkers to recreate visually classical accounts such as that of Pliny the Elder (AD 23–79), who had commented in the *Naturalis Historia* how glassware 'has now come to resemble rock crystal in a remarkable manner, but the effect has been to flout the laws of nature and actually to increase the value of the former without diminishing that of the latter.'[153]

This very conscious appreciation of flouting nature is reinforced in Marcantonio Sabellico's statement in *De Venetae urbis situ* (1494), where in Book III he asserts: 'there is no kind of precious stone which cannot be imitated by the industry of the glassworkers, a sweet contest of man and nature.'[154] Sabellico's reference to the range of precious stones able to be produced in Murano could refer to the decorative effects achieved through the addition of gold leaf, enamels, or prunts of coloured glass to plain vessels (Plate 7), as well as 'new' styles of glassware, such as chalcedony glass (*calcedonio*). Like *cristallo*, *calcedonio* glassware also imitated the semi-precious stone from which its name derived. This type of glass was made by mixing a range of different colourants together in the batch, which gave the finished wares a layered veined effect whose translucent colours changed their appearance when placed against direct light.

Within the Tornabuoni inventory (1497) there are 41 separate pieces of *cristallo* glassware.[155] Though particularly significant in terms of their quantity, the general descriptions employed suggest a limited range of vessel types: glasses (*bicchieri*, *tazza*, *tazzoni*), large deep-sided dishes (*rinfreschatii*) and carafes with long straight necks (*ghuastade*). Notably, none of these wares is recorded as stored in chests or containers, but rather appear to have been displayed in the rooms in which they are listed. The novelty and perceived importance of *cristallo* as a domestic object worthy of display is confirmed by Pontano's inclusion of crystal vases (*vascular a cristallo*) as examples of ornamental objects.[156] Though examples can be found in inventories of glassware safely stored away in chests or cupboards – as with the collection of Gismondo della Stufa – this was seldom the case.[157]

The inherent fragility of the new thin, light, and translucent Renaissance glassware was recognized as another of its virtuous qualities, and may well have outweighed concerns over its durability. Both the delicateness and transience of glassware was acknowledged by the Sienese metalworker Vannoccio Biringuccio who wrote in his treatise *Pirotechnia* (printed 1540) that 'though all the effects of glass are marvellous' given 'its brief and short life, it cannot and should not be given too much love.'[158] In this sense, glassware also recalls Pontano's description of splendour, which he stated 'does not despise something for being of short duration or small.'[159] The particular quality of the two *cristallino* vases in Lorenzo Tornabuoni's *camera* is suggested by the specification that they were from Murano (*di Murano*) and included additional decorative work (*chon lavori*). Significantly, none of the other *cristallo* wares listed in the inventory are described in this way.

By the sixteenth century, the pre-eminence of Muranese glassware was well-established as Biringuccio confirmed when he wrote: 'the best glasswork that is made in our time and that which is of greater beauty, more varied colouring, and more admirable skill than that of any other place is made in

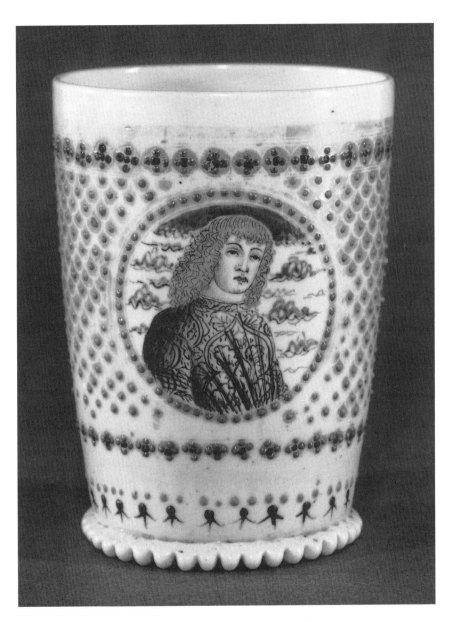

38. Marriage beaker in *lattimo* glass with enamelled and gilt
decoration. Venice, late fifteenth century. 10.2 × 7.4 cm

Murano.'[160] The Tornabuoni vases may well have been prominently displayed
on the mantelshelf above the fireplace that the room clearly included. This

is suggested by the listing of the vases in the room, just after the entries that record the presence of the pair of fire-irons (*paio d'alari*), tongs (*paio di molli*), shovel (*paletta*), and fork (*forchetta*). A precedent for such a display of glassware is found in the 1492 inventory of Lorenzo de' Medici, where in the important *camera grande terrena* two vases of purple glass are described as located above the fireplace.[161]

An opaque white glass, referred to as *lattimo* in the documents, was developed as an attempt to imitate Chinese porcelain (*porcellana*), which had become a new and highly prized import during this period. The development of *lattimo* demonstrates both the remarkable invention of Venetian glassworkers and their ability to quickly react to new demands in the luxury goods market. In contrast to many of the other glassware techniques perfected during the late *quattrocento*, *lattimo* represented the attempt to imitate a man-made material. Extant examples of *lattimo* glassware are extremely rare and less than 20 pieces are today known to have survived. Though the majority of these are – as with Chinese porcelain – decorated with painted enamels, the overall effect achieved is distinctly Venetian in character. As a *lattimo* beaker at the Cleveland Museum of Art demonstrates, such 'milk glass' could also include gold-leaf decoration as well as painted enamels applied in a typically Muranese style of dotted ornamentation (Illustration 38). Here the quality and importance of this beaker is demonstrated by the inclusion of portraits of a man and woman on either side suggesting the commemoration of a betrothal.

The glassware listed in the *Pupilli* inventory of Francesco Inghirrami (1471) provides a useful example of the range and type of wares available in Florence during the last third of the fifteenth century. Though many of the vessels are familiar from the Tornabuoni inventory, other forms are also cited including bowls (*schodelli*), cups (*bossoli*) and salt-cellars (*saliere*). In addition, the colours and type of glassware ranged from *lattimo* and *cristallo* to green (*verde*) and pale blue (*azurri*) glassware, as well as apparent combinations such as blue and white (*azurro e biancho*) or gilded green (*verde dorato*).[162] By far the greatest concentration of glassware is detailed in Francesco's *schrittoio*.[163] The display of such an important range of glassware – in terms of their different colours, types and shapes – in a domestic space as significant as the principal study, is instructive.[164] As the nomenclature and sequence of rooms within the inventory suggests, the study was located either next to or within Francesco's principal *camera*. While the precious examples of *lattimo* and *cristallino* glassware were on view in the *scrittoio*, the glass vessels located in other rooms are predominantly recorded as stored within various chests (*casse, cassone, forzeretti*).

Among the range of decorative and costly goods also on display in the Inghirrami study are five different pieces of maiolica, or tin-glazed

earthenware.[165] Like the new glass techniques developed during the second half of the fifteenth century, maiolica represented a further technological development to rival the achievements of antiquity. The evolution of the term maiolica may have derived from the Tuscan name for the island of Majorca or the Spanish term for Malaga wares, from where the Hispano-Moresque goods were initially imported. References to maiolica can be found in the *Pupilli* registers from the late 1420s, as in the inventory of the druggist Salvestro di Francesco Neretti.[166] The 1448 inventory of Antonio di Marsilio Vecchietti provides an early example of a significant number of maiolica wares stored together in one location. These are listed as being in a locked *cassone* within the *camera terrena*, and comprised 33 pieces of maiolica including small plates, footed bowls and one large plate.[167]

Such early descriptions of maiolica would seem to refer to imported pottery, rather than indigenous wares. In a similar way to the damascene products introduced from Islamic cities in significant quantities, maiolica ware soon became tailored to suit Italian tastes. The Spanish port of Valencia became an important centre for the Italian market, with Muslim and Christian potters producing wares in a modified Islamic style, both for general export and specific commissions. Such tin-glazed earthenware, often decorated with lustre and cobalt blue, could be personalized with the incorporation of coats-of-arms and other devices, as is demonstrated in a particularly lavish example ordered by the Medici family between 1465 and 1492 (Plate 8). The vase, which assumes a typically Islamic shape, includes the Medici arms on one side and a familial device of the diamond ring with two feathers on the other. The gleaming, polished effect achieved by the lustre, still impresses the spectator today, and must have created a striking display piece. The prestige that such wares achieved can be gauged from an undated letter written by Lorenzo de' Medici to a member of the Malatesta family:

Two days ago I received with a letter from your honour those pottery vessels that you have graciously sent me through Giovanfrancesco… Since they are perfect and much to my taste, they gave me great pleasure. I cannot adequately thank you, because if rare things are to be valued, I value these vases more than if they had been of silver because they are very excellent and rare, and new to us here.[168]

Significantly, it is the rarity and excellence of the vases, together with their newness, that leads Lorenzo to value the wares 'more than if they had been of silver'. Although such wares never exceeded the market value of silver, nevertheless the comparison is interesting. In Pontano's discussion of the furnishings appropriate to the splendid man he stated that 'some should be made precious by their cost and size, others exclusively by the refinement and rarity which comes from the hand of the artist or for some other reason.'[169] As with glass, the technical difficulty involved in the manufacture process,

together with the skill of the craftsmen in decorating such objects, contributed to its widespread appeal. So extreme were the procedures of throwing, firing, glazing and lustring that Cipriano Piccolpasso estimated in his *Tre libri dell'arte del vasaio* (1557) that only six from 100 pieces were of perfect quality.[170] As the inventories of Francesco di Neretti and others confirm, the appeal of maiolica and lustred ceramics extended beyond elite circles. That such wares appear in the inventories of members of the artisan class suggests that maiolica was imported in both significant quantities and in varied qualities, which helped to keep prices at affordable levels.

By the last decades of the fifteenth century a significant factor in the wide availability of ceramics was the development by Italian potters of indigenous maiolica centres. Within a remarkably short period, specialist markets developed in towns such as Deruta, Faenza, Montelupo and Pesaro. Many of these were patronized by local rulers or wealthy patrons, as in the case of the Cafaggiolo factory just outside Florence which was established by Pierfrancesco de' Medici in 1498.[171] Once Italian potters had developed the necessary technical virtuosity, Italian centres rapidly moved from an eclectic appropriation of imported ceramics to one that, by the beginning of the sixteenth century, had begun to surpass Spanish wares. Though inventories during the *quattrocento* do not make a taxonomic distinction between imported and indigenous maiolica, the large numbers of regional ceramics that survive suggest the speed with which Italian output negated the demand for Hispano-Moresque wares.

A significant factor in the success of Italian maiolica was the variety of goods to which the technique was applied. As inventories from this period confirm, these ranged from various plates, bowls, basins and jars to inkstands and devotional reliefs or busts. In its diversity of functions, maiolica achieved both of Pontano's prerequisites for splendid goods that 'some should seem to be acquired for use and for ornament, and others for ornament and elegance alone.'[172] The most consistent appearance of references to maiolica in the *Pupilli* registers is to vessels apparently related to or connected with tableware, though these are rarely found listed solely in halls (*sale*) or kitchens (*cucine*), but in prominent locations within the domestic interior. This occurs for example in the Inghirrami inventory where maiolica is listed in each of the studies.[173] It is also apparent in the inventory of Lorenzo Tornabuoni where his 'beautiful *camera*' and the *camera* of the golden ceiling (*palco d'oro*) both contain references to maiolica.[174]

On occasion the adjectives used to describe the maiolica confirm that the wares on display in prominent rooms are of superior quality to those pieces kept in the service areas.[175] Nevertheless, as the reference to the maiolica in the *camera del palco d'oro* suggests, even the goods on display could be used. There the five large maiolica plates are described as 'used' (*usati*). Given their

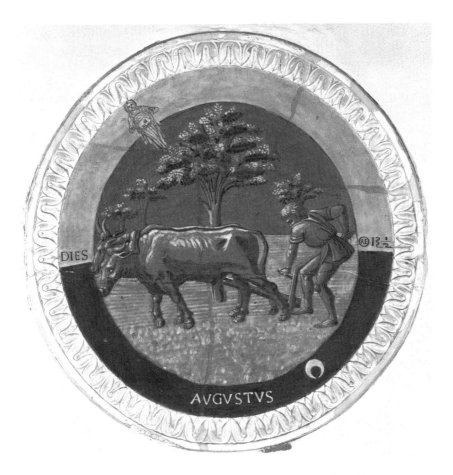

39. Luca della Robbia, *Labours of the month (August)*, c. 1450–56. One of
12 tin-glazed terracotta roundels from the ceiling of Piero de' Medici's
studietto. Diameter: 59.7 cm. The borders are coloured dark and light blue
to indicate the period of light and darkness. Each bears an inscription
giving the number of daylight hours and the relevant sign of the zodiac

display in such a prominent room and the reference to the additional work
that they included, these pieces were clearly considered important and worthy
of display but also – significantly – not too worthy for use.

With all inventories, it is necessary to also consider what is not specifically
listed in the domestic space. In particular, one must be conscious of the potential
for a room's appearance to have been further enhanced or embellished by
the immoveable decoration applied to the floor, walls and ceiling. As with
furnishings and ornamental objects, the use of gold, wood inlays or tin
glazes for such areas replicated the dual effects of shine and polish, thereby

complementing or further enhancing the splendour of a domestic space. The reflective quality of gilded ceilings and polished floors were singled out for praise in the descriptive accounts of the Medici palace interior. In the *Trattato di Architectura* (1464), Filarete praises Piero's 'extremely ornate *studietto* with the pavement and also the ceiling made of figurative enamelled terracottas, in such a way that it creates the greatest admiration in whosoever enters the room.'[176] The cohesive and lavish effect achieved in this space required careful planning between the patron, the architect Michelozzo (1396–1472) and the designer Luca della Robbia (*c.* 1399–1482). The concave roundels depicting the labours of the months, curved to accommodate the ceiling vault, demonstrate that Piero's study was an intimate barrel-vaulted room measuring about 3 x 5 metres (Illustration 39).

The importance of the immoveable decoration applied to an interior space can on occasion be inferred from the nomenclature used by the inventory assessors to describe a particular domestic room. In the Tornabuoni inventory, the two rooms immediately following Lorenzo's 'beautiful room' are referred to as the *chamera del palco d'oro* and the '*camera* of the cypress wood' (*chamera del'arcipresso*). In the first of these rooms the effect achieved by the gold ceiling was complemented by the use of gilding on key furnishings and decorative objects. Notably, the major furniture form comprising the *lettiera*, *lettuccio* and *chappellinaio* is described as covered in walnut, complete with additional gilded details.[177] In its massiveness of scale, as well as the quality of materials, this ensemble recalls that listed in Lorenzo's own *camera*, a space with which it was intrinsically connected. Similarly, gilded work is also described on the frames of a *tondo* of the *Virgin and Saint John* and a portrait of Lorenzo's first wife, Giovanna degli Albizzi (see Illustration 17).[178]

In the second *camera*, the nomenclature of this space is explained by the reference to a cypress wood bed as well as *spalliere* and chests, also made of cypress woods, which are described as running around the room.[179] The exact meaning of the term *spalliere* here is unclear. One possible interpretation is that this related to the backboards attached to the chests, and which would therefore have provided a basic form of seating bench. Such bench-chests, or *cassapanche* as they were frequently referred to in inventories, were often listed in domestic areas such as courtyards or halls, where their dual function of storage and seating served both a practical and decorative function. Another related interpretation for the meaning of the term *spalliere* was that this referred instead to the wainscoting fitted throughout the room. By the end of the fifteenth century such wainscoting, often in the form of inlaid woodwork, became extremely popular in Florence.

A sense of the lavish effect of this wainscoting is suggested in Domenico Ghirlandaio's *Birth of the Virgin* fresco in the *cappella maggiore* of Santa Maria Novella (Illustration 40). Commissioned by Lorenzo Tornabuoni's

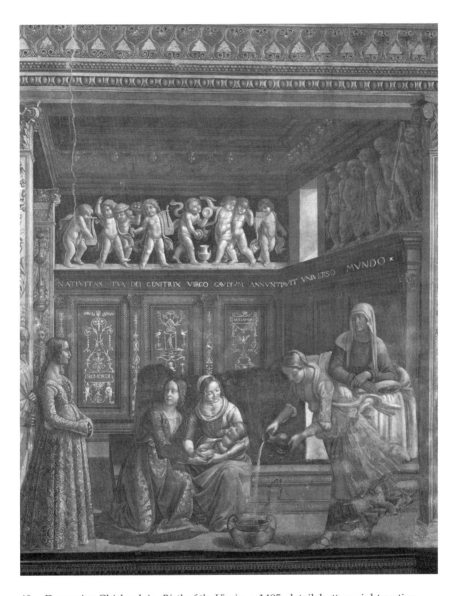

40. Domenico Ghirlandaio, *Birth of the Virgin*, *c*. 1485, detail, bottom right section

father Giovanni, it is tempting to suggest that this scene conveys, if not an appropriation of a room in the family palace, then at least a depiction of an interior space that would have been appreciated as familiar and up to date by both its patron and contemporaries. Certainly, Ghirlandaio's fresco reflects the latest fashion among wealthy Florentines for elaborate inlaid wood panelling

replicated in an *all'antica* style. This represented a significant shift away from the late *trecento* tradition for fresco decoration personified in the Palazzo Davanzati in Florence and Palazzo Datini in Prato. At Palazzo Davanzati (*c.* 1385), the decoration of the walls of one of the principal chambers is divided into three painted horizontal areas or bands. On the lowest tier fictive wall hangings were depicted, followed above by a band of geometric shapes, and lastly just below the ceiling, scenes from the chivalric romance of the Castelaine de Vergi.[180] Though the effect achieved was very different, the horizontal divisions created by the wall decorations were ultimately maintained in Ghirlandaio's fresco.

As Ghirlandaio's fresco suggests, and select late *quattrocento* inventories record, the wainscoting, bed, *lettuccio*, *cappellinaio* and different types of chest could be conceived as an elaborate architectonic ensemble united through the use of the same woods, inlays and ornament. This is particularly well demonstrated in the *anticamera* of Giovanni di Lorenzo de' Medici which is recorded in the famous 1492 inventory of the Medici family possessions. The long first entry records that there was a *spalliera* of 20 × 4 *braccia* (over 11.5 × 2.3 metres) running around the room.[181] The *spalliera* was made of pine with a cornice of walnut and intarsia, complementing the *lettuccio* and a lockable wardrobe. There was also further decoration at the side, head and foot of the bed, which is described as fixed to the *spalliera* with inlaid work in the same fashion.

The architectonic appearance of *spalliere* panels is further suggested in Giovanni di Lorenzo's principal *camera.* This room contained a single *spalliera* panel of 13 × 1½ *braccia* (7.6 × 0.87 metres) with a cornice and small gilded columns. The *spalliera* was divided into three parts and complemented the three chests that were placed below.[182] Ghirlandaio's fresco of the *Birth of the Virgin* at Santa Maria Novella and Benedetto da Maiano's (1442–97) *Birth and Naming of Saint John the Baptist* in terracotta from around 1477 (see Illustration 21), similarly depict *spalliere* panels divided up by a row of columns complete with capitals.

In Giovanni di Lorenzo's *camera,* the *spalliera* does not contain inlaid work but rather pictorial scenes painted by Giovanni di Ser Giovanni, known as Lo Scheggia, depicting the joust held by Lorenzo de' Medici in 1469. The representation of a contemporary event was unusual. More familiar was the classical subject matter on the two *forzieri* that recorded the victory of Marcus Marcellus. These *forzieri*, described as *a sepoltura*, were lavishly decorated with gilded consoles (*mensole*) and architraves (*architrave*). Since the *spalliere* panels in both Giovanni's *camere* and *anticamera* were fixed to the walls, their presence as immoveables would not have been recorded in the *Pupilli* inventories.

It seems likely that such decoration would have appealed to other wealthy patrons, and clearly the range of possible stylistic parameters was broad. If

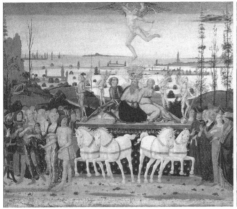

41. Jacopo del Sellaio, *Triumph of Love* and *Triumph of Chastity*. 75.5 × 89.5 cm and 76 × 86.5 cm

the Ghirlandaio and da Maiano birth depictions represent one possible style, then the four painted panels that survive at the Museo Bandini may reflect the development of incorporating pictorial scenes into an ensemble of *spalliere* fixed around a room. Isolated examples of extant paintings have been persuasively identified as originally forming an integral part of individual *spalliera* panels associated with furniture. This is most familiar from the probable reference to Botticelli's *Primavera* in the *camera terrena* of the 1498 inventory of Lorenzo di Pierfrancesco de' Medici, where it was described as '*apicato sopra el letucio*'.[183]

At the Museo Bandini the four panels, attributed to Jacopo del Sellaio (1442–1493), depict scenes from Petrarch's (1304–74) *Trionfi*: those of Love, Chastity, Time and Eternity (Illustration 41). Of similar dimensions – which are both too short and deep to be intended for chests – the scenes suggest that they were conceived as a pictorial whole in which each panel would have been set into, and divided by, the architectural columns or frames formed by the *spalliera* panelling. In the first three *Trionfi*, the theme of procession is complemented by the consistency in the tonal variation of the hills, trees and rocks in a landscape, together with the horizon line that continues across each panel. Only the transition between the Time and Eternity panels appears more abrupt, though here too a visual connection is made by the branches of a tree being divided in half and appearing on the adjacent edges. This degree of awkwardness, however, together with the slightly larger dimensions of the Eternity panel, suggests that the ensemble may originally have consisted of six Triumphs, as described in Petrarch's narrative, and would therefore have included Death and Fame.

It was not only *spalliere, cassoni* or *forzieri* panels which provided opportunities for pictorial decoration within the interior. Another important category of decorative objects painted for the home was the *desco da parto* or birth tray – a platter on which gifts of food and sweets were brought to the new mother to celebrate the birth of her child. The exquisite *Medici-Tornabuoni birth tray* (c. 1448–9) now in the Metropolitan Museum of Art demonstrates the quality of such objects, and visually underlines that *deschi* were more than simply functional items associated with Florentine social conventions, but could also serve an important related purpose as display pieces (see Illustrations 15 and 16). Close analysis of the *Pupilli* registers also records the presence of painted *tondi* which, like the birth tray, had a particular Tuscan provenance and can be found in inventories from around 1430 onwards. While early archival references suggest a direct link between *tondi* and *deschi da parto*, presumably on account of their similar formats or related social functions, towards the end of the century the *tondo* emerged as a distinct entity. This, together with the number of extant works that survive by leading Florentine artists and their workshops through to the opening decades of the sixteenth century, suggests the popularity of this format in the domestic interior.[184]

The 'beautiful *camera*' of Lorenzo Tornabuoni contained a *tondo* by Ghirlandaio depicting the *Adoration of the Magi* (see Plate 6). Dated 1487 on the stone block in the foreground, the large and sumptuous *Adoration* shows a retinue of soldiers, servants and attendants accompanying the three Magi who kneel to offer gifts to the Christ child. The lavish quality of the *tondo* with its elaborate gold frame was considered important enough to warrant specific reference in Vasari's *Lives* where he stated: 'in the house of Giovanni Tornabuoni there is a *tondo* with the Story of the Magi, wrought with diligence.'[185] The Ghirlandaio brothers had received significant patronage from the Tornabuoni during the 1480s, not least with their decorations for the *cappella maggiore* in Santa Maria Novella, and it seems likely that other paintings recorded in the 1497 *Pupilli* inventory were produced by the Ghirlandaio *bottegha*.

Pontano had specifically cited paintings (*tabulae pictae*) as exemplars of his categorization of ornamental objects (*ornamenta*).[186] Certainly by the close of the fifteenth century, when *De splendore* was published, the *Pupilli* inventories do record increasing numbers of specific references to paintings (*quadri*). In the 1522 inventory of Antonio di Messer Michele Strozzi four different paintings are recorded, each of which were specifically referred to as *bella*.[187] While a range of objects are found in the inventories referred to as painted (*dipinto*), the new taxonomic usage of the term *quadri* would seem to suggest a shift in the status and display function of paintings. Where earlier in the century painted panels had been inserted low down into chests, now paintings were

'elevated' onto the walls to be inserted into the *spalliere* or wainscoting of a room, or even displayed separately as distinct entities in their own right. This heightened status of pictorial forms is reinforced by inventories in which *quadri* and *tondi* appear as the first entries listed collectively within prominent rooms.

As with glass and maiolica wares, the *tondo* represented a new decorative art form intended for the domestic interior. Like the *tondo*, the painted picture generically referred to as *quadri*, served a predominantly devotional function. The vast majority of paintings recorded in the *Pupilli* registers featured the Madonna and Child, frequently accompanied by various saints connected to the donor or his family. In the domestic setting such works could serve as exemplars for Florentines, encouraging them to emulate the holy family depicted on the walls of their palaces. Writers such as Fra Giovanni Dominici (1357–1419), St Antoninus (1389–1459) and Savonarola (1452–98) had promoted the devotional or meditative value of images.[188] In a woodcut to the latter's *Predica dell'arte del ben morire*, a *tondo* of the Virgin and Child is found in a principal *camera*, placed high on the wall adjacent to a *lettuccio* (see Illustration 35).

In the *Vite* (1550), Giorgio Vasari recorded how even the 'most excellent painters' were not ashamed to paint works of art for domestic consumption. Dello Delli is commended by Vasari for applying himself 'to his great profit and honour to nothing else save adorning and painting *cassoni*, *spalliere*, *lettucci* and other ornaments',[189] while 'in many houses of Florence' there were 'pictures in perspective' by Paolo Uccello (*c.* 1396–1475) for the 'adornment of *lettucci*, beds and other little things.'[190] These accounts complement an entry in the *zibaldone* of the merchant Giovanni Rucellai, who writing in around 1470 proudly asserted: 'we have in our house many items of sculpture, painting, intarsia and inlays from the hand of the best masters who have existed over a good period, not only in Florence, but also in Italy.'[191] Unlike the inventory assessors who only rarely recorded the master's name when describing *mobili*, Rucellai provides a record of these 'best masters'. Reflecting his discerning taste the list included painters, sculptors and goldsmiths, as well as masters of carving, intarsia, inlays and design. The diversity of professions detailed by Rucellai are marked and would seem to substantiate the ability of prominent *botteghe* to design and produce a wide range of decorative goods.[192]

With just 42 separate entries, the number of objects present in the '*camera bella*' of Lorenzo Tornabuoni is in marked contrast to the principal chambers listed in other inventories. For example, in the contemporaneous inventory of the wealthy merchant Gismondo della Stufa (1495), whose imposing palace can still be seen in Piazza San Lorenzo, his *camera* includes 428 separate entries of objects displayed in the room or stored away in a range

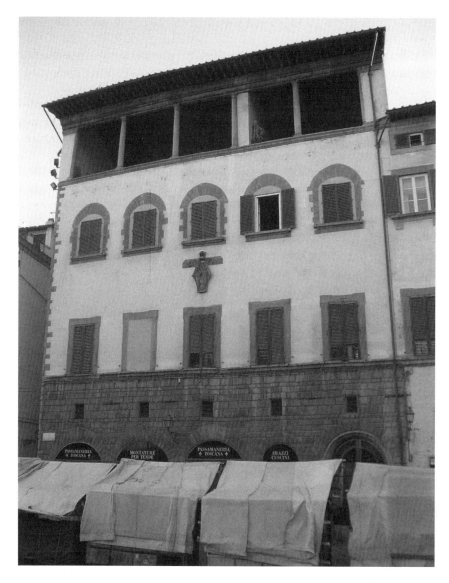

42. Palazzo della Stufa, Florence. Prominently located in Piazza San Lorenzo, the original fourteenth-century palace with its ground floor rustication and loggia on the upper storey, was greatly enlarged during the seventeenth century through the acquisition of adjoining properties

of furniture forms[193] (Illustration 42). Since no single entry is specifically described as *bella* in the *camera* of Lorenzo Tornabuoni, one must conclude that it was the appropriate and harmonious display of decorative wares,

furnishings and immoveable decoration that collectively rendered this room 'beautiful'.

Though the reference to Lorenzo Tornabuoni's *camera* as 'beautiful' is unusual it is not unique. Significantly, a 1498 inventory of the possessions of Lorenzo di Pierfrancesco de' Medici also includes a 'beautiful room'. This occurs in the *casa vecchia* in Florence and is specifically identified as the principal *camera* of Lorenzo di Pierfrancesco.[194] As in Lorenzo Tornabuoni's *camera*, this space is also characterized by a limited number of domestic goods. Here, however, issues of *egregia* can be assessed from not only the descriptions of the objects, but also by the estimates that accompany them.

The values of the 22 entries detailed in the room ranged from 240 to just 3 *lire* for two small feather pillows covered with linen.[195] At the highest end of the scale were two large *forzieri* in an *all'antica* style, complete with gilded work and historical scenes.[196] The collective quality of these chests presumably conditioned their high estimate. This is substantiated by the next entry that refers to a *cassone* of inlaid walnut with carvings and perspective designs.[197] As with the *forzieri*, this *cassone* also included a *spalliera* and raised platform but it was estimated at the lower amount of 80 *lire*. The next highest estimates are reserved for the *lettiera* and *lettuccio* that were each valued at 200 *lire*.[198] Both forms were clearly ornate and lavishly embellished. The *lettiera* was of inlaid walnut, with a decorated headboard also of perspective designs; while the *lettuccio* contained similar inlaid work together with two large gilded brass balls.

As the *camera* of Lorenzo di Pierfrancesco underlines, massive furniture forms were both practical and highly decorative at the same time. In the *quattrocento*, when a restricted number of major furniture pieces existed, the inclusion of such costly beds and 'day beds' served as a reinforcement of its owner's splendour and prestige. In Lorenzo di Pierfrancesco's *camera*, the importance of the *lettiera* is underlined by the range and value of the associated accoutrements that are recorded in the room. These varied from the mattress to sheets, pillows and covers, which collectively totalled the large amount of 277 *lire*;[199] while the *lettuccio*, which included a more restricted number of associated covers, nevertheless totalled an additional 66 *lire*.[200]

The value of such furniture forms in the context of their cost, quality and excellence collectively made them worthy of display. Beds, day beds and chests had the potential to be considered as beautiful objects in their own right, with a decorative or display function, as well as having an important practical use. A letter written by Marco Parenti to his brother-in-law Filippo Strozzi in Naples provides fascinating insight into the appeal of domestic goods in a context removed from the home. Written in 1473, the letter refers to a *lettuccio* that Strozzi had ordered on behalf of King Ferrante of Naples. Parenti records that the *lettuccio* was to be made by Benedetto da Maiano

and was clearly a lavish piece. Da Maiano received 110 *fiorini largi* for the commission,[201] while a staggering 300 pieces of gold leaf were employed in the ornament.[202] The letter indicates the genuine interest and excitement this piece of furniture generated by its impromptu display within da Maiano's *bottegha*, where it was presumably awaiting shipment to Naples: 'It is held by those who have seen it to be a beautiful thing (*bella cosa*) that gives great pleasure to all, not only to artists but citizens as well.'[203] To further reinforce the impact the 'beautiful' *lettuccio* had on those who viewed it, Parenti adds how a number of people returned to see it more than once.[204] Given the appeal of such an esteemed object outside the domestic interior, through the analysis of inventories one can visualize the impact such furnishings could generate when viewed collectively within their intended settings inside the home.

The information contained in the *Magistrato dei Pupilli* registers permits a credible reconstruction of the Florentine Renaissance palace. A cohesive interior design was achieved by combining immoveable objects – gilded ceilings, polished floors, and wainscoting in diverse woods – with architectonic furniture forms, which in their use of gilding, costly materials and inlays, unified the domestic space. The sensory impact was enhanced by the use of diverse materials, colours and textures – from the tactile qualities of tapestries, hangings and fabrics, to the fragility of glass and maiolica wares; from the aromas of woods and incense to the visual intensity of the gemlike quality of coloured glassware. The interplays of natural and artificial light further transformed domestic space as it moved or flickered across furniture forms, metallic goods, mirrors and other reflective surfaces. The decorum associated with domestic display illustrates how goods and furnishings transcended their inherently functional purpose and collectively enhanced the aesthetic of the Florentine palace interior. At the end of the *quattrocento* the shine and polish achieved, visually recreated Pontano's theoretical discussion of the furnishings and ornamental objects 'appropriate to the splendid man.'[205]

Notes

1. See for example the invocation to MPAP 181 fol.1r.

2. On the *Magistrato dei Pupilli* statutes see: F. Moradini, 'Statuti e Ordinamenti dell'Ufficio dei Pupilli et adulti nel periodo della Repubblica fiorentina (1388–1534)', *Archivio Storico Italiano*, Part 1: 113 (1955): pp. 522–551; Part II: 114 (1956): pp. 92–117; Part III: 115 (1956): pp. 86–104.

3. Inventories from the first quarter of the fifteenth century regularly include extensive lists of the debtors (*debitori*) and creditors (*creditori*) applicable to the estate. See for example MPAP 165.

4. For example rubric 20: 'Gli ufficiali de' pupilli possono ritractare le sententie de' beni de' pupilli dati alla madri per le loro doti.' Ibid., Part I (1955): pp. 550–1.

5. The Office's involvement with male heirs ceased at the age of 18 and females at 25. See rubrics 27: 'E' pupilli s'intendino essere usciti delle mani di decti uficiali finiti i diciocto anni'; and 28: 'Le fanciulle pupille eschino dal governo di decti uficiali finiti

venticinque anni'. Ibid., Part II (1956): pp. 100–02. If the female heir married before this age, then the Office's commitments ceased (Rubric 9: 'Le pupille, poi che sieno ite a marito, non sieno più sopto il governo di decto uficio.') Ibid., Part I (1955): p. 537.

6. See rubrics 22: 'Gli actori rendino il conto ogni anno del mese di novembre et dicembre' and 32: 'Gli actori rendino e' conti del mese di marza et d'aprile.' See Ibid., Part II (1956): pp. 94–5 and pp.106–7.

7. Ibid., Part III: 115 (1956): pp. 90–91.

8. In the *Pupilli* registers *villa, podere, casa, casolare* or *casamento* denote country residences, while more prestigious properties are described as *case da signiore*, often accompanied by *case da lavoratore*, presumably inhabited by tenant farmers or labourers. As with other properties that generated rental income, the monthly or annual amounts are specified together with the occupants' name.

9. See the town palace or *chasa grande* of Lorenzo di Giovanni Tornabuoni (1497) MPAP 181 fol.146v.

10. '*Segue detto inventario e nella loggia terrena di detto palagio*: Quattro panche di pino corniciate di nocie e pettorali et intarsiate intorno a detta loggia, di br.80, tutte di stima f.20.' M. Spallanzani and G.C. Bertelà, eds., *Libro d'inventario dei beni di Lorenzo il Magnifico*. Florence (1992): p. 7 (fol.3r).

11. Inventory of Tommaso di Federigho Federighi (1489) MPAP 179 fol.189r. *Nel logia*: 1° descho a uso di chredenzieria di br.2½ incircha; 3 panche d'albero usate di br.18; 1° botte di barili 5 vuota; 1° descho, 1° schudo dell'arme loro; 1° chatasta di legnie grosse incircha cioè 2/3.

12. Inventory of Bartolomeo di Mariotto di Giovanni dello Stecchuto (1496) MPAP 181 fol.44v. *Nella logia*: panche intorno vechie; una tavola regholata di nocie di br.6 incircha; uno boticinno di barili 1° pieno di gieso; uno palvese e 1ᵃ ttargha chol'arme; uno descheto vechi e 1ᵃ segiola vechie.

13. 'Hospitem collocabimus aedium parte, quae sit proxima ad vestibulum, quo se sui liberius salutatores adeant et familiam reliquam minus sollicitent.' Alberti *De re aedificatoria* Book V, 17 ed. G. Orlandi. Vol. I. Milan (1966): p. 427; trans J. Rykwert, N. Leach and R. Tavernor, *On the Art of Building in Ten Books* Cambridge, Mass. (1988): p. 149.

14. Datini also commissioned the Anjou coats-of-arms to be painted over the main entrance to the *palazzo*. Since this is the only other area in the *palazzo* where Anjou motifs occur, it is highly likely that Louis resided in this room. See B. Cole, 'The interior decoration of Palazzo Datini in Prato', *Mitteilungen des kunsthistorischen Institutes in Florenz*, 13 (1967): pp. 61–82, esp pp. 76–80 and I. Origo, *The Merchant of Prato*. London (1960): pp. 225 and 333–35.

15. 'Chamera ch'è su l'andito, detta la camera delle due lette overo de' forestieri.' Spallanzani and Bertelà (1992): p. 172 (fol.83r). Although the *camera terrena* in Palazzo Datini also had two beds, my analysis of inventories has shown this to occur infrequently in chambers, whether ground floor or elsewhere in the interior. One of the few examples of two *lettiere* is found in the *chamera di sala* of Simone di Matteo di Piero Cini (1485) MPAP 179 fol.61r–65r.

16. 'Lautissimi est uti coenacula ita et cubicula non eadem habere aestate atque bruma.' Book V, 17, Orlandi (1966): p. 425; trans Rykwert (1988): p. 149.

17. Francesco di Giorgio Martini had referred to the relative functions served by wall thickness in his treatise on architecture stating: 'poca grossezza di muro e suffiziente a resistare al freddo, ma volendo ostare al caldo bisogna fare li muri grossi.' Francesco di Giorgio Martini *Trattati di architettura ingegneria e arte militaria*, ed. C. Maltese and L.M. Degrassi. Vol.II. Milan (1967): p. 329.

18. For example Matteo di Ghuiciozo de Ricci (1420) MPAP 153 fol.24v: *In sala terrena*: iii paia di trespoli da tavole; 1ᵃ tavola da mangiare di braccia 5 1/1.

19. The *chasa grande* of Lorenzo di Giovanni Tornabuoni (1497) MPAP 181 fol.146v– 150r included: *sala terrena chon panche intorno; salotto di sopra; sala grande chon panche e spalliera intorno; sala grande.* See also Salvestro di Simone Ghondi (1429) MPAP 165 fol.243r–252r: *prima sala* and *seconda sala.* Taddeo di Chimenti di Stefano entagliatore (1430) MPAP 165 fol.521r–527v: *sala terrena* and *sala.*

20. 'Ex sinu dabitur in coenacula ingressus. Ea erunt pro usus necessitate alia aestiva, alia hiberna, alia, ut ita loquar, medioxuma.' Book V, 17, Orlandi (1966): p. 421; trans Rykwert (1988): p. 147.

21. Vitruvius refers to winter, spring, autumn and summer dining rooms (*triclinia*) with their position relating to the seasonal setting sun and the need for light and warmth. *De Architectura libri decem* Book VI, 4; ed F. Granger. Vol.II. London (1931): p. 34.

22. 'Tricliniorum quanta latitudo fuerit, bis tanta longitudo fieri debebit.' Ibid., Book VI, 3, Granger (1931): p. 30.

23. Piero di Ghodenzo Banditore (1420) MPAP 153 fol.179r: *sala terrena*; Messer Matteo degli Scholari (1429) MPAP 165 fol.606r: *Sala di sopra principale*; Domenicho d'Antonio Maretti righatiere (1479) MPAP 177 fol.93v: *Sala prencipale*.

24. H. Saalman, 'The Authorship of the Pazzi Palace', *Art Bulletin*, 46 (1964): pp. 388–94. The Palazzo Medici rooms were off the *andito di chapo di schala che va alla chappella* and referred to as *sala grande* and *saletta rimpetto alla sala grande*. See: Spallanzani and G.C. Bertelà (1992): pp. 23, 25 and 70 (fol.12r, 13v and 38r).

25. '*Nella sala grande*: Panche e spalliere atorno che ricinghono detta sala, di br.80 incircha, di pino corniciate di nocie e tarsie, e piedi di dette panche intagliati pure di nocie. f.20.' For the 1492 inventory see: Ibid., p. 25 (fol.13v).

26. Tommaso di Federigho Federighi (1489) MPAP 179 fol.190v: *salotto in sulla sala*; Salvestro di Zanobi di Mariano chartolaio (1496) MPAP 181 fol.31v: *saleta terena*; Bartolomeo di Mariotto di Giovanni Stecchuto (1496) MPAP 181 fol.45v: *salettina di dirieto al chamera*.

27. The relevant passage reads: 'Sunt, quae ad foci usum pertinent, haec: ut promptus extet, ut plures una foveat, luminis habeat satis, ventorum nihil. Habebit tamen qua respiret fumus, alioquin non conscenderet. Ergo non in angulum, non multo intra parietem cogetur: non tamen primores convivarum mensas occupabit.' Book V, 17, Orlandi (1966): p. 423; trans Rykwert (1988): p. 148.

28. For example the inventory of Salvestro di Franciescho Neretti speziale (1429) MPAP 165 fol.82v. Entries *In sala prima* include: 1° paio d'alari; 1ª forchetta; 1° paio di molli; 1ª paletta; ii paia di forbici.

29. Inventory of Piero del Rosso di Messer Buondelmonti (1497) MPAP 181 fol.155v: *In sala* (19 entries).

30. The sequence of rooms in Salvestro di Franchiescho Neretti speziale (1429) MPAP 165 fol.82r was *chucina terrena; chamera de fanciulli; sala prima*. For Salvestro di Simone Ghondi (1429) MPAP 165 fol.244r–v the sequence followed *prima sala; chamera dal pozo suso la prima sala; androne dal pozzo; chucina*. Arrigho di Messer Coluccio Salutati (1429) MPAP 165 fol.365v, son of the Florentine chancellor had a room listed *chucina in su la sala*, as did Salvestro di Zanobi di Mariano chartolaio (1496) MPAP 181 fol.32r.

31. Giovanni di Ser Piero Ciantelini (1430) MPAP 165 fol.390r–392r and Jachopo di Francesco di Cino righatiere (1477) MPAP 175 fol.157v–158r each had two *sale* and two *chucine*.

32. *PII Secundi Pontificis Maximi Commentarii*, I. Bellus and I. Baronkai eds. Budapest (1993): p. 432.

33. The passage reads: 'Coenaculis debetur coquina et cella obsonaria, ubi reliquias coenae et vasa et mantilia referantur. Coquina neque in gremium convivarum habenda est, neque porro longius semovenda, quod quae calida conviviis exiguntur inter veniendum refrigescat; sat erit, si lixarum patellarum cortinorum strepitus et feditas excludetur. Ferculorum comportationes ne imber aut itionum ingrati amfractus aut locorum obscentias impediat, neve ab his digniora dehonestentur providebitur.' Book V, 17, Orlandi (1966): p. 425; modified from Rykwert (1988): pp. 148–9.

34. See W. Bulst, 'Die ursprüngliche innere Aufteilung des Palazzo Medici in Florenz', *Mitteilungen des Kunsthistorischen Institutes in Florenz*, 14 (1970): pp. 369–92.

35. Inventory of Giovanni di Francesco Tornabuoni (1497) MPAP 181 fol.141r–150r. The relevant *camere* are: (fol.148r) *chamera di L[orenz]° bella in sula sala in palco*; (fol.148v) *antichamera di L[orenz]°; chamera in sula saletta di Giovannino*; (fol.149r) *chamera dove dorme Giovannino; chamera di Giovanni vecchia in sula sala*; (fol.150r) *chamera delle fante; chamera del maestro*. For examples of inventories specifically detailing *camere* of family members other than the houseowner see: Jachopo di Francesco di Cino righatiere (1477) MPAP 175 fol.157v. This includes the *camera* of Jachopo's mother Ginevra: *chamera di m[on]ª Ginevra madre di deto Jac[hop]°*; and Francesco di Giano di Giovanni chalzaiuolo (1497) MPAP 181 fol.124v, which details the *camera* of Francesco's deceased brother Antonio: *chamera fu d'Ant[oni]° di Giano*.

36. 'Curatores ministri servi ab ingenuorum commertiis ita segregabuntur, ut pro cuiusque officio decens et paratus locus attribuatur. Ancillae et cubicularii suis commissi locis non longius aberunt, quam ut extemplo audire et praesto ad iubentis imperia possint.' Book V, 17, Orlandi (1966): p. 427; trans Rykwert (1988): p. 149.

37. Giovanni di Francesco Tornabuoni (1497) MPAP 181 fol.150r: *chamera delle fante*.

38. Bartolomeo di Mariotto di Giovanni dello Stecchuto (1496) MPAP 181 fol.47r.

39. For example: Ghabriello di Messer Bartolomeo Panciatichi (1430) MPAP 165 fol.440r: *chamera di Ghabriello* (226 entries); Jachopo di Francesco di Cino righatiere (1477) MPAP 175 fol.156r: *chamera di deto Jac[op]° in sul chasa* (147 entries); Gismondo di Messer Agniolo della Stufa (1495) MPAP 179 fol.368r: *chamera di Gismondo* (259 entries); Francesco di Giano di Giovanni chalzaiuolo (1497) MPAP 181 fol.124v: *chamera fu Franc[esc]°* (87 entries).

40. Matteo di Ghuiciozo de Ricci (1420) MPAP 153 fol.25r–v: *letto fu di matteo de Ricci* (59 entries).

41. 'Poi rivenimmo in camera mia, e ivi serrato l'uscio le monstrai le cose di pregio, gli arienti, gli arazzi, le veste, le gemme, e dove queste tutte s'avessono ne' luoghi loro a riposare.' L.B Alberti *I libri della famiglia*, ed. C. Grayson. Vol. I. Bari (1960): p. 218.

42. '…volli quelle essere riposte in luogo ove elle si serbino salve e libere da fuoco e da ogni sinistro caso, e dove spessissimo e per mio diletto e per riconoscere le cose io possa solo e con chi mi pare rinchiudermi, senza lasciare di fuori a chi m'aspetta cagione di cercare di sapere e' fatti miei più cho io mi voglia. Nè a me pare a questo più atto luogo che la propria mia ove io dormo…' L.B. Alberti *I libri della famiglia* (1960): p. 219; trans R.N. Watkins as *The Family in Reniassance Florence*. Columbia (1969): p. 209.

43. Book IX, 1 Orlandi (1966): p. 787; see Chapter 3 note 66.

44. For example Taddeo di Chimenti di Stefano entagliatore (1430) MPAP 165 fol.521r–523v: *sala* (31 entries), *chamera in su la detta sala* (196 entries); Francesco di Romolo Ducci banchiere (1479) MPAP 177 fol.68r–v: *sala* (14 entries), *chamera di sala* (120 entries); Francesco di Giano di Giovanni chalzaiuolo (1497) MPAP 181 fol.124v: *prima sala* (3 entries), *chamera fu Franc[esc]°* (87).

45. For Cosimo de' Medici: 'Ritornando a Cosimo, a quanto era cauto nelle sua risposte, dove consiste assai la prudentia d'uno uomo, venne un dì sendo io in camera di Cosimo uno che aveva diferenza cor uno cittadino, gli aveva fatte molte violenze, et ocupatogli certi sua terreni.' Vespasiano da Bisticci: A. Greco ed., *Le Vite: Edizione critica*. Vol.II. Florence (1976);pp.196–7. For Lorenzo de' Medici: '…sedens ad cautelam in camera sue habitationis', NA, M 530 (Ser Niccolò Michelozzi, 1468–1515), fol.21r cited in F.W. Kent, 'Palaces, Politics and Society in Fifteenth Century Florence,' *I Tatti Studies*, 2 (1987): p. 62.

46. M. Phillips, *The Memoir of Marco Parenti: A life in Medici Florence*. Toronto (2000): p. 134.

47. 'trovando in camera sua molta gente' cited by W. Bulst, 'Uso e trasformazione del palazzo medico fino ai Riccardi', in G. Cherubini and G. Fanelli ed., *Il palazzo mediceo di Firenze* Florence, (1990): p. 111, who in turn refers to Corbinelli, *Histoire genealogique de la maison de Ghondi*. Paris (1705): I, preuves p.cxcviii.

48. 'E fu aspettato dalla magnifica Signoria in su la ringhiera, e el dì seguente da e nostri magnifici Signori alla casa de' Capponi, cioè alla casa che fu di Niccolò da Uzano, con gran numero di cittadini circa 100. La ceremonia fu questa. Fèssi incontro alla Signoria nostra el legato perfino alla dogla dell'uscio della camera, e con grata accoglenza nella anticamera dette udienza, lui soloe la Signoria, e non vi altra persona. La riverentia de' magnifici Signori fu inginocchiarsi come di costume quando arrivarono alla presentia del legato.' The specific identification of the palace with Niccolò da Uzzano who had died 70 years earlier in 1430 highlights the histories attached to a palace and its builder. R. Trexler, ed., *The Libro Cerimoniale of the Florentine Republic. By Francesco Filarete and Angelo Manfidi*. Geneva (1978): p. 117, fol.33v.

49. Piero e Ghugliemo di Ser Tomaso Cionni (1469) MPAP 173 fol.201v.

50. Francesco di Giorgio di Ser Nicholaio da Pescia (1476) MPAP 175 fol.92v. The *antichamera* follows the principal *chamera di sopra*.

51. For examples of important *anticamere* see the inventories of Lorenzo di Giovanni Tornabuoni (1497) MPAP 181 fol.146v–150r; and Piero del Rosso di Messer Andrea Buondelmonti (1497) MPAP 181 fol.155v–156r.

52. Francesco di Romolo Ducci banchiere MPAP 177 fol.68r–v. The *chamera di sala* (120 separate entries) included sequentially listed items suggesting a defined space within the room: 1° descho da scrivere; 1ª chassetta di br.2 circa; 1ª chasette di br. 1° di nocie basse da scritture; 1° libro di Dante leghato in nasse chiosato cioè Dante; 1° libro da legiere leghato in nasse d'opere di Romani; 1° paio di schodelle di maiolicha da parto [sic] e piu mazzi di lettere; 1° libro di filosofi e altre scritture; 1° schanello piccholo coperto di panno lino verde; 8 tra libri e quaderni apertenti al bancho in chasse 8; 1° giornale vecchio; 1° tachuino in charta; 1° paio di bilancie.

53. Benedetto Cotrugli, *Della mercatura e del mercante perfetto* (Venice 1569, Brescia, 1602): p. 86; U. Tucci ed., *Il libro dell'arte di mercatura* Venice (1990): pp. 230–31. Cited and translated in D. Thornton, *The Scholar in His Study: Ownership and Experience in Renaissance Italy*. New Haven (1997): p. 32. Although written during the fifteenth century Cotrugli's text was not published until 1569 in Venice.

54. Lorenzo di Giovanni Tornabuoni (1497) MPAP 181 fol.149v: *Nello schrittoio in chapo alla schala*: 1° armario a 2 serrami chon più schritture e libri apartenenti alla ragione di L[orenz]° che va la chiave Francesco Pitti e Domenico Alamanni; 1° Prinio in forma e 1° reale di Francia.

55. Lorenzo di Giovanni Tornabuoni (1497) MPAP 181 fol.149v: *Nello schrittoio*: 1° paio di falchole di ciera biancha di libre 6; 1ª chassettina d'arcipresso che n'è dentro più medaglie chon teste di rilievo e 1ª scharsella richamata di brochato e 1° tabernacolino dov'è Nostra Donna e Santo Girolamo e Santa Francesco; 1° sacchetto dov'è 1° libretto e più schritture rinchiuse nella chassetta dello schrittoio che ne la chiave Simone; 2 choppe di rame inarientato smaltate.

56. '*scrittoio*: a Counting-house, a writing deske. Also a Standish or pen and inke-horne.' John Florio, *Queen Anna's New World of Words*. London (1611) reprinted edition (1968). Dora Thornton argues that Florentines referred to cabinets or desks as *studioli* to distinguish from the study or *scrittoi*, while Venetians reversed these terms. My research for fifteenth-century Florence has not presented a single reference to a *studiolo*, suggesting a more complex relationship with the application of the term *scrittoio*. See Thornton (1997) esp p.18.

57. For examples of a *scrittoio* denoting a desk or space within a *camera* see: Messer Matteo degli Scholari (1429) MPAP 165 fol.606r: *schrittoio in detta chamera* (2 separate entries): 1 bacino d'ottone, 1 lucierniere di marmo usato; Salvestro di Zanobi di Mariano chartolaio (1496) MPAP 181 fol.31v: *Nelo schritoio* (2 separate entries): ii schanegli vechi; una tavola dipinta al muro. For examples of *scrittoio* as separate rooms see: Piero e Ghugliemo di Ser Tomaso Cionni (1469) MPAP 173 fol.201v: *anticamera overo iscritoio* (27 separate entries) including '1° descho da iscriptere di bracia 4 incircha'; Lorenzo di Domenicho di Lorenzo Francheschi (1499) MPAP 181 fol.296v: *ischrittoio* (13 separate entries) including '1° descho con trespoli per schrivere'.

58. MPAP 181 fols.46r and 47r.

59. Fol.12r: *Segue detto inventario e nella stanza a meza schala, detto lo schrittoio* (2 separate entries); Fol.17r–31r: *Segue nello schrittoio* with the entry (fol.18r) 'Uno schodella di sardonio e chalcidonio e aghata, entrovi più fighure et di fuori una testa di Medusa, pesa lib.2 once 6. f.10,000'. Spallanzani and Bertelà (1992).

60. See Giovanni di Polito dalla Casa (1431) MPAP 165 fol.546r: *scrittoio di detta casa*; Piero e Ghugliemo di Ser Tomaso Cionni (1469) MPAP 173 fol.201v: *anticamera overo iscritoio*; Lorenzo di Domenicho di Lorenzo Francheschi (1499) MPAP 181 fol.296v: *ischrittoio*.

61. Ser Bonachorso di Piero Bonachorsi (1431) MPAP 165 fol.556r: *Nello scrittoio di terreno* (13 entries).

62. Salvestro di Zanobi di Mariano chartolaio (1496) MPAP 181 fol.31v: *Nelo schritoio* (2 separate entries): ii schanegli vechi; una tavola dipinta al muro; fol.34r: *Nota di chose a la bottegha del chartolaio, che sono presente in deta chasa.*

63. Examples of *botteghe* within the house often relate to members of the artisan class, whose level of domestic goods indicates they were relatively successful commanding a moderate degree of comfort. See the silk merchant/weaver Bartolomeo di Domenicho del Frale settaiuolo a Minuto (1476) MPAP 175 fol.133r–136r; the second-hand dealer Domenicho d'Antonio Maretti righatiere (1479) MPAP 177 fol.93r–97v; and the shoemaker/hosier Francesco di Giovanni chalzaiuolo (1497) MPAP 181 fol.124r–125v.

64. Piero di Jachopo di Puccio (1517) MPAP 185 fol.92r: *In tereno dal' uficio* and fol.93r: *nelo scritoio*.

65. Lorenzo di Giovanni Tornabuoni (1497) MPAP 181 fol.141r–150r.

66. Inventory of Ser Andrea Machallo (1497) MPAP 181 fol.153r: The household possessions comprised: 1ª lettiera di br. 4 pratese; 1° paio di chasse chon dua serrami; 1° sacchone di 1° pezzo usato; 1ª materassa di chapecchio; 1ª choltricie e 2 primacci usata pieno mantovano di lb.130; 1ª cioppa monachina da donna vedova fu di m[on]ª Lesandra loro madre; 1ª ghamurra di rascia bigio di detta m[on]ª Lesandra; 1ª ghamurraccia tane piena tutta rotta di detta; 1ª cintola paghonazza con pelo chon 10 spranghe peso di lb.23; 2 botte usate di tenuta di barili 12 in circha.

67. Referred to as *Campioni d'inventari e ragioni rivedute* these are the registers predominantly consulted in my archival research.

68. The Buonomini of San Martino del Vescovo was a charitable institution established to assist the 'shame faced poor' who were reduced to begging through their impoverished circumstances. On the Buonomini see: P. Bargellini, *I buonomini di San Martino*. Florence, 1972.

69. Inventory of Salvestro di Simone Ghondi (1429) MPAP 165 fol.245r–v. Salvestro's children, specified as Simone, Filippo, Charlo, Mariotto, Ginevra and Checcha are described as staying with their mother (*istanno cholla madre*). The *chamera di m[on]ᵃ Alesandra* contains 92 separate entries.

70. Simone di Matteo di Piero Cini (1485) MPAP 179 fol.62r. This room contained the greatest concentration of domestic objects with 169 separate entries. In Simone's second property in the *popolo* of Santa Felicità there are two further rooms specifically attached to Alesandra (fol.63v): *chamera sulla detta salla che si chiama di m[on]ᵃ 'lesandra* and *chamera di detta sala principale di m[on]ᵃ 'lesandra*. For another example of a principal *camera* appropriated by the deceased's wife see: Piero di Jachopo di Puccio (1517) MPAP 185 fol.93r: *chamera di m[on]ᵃ Ginevra*.

71. 'Viro atque dormitio singulis singula debetur; non id modo ut parturiens aut malfata mulier molesta viro non sit, verum et aestivos etiam somnos illesiores peragat, cum lubuerit. Sua cuique aderit ianua, et praeter id commune aderit posticulum, quo mutuo se possint petere sine interprete. Sub uxoris conclave vestiaria, sub viri libraria cella comparabitur.' Book V, 17, Orlandi (1966): p. 427; trans Rykwert (1988): p. 149.

72. 'Ubi uxoribus conveniant, nonnisi dignissimos hominum et formosissimos vultus pingas monent; plurimum enim habere id momenti ad conceptus matronarum et futuram spetiem prolis ferunt.' Ibid., Book IX, 4, p. 805; trans Rykwert (1988): p. 299.

73. 'Quando io ebbi alla donna mia consegnato tutta la casa, riduti come racontai serrati in camera, e lei e io c'inginocchiammo e pregammo Iddio ci desse facultà di bene usufruttare quelli beni de' quali la pieta e benificenza sua ci aveva fatti partefici… Grayson (1960): p. 223; trans Watkins (1969): p. 212.

74. In chapter 2 Vitruvius writes: 'In his locis introrus constituuntir oeci magni, in quibus matres familiarum cum lanificis habent sessionem. In prostadis autem dextra ac sinistra cubicula sunt conlocata, quorum unum thalamus, alterum amphithalamus dicitur. Circum autem in porticibus triclinia cotidiana, cubicula, etiam sellae familiaricae constituuntur. Haec pars aedificii gynaeconitis appellatur.' Vitruvius *De Architectura libri decem* Book VI, 2 ed F. Granger. Vol.II. London (1931): p. 47.

75. In chapter 4 Vitruvius writes: 'In his oecis fiunt virilia convivial; non enim fuerat institutum matris familiarum eorum moribus accumbere. Haec autem peristylia domus andronitides dicuntur, quod in his viri sine interpellationibus mulierum versantur.' Ibid., Book VI, 7, Granger (1931): p. 49.

76. 'Inter duo autem peristylia et hospitalia itinera sunt, quae mesauloe dicuntur, quod inter duas aulas media sunt interposita; nostri autem eas andronas appellant. Sed hoc valde est mirandum, nec enim graece nec latine potest id convenire. Graeci enim andronas appellant oecus, ubi convivial virilia solent esse, quod eo mulieres non accedunt.' Ibid., Book VI, 7, Granger (1931): p. 49.

77. 'Sed ut ipsa ornamenta quam potest exigitur ut sint magnifica et varia, sic ut collocentur suis in locis. Aliud aulam decet, aliud gynaeceum; quin etiam alia sunt ad quotidianum ornatum, alia seposita ad festos ac solennes dies.' F. Tateo ed., *Giovanni Pontano I Libri delle virtù sociali*. Rome (1999): p. 232.

78. 'Neque enim domum splendidi hominus instituimus, sed qualem eum esse velimus, liniamentis quasi quibusdam inumbramus.' Ibid., p. 234.

79. The relevant entry reads: 'Ornamenta autem vocamus ea, quae non tam ad usum comparata sunt, quam ad ornatum ac nitorem, ut sunt signa, tabulae pictae, aulea, fulcra, eburnae sellae, stragola gemmis intertexta, pixides et arculae ex Arabicis pigmentis, vascula e christallo et huius generis alia, quibus domus pro tempore ornatur et abaci mensaeque instruuntur; delectat autem eorum aspectus, ac domino pariunt auctoritatem, dum multi, ut ea videant, domos ipsas frequentant. Ibid., p. 232.

80. 'quin etiam alia sunt ad quotidianum ornatum, alia seposita ad festos ac solennes dies.' Ibid., p. 232.

81. 'Qualem esse deceat viri splendidi supelectilem.' Ibid., p. 228.

82. 'Supelectilem vocamus omne domesticum instrumentum, ut vasa, lances, textilia, lectos et id genus coetera, sine quibus commode vive non potest.' Ibid., p. 228.

83. 'cum aliqua etiam vel artificis, vel materiae, vel utriusque praestantia.' Ibid., p. 228.

84. 'Erit etiam supelex ipsa talis, quae habentem non dedeceat.' Ibid., p. 230.

85. 'quid enim indignius quam rusticanum hominem bibere gemmato poculo?' Ibid., p. 230.

86. 'Quin etiam laudari admodam solet, ubi ad multitudinem raritatemque supelectilis illud accesserit, ut quae sunt eiusdem generis, ea sint vario ex opere, artificio atque materia.' Ibid., p. 230.

87. 'Neque enim hoc solum exigitur, ut plurima pocula niteant in abaco, verum ut varia eaque vel aurea, vel argentea, vel porcellanica. Itemque aliae atque aliae formae, calices item crateres, gutti, paterae, carchesia, scyphi…' Ibid., pp. 230 and 232.

88. 'et maxximamente una chredenziera fornita d'arienti lavorati, molto richa.' A. Perosa ed., *Giovanni Rucellai e il suo Zibaldone*. London (1960): p. 28.

89. Piero di Jachopo Puccio (1517) MPAP 185 fol.92r: 1ᵃ credenziera con 2 palchetti d'albero di br.2 in su 2 palchetti; and fol.92r: *in terreno dal'uficio*: 1ᵃ credenziera di br.3 con 2 palchetti di sopra. *Credenze* can also be found in other domestic areas. See Franciescho di Baldino Inghirrami (1471) MPAP 173 fol.265v: *Nella sala della chasa grande*: 1° armario a uso do credenzieria chon più serami; Francesco di Romolo Ducci banchiere (1479) MPAP 177 fol.68r: *nella chorte*: 1° descho da credenziera di br.3½ circa con armario, 1ᵃ tavola di br. 3 in su detta credenziera.

90. Lorenzo di Giovanni Tornabuoni (1497) MPAP 181 fol.142r *Nella sala terrena*: 1ᵃ chredenziera con più serrami. See also Antonio di Messer Michele Strozzi (1522) MPAP 185 fol.221r: *in sala sua prima*: 1ᵃ credenza di br.3 incircha chon armardi e palchetti e treppie e chiave e palcheto di sopra; and fol.224v: *in sala terrena nuova d'Ant[oni]°*: 1ᵃ credenza nuova chon armario toppa e chiave.

91. Franciescho di Baldino Inghirrami (1471) MPAP 173 fol.265r–73v. The inventory also comprised a 'chasa dela sua abitazione' at Careggi. For a transcription of the Inghirrami inventory see: J.M. Musacchio, *The Art and Ritual of Childbirth in Renaissance Italy*. New Haven, 1999: Appendix A pp.158–173.

92. Ibid., pp. 158–173.

93. For the recent re-attribution of the 'Davanzati bed' from the fifteenth century to the late nineteenth or early twentieth century see: M. Ajmar-Wollheim and F. Dennis, *At Home in Renaissance Italy*. London (2006): p. 20.

94. For select examples of *casse* connected with the bed see: Angelo da Uzzano (1424) fol.6, number 40: 1 lettiera di braccia 5½ con cassapanche dinanzi et dietro et mezze casse dappiè; fol.18, number 1084: 1 cassetta d' albero a piè del detto letto di braccia 2¼. See W. Bombe, 'Nachlass-Inventare des Angelo da Uzzano unde des Lodovico di Gino Capponi', *Beiträge zur Kunstgeschichte des Mittelalters und der Renaissance herausgegben von Walter Goetz*, Vol.36. Leipzig and Berlin (1928): pp. 14 and 40; Gismondo di Messer Agniolo della Stufa (1495) MPAP 179 fol.369r: *nelle chasse a ppie de letto*; Arigho di Francesco Lanino (1497) MPAP 181 fol.139r: 1ᵃ lettiera di br.4 d'albero e chasse intorno.

95. See Franciescho di Baldino Inghirrami (1471) MPAP 173 fol.266v: secondo forziere overo chassone nela detta chamera dipinto; and Piero e Ghugliemo di Ser Tomaso Cioni (1469) MPAP 173 fol.200v: 1° armario overo ischasone chon più chasete.

96. See J.R. Lindow, 'For use and display: selected furnishings and domestic goods in fifteenth-century Florentine interiors', *Renaissance Studies* Special Issue, 19 (2005): pp. 634–46; and R.J.M Olson, P.J Reilly, and R. Shepherd eds. *The Biography of the Object in Late Medieval and Renaissance Italy*. London (2006): pp. 54–66.

97. 'Le qual cosa gli venne molto proposito, perchè, usandosi in que' tempi per le camere de' cittadini cassoni grandi di legname a uso di sepolture…' Giorgio Vasari 'Vita di Dello Delli' *Le vite de più eccellenti pittori scultori e architettori*, ed. A. Rossi. Vol. II. Milan (1962): p. 119.

98. For the *bottegha* account book see E. Callmann, *Apollonio di Giovanni*. Oxford (1974): Appendix 1.

99. See Gismondo di Messer Agniolo della Stufa (1495) MPAP 179 fol.369v: 1° forzerettino dipinto da spose; fol.370v: 2 forzieri dorati al'anticha da spose and fol.371r: 2 forzieri grandi dipinti dorati a sepoltura chon predella disotto da spose belli; Bartolomeo

di Mariotto di Giovanni dello Stecchuto (1496) MPAP 181 fol.47r: Uno forziere v[echi]° da sposse chon fighure al'antica chon più libri e schriture vechie; Lorenzo di Giovanni Tornabuoni (1497) MPAP 181 fol.148r: 2 forzieri da spose dorati e dipinti chon ispalliere dorate e dipinte. The inventory of Daddo di Messer Jachopo Gianfigliazzi (1429) MPAP 165 fol.36v suggestively refers to two *forzieri* his wife Mona Tita, 'brought to her husband': ii forzieri che recho m[on]ª Tita a marito.

100. Francesco di Giorgio di Ser Nicholaio da Pescia (1476) MPAP 175 fol.91r.

101. Ibid., fol.91r. The entries grouped together read: 1ª chasapancha a 2 serami al'antica cho' predella da pie, 1° chasone grande intarsiato choperto di nocie di br.3½, 1° paio di forzieri dipinti da sposa, 1° forzieri dipinto al'antica, 1ª chasa alta di br.2 a 1° serame.

102. See M. Vidas, *Representation and Marriage: Art, Society and Gender Relations in Florence from the Late Fourteenth through the Fifteenth Century.* New York University, PhD Thesis, 1997; Lydecker (1987): esp. chapter 3; and B. Witthoft, 'Marriage Rituals and Marriage Chests in Quattrocento Florence', *Artibus et Historiae* 5 (1982): pp. 43–59.

103. I. Chabot, 'La sposa in nero. La ritualizzazione del lutto delle vedove fiorentine (sec.XIV–XV)', *Quaderni storici*, 86 (August 1994): pp. 421–462.

104. C. Klapisch-Zuber, 'Les coffres de marriage et les plateaux d'accouchées à Florence: archive, ethnologie, iconographie', in S. Deswarte-Rosa ed., *A travers l'image: lecture, iconographie et sens de l'oeuvre.* Paris (1994): pp. 309–23; Vidas (1997): chapter 1.

105. Lydecker (1987): chapter 3.

106. For example: Piero e Ghugliemo di Ser Tomaso Cioni (1469) MPAP 173 fol.200v: *nel tereno in deta chasa*: 1ª pancha regholata di lb.6 incirca nuova; and fol.201v: *nela chamera di Guigluemo in deta*: 1ª lettiera di lb.6 incirca choperta chon tarsia e nocie nuova. See also: Franciescho di Baldino Inghirrami (1471) MPAP 173 fol.265v: *Nel primo forziere grande in detta chamera*: 2 tappeti nuovi di braccia 3 l'uno; and fol.267r: *Nello schrittoio dela chamera dov'abita Francesco*: 6 chandellieri d'ottone chol piè alto nuovo.

107. Salvestro di Zanobi di Mariano chartolaio (1496) MPAP 181 fol.31r–34v and 42r–v.

108. Ibid., MPAP 181 fol.32r: una ttesta e busto di n[o]s[tr]o S[ignor]e di gieso dipinta; uno tabernacholuzo meso a pino chon Madonna e S° Pagholo el Sa[n] Bernedetto; uno taliero di ttela br.[] chon una Piatà e altri Santi; uno ttaliero chon tela lina dipinta chon piu cose ala franzese; uno ttaberncholuzo chon n[ostr]ª dona al'antica in piana; uno tabernacholuzo chon n[ostr]ª donna picholo di rilievo di giesso; un tondo da parto chon tarsie al'antica; uno lettiera d'albero senplice di br. 4½ cho' maze e panche e ttrespoli; uno lettucio chon chapelinaio di br. 4 incircha chon piu ttarsie al'antica.

109. See also the inventory of Lorenzo di Giovanni Tornabuoni (1497) MPAP 181 fol.144r where the *chasa da signiore* at Chiasso a Macieregli includes a *chamera nuova di sopra*. The penchant for new rooms applied to other spaces as in *sala terrena nuova d'Ant[oni]°* of Antonio di Messer Michele Strozzi (1522) MPAP 185 fol.224v.

110. Antonio di Marsilio Vecchietti (1448) MPAP 171 fol.140v: 1 paio di chassoni intarsiati di noce chon arme sua; Jachopo di Francesco di Cino righatiere (1477) MPAP 175 fol.157v: 1° chassone dipinto di br.3; Francesco di Romolo Ducci banchiere (1479) MPAP 177 fol.68v: ii chassoni di chomesso intarsiati a sepolture di br.4 incircha l'uno nuovi; Piero del Rosso di Messer Andrea Buondelmonti (1497) MPAP 181 fol.155v: 2 chassoni a sepoltura storiati; Lorenzo di Giovanni Tornabuoni (1497) MPAP 181 fol.149r: 1° chassone a sepoltura di prospettiva di bracia 4 in circa.

111. Gismondo di Messer Agniolo della Stufa (1495) MPAP 179 fol.369v where the *cassoni* are described as: 2 chassoni a sepoltura dipinti da spose; and in the same room: 2 forzieri dorati al'antica da spose. Lorenzo di Giovanni Tornabuoni (1496) MPAP 181 fol.149v: 2 chassoni a sepoltura da spose chon l'arme di chasa e de' Pitti di bracia 4 l'uno chon serami choperti di tela verde.

112. 'cassoni grandi di legname a uso di sepolture…' Rossi (1962): p. 119.

113. For examples of *a sepoltura* chests see: Francesco di Romolo Ducci banchiere (1479) MPAP 177 fol.68v: ii chassoni di chomesso intarisiati a sepolture di br.4 incircha l'uno nuovi; Tommaso di Federigho Federighi (1489) MPAP 179 fol.190v: un p[ai]° di forzieri storiati da sepoltura savi 2 teli verdi; Gismondo di Messer Agniolo della Stufa (1495) MPAP 179 fol.371r: 2 forzieri grandi dipinti dorati a sepoltura chon predella di sotto da spose belli; Salvestro di Zanobi di Mariano chartolaio (1496) MPAP 181 fol.31v: Un chassone a selpolttura chon tarsia al'antica di br.4 incircha.

114. Size could also be a distinguishing factor for storage forms. Common diminutives of *forzieri* were *forzieretti* or *forzerini*; and for *casse* were *cassette* or *cassettini*. See the inventory of Gismondo di Messer Agniolo della Stufa (1495) MPAP 179 (fol.366r–73r) Appendix 2.

115. On the Horne *lettuccio* see C. Paolini, *Il mobile del Rinascimento: La collezione Herbert Percy Horne*. Florence, 2002.

116. Lorenzo di Lorenzo Domenicho Francheschi (1499) MPAP 181 fol.296v.

117. Piero del Rosso di Messer Andrea Buondelmonti (1497) MPAP 181 fol.155v: *In chamera in su la sala*: 1° lettuccio chol chornicione di nocie inpiallacciato a prospettive chol chassone.

118. Measurements given in inventories for *lettucci,* as with chests, applied to their width not depth or height.

119. Gismondo di Messer Agniolo della Stufa (1495) MPAP 179 fol.368r–v: *nel chassone di detto lettuccio*. See Appendix 2.

120. Lorenzo di Giovanni Tornabuoni (1497) MPAP 181 fol.147r: *Nella chamera di detta sala*: 1° *lettuccio* chon chappellinaio choperto di nocie di bracia 5; 1° materassino di bordo con lana; 1ª choltrina banbagina a detto lettuccio; 2 ghuanciali con federe dozinali a detto lettuccio; 2 ghuanciali choperti di baldachino con lavori di seta.

121. Florio (1611) reprinted edition (1968).

122. Taddeo di Chimenti di Stefano *entagliatore* (1430) MPAP 165 fol.522r: *in chamera in su la detta sala*: 1° lettuccio e chanaio e trespolo; Francesco di Giano di Giovanni *chalzaiuolo* (1497) MPAP 181 fol.124v: *in chamera di fr[ancesc]°*: 1ª letiera co' letuccio chase di nocie intarsiate.

123. Lorenzo di Lorenzo Domenicho Francheschi (1499) MPAP 181 fol.296v.

124. Francesco di Romolo Ducci *banchiere* (1479) MPAP 177 fol.68r: 1ª lettiera di br.5 incircha intarsiata con palle in testa e cholle chassapanche intorno commesse; Piero del Rosso di Messer Buondelmonti (1497) MPAP 181 fol.155r: 1ª lettiera chon chornicie di br.5 trespoli panche e 2 chasse intorno apicchate a 4 serrami.

125. See also Maestro Ugholino di Giovanni da Montecatini (1429) MPAP 165 fol.190r: 1ª lettiera di br.5 chon trespolo e channaio; Francesco di Giorgio di Ser Nicholaio da Pescia (1476) MPAP 175 fol.90v: 1ª lettiera salvaticha di br.4½.

126. For painted beds see: Franciescho di Baldino Inghirrami (1471) MPAP 173 fol.265v: 1ª lettiera vechia dipinta di braccia 5 ingessata con sacchone in 2 pezi e trespoli e channaio; Domenicho d'Antonio Maretti *righatiere* (1479) MPAP 177 fol.94r: 1ª lettiera di br.5 verde dipinta con trespolo e canaio, 2 panche.

127. See P. Thornton, *The Italian Renaissance Interior 1400–1600*. London (1991): esp pp.111–48.

128. Jachopo di Francesco di Cino *righatiere* (1477) MPAP 175 fol.157v listed in the *chamera di m[on]ª Ginevra madre di deto Jac[hop]°*.

129. Piero del Rosso di Messer Buondelmonti (1497) MPAP 181 fol.156r listed in the *chamera in su la sala*.

130. Piero di Jachopo di Puccio (1517) MPAP 185 fol.92v contains '1° padiglione' in the *camera in sulla sala*.

131. Gismondo di Messer Agniolo della Stufa (1495) MPAP 179 fol.370v. The first entry for the *lettiera* reads: 1ª lettiera senpice di br.5 incircha chon predella da' lato chon trespolo e maze.

132. Maestro Mario di Maestro Girolamo di Messer Mateo di Brocardi da Imola medico e citadino fiorentino (1484) MPAP 178 fol.50v: *in chamera in sul verone*: 1° cortinagio co' sopracielo a detta lettiera di pano forestiere a 4 lati con piede tutto a frange e alario; 2 spiritegli di gieso in su la lettiera dipinti. See also Simone di Matteo di Piero Cini (1485) MPAP 179 fol.61v: *in chamera di sala*: 1° cortinagio verghato a dua lati istoriato di tovaglie.

133. Lorenzo di Giovanni Tornabuoni (1497) MPAP 181 fol.148r: 1ª lettiera chon lettuccio e chappellinaio apichato a chassone tutto di nocie chon più lavori e messo d'oro e ariento di bracia 4½ in circha.

134. Lorenzo di Giovanni Tornabuoni (1497) MPAP 181 fol.148r: 1° chortinagio a padiglione chon dua pendenti; 1° materassino di fustano pieno di chotone.

135. Lorenzo di Giovanni Tornabuoni (1497) MPAP 181 fol.148r.

136. Lorenzo di Giovanni Tornabuoni (1497) MPAP 181 fol.148r: *chamera di L[orenz]° bella in su la sala in palco.* See Appendix 3. In the study (*scrittoio*) of the *casa da signiore* at Chiasso Macieregli is (fol.145r): 1ª choltelliera con 12 choltegli e 1ª grande con manichi begli; while in an *anticamere* of the Florentine palace is (fol.147r): 1ª sella di velluto nero chon fornimenti d'ottone dorati molto bella da chavagli.

137. Franciescho di Baldino Inghirrami (1471) MPAP 173 fol.271r: 'xxiiii° chuchiai begli nuovi di peso di libbre dua e oncie tre denari venti di stima di lire 3 soldi 12 l'oncia' and 'xii forchette belle nuove chon uno Erchole di sopra d'ariento di peso d'oncie sette di stima di lire tre soldi 12 l'oncia.'

138. Franciescho di Baldino Inghirrami (1471) MPAP 173 fol.265v: 2 forzieri dipinti begli al'usanza cho' l'arme; 1° lettuccio [e] 1° chapellinaio begli di noce con tarsia di braccia 4; fol.269r; 1° libriccino in charta pechora da donna bello basso letera parigina chon fibia e puntale d'ariento dorato.

139. Messer Matteo degli Scholari (1429) MPAP 165 fol.605v: 2 tovaglie chapitate belle braccia []; fol.606v: 1 bacino grande e bello smaltato per tutto chon lettere; 1 bacino mezzano smaltato tutto bello; 1 horiuolo cholla chanpanuzza bello.

140. Ghabriello di Messer Bartolomeo Panciatichi (1430) MPAP 165 fol.436r: ii messali begli chovertati l'uno di scharlatino e l'altro di valescio; fol.437v: 1° zaffiro leghato alto bello leghato in ghanbo d'oro sodo; fol.440r: 1° cholmo bello di nostra donna chogli usciuoli; fol.441r: 1° tabernacholuzzo di nostra donna bello che si rinchiude; fol.442r: viii chandelieri d'ottone bassi begli. See Appendix 1.

141. Lorenzo di Giovanni Tornabuoni (1497) MPAP 181 fol.148r: 2 forzieri da spose dorati e dipinto chon ispalliere dorate e dipinte.

142. Ibid., fol.148r: Uno tondo chon chornicione d'oro di Nostra Donna e Magi che ofersono a Christo; 2 'appamondi chon chornicie dorati; 1° specchio in 1° tondo dorato chon più lavori.

143. Ibid., fol.148r: 2 banbini dorati abracciati insieme; 1ª segiola choperta di velluto tanè chon frangie e palle d'ottone dorate.

144. Ibid., fol.149v: 2 choppe di rame in arientato smaltate.

145. Gismondo di Messer Agniolo della Stufa (1495) MPAP 179 fol.367v: 1ª figuretta di bronzo dorata; fol.368r: 1° paio di sproni dorati da donna d'ottone; fol.368v: 1ª choltelliera chon tre choltelli cholle maniche d'ottone inarientati cholla ghuaina. See Appendix 2.

146. Inventory of Piero di Cosimo de' Medici (fols.20r–21r), in M. Spallanzani ed., *Inventari Medicei 1417–1465* Florence (1996): pp. 117–19.

147. Spallanzani and Bertelà (1992); and M. Spallanzani 'Metalli islamici nelle collezioni medicee dei secoli XV–XVI', in C. Adelson et al, *Le arti del principato mediceo.* Florence (1980): Doc.3 pp. 111–14.

148. 'un altro bochale dommaschino sanza bechuccio. fl.200' and 'uno bacino alla dommaschina, lavorato doppio el fondo e l'orlo. fl.60'. Spallanzani (1980): pp. 111–12.

149. '8 candelieri alla domaschina coll' arme de Monaldi'. Bombe (1928): p. 20, entry number 266.

150. Gismondo di Messer Agniolo della Stufa (1495) MPAP 179: 1ª schatoletta dipinta alla moresca; 1° sciughatoio alla moresca lavorato le teste; 1ª chotta di raso alessandrino cho'maniche di veluto alessandrino. See also fol.369r, 370r and fol.370v in Appendix 2.

151. See Appendix 3. There are 24 separate entries for sheets or linen described as *forestiera* or *forestiero* in the Tornabuoni inventory. Textiles described as 'ours' (*nostrale*) denoted local products rather than imported or in an imported style.

152. Lorenzo di Giovanni Tornabuoni (1497) MPAP 181 fol.148r: 2 vasi di Murano christallino chon lavori.

153. 'mire his ad similitudinem accessere vitrea, sed prodigii modo, ut suum pretium auxerint, crystalli non deminuerint.' Pliny *Naturalis Historia* Book XXXVII, x, 29; trans H. Rackham, *Naturalis Historia.* Vol. X. Cambridge, Mass, (1938–52): pp. 184–5.

154. Cited in W.P. McCray, *Glassmaking in Renaissance Venice: The Fragile Craft.* Aldershot (1999): p. 96.

155. Lorenzo di Giovanni Tornabuoni (1497) MPAP 181, (fol.141v): *Nell'antichamera di detta chamera*: 8 bicchieri di christallo e 1ª ghuastada e 1ª tazza; (fol.142r): *Nella sala terrena*: 2 rinfreschatoii di christallo; (fol.145r): *Nello schrittoio*: 4 ghuastade e 8 bicchieri di christallo; (fol.147r): *Nella chamera terrena dell'arme*: 1° rinfreschatoio chon piè di christallo; (fol.147v): *Nella chamera terrena in sul' androne*: 2 ghuastade di christallo; (fol.148r) *Nella chamera di L[orenz]° bella in su la sala in palco*: 2 vasi di Murano christallino chon lavori; (fol.148v) *Nell'antichamera di L[orenz]°*: 1° tazone di christallo e 1° rinfreschatoio di christallo; 1° rinfreschatoio piccino di christallo; (fol.149r) *Nel salotto di sopra*: 2 rinfreschatoi di christallo chol piede; 2 tazzoni di christallo e 5 quarti chol'arme di chasa.

156. On the relevant passage in *De splendore* see note 79.

157. Gismondo di Messer Agniolo della Stufa (1495) MPAP 179 fol.370r; see Appendix 2. The glassware is kept together in a small chest (*chasetta*) located in the *schrittoio*: 4 tazze di vetro christallino;…2 saliere di vetro; 9 vasi di più sorti di vetri di Marano chon più lavori; 5 bicchieri grandi christallini; 1ª saliera di latimo.

158. McCray (1999): p. 66.

159. See Chapter 3, note 11.

160. McCray (1999): p. 66.

161. 'Dua orciuoli di vreto [sic] paghonazo sopra il chamino. f.1' (fol.6r). Spallanzani and Bertelà (1992): p. 11.

162. Franciescho di Baldino Inghirrami (1471) MPAP 173 (fol.266r) *Nelo schrittoio in detta chamera*; (fol.266v) *Nela prima chassa a chapo a letto in detta chamera*; (fol.267r) *Nello schrittoio dela chamera dov'abitava Francesco*; (fol.268v–69r) *Nel chassone in detta chamera*; (fol.272r) *Nela prima chassa a piè del letto*; *Nela ¼ chassa*; (fol.272v) *Nel necessario della detta chamera*; *Nel antichamera della detta chamera*; (fol.273r) *Nel forzeretto da some*; *Nela ¼ chassa*.

163. Ibid., fol.267r: *Nello schrittoio dela chamera dov'abitava Francesco*: 1ª schodella [e] 2 schodellini di lattimo; 4 saliere di lattimo di mistura da Murano; 6 saliere di vetro cristallino; 2 saliere chol piè di vetro cristallino; 2 taze 1° bicchiere di vetro cristallino; 2 bossoli da spezie di vetro azurri e bianchi; paneruzolini di vetro azurri e bianchi; 1° anpolluza picchola di vetro; 1° bossolo di vetro chol choperchio; 1ª saliera di vetro dipinta; 3 saliere di vetro azurro.

164. For the wealth of goods listed in Francesco Inghirrami's study see the inventory transcription in Musacchio (1999): p. 162.

165. *Nello schrittoio dela chamera dov'abitava Francesco* (fol.267r): 1° rinfreschatoio da maiolicha chol piè; un paio di rinfreschatoio da maiolicha da donna di parto [scored through], cioè novella; 1° piatello da maiolicha piano; 1° chalamaio da maiolicha.

166. Salvestro di Franciescho Neretti speziale (1429) MPAP 165 (fol.84r): taglieri da maioliche; (fol.84v): ii piatelli grandi di maiolicha; xii schodelle di maiolicha; ii piatelli da maiolicha; (fol.85r): schodelle invetriate.

167. Antonio di Marsilio Vecchietti (1448) MPAP 171 fol.138v: *in chamera terrena*: 1° chasone di 1° serame di braccia 2½ nel quale sono lavori da maioliche dichono essere della Maria cioè 33 pezzi tra piateletti e schodella da maiolicha e 1° piatello grande da maiolicha.

168. 'Due dì fa che io ricevecti con una di v.s. quelli vasi fictile, che ha degnato mandarmi per Giovanfrancesco… li quali esser in perfectione et molto secondo l'animo mio, mi sono suti gratissimi; nèso in che modo renderli conveniente gratie, perchè se le cose più rare debbono esser più chare, questi vasi mi sono più chari, et più li stimo che fussino de argento, per esser molto excellenti et rari, come dico, et nuovi a noi altri di qua.' Cited in P. Berardi, *L'antica maiolica di Pesaro*. Florence (1984): p. 42.

169. 'quaedam etiam precium ac magnitudo commendet, quaedam sola elegantia et raritas, aut artifices manus, aut item laus alia.' Tateo (1999): p. 232; trans E. Welch, 'Public Magnificence and Private Display: Giovanni Pontano's "De Splendore" (1498) and the Domestic Arts', *Journal of Design History*, 15 (2002): p. 224.

170. R. Lightbown, *I tre libri dell'arte del vasaio by Cipriano Piccolpasso*. Vol. I. London (1980): p. 49.

171. A. Norman, *The Wallace Collection Catalogue of Ceramics I*. London (1976): p. 10.

172. 'quorum etiam alia videantur comparata ad usum atque ornamentum, alia solius ornamenti atque elegantiae gratia…' Tateo (1999): p. 232; trans Welch (2002): p. 224.

173. Franciescho di Baldino Inghirrami (1471) MPAP 173 fol.266r: *Nelo schrittoio in detta chamera*; (fol.267r) *Nello schrittoio dela chamera dov' abitava Francesco*; (267v) *Sotto lo schrittoio*. See Musacchio (1999): pp. 160 and 162–3.

174. Lorenzo di Giovanni Tornabuoni (1497) MPAP 181 fol.148r: *Nella chamera di L[orenz]° bella in su la sala in palco*: 1° piatello grande di maiolicha; (fol.148v) *Nella chamera del palco d'oro*: 5 piattegli di maiolicha usati grandi p° lavoro.

175. Franciescho di Baldino Inghirrami (1471) MPAP 173 fol.270v, where a reference in the *antichamera di detta chucina* refers to '6 pezi di maiolicha rotti'.

176. 'Il suo studietto, hornatissimo il pavimento e così il cielo di vetriamenti fatti a figure degnissime in modo che a chi v'entra dà grandissima admiratione.' Filarete *Trattato di Architettura* Book XXV, Fol.190r; A.M Finoli and L. Grassi eds. Vol. II. Milan (1972): p. 696.

177. Lorenzo di Giovanni Tornabuoni (1497) MPAP 181 fol.148r: 1ª lettiera con lettuccio e chappellinaio choperta di nocie apicchato insieme chon palle d'ottone dorate chon panchetta bassa intorno.

178. Ibid., fol.148r: Uno tondo chon festone messo d'oro dov'è Nostra Donna e Santo Giovanni; and 1° quadro chon chornicione messo d'oro chon testa e busto della Giovanna degli Albizi.

179. Ibid., fol.148v: Intorno spalliere d'arcipresso e chasse.

180. The authenticity of the interior decoration must be treated with caution, due to the extent of repainting during the late nineteenth and early twentieth centuries. On Palazzo Davanzati see L. Berti ed., *Il museo di Palazzo Davanzati a Firenze*. Florence, 1972.

181. The entry appears in the room detailed as *antichamera di detta chamera* and reads: 'Una spalliera di pino intorno a detta antichamera di giro di br. xx, alta br. 4 con pettorali et cornice di nocie, chon una chassa di detto lavoro all'entrare di detta antichamera, lungha br. –, che una parte di detta spalliera serve al lettuccio e una parte all'armadio a 2 serrami e più le chose dallato e el chapezale da piè d'una lettiera commessa in detta spalliera per uso di letto, lavorate in detto modo, in tutto f.20.' Spallanzani and Bertelà (1992): p. 77 (fol.41r).

182. The three consecutive entries read: 'Dua forzieri a sepultura, richi, con console e architrave, messe d'oro fine tutto e storiato della storia della vittoria di Marcho Mar[c]ello della Sicilia. f.50; Uno chassone di pino di br. 4, cornicie e squarciato di nocie con tarsie e più lavori di silio e una predella di nocie con tarsie sotto a' detti forzieri et chassone. f.12; Una spalliera di br. xii lungha e alta br. una e ½ sopra a' detti forzieri et chassone, dipintovi drento la storia della giostra di Lorenzo con cornicie e colonnette messe d'oro, divisa in 3 parte, di mano dello Scheggia. f.60.' Ibid., p. 73 (fol.39r).

183. The entry reads: 'Uno quadro di lignamo apicato sopra el letucio, nel quale è depinto nove figure de donne ch' omini, estimato l. 100.' Lorenzo di Pierfrancesco de' Medici (1498), Archivio di Stato Firenze, Medici Avanti il Principato CXXIX fol.516v. See J. Shearman, 'The Collections of the Younger Branch of the Medici', *Burlington Magazine*, 117 (1975): p. 25.

184. See R.J.M. Olson, *The Florentine Tondo*. Oxford, 2000; and 'Lost and Partially Found: The Tondo, a Significant Florentine Art Form in Documents of the Renaissance', *Artibus et Historiae*, 27 (1993): pp. 31–67.

185. '…in casa di Giovanni Tornabuoni, un tondo con la storia de' magi, fatto con diligenza'. Giorgio Vasari 'Vita di Domenico Ghirlandaio' *Le vite de piú eccellenti pittori scultori e architettori*, ed. A. Rossi. Vol. III. Milan (1962): p. 157.

186. See note 79 above.

187. Antonio di Messer Michele Strozzi (1522) MPAP 185 fol.219r: 1° quadro grande d'una nostra donna cho Magi ch'oferischano bella; 1° quadro di pano di Davite e sua istoria bello; 1° quadro della istoria del Vitello Saginato bello; 1° quadro grande di Santa Marta e tutto in su telai nuovi e begli.

188. E. Welch, *Art and Society in Italy 1350–1500*. Oxford (1997): pp. 138–9; and Olson (2000): pp. 3–4, 94–5.

189. '…per molti anni, con suo molto utile et onore, ad altro non attese che a lavorare e dipignere cassoni, spalliere, lettucci et altri ornamenti…' Giorgio Vasari 'Vita di Dello Delli' *Le vite de piú eccellenti pittori scultori e architettori*, ed. A. Rossi. Vol. II. Milan (1962): p. 119.

190. 'In molte case di Firenze sono assai quadri in prospettiva, per vani di lettucci, letti, et altre cose piccole, di mano del medesimo.' Giorgio Vasari 'Vita di Paolo Uccello' Ibid., p. 164.

191. 'Memoria che noi abiamo in chasa nostra più chose di scholtura e di pitura di tarsie e comessi, di mano de' miglori maestri che siano stati da buono tenpo in qua, non tanto in Firenze ma in Italia.' A. Perosa ed., *Giovanni Rucellai e il suo Zibaldone.* London (1960): pp. 23–4.

192. Those listed by Rucellai are: 'maestro Domenicho da Vinegia, pittore; frate Filippo de l'ordine [], pittore; Giuliano da Maiano, legnaiuolo, maestro di tarsie e comessi; Antonio d'Iacopo del Pollaiuolo, maestro di disegno; Maso Finighuerra, orafo, maestro di disegno; Andrea del Verochio, schultore e pittore; Vettorio di Lorenzo Bartolucci, intaglatore; Andreino del Chastagno, detto degl'inpichati, pittore; Paolo Uccello, pittore; Disidero da Settignano, Giovanni di Bertino, maestri de scharpello.' Ibid., p. 24.

193. Gismondo di Messer Agniolo della Stufa (1495) MPAP 179 fol.368r–370v. See Appendix 2.

194. Lorenzo di Pierfrancesco de' Medici (1498), Archivio di Stato Firenze, Medici Avanti il Principato 129 fol.519r–v: *camara di Lorenzo dicta camera bella.* For a partial transcription of the inventory see Shearman (1975): pp. 12–27.

195. Ibid., fol.519r: Dua guanzali di piuma picoli da lecto con la fodra panno lino. l.3.

196. Ibid., fol.519r: Dua forzeri al'anticha grandi, storiati, missi a horo fino, chole spaliere et predelle di sotto, estimati. l.240

197. Ibid., fol.519r: Uno cassone di noce intarsiato con prospetive, intagli, con la spalera e predella, est. l.80.

198. Ibid., fol.519r: Una lietiera di notie intarsiata di br. sey con uno ornamento al capezale di prospetiva, con ln predella dinanzi e da piè e de drieto, et uno sacone di canevazo el chanaio, est. l.200; Uno letuzo di br. sey di nocie intarsiato e comisso di prospetiva e a chassone chon serame, hornate con dua palle grosse d'octone dorato, e di sopra una moresca di figure di relievo, e cholla predella d'intorno, est. l.200.

199. Ibid., fol.519r.

200. Ibid., fol.519r.

201. 'Òllo fatto vedere da 3 per me medesimo: ognuno in di grosso dice che passa fiorini larghi.' Letter dated 12 April 1473. Archivio di Stato, Florence Carte Strozziane III, 133 cited in E. Borsook, 'Documenti relativi alle cappelle di Lecceto e delle selve di Filippo Strozzi', *Antichità Viva*, 3 (1970):Document 9, p. 14.

202. 'Òvi già messo a dorate 300 pezi d'oro'. Borsook (1970): p. 14.

203. 'È tenuto da chi l'à veduto, una bella cosa e piace molto a ognuno, chosì dell'arte chome cittadini.' Ibid., p. 14.

204. '16 o 17 vi ritornorono a vedere più di una volta, perché stimo piacessi assai;' Ibid., p. 14.

205. Chapter III of Giovanni Pontano's *De splendore* is entitled: 'Qualem esse deceat viri splendidi supelectilem'. Tateo (1999): p. 228.

Conclusion

But the beauty of Florence cannot be appreciated unless seen from the inside. Therefore the sort of careful scrutiny that brings shame to other cities only serves to raise the esteem held for Florence, for behind the walls of the buildings of Florence there are no fewer ornaments and no less magnificence (*magnificentie*) than there is outside.[1]

Leonardo Bruni, *Laudatio florentinae urbis* (*c.* 1403)

Magnificence was not simply a re-creation of humanists and court theorists during the fifteenth century. In the 1330s, Galvano Fiamma had adopted the term to glorify the building projects and achievements of the Milanese ruler Azzone Visconti. Fiamma's use of magnificence in the *Opusculum de rebus gestis ab Azone, Luchino et Johanne Vicecomitibus* was firmly within the Aristotelian tradition of the term, and indeed the Greek philosopher was frequently cited in his text as both the justification and source. In Aristotle's *Ethica Nicomachea* the Greek term used for magnificence had been *megaloprepeia*, meaning literally 'appropriateness in great things', and was applicable to the act of major expenditure. Within this interpretation, Aristotle had made the specific connection with private building, stating that it was also 'characteristic of the magnificent man to furnish his house in a way suitable to his wealth,' adding that 'even this is a kind of public ornament'.[2]

For Leonardo Bruni, writing in the opening years of the *quattrocento*, magnificence extended beyond merely a discussion of the architectural shell of a building to encompass the role private building could serve as a 'public ornament' to the city. Here the essential argument promoted by Bruni rested on the important effect private palaces could have – both within and without – on visitors to Florence, by beautifying the city and thereby reflecting or enhancing its magnificence. The ultimate achievement of Bruni and his successors is demonstrated by the extent to which texts discussing *magnificentia* were accessible to Florentines during the *quattrocento*. As *The Renaissance Palace* has revealed, where *ricordanze* and post-mortem inventories

denote specific ownership of 'ancient' and 'modern' texts, the frequent and regular incunabula editions suggest the broad levels of interest in – and accessibility of – such theories.

The public function of private building was reinforced in Benedetto Dei's chronicle where he provided a list of what he considered to be the city's most notable structures. Written in 1472, the list suggests how the effects achieved by architecture, whether secular or religious, could complement one another and collectively beautify the city. Under the heading of 'beautiful Florence' Dei records 33 'very grand structures of great fame and of very great expense', ranging from the Ospedale degli Innocenti to the churches of Santo Spirito or San Lorenzo and the houses of the Medici, Tornabuoni and Rucellai.[3]

Similar motivations to build were also expressed by the patrons themselves. Just as the structures erected by the Rucellai merited acclaim in Dei's list, so too did Giovanni Rucellai record the reasons for his vast expenditure on public and private building. In an entry written in around 1473, Rucellai proudly stated that his architectural projects – which included the family palace and loggia, together with the façade for the church of Santa Maria Novella – had given 'the greatest contentment and greatest satisfaction, as they serve in part the honour of God, the honour of the city and the memory of me'.[4]

The building activity of Cosimo de' Medici during the 1450s, provided the theory of magnificence with both a justification and a powerful counter-weight to criticisms – which typically centred on the envy felt by some citizens towards his inequitable wealth and the manner of his expenditure. The tract written in defence of Cosimo's architectural patronage by Timoteo Maffei, rector of the Badia at Fiesole, suggests that it was drafted as a retort to detractors of magnificence. Though Maffei shows himself well versed in Aristotelian thought, his model was Saint Thomas Aquinas' discussion of magnificence in the *Summa Theologiae* (before 1273), where a series of arguments against this virtue were countered by a number of replies. Particularly important was Maffei's statement that Cosimo's patronage deserved 'extraordinary praise and should be recommended to posterity with the utmost enthusiasm.'[5] For Maffei, Cosimo's architectural projects were intended to serve as an encouragement to others to undertake similar exemplary building.

At the end of the fifteenth century, Giovanni Pontano specifically commended Cosimo as an exemplar of modern magnificence. Central to such praise was the connection between the antique magnificence demonstrated by Cosimo and the classical architectural style of the Medici palace. Thus in *De magnificentia*, Pontano perceived Cosimo as representing 'antique magnificence' (*priscam magnificentiam*) and his palace as renewing a 'most antique and nearly forgotten architectural style,' which he concluded had been erected to demonstrate to others how to build.[6]

The Renaissance Palace has examined the integral role served by palaces in connection with official visits and highlights the importance of the interior as a suitable setting in which to demonstrate lavish hospitality. Aristotle had cited the reception of dignitaries and other important foreign guests as events when magnificence could be demonstrated. In *De Officiis* Cicero described how hospitality and entertainment were duties of the 'distinguished man' (*clari hominis*), arguing that since crowds of every sort were to be received, it was necessary that his palace should be spacious enough to fulfil this requirement.[7] By the end of the fifteenth century, Pontano specifically extended his discussion of the hospitality required of the 'splendid man' (*splendidi hominis*) to comprise the range and type of domestic furnishings within the palace interior, arguing that 'if a guest should arrive, he will be ready to receive him in a manner which is not only welcoming but also magnificent (*magnifice*).'[8]

Considered from the standpoint of the function of the palace as a semi-public entity, this book has demonstrated how the reception, entertainment or meeting of friends, guests and visitors was an established and indeed expected purpose of domestic space. Through Vitruvius' classical text on architecture *De Architectura libri decem*, issues of accessibility have been analyzed and parallels found between the ancient *domus* and the fifteenth-century house. Rather than simply interpreting the interior in terms of 'public' and 'private' space, *The Renaissance Palace* has explored the distinction applied by Vitruvius between the 'invited' and 'uninvited' visitor and its relevance for the Renaissance home. In the degree of accessibility to be offered, Vitruvius' text shows a desire to regulate the flow of visitors around specific areas of the *domus*. Alberti similarly explored questions of domestic access in *Decem libri de re aedificatoria* (*c.* 1443–52), adopting Vitruvius' theme that issues of openness and closure rested with the social standing of both the owner of the house and the visitor.

A further theme explored has been the concept of *decor* and its relevance to both magnificence and splendour. Adapted from the Greek *to prepon*, or 'that which is fitting', the term was discussed in classical texts as diverse as Cicero's *De Officiis* and Vitruvius' ten books on architecture. Notwithstanding the different intended purposes of these texts, each author had applied the principle to similar ends. Cicero's text on duties had attempted to prescribe models for each class of citizen, indicating what was fitting or appropriate to their level in society. Similarly, Vitruvius extended this maxim to the type of architecture deemed appropriate to the status of its owner.

During the Renaissance the application and meaning of the principle of *decor* was not lost on fifteenth-century theorists. Decorum, or the beauty derived from appropriateness, was an important concept in the architectural treatises of Filarete and Alberti. In his *Trattato di architectura* (*c.* 1461–4), Filarete had gone as far as to provide measurements, plans and architectural

drawings for the types of dwellings suitable for a Duke, Bishop, gentleman, merchant, artisan and lastly the poor. Alberti, in contrast, adopted a more nuanced approach, expanding Vitruvius' discussion of the interior to consider in broad terms the suitability of different domestic spaces and their inter-relationships to one another. The principle of decorum was also central to Pontano's discussion of splendour. In *De splendore*, reference had been made in broad terms to different levels of appropriateness for furnishings and goods within the domestic space – which extended from the types considered suitable for particular rooms, to the way they were to be displayed within these spaces.

The inventories contained in the *Magistrato dei Pupilli* registers have provided details on the urban palace and have highlighted the multi-functionality of the interior and its spaces. These registers confirm that the principal *camera*, often specifically associated with the owner, was the locus for domestic goods. It was there that the qualities of shine and polish, inherent virtues of splendour, were frequently replicated. At the end of the century the existence of the *camera bella* suggests a developed understanding and appreciation of the potential for domestic space to collectively demonstrate the beauty derived from appropriateness.

Through examination of inventories, we are permitted access to key domestic spaces and gain a unique awareness of the visual experiences of fifteenth-century Florentines. Unlike contemporary visitors and guests, our insight into the interior pervades all areas – from the most sumptuous rooms to the service quarters. Guided or channelled through the domestic space, the inventories allow us to experience the accessibility granted to the invited and uninvited visitor, as well as to family members and domestic staff. Analyzed across the *quattrocento* these documents facilitate a greater understanding of the Renaissance interior and the function domestic goods could serve as objects of both use and display.

This book has expanded the discourse on magnificence behind the walls of the fifteenth-century urban palace. Opening up the potential to consider the splendid interior as more than simply private space, *The Renaissance Palace* has underlined the particular importance of the Florentine *palazzo* to the city as emblems of civic pride and integrated structures where business, hospitality and entertainment were regularly conducted.

Notes

1. Leonardo Bruni, *Panegirico della città di Firenze*, ed. G. de Toffol. Florence (1974): p. 22; trans B.G. Kohl and R.G. Witt (1978): pp. 140–1. See Chapter 3, note 3.

2. Aristotle *Nicomachean Ethics* IV, ii, 16–17, trans J.A.K. Thomson London (1953) revised edition (1976): p. 151. See Chapter 1, section 1.

3. R. Barducci ed., *Benedetto Dei La Cronica dall'anno 1400 all'anno 1500*
 Florence (1984): p. 86. See also Chapter 2, section 1.

4. A. Perosa ed., *Giovanni Rucellai ed il suo Zibaldone: 'Il Zibaldone Quaresimale*. Vol. I. London (1960):
 p. 121. For a wider context to Rucellai's motivations to build see also Chapter 2, section 1.

5. Timoteo Maffei *In magnificentiae Cosmi Medicei Florentini detractores libellus*
 (*c*. 1454–6). For a discussion of Maffei see Chapter 2, section 2.

6. F. Tateo ed., *Giovanni Pontano I libri delle virtù sociali*. Rome (1999): p. 190. See Chapter 2, section 2.

7. Cicero *De Officiis* Book I, xxxix, 139; trans W. Miller. London
 (1913): p. 142. See Chapter 3, section 2.

8. Tateo (1999): p. 234. See Chapter 3, section 3.

Appendix 1

Gabriello di Messer Bartolomeo Panciatichi (1430)
MPAP 165 fols.435r-443r

By the early eleventh century the powerful Panciatichi family had already established considerable land and wealth in the *contado* around their native Pistoia. In 1376 Gabriello's father Bartolommeo was granted Florentine citizenship with the stipulation that they were not to hold public office for twenty years.[1] Gabriello was born in 1352 and as the 1427 *catasto* confirms both he and his brother, Giovanni had firmly established themselves as among the city's wealthiest citizens. Gabriello rated as the fourth richest individual with a total assessment of 80,994 florins, while Giovanni was the fifth with 70,548 florins.[2] Although the Panciatichi family did secure some minor government posts later in the fifteenth century, their status as outsiders continued to exclude them from prominent positions long after the 1396 condition had passed. The palace in which Gabriello and his brother resided in the Drago *gonfalone* of the San Giovanni quarter was destroyed in the early nineteenth century.

[fol.435r]

+ mcccc°xxx

Rede di Ghabriello di messer Bartolomeo Panciatichi

Qui riduremo lo 'nventario delle sustanze di dette rede le quali venono al ghoverno degli uficiali a dì iii d'aghosto 1430 per vighore di testamento di detto Ghabriello roghato per ser Antonio di Lodovicho di Paolo d'Agnello di quello di Pistoia el quale inventario fu fatto per ser Antonio di ser Piero di ser Bettino notaio di detti uficiali e apare a uno libro di fogli reali chon choverta di charta pechorina chon choregine nere segnato D el quale libro è tenuto per ser Mainardo di Francescho da Vinciolo loro attore.

Le rede sono queste

Bartolomeo d'eta d'anni []
Piero d'eta d'anni []

[…]

[fol.435v]

[…]

[fol.436r]

Inventario di masserizie che al presente si truovano dette rede chome apare a libro del atore segnato D charta 2

 Nello scrittoio

1° quaderno segnato G di paghamenti di Ghabriello di merchatantia
1° qu[adern]o lungho di carte 239 chomincia l'anno 1392 e finiscie l'anno 1428 detto quaderno [sic] di messer Bartolomeo segnato D
1° quaderno lungho di sichurta segnato B iscritto insino a charta 130 chomincia l'anno 1416 e finiscie l'anno 1430
1° libro quadro detto di merchantantia segnato B apartenente a Ghabriello proprio chomincia l'anno 1399 e finiscie 1429 iscritto insino a carta 268
1° quaderno di messer Bartolomeo apartiene a Ghabriello e Giovanni Panciatichi iscritto insino a carta 55 e chomincia l'anno 1394 e finiscie 1402
1° libro grande segnato C di Ghabriello proprio chomincia l'anno 1415 e finiscie 1429 iscritto da charta 1 in sino charta 201
1° quaderno di richordi di fini nel detto libro
1° libro vecchio di fittaiuoli il quale apartiene a Ghabriello e Giovanni Panciatichi segnato B e chomincia nel 1394 e finiscie nel 1419

1° libro di fittaiuoli nuovi segnato C partenente a a Ghabriello e Giovanni Panciatichi chomincia nel 1417 e finiscie nel 1427

1° libro grande di chonpere di messer Bartolomeo chomincia nel 1354 e finiscie nel 1423 iscritto da charta 1 insino charta 105

1° libro di richordanza segnato A chomincia nel 1395 e finiscie nel 1421 iscritto da charta 1 insino charta 90

1° libro di sichurta quadro segnato A chomincia l'anno 1408 e finiscie 1419 iscritto da carta 1 insino charta 138

1° libro quadro di Ghabriello propio segnato A chomincia nel 1387 e finiscie 1399 iscritto da charta 1 insino charta []

1° quaderno lungho segnato A di spese e salari di fanti chomincia nel 1408 e finiscie nel 1414 iscritto da charta 1 insino charta 175

1° libro basso quadro di chonpere di panni e di lane apartiene a Ghabriello e Giovanni chomincia nel 1395 e finiscie 1404 iscritto da charta 2 insino charta 255

1° libro basso di sichurta chol sengnio chomincia nel 1394 e finiscie 1400 iscritto da charta 1 insino charta 32

1° quaderno lungho di Ghabriello e Giovanni segnato G chomincia nel 1388 e finiscie nel 1394 iscritto da charta 2 insino charta 89

ii messali begli chovertati l'uno di scharlatino e l'altro di valescio

1° testamento in volghare di mano di Ghabriello in uno quaderno di fogli

1° libro in volghare in charta di chavretti in assi choverti di chuoio rosso detto libro di Vertù

[fol.436v]

1° Vergilio cholla Bocholicha in charta di chavretti alla moderna in asse e chuoio biancho

1° Vergilio in fogli chon certe Pistole e altre legiende

1° libro in volghare de fatti di Dante in charta banbagina

1° libro in volghare di legiende in chavretti di San Giovanni e Sancta Doratea

1° Prologho sopra Quintiliano in chavretti in volghare

1° libro ghuadro in fogli di banbagia della Vita di Sancto Franciescho e sopra altre chose in lettera moderna tonda

iiii° libri grandi in volghare in fogli reali di banbagia iscritti di mano di Ghabriello choverti d'asse cioè la Bibia e la Vita di Giobo e fatti di Troia e altre chose

 Nella volta e nel primo volticino

più lengniame dimesticho tristo da ardere

1ª botte da aceto di barili 7 entrovi barili 5 d'aceto

1ª botte da aceto drentovene un pocho

iiii° barili, 1° paio vecchi e 1° paio nuovi

iiii° orcia vecchie

1° chorbello vecchio

Nella volta grande

1ª botte di tenuta di barili 8 o circha vota
1ª botte di tenuta di barili 8 o circha vota
1ª botte di tenuta di barili 5 vota
1ª botte di tenuta di barili 5½ entrovi vino chotto
1ª botte di tenuta di barili 10 o circha vota
1ª botte di tenuta di barili 12 vota
1ª botte da aceto di barili 5 entrovi aceto
1ª botte di tenuta di barili 5 vota
1ª botte di tenuta di barili 3 vota
1ª botte di tenuta di barili 4 vota
1ª botte trista da aceto di barili 5 entrovi aceto
1ª botte grande trista di barili 14 vota
1ª botte di tenuta di barili 10 piena di vino vermiglio
1ª peviera

Nella terza volta

1ª botte di tenuta di barili 6 entrovi vino che si beve
1ª botte di tenuta di barili 7 o circha

[fol.437r]

1ª botte di tenuta di barili 6½ piena di vino vermiglio
1ª botte di tenuta di barili 7 piena di vino vermiglio
1ª botte di tenuta di barili 6 vota
1ª botte di tenuta di barili 7 piena di vino vermiglio
1ª botte di tenuta di barili 6 vota
1ª botte da biancho di barili 4 vota
1ª botte da biancho di barili 4 entrovene
1ª botte da biancho di barili 5 piena di vino biancho
1ª botte da biancho di barili 5 vota
1ª botte da biancho di barili 6 vota
ii mezzi barili
1ª zana

In chamera terrena

1ª tavola di nostra donna
1ª lettiera di braccia 4½
1ª chassapancha a due serami ismissa }
1ª chassapancha a uno serame } a piè di detto letto
1º mezo sacchone trespolo e chanaio
1ª materassa di bordo di braccia 5
1ª choltricie chon dua pimacci piena di piuma di braccia 5

1° paio di lenzuola di teli iii l'uno di braccia vii
iii ghuancialetti per la notte chole federe
1° chopertoio a gigli gialo e azuro di braccia vii
1ª sargia rossa dipinta braccia viii
1° lettuccio vecchio di braccia iiii°
1° materassino di bordo a detto lettuccio
ii ghuanciali cholle federe lavorate di drappo rosso afighurato
1° ghuanciale cholla federa
1° chassone a due serami grande dice essere di Bartolomeo
1ª chassa vecchia a ii serami di braccia ii½
ii tovagliuole l'una chapitata
1° farsietto di zetani velutato nero dice essere di Bartolomeo
1° mantello paonazo vecchio da uomo alla uzana
1° mantello rosato usato di Ghabriello alla uzana
1° mantello nero grosso usato di Ghabriello
1ª cioppa di rosato a maniche aperte foderata di taffeta di grana frescha
1ª cioppa rosata frapata a ghozi foderta di verde dice essere di Bartolomeo
1ª cioppeta rosata di Ghabriello foderata di panno nero a maniche strette

[fol.437v]

1° mantello cilescrino vecchio dice essere di Bartolomeo
1° chapuccio rosato nuovo grande dice essere di Bartolomeo
1° uccho isbiadato foderato di taffeta di grano dice essere di Bartolomeo
1ª beretta grande isbiadata dice essere di Bartolomeo
ii paia di chalze isbiadate di Perpingniano fine di Bartolomeo
1° paio di chalze rosse Perpingnaiane fini di Bartolomeo
1ª cioppa di cianbelotto rosso vecchia a maniche aperte istrette foderata di taffeta di Ghabriello
1° farsetto di zetani rosso alesandrino di Bartolomeo
1ª cioppa isbiadata nuova di Bartolomeo foderata di zanpe orlata d'ermelini bianchi a ghozi
1ª cioppetta bigia vecchia
1° falcionetto cholla ghuaina rossa
1° braccio di panolino o circha
v oncie di ritagli di taffeta di grana
1ª tavoletta picchola di nostra dona in dua pezi di Bartolomeo
1° forzerino di chuoio ispranghato di ferrro introvi queste chose
1ª turchiessa in ghanbo d'oro sodo }
1° diamante leghato basso in ghanbo d'oro sodo } tutte da donna dichono
1ª perla grossa leghata in ghanbo d'oro sodo } essere di m[on]ª Mea
1° zaffino leghato alto bello leghato in ghanbo d'oro sodo } donna fu di Ghabriello
1° balascio leghato alto leghato in ghanbo d'oro sodo }
1° smeraldo leghato alto in ghanbo d'oro sodo }
1° anello di venti perle grosse infilzate }
1ª crocielina d'ariento leghatovi dentro una pietra
1° dente chavalino chon ghiera d'ariento

1ª turchiessa leghata bassa in ghanbo d'oro sodo
1º anello d'oro sodo intagliatovi dentro uno San Giorgio in pietra nera era di Ghabriello
allo Bartolomeo
1º anello d'oro chon una chorniuola di Ghabriello
vii oncie d'ariento in fogliette
1º chapello di paglia fine frangiato foderato di taffeta isbiadato richamato chon ariento
di Bartolomeo
1º chornamusino pieno di sonagli inarientati di Bartolomeo
vi quaderni testamenti in volghare e in gramaticha di Bartolomeo
1º libro quadro segnato A di Bartolomeo
1ª charta di fine
vii libre e ii oncie di lino alesandrino petinato
1ª cioppa bigia da dona cho' maniche istrette foderata di pelle sardesche
ii paia di chalze nere vecchie di Ghabriello
1º mantello paonazo ala uzana usato di Ghabriello

[fol.438r]

1º mantello nero grosso di Ghabriello
1ª cioppa bigia vecchia foderata di pelle bianche loghora
1ª ciopetta rosata veccie cho ghozietti di fodero biancho
1ª ciopetta azurina orlata di lontra foderata di fodero nero
1ª ciopetta nera loghora di m[on]ª Bartolomea
1ª ciopetta nera da donna a maniche istrette di m[on]ª Bartolomea
xlii libre di lino graffiato
clxxi libra di lino sodo
ii sacchi pieni di libri in uno palchetto
iiiiº filari di libri in su detto palchetto
1º descho da parto
1ª chassetta bassa dice essere di Bartolomeo
1º saccho pieno di scritture
1º donadello vecchio
1º Isopo
1º libro di gramaticha in charta banbagina
1º libro di gramaticha in charta di chavretti
1º tavoliere
1º forziere
1ª pianiella di ferro di Ghabriello
1º descho da scrivere
1ª cholteliera entrovi iii choltella

 Nella logia e chorte

vi palvesi chol'arme loro
ii tavole da mangiare
v deschetti

1º paio di trespoli
1º descho cho' trespoli chonfitto tristo
1º descho vecchio da Arte di Lana
1º paio di cieste vecchie
xiiiiº balle di lana franciesche
1º secchione da aquaio
1º paio di sechie cholla chatena al pozo
iiiiº chataste di lengnie
1º bacino cholla misciroba picholo
1º ronzino leardo chon buono fornimento

[fol.438v]

In chamera del fante a meza schala

1ª lettiera vechia di braccia iiiiº chol trespolo e chanaio
1ª choltricietta vecchia
1º pimaccio
1º lenzuola a teli iii
1ª tavola vecchia cho' trespoli
1º fastello di cierchi da botti
1º tavoliere da giucchare a tavole
1º forzieretto picholo vecchio da soma tristo dice essere del famiglio

In sala

1ª tavola vecchia cho' trespoli
1º descho chonfitto da orciuoli
1º chassone a ii serami
ii deschetti, 1º picholo e 1º grande
1º paio d'alari
1ª segiola
1ª forchetta }
1º paio di molli } da fuocho
1º paletta }
lvi libre d'accia chotta fine
ii saliere di stangnio
1ª predella
1ª zana grande
1º aspo da fare lume apichato al palcho

In chucina

1º chatino di rame usato
1ª padella grande
ii padelle picchole

ii teghie mezana di rame
1ª teghia pichola
1º ramaiuolo grande da chuociere tonina
1ª padella grande da chuociere bruciate
1º trepie grande
1º trepie picholo
1º paioletto mezano
1º ramino piccholo
ii treppie da teghie da migliacci
1ª paletta }
1º paio di molli } da fuocho
xx libre di stangnio tra inpiategli schodelle e schodelini
iii mortai di pietra cho' pestegli

[fol.439r]

1ª gratugia
v lucierne
1º paio di stadere pichole
1º schidone grande di ferro
iii schidoni piccholi di ferro
x schodelle di stangnio
xliiii° taglieri
ii orciuoli di rame mezani
ii mestole di ferro
viii schodelle di maioliche
1º descho da chucina
1º orciolino di rame
1º paiuolo di rame grande
1º chassone da pane

In sala da polli overo chucina di sopra

1ª chaldaia grande da buchato chol trepie e tozzo
1º paioluzo picholo
1º bacino mezano d'ottone
1ª teghie mezana di rame
1ª stia da polli chonfitta
1º vaso grande da buchato
1ª chonchetta picchola
ii archette
1ª madia
iii staia di farina
1º staio di ferro
1º lettuccio da pane chol sachone e 1ª choltricuza di penne di polli
1º quarto di lengnio

iii paia di maniche di ferro
iii paia di falde di maglie di ferro

Nel palcho sopra

1ª choncha di rame grande da chucina
1ª secchia pichola
1º chorbeletto nuovo
più lengniamaccio
xxi enbricie da letto

In sala detta sala del granaio

vi pezi di charne seccha
1ª teghia grande di rame
1ª schure vecchia
iiiiº choppi da olio entrovi una libra d'olio
xl staia di grano

[fol.439v]

In chamera di sopra della fante

1ª tavola di nostra donna
1ª ischiava che a nome Marta d'eta d'anni 40
1ª lettiera di braccia v
1º sacchone
1ª materassa
1ª choltricie di piuma buona di braccia v
1º paio di lenzuola di teli iii di braccia vi o circha
1º chopertoio vecchio tristo
1ª chassapancha a ii serami
1ª ciopetta bigia da fanciugli
1º fodero da donna di m[on]ª Bartolomea
1º paio di lenzuola vecchie a teli iiiiº l'uno
1º paio di lenzuola a teli iii l'uno
1º paio di lenzuola picchole da pane
1ª cioppa isbiadata }
1ª ghamurra }
1º ghuarniello } della Marta
1º fodero }
1º forzeretto }
1ª cioppa mormorina vecchia foderata di volpi di Ghabriello
1ª ciopetta cilestra a ghozi foderata di drappo verde vechia
lii braccia di maglia di bianchetta in quarto pezi nuovi
1ª ciopa monachina a ghozzetti foderata di panno rosso

1ª chortina vecchia di tovaglie a iii faccie da letto di Ghabriello
1º chassone a ii serami
1ª sargietta vecchia a papaghalli di braccia v
1º gianetto vecchio da letto di chate salvatiche
1ª sargia vecchia verghata rotta di braccia viii
1º mantello foderato chon lettere
ii spalliere vecchie e rotte di braccia xx
1º chopertoio a chastelucci biancho e rosso di braccia viii o circha buono
1º panno rosso da letto nuovo di braccia x
1º panchale di braccia x o circha
1º panchale vecchio di braccia v
1º panchale quasi nuovo di braccia xi
1º panchale vecchio di braccia viii
1º spalliera quasi nuova di braccia xi
viii braccia di maglia bigia d'Inghliterra
1ª choltricie di braccia v o circha
ii primacci buoni
1ª materassa grande da letto di Ghabriello

[fol.440r]

1º letuccio e
1º materassino
1º panchalaccio
1º lenzoletto a tre teli
1º lucierniere di lengnio
1ª segiola forata
lii libre di lino sodo
xlviii libre di lino sodo
xxxiiiiº libre di lino sodo
1ª pancha di braccia iiiiº
1ª lettiera di braccia iiiiº
1º paio di trespoli
1ª misciroba picchola rotta
1º paio di pettini da stoppa
ii paia di stadere mezane
ii paia di forbici da Arte di Lana
ii selle da giostra
1ª spada grande
1ª alare da arosti

In nel antichamero di detta chamera

1ª choltriciuza da chulla da fanciugli
1º deschuccio cho più pezi di funi
1º pezzo di choltriciaccia

1° pezzo di saccho di chuoio da grana
1° forzeraccio entrovi lx taglieri
1ª zana da tenere fanciugli
1ª ghabia da pipioni
1° panno rosso vecchio di braccia viii
1° panno rosso vechio di braccia viiii°
1ª sargia grande di braccia x o circha
1° tapeto grande lungho braccia iiii° e largho braccia ii½
x schodelle di stangnio nuove
ii choltella e ii choltelini

In chamera di Ghabriello

1° cholmo bello di nostra donna chogli usciuoli
1ª lettiere grande di braccia vi
1° sacchone mezzo rosso
1ª choltricie
ii pimacci

[fol.440v]

1ª choltre sottile vecchia di braccia vii
1ª sargia rossa dipinta buona di braccia viii
ii chassapanche a iii serami l'una a piè di detto letto
1° lettuccio
1° materassino di bordo
1ª choltruccia biancha a detto letuccio
ii ghuanciali, 1° picholo e 1° grande
1° tapetaccio
1° zenzienere in tre pezzi dipinto
iii libre di riefe di più ragioni
1ª libra di banbagia dipinta
lv braccia di panno lino in una piazza
xxviiii° braccia di panno lino fine in una peza
v braccia di panno lino in dua charegli
vi isciughatoi in uno filo sottili
vi isciughatoi sottili in dua fili
iiii° bende da donna
ii isciughatoi verghati fini grandi
1° isciughatoio fine verghato
v isciughatoi grossi verghati in un filo
iiii° isciughatoi grossi in un filo
v benducci in uno filo
vi benducci fini in uno filo
ii federe belle nuove lavorate
ii mutande di Ghabriello nuove

xviii isciughatoi in uno filo
v chamicie di m[on]ᵃ Mea
viii chamicie di Ghabriello
ii bandinelle rotte di braccia iii l'una
1° sciughatoio nuovo grosso e grande
ii federe vecchie
1° isciughatoio grosso da piedi
ii invoglie da mano
ii bende, 1ᵃ nuova e 1ᵃ vecchia
1ᵃ cintola d'ariento in fetta rossa di Piero
1° farsettino di veluto azurro
1ᵃ giornea di domaschino frapata
1ᵃ cioppa paonaza a maniche a burategli frapata e foderata di panolino rosso
1ᵃ ghamurra rossa foderata di pelle bianche
1ᵃ cioppa isbiadata a maniche a burategli foderata di pelle sardesche
1° paio di chalze dovise bianche e nera
1° paio di chalze nere

[fol.441r]

1° balzo a poponi di puzole chon chochuzolo di chermusi pieno di chopette d'ariento
1° chapuccio rosato frapato
1° chapuccio verde frapato
1ᵃ ciopetta mormorina
1ᵃ ghamurra chon xxxvii bottoni d'ariento di m[on]ᵃ Mea
v½ libre d'accia fine di panata
1ᵃ tazziera di chuoio entrovi più libri
1° libricciuolo di Nostra Donna choverto di panno lino biancho
1° libricciuolo di Nostra Donna choverto di valescio azuro bello
1° tabernacholuzzo di nostra donna bello che si rinchiude
1° paio di lenzuola a teli iii½ di braccia vii l'uno
1ᵃ segiola forata
xxiiii° pezze di panno bianchette fini d'Inghilterra
1ᵃ sargia a rosette di braccia vii½
1° pezzo di nuoglia di braccia iii
ii bacini d'ariento chol'arme chon cimieri di smaltati } di peso di libre xiii oncie viii
ii orciuoli d'ariento chol'arme } in tutto el detto ariento
1° mappo d'ariento chol'arme }
iiii° tazze d'ariento }
xii forchette d'ariento a liopardi cholla chasa biancha
1ᵃ cholteliera chon ii choltella grandi e ii choltelini chon ghiere dopie d'ariento ismaltati chon ii chucchia[i] e ii forchette d'ariento
xii chucchiai d'ariento nuovi chon brancha di lione chon una palla in mano cholla chasa biancha
vi chucchiai vecchi d'ariento

1ª choltelessa chon ghuaina nera fornita d'ariento

1ª cintola in setta rossa di Ghabriello chon puntale e fibia e Lviiiiº ispranghe a. o. d'ariento

1ª cintola d'ariento di Ghabriello chon fibia e puntale e l ispranghe a rosette

1º paio di lenzuola da parto chon reticielle dopie lavorate a teli iiiiº l'uno di braccia viii l'uno

Lxxx braccia di pano lino

Lxxxx braccia di pano lino sottile

cxl braccia di pano lino sottile

L braccia di pano lino in pettinella grosso

c braccia di pano lino sottile

clx braccia di pano lino sottile

cxx braccia di pano lino sottile

xxviiiiº tovagliolini nuovi in uno filo

xii isciughatoi grossi in uno filo

[fol.441v]

xxv isciughatoi da chapo } in uno filo

vi isciughatoi grandi di chapo }

xxii benducci grandi

xii benducci grandi e xxii piccholi in un filo fiorini v in grossi e piccolo e quatrini ebe m[on]ª Mea

1ª cintola in fetta rossa di grana chon puntale e fibia e viii ispranghe e viii cingnitoi ismaltati d'ariento dice fu di Meo de Rosso disse gli rimase per cierti danari

1º forziere entrovi queste chose

1ª tovaglia verghata a chapitinti usata di braccia xi

1ª tovaglia verghata a buchi usata di braccia viii

1ª tovaglia verghata a buchi usata di braccia viiiiº

1ª tovaglia a buchi usata di braccia vi½

1ª tovaglia a buchi usata di braccia viiiiº

1ª tovaglia sottile a buchi usata di braccia x

iii tovagliette nuove in un filo di braccia v l'una

1ª tovaglia a buchi usata di braccia viiiiº

1ª tovaglia a buchi usata di braccia viiiiº

1ª tovaglia verghata a chapi tinti

ii mantiletti verghati da parto di braccia ii½ l'uno

ii mantiletti a buchi da parto di braccia ii½ l'uno

1ª ghuardanappa a chapi tinti usata di braccia x

1ª ghuardanappa a chapi tinti usata di braccia viii

1ª ghuardanappa a chapi tinti a buchi vecchia di braccia viii

1ª ghuardanappa usata a buchi di braccia viiiiº

1ª ghuardanappa usata a buchi di braccia vii

1º mantile da parto verghato di braccia iii

1ª ghuardanappa a buchi buona di braccia viiiiº

vi ghuardanappe in uno filo in tutto fi braccia xlviiiiº

ii ghuardanappe nuove in un filo di braccia xx in tutto
1ª ghuardanappa nuova a chapi tinti di braccia x
ii ghuardanappe nuove in un filo a buchi di braccia xiiiiº
1ª ghuardanappa nuova a buchi di braccia viiiiº
vi tovaglie nuove a buchi in tutto di braccia xxxiiiiº
ii tovagliuole chapitate a buchi nuove
ii tovagliuole nuove a buchi di braccia vi in tutto
iii tovagliuoli grossi in un filo nuovi
1ª tovagliuole chapitata a chapi tinti vecchia
vi tovagliolini a 1ª vergha nuovi in un filo
ii tovagliolini nuovi verghati
1º tovagliolino nuovo verghato
1º tovagliolino grosso

[fol.442r]

1ª cioppa di veluto in grana	} porto indosso messer Bartolomeo ala sopoltura
1º chapuccio e ghuanti in grana	}

1ª chassapancha a ii serami
iii paia di chalze nere di Ghabriello
ii chapucci neri foderati di panno bianco di Ghabriello
1º chapuccio monachino di Ghabriello
ii chapucci di paonazo di Ghabriello
ii berette a agho pichole di grana
1º chapuccio bigio vechio tristo di Ghabriello
1ª chortina vecchia rotta
1º descho da donna di parto
1º schacchiere
1º chapelinaio
1º pezzo di nuoglia
v farsetti di ghuarnello usati
1º chopertoio a gigli chon banda a viti giala e azurra di braccia viii
1º chapuccio nero picholo di Ghabriello
1ª lucierna
1º paio di stadere
1º paio di forbicette pichole
1º legio picholo
1º oriuolo grande d'ore xii
1º oriuolo picholo d'ore 1ª
vi charegli vecchi
1º stocchetto
1ª finestra inpanata
1º forziere al'anticha entrovi queste chose:
1º cianbelotto mazerato isbiadato foderato di dossi di vai loghori a ghozzi
1ª cioppa di zetani foderata di dossi di vai nuova a maniche a ghozi rossa
1ª cioppa mormorina foderata d'angnielini a maniche a parte e strette da donna

1ª cioppa mormorina foderata di puzole a maniche a ghozi a tronba

1ª cioppa rosata rosata foderata di scheruoli chon maniche aperte richamate una di perle e di Piero

1º mantello di monachino vechio da donna e di m[on]ª Mea

1ª cioppa monachina vechia chon manicha asetate di m[on]ª Bartolomea

1º chapello di paglia foderato di veluto nero di piano

1ª fodera di dossi di vaio loghori

ii ghamurini bianchi da portare sopra il farsetto di Ghabriello

1º chapuccio all'anticha da donna richamato a ucciegli a oro

viii chandelieri d'ottone bassi begli

ii piategli grandi	}	
ii piategli mezani	} di stangnio nuovi di peso in tutto di libre xlviii	
xiiiiº schodelini	}	

[fol.442v]

1ª choltre di drappo rossa e verde foderata di panno lino roso usata di braccia vii

1ª choltre biancha lavorata a viti usata di braccia vii½

1º mantello a cespe rosato foderato di pano biancho da donna di parto fine

1º mantelino monachino usato da donna

1º mantello azurino da chavalchare usato di Ghabriello

1º mantello isbiadato usato di peracino

1º ciopetta da fanciulo di paonazo di zanpe loghore

1º ghuarnelino verde a maniche a burategli frapata di vaio richamato di chopette chon maglie dinanzi d'ariento

1ª ciopetta frapata di saia rossa di Piero

1ª choverta da chavallo rossa chol'arme loro

1º stocchetto

1º sacchetto di più ritagli e cintoli di più cholori

1º½ braccio di rosato nuovo

ii braccia di scharlatino fine

1º braccio di paonazzo

ii stricie di panno nero

1º braccio di Perpingniano

1ª beretta biancha all'Inghilese

1º paio di maniche di bianchetta

più pellame

Una manicha e mezo grandi di dossi di vai nuovi

1º mantile vecchio di braccia iii

1º lenzuolo a teli ii½ di braccia v

1º lenzuolo a teli ii½ di braccia vi

1º lenzuolo a teli ii½ di braccia v

1º lenzuolo usato a teli ii½ di braccia v

1º lenzuolo vecchio grosso di braccia v

ii paia di lenzuola a teli iiiiº di braccia viiiiº l'uno

ii chassoni a ii serami
1ª tovaglia vecchia a buchi di braccia iiii°
xxiii libre d'accia dipanata in uno sacchetto
xxii libre d'accia cruda
xlii½ libre di lino alesandrino petinato
xxxii libre di lino fine petinato
iiii° chandelieri d'ottone da torchietti lavorati
xvi libre di chandele di ciera benedette
ii salviere di stangnio
più bulette e spranghe da libri
iii misciroba grandi rotte
ii bacinetti d'ottone
1° uncino da ripeschare secchie

[fol.443r]

1° bacino grande d'ottone
iii predelle
1ª chassetta entrovi berichuocholi
1° rinfreschatoio da maiolicha
xii ischodelle tra pichole e grandi di maioliche
viii orciuoli tra picholi e grandi di terra
iii forzieri al'anticha
1° paio di lenzuola di teli iiii° l'uno di braccia viiii°
ii tovaglie a buchi di braccia xiiii° in tutto
ii mantili grossi di braccia v l'uno
1° mantile grosso di braccia iiii°
1ª tovaglia a buchi vecchia di braccia v
1ª tovaglia a buchi vecchia di braccia vii
1ª ghuardanappa vecchia di braccia vi
1ª ghuardanappa a buchi vecchia di braccia vi
1ª ghuardanappa a buchi vecchia di braccia vi½
1ª ghuardanappa a buchi di braccia vii
iiii° chamicie di Ghabriello
ii chamicie da donna
xiii tovagliolini vecchi
x chanovacci tristi
iiii° tovagliuole vecchie da mano
iii isciughatoi vecchi grossi
iii federe vecchie

La meta per non diviso d'una chonfettiera grande chol'arme e nove forchette d'ariento a
apresso di Ser Giovanni di messer Bartolomeo Panciatichi e chosi raporto Francieschino
di deo famiglio degli uficiali chosi avere detto e chonfessato avere il detto Giovanni.

Notes

1. The privilege was granted on 30 June 1376. See L. Passerini, *Genealogia e storia della famiglia Panciatichi*, Florence (1858): p. 62.

2. See the Online catasto: www.stg.brown.edu/projects/catasto/newsearch/M1427w.html.

Appendix 2

Gismondo di Messer Agniolo della Stufa (1495)
MPAP 179 fols.366r-371v

The ancient Della Stufa family, many of whom had held the highest offices in Florence, were staunch Mediceans. This was vividly demonstrated during the 1478 Pazzi conspiracy when Gismondo played a major role in defending Lorenzo de' Medici from his assailants in the Sacrestry of Florence's Duomo. The bravery displayed by Gismondo was immortalized in Angelo Poliziano's (1454–94) account of the conspiracy where he was described as 'a valiant young man, bound to Lorenzo by many ties of love and duty since childhood'.[1] The closeness between the della Stufa and the Medici is also indicated in this inventory where among the books and writings detailed in Gismondo's study (*schrittoio*) a provision is listed regarding the guardianship of his and Lorenzo de' Medici's children.[2] The palace detailed in the inventory is located in Piazza San Lorenzo, a short distance from the Medici Palace. Still extant, the fourteenth-century della Stufa palace with its ground floor rustication and loggia on the upper storey was greatly enlarged during the seventeenth century by adjoining newly acquired properties.

[fol.366r]

mcccc°lxxxxv

Rede di Gismondo di messer Agniolo della Stufa

Questo dì 13 di settembre 1495 e detti uficiali di pupilli e adulti del commune di firenze presono e acettarono la tutera per tenpo chura de figliuoli e rede de di Gismondo di messer Agniolo della Stufa perche non testo e per rimessione di Luigi e Pandolfo fratelli e figliuoli di messer Agniolo della Stufa e di m[on]ª Chaterina donna fu di detto Gismondo e per altre ragioni e chagioni referitozi prima e dette uficiali agli ordini chonsueti de loro uficio chome de tutti fu roghato ser Bastiano d'Ant[oni]° Forixi notaio al detto uficio sotto detto dì []

E questo da ppiù chome si chura si fara richordo e aventario di tutti e beni mobili e imobili richordi e altre chose apartenente a detta redita

Pupilli

Gismondo di Gismondo detto d'eta d'anni 6 incircha
Tita di Gismondo detto d'eta d'anni 11 incircha e marittatta {in different hand}
Albiera di Gismondo detto d'eta d'anni 9 incircha

[fol.366v]

[col.1]

Libri che si truovono nello schrittoio cioé

1° libro in charta pechora chon asse choverta paghonazze chiamato Tito Livio
1° libretto delle Chonposizione della Luna choverta de quoio paghonazzo
1° libretto di Ghalieno in charta pechorina
1° libro di messer Glionardo d'Arezzo e titolato Bellu Ghottorum
1° libro in charta banbagina choverta paghonazze titolato De Rerum Nature
1° libretto di mesprana in charta pechorina vecchio e non è titolato
1° libro di Priano detto Epitome in charta pechorina e quoio rosso
1° libro di Ghiribizzi di Giovanni Betti choverta rossa
1° libro di charta pechora titolato Di Senetute
1° libro in charta banbagina choverta paghonazza sopra la Retoricha
1° libro titolato Vanbolisstario in charta pechora choverta rossa
1° libro in charta pechora rosso titolato Salustro
1° libro de Reghole di messer Guid'Ant[oni]° Vespucci in charta pechora choverta rossa
1° libro in charta pechora paghonazza titolato Trionfi del Petrarcha
1° libro d'asse in charta pechora titolato Orazio d'amio

1° libro chiamato Stano di bardos in charta pechora choverta paghonaza
1° libro in charta pechora choverta paghonazza titolato le Parabole di Salamone
1° libro in charta pechora di Vochabolexi
1° libretto in charta pechora titolato Tibullo e altre opere
1° libricino di Nostra Donna grando schritto alla fiammingha
1° libricino in charta pechora choverta azzurra de Trionfi del Petrarcha
1° libricino in charta pechora choverta paghonazza De sono Scipionis
1° libricino in charta pechora choverta rossa chiamato Erotimate in grecho
1° libricino titolato Erotimate greche
1° libricino di sette Salmi Penitenziali
1° libro in charta pechora choverta rossa d'Ocamo francho
1° libretto in charta pechora choverta paghonazza chiamato Sutonio
1° libretto in charta pechora choverta rossa titolato la Boccholicha
1° libro d'asse in charta banbagina chiamato Proemio sopra Vergilio
1° libro in charta banbagina e de in forma choverta rossa chiamato Giuliamo consolo
1° libro in charta banbagina choverta rossa chiamato Quintiliano è de Risstituzioni
1° libro rosso in charta pechora espone chiamate le Tregiende
1° libro rosso in forma chiamato Bartolo Fenzio al Sassetto
1° libro rosso in forma chiamato Guistiniano Sstrolagho
1° libro in forma choperta rossa chiamato le Reghole di Nicholaio Peretto
1° libro in charta pechora chiamato Fiontimio
1° libro grande choverta verde in forma chiamato Prima Deccha
1° libro grande choverta rossa in forma chiamato in Chanpana
1° libro grande choverta rossa chiamato Cimondi
1° libro grande choverta rossa in forma chiamato Tito Livio
1° libro grande choperta bigia in forma detto le Pistole di San Girolamo secunde parte

[col.2]

1° libro grande choverta azurra in forma chiamato le Pistole di San Girolamo prima parte
1° libro choverta bigiella in forma chiamato Chroneteri di Ceseri
1° libro choverte gialle in charta pechora chiamato tutte l'Opera di Vergilio
1° libretto choverta azzurra in charta pechora chiamato Marcho Velio de Republiche
1° libro rosso in charta pechora chiamato Orazio francho
1° libro choverto di zetani verde in charta pechora chiamato Basilio Parmensis
1° libro in choverta paghonazza in charta pechora chiamato Terenzio
1° libro chiamato Latanzia Firmiano choverta gialle in charta pechora
1° libro choverta gialla in charta pechora chiamato la Retoricha di Natrone
1° libro choverte paghonazze in charta pechorina chiamato le Pistole di Tulio
1° libro paghonazzo charta pechora chiamato Marziale
1° libro choverta rossa in charta pechorina chiamato Terenzio
1° libro choreggie rosse in charta pechorina chiamato Satire di Juvinale
1° libro choverta rossa in charta pechora chiamato la Nischulanti di Cecerone
1° libro choverta rossa in charta pechora chiamato Fallare
1° libretto choverta rossa in charta pechora del Salmi Penitenziali

1° libretto di Regholuzze
1° libro grande nero in forma chiamato le Pistole di San Jeronimo
1° libro simule chiamato Prima parte di dua Pistole
1° libro choverta rossa in forma chiamato de tutti e Profecti
1° libro choverta rossa in forma chiamato Choissts
1° libro choverta paghonazza in forma chiamato libro de re []
1° libro choverta rossa in forma chiamato Testamento Nuovo
1° libro choverta biancha in charta pechorina chiamato la Retoricha
1° libro in charta banbagina choverta paghonazza chiamato Lioredo Aretino a Ant[oni]°
degli Albizi
1° libro in charta pechora choverta rossa chiamasi Luchano
1° libro in charta pechora overo rossa lavorate di sopra con serrami a buletta d'ariento
chiamato Lorentane Firmiano messo in una chassetta a uso di libro
1° libro leghato in charta pechora in forma chiamato le Pistole di San Pagholo
1° libro leghato in charta pechorina in forma chiamato Viviano
1° libro leghato in charta pechora in forma chiamato Marziale
1° libro leghato in charta pechora in forma chiamato a X Batista Alberti Edifichatorio
1° libro leghato in charta pechora in forma chiamato Auli Gilio
1° libro leghato pechora in forma chiamato l'Orazione di Cecerone
1° libro leghato in detto modo del Vichariato di Lari
1° libro di leggie in charta pechora in forma chiamato Racholto di detti
1° libro leghato in charta pechora in forma chiamato le Pistole di Frate Ambruogio

[fol.367r]

[col.1]

1° libro leghato in charta pechora in forma chiamato Sermoni di Santo Lione Papa
1° libro leghato in charta pechora di mano di Gismondo tratti di Priano
1° libro leghato in charta pechora tratta di Medicine di Chavagli
1° quadernone a veduti a 3 Maggiori
1° libro nero di dare e avere di messer Agniolo
1° libro leghato in charta pechora in forma chiamato Marcho Marone e Nono Marcello
1° libro di mano di Pand[olf]° di dare e d'avere tenuto alla morte di messer Agniolo
1° libro choverte rosse in charta banbagina inpone chiamato le Pistole di Rezente overo
di Cecerone
1° libro di Gismondo dove teneva e fatti de' fitti della Badia d'Agniano di mano di
Charlo del Grosso e sua
1° libro de chonti delle podessterie di Pixa
1° libro leghato in charta pechora in forma chiamato Lorenzo Vale
1° quadernuccio d'inventario quando torno da Pixa
1° libro leghato in charta pechora in forma chiamato la Felipicha
1° libro leghato in charta pechora in forma chiamato Terenzio
1° libro leghato in charta pechora in forma chiamato De Uficis tamiane e Senetuti e
Paradosse
1° libro rosse di dare e d'avere di messer Agniolo

1° quadernuccio di Vochabolexi

1° xltro simile

1° libretto in forma overo in charta pechora e Meditazione di San Aghostino

1° libretto in forma chonverta nera pechora chiamato Epitassi de' Munimenti di Roma

1° libro choverta di chaverto in forma chiamato Juivinale

1° quadernuccio picholo di ragioni

1° libretto d'Orazione de Ponpeo

1° quadernuccio di sopra schritti

1° Bibia in charta pechora in picholo vilume venne di Spagnia

1° libretto choverta di chuoio verde brune charta pechorina tratta De Ripubliche

1° libro choverte paghonazze in charta banbagina titolato Lionardo Aretino

1° libretto choverte paghonazze charte pechora chiamato sceluziumi umane nature

1° libro choverto d'asse verde in charta pechora Prologho de Rendizionibus

1° quaderno dov'è inventario quando ando a Lari

1° libro choverte charta pechora di mano di Gismondo di detti tratti di più debitori

1° libro choverte charta pechora in forma chiamato Diomedi Anbri

1° libro choverto di charta pechora in forma che tratta de re De Filentate Regnio

1° libretto choverte di charta pechora in forma picholo di Frate Cherubino volghare

1° librettuzzo in onore delle Albiere in charta pechora e leghato in charta pechorina

1° libretto choverte verde che non è schritto

1° libro avere di charta pechora in prima in charte banbagina la Fipriche di Cecerone

[col.2]

1° quadernetto dove è scritto le chopie delle chose toccha nella divixa di Gismondo fece con fratelli alla morte di messer Angiolo

1° libretto choverte di chaverto di dare e avere tenuto per mano di Giorgio da Barbissio fattore della Badia d'Agniano

1° libro scritto memoriale charte segnato A de chonti quando fu Podesta di Pisa 1486

1° libro choverta di charta pechora quando fu Podesta di Pixa l'an[n]° 1486

1° libretto verde in charta banbagina

1° libretto in charta pechora chiamato cho l'arme in sulla choverta

1° libretto schritto in forma di Bart[olome]° Fonte a L[orenz]° de' Medici

1ª carta pechora dov'è il chontratto delle chonpere del podere di Chapalle

1° libretto chon choverte di charta pechorina schritto in charta pechora di chontratti della Badia d'Agniano

1ª carta pechora dov'è un lodo di Giovencho della Stufa

1ª carta della chonpre in perpetua di beni di Santa Mª a Chastagniuolo da l'Arte della Lana

1ª carta pechora della mance pagione fatte di Gismondo per messer Agniolo

1ª provisione fatta per gli oportuni chonsigli per il ghoverno de figliuoli di Gismondo e Lorenzo de' Medici

1ª scritta che chontiene l'achordo chon Gismondo e Nicholo e Domenicho d'Andrea di Lorenzo della Stufa pel podere da Chapalle

1ª schritta che chontiene 1° richorso auto Gismondo del podere di Chapalle agli uficiali del Monte

1ª schritta di chonto di sentenzia

1ª chopia di mano d'Ant[oni]° della chonpagnia del Batiloro

1ª schritta cioè chopia della chonpagnia del nome di Gherardo Paghanelli chon Bart[ol]° Pandolfini all'Arte della Seta

1° libretto in choverta di chaverto schrittovi uno richorso degli uficiali del Monte della posizione di Chapalle cho Nicholo e Domenicho d'Andrea della Stufa

1ª fede chome m[on]ª Chaterina donna fu di Gismondo pagho la ghabella de l'avere preso il podere di Chapalle

1ª schritta di un'obrighazione di più chose e fini Nicholo d'Andrea della Stufa e Domenicho suo fratello e m[on]ª Lena

1ª schritta di mano di chanbio di Manno Petrucci fatta chon m[on]ª Chaterina d'An[oni]t° Paghanelli

1° sacchettino di pannolino introvi 1ª poliza d'Ant[oni]° Paghanelli debitore di m[on]ª Chaterina di florini 24 d'oro in oro

1ª poliza di florini 10 la[rga] d'oro in oro e lire 100 di quattrini bianchi e soldi 10 piccoli e più in detta poliza fl.23 la[rga] d'oro in oro auti da detto suo lavoratore a Chapalle

1ª poliza di mano d'Ant[oni]° d'Andrea della fine e choncessione del podere di chapalle e più 2 poliza che non portano molto

2 quadernucci di mano di m[on]ª Chaterina segnato A uno dare e avere e l'altro di richordi

74 schritte de più chonti e richordi e chontratti e piente e fedi e altre chose segnato da n° 1° a n° 74 soprascritte da Franc[esc]° da Charigi

1° sacchetto mezzano pieno di quadernacci e lettiere fede e chonti di più ragioni e altre polize

1° libro nero segnato 2 il chiamato memoriale di charte 336 schritto insino a charta 331 apartenente tutto a detto Gismondo

[fol.367v]

[col.1]

1° libretto segniato B choverta di chaverto di detto Gismondo in fogli mezzani debitori e chreditori schritto di suo mano

1° libretto paghonazzo S[egnato] A choverto di quoio paghonazzo di charte 192 schritto di mano di detto Gismondo in sino c[harte] 112

Sopra al'antichamera

1° bacino grande di piedistallo

1ª caldaia di rame di braccia 1° ½

1° catino grande d'ottone col piè

2 secchie da pozzo nuove che amendue di ferro

1ª chatena di ferro stagniate da pozzo di braccia 15

1° tozzo da buchato di rame nuovo

più cignie da letto e fune

2 torciere dipinte alla divixa di chaxa

2 caldani di terra
1° staio di ferro
1° catino di rame grande
1° horciuolo di rame grande
1° descho di noci cho' serrami
2 telaetti con fighure nere
2 zane
2 ronchole
1ª zana da fanciulli
1° saccho pieno di sstoppa fine
2 zane mezzane
16 ghuanciali tra grandi e picchloli e 1ª vote
1° cenbolo
1° paio di forzeretti a uso di letto entrovi
1° cortinagio di bocchaccino in più pezzi
1° bacinuzzo d'ottone picholo
1° paio di forzeretti bianchi entrovi
24 saccha fra grande e mezzane
2 coltricette da zana
1ª capanuccia chon più agnioli di charta
1° candeliere di ferro d'apicchare
1ª figuretta di bronzo dorate

Sopra al'antichamera

7 lucerne nuove
3 catelane cholle ghuaine
1° falcione chon ghuaina fornita d'ariento
1° pugnialetto chon puntale d'ariento
1ª mazza di ferro a martellino
14 chanpanelle di ferro istagniate
1° paio de formi da palottole da cerbottana
1ª cassetta grande dipinta
1ª mezza schatola biancha da salmerie
2 broche di rame
1° chatino grande da lavare piè di rame
1° staio de ferro tristo
2 catini di rame usati
1° paio di sstivali neri
1° paio di sstivaletti gialli usati

[col.2]

4 morse da chavallo di più sorte
2 paia di sstaffe alla franzese
1° fornimento di mulo di panno nero

1° fornimento da chavallo nero
1° fornimento da chavallo rosso
1° paio di scharpette usate
1ª feriera chon chiovi
4 pezze di porfidi picholi
2 piè d'archolaio
2 saccha e 2 sacchetti
1ª broccha di rame chon choperchio nuova
1ª teghia grande grande di rame
1ª teghia di rame mezzana
3 palette da fuocho
1° paio de formi da cialdoni
1° paio di molli chon presa d'ottone
1ª teghia picchola di rame
1ª teghia di rame mezzana
1ª paletta grande forata di ferro
1° forchone di ferro nuovo
1ª pala di ferro usata
1° feriera rossa chon fornimenti
1° paio di palette apicchate insieme
1° paletta forata di ferro
1° chorbello chon 3 fiaschi grandi
1° armario a 3 palchetti entrovi
più vetri di più sorte e d'altre ragioni
1° paio di forbice di ferro grandi
1° pezzo di nastro larghi di refe di braccia 16
2 piatellini di maiolicha
1° profumiere di maiolicha
1ª chassetta da rachore oro filato
1° channone da fare archomenti

Nella antichamera

1° quadretto dipinto la tessta di Nostro Signore
1° quadretto la morte di San Girolamo
1° quadretto dov'è la Passione di Nostro Signore
1° Davit in pionbo
1ª testta di rilievo di Christo di giesso
1ª lettiera chon testa choperta di noci e tarsia di braccia 3½ incircha
1 testa di giesso di terra dipinta
1° sacchone in dua pezzi
1ª materassa di federa cho' lana
1ª materassa di bordo cho' lana
1ª choltrice nuova chon piume S°
2 primacci a detto letto
1° paio di lenzuola a 3 teli usate

1º panno chatelanescho biancho usato da letto
1ª choltre biancha di tovaglie chon frangie intorno
1º lettuccio choperto di nocie a tarsia a chassoni chon predella da ppiè
1º materassino di bordo cho' lana
2 ghuanciali tristi alla brochata
1ª choperta da lettuccio di banbagino
1º ghamurino biancho di banbagino
1º chassettino di noci da fanciulli
6 paniere di veretice di più sorta

[fol.368r]

[col.1]

8 schudiciuoli in tela chol'armi
2 schudicciuoli chol' armi
1º ½ charello a schacchi
5 chunfioni di ghuarnello e 1º paio di mutande
1ª panieretta di veretice da serrare chon uno chovare di domaschino biancho
1º beretta di chermisi da donna
2 schatole d'acero chon più lavori entrovi
1º paio di ghuanti
1ª scharsella di raxo usata chon parecchi perle minute entrovi
1º tabernacholino dipinto introvi
1º messer Domenedio chon una vessta di brochato a'oro chon chorona
1ª schatola introvi certi richami
1º paio di sproni dorati da donna d'ottone
1ª chassetta introvi 1ª Passione di Christo lavorata alla tedescha chon più lavori
1ª schatola lungha introvi
2 libre incircha di zafferano
1º forzeretto dipinto chol'arme di chasa e Paghanelli
più chosette da fanciulli
2 paia di ghuanti da fanciulli
1º chordiglio da chapelli cho' lavoro
2 federe da ghuanciali pichole
1ª berettuzza da brocchato d'oro
1ª schatola cho lavori cho' libre 1ª da pepe inchirca
1º chalamaio d'arcipresso chon più lavori
1ª schatoletta dipinta alla moresca introvi
4 anpolette d'olio di spigho
1º lucernieruzzo di ferro chon piè di marmo nero
1ª setola chon più lavori al'anticha
4 quarti di valoscio rosso da ghamurra
1º chapello di trippa biancho chon chordoni a rose d'oro e altri lavori da uomo
1º taglio di raso di chermixi di braccia 3 incircha
2 teli di lenzuolo spicchati

1º asso chon sette teste lavorato in un sacchetto
1º sciughatoio alla morescha lavorato le tesste
1º sparviere da letto da forzeretti
1ª turcha di pannolino chon cholare di seta
4 sciughatoi da chassoni usati
1º chamiciotto di panolino da donna
1ª chamicia usata da donna
1ª chasetta d'albero appie della finesstra introvi
1º paio de forbici de ferro
1º panteruolo d'avorio
1º sugiello e punteruolo chon ariento
1ª paniera di veretice chon più chosette da fanciulli
1º paio di lenzuola nuove a 3 teli
4 chamice da donne usate
4 chamiciotti da fanciulli
1ª bolgietta usata
3 forzeretti da soma dipinti introvi
1º sacchettino chon oncie 6 di pepe sodo
1º paio di lenzuola usate da fanciulli a 3 teli
1º chamiciotto di bocchacino disfatto da donna
1ª tovaglia chapitata chon verghe e buchi fine
30 braccia di reticella da ghuanciali
1º chamiciotto a ghamurra usato di brocchaccino
1º sciughatoio alla morescha
3 sciughatoini piccholi

[col.2]

16 federe di più sorta da ghuanciali
2 benducci nuovi da donna
2 chamice triste
1ª federa chon refe e 1ª matassa di seta chruda
1ª tovaglia e 1ª ghuadonappa di rensa di braccia 8 incircha l'una
1ª tovaglia e 1ª ghuardonappa di rensa usata di braccia 12 circha l'una
1º mantile da parto alla parigina usato
2 bandinelle da mano usate
3 mazzi d'accia biancha e matasse di libre 8 oncie 8 da lenzuola
1º paio di lenzuola usate a 3 teli
1ª chassettina chon più chose cioe chalze e panuzzi di fanciulli usati
1ª chasetta d'albero di braccia 3 incircha entrovi
13 libre di lino di pezzuoto fine pettinato

Nel necessario

1º paio di lenzuola a 3 teli buone sucide
2 teli di lenzuolo vecchi

1ª bandinella da mano usata
1º grenbiule da donna e 1º sciughatoino da chasa usato
1º stagnione da utriacha chon un pocho
1ª schatolina rossa e più in uno armario più fiaschi e fiaschetti e alberelli

In chamera di Gismondo

1ª Vergine Maria dipinta in tela
1º telaio dipinto entrovi una Trinita
1º quadretto entrovi dipinto San Gismondo
1º tondo di legniame ingiessato
1º San Giovanni di rilievo di giesso
1ª lettiera di braccia 5 incircha chon chornicione di noce e tarsia chon predelle basse
da ppiè
1º sacchone in dua pezzi
1ª materassa di federa cho' lana
1ª materassa di bordo e tela rossa cho' lana
1ª choltrice chon federa amezzata chon penna di libre
2 primacci a detto letto di libre
1º paio di lenzuola a 3 teli usate
1º choltrone pieno di banbagia usate
1ª sargia rossa dipinta usata
2 ghuanciali e 1º ghuancialuzzo chon federe
1º lettuccio choperto di noci e tarsia a 2 serami di braccia 5 incircha
1º materassino di bordo pieno di lana usato
1º tappetto piloso di braccia 6 incircha all'anticha
2 ghuanciali alla brocchata di chuoio usati
4 sciughatoi e chapellinaio usati

Nel chassone di detto lettuccio

1º bacino d'ottone alla domaschina chon più lavori
1ª misciroba d'ottone alla domaschina chol'arme di…

[fol.368v]

[col.1]

6 chandelieri bassi alla domaschina
1º bacino d'ottone chol'arme di chasa e degli Spini
1º bacino d'ariento chon più lavori e chol'arme di chasa
1º bacino d'ottone chol'arme di chaxa e de' Paghanelli
1º bacino d'ottone usato chol'arme di chaxa e de Ridolfi
26 libre di lino pettinato
2 micirobe d'ottone e chol'arme di chaxa
18 chandellieri d'ottone di più sorte

2 brocche de rame mezzane chol choperchio

1° spiede nuovo

1° paio di staffe invernichate

4 pugnialuzzo e 1° choltello chon ghuaina e choltelli

4 paia di sproni di più sorte

1° specchio dorato

1ª lancettina di ferro

1ª granatuzza leghata alla piana

2 scharselle vecchie alla tedescha

1° paio di sstaffe da fanciulli

5 pezzi de porfido e serpentino

2 pezzuoli di bronzo

1° ghagliardetto chol'armi

1ª bolgietta di chuoio alla tedescha

6 borsette di rame dorate

4 chanpanelle d'ottone dorate chon rosette

1ª chanpanella grande dottone d'orata

2 salisciendi de ferri chol loro fornimenti

2 girelle d'otone

4 paia di molette d'otone

1ª girella d'otone a uso di gharucholina

3 chanpanelle

42 schodellini grandi di più sorte di libre 40 di stagnio

33 piatelli piani di più sorta di libre 50

9 piatelli di più sorte di libre 31

18 schodelle di sttangnio di libre 28

1° rinfresachatoio d'ottone chon più lavori alla domaschina

1ª choltelliera chon tre choltelli cholle maniche d'ottone inarientati cholla ghuaina

1ª predella alta da parto a uso de porfido dipinta

1ª predellina forata

2 picchole da fuocho

2 segiolette d'asse

1° schaldaletto di rame

1° paio di molli paletta e forchetta

1° paio d'alari d'assi di libre 26 incircha

1° orciuolo di rame mezzano

1° libriccino di Salmi e altre Orazioni

1ª chassetta di noci d'uno braccio

1° paio di forbici

3 federe usate

1° grenbiule lino da donna

2 pezze e 2 sciughatoini

1° robettino di mischio foderato chassetoni bianchi

1° ghuarneletto chon fodera di taffettà rosa

[col.2]

1° chandelliere d'ottone cholla lucerna
1° orciolino di rame piccholo
3 chamice e uno leghato tagliate e non chucite
3 chamice da donna usate
1° rinfreschatoino da maiolicha
2 sciughatoini e 2 pezze e 1° sacchetto da fanciuli [] uso
1° pezzo di bordo di materassino di braccia 45 incircha
1ª ghamurra di panno nero logra da donna
1ª cioppa di fregio nero foderata d'indisia biancha
3 ghuanciali da letto sanza federe
1° mantile alla parigina di braccia 8
1ª paniera con un cerchio
1ª chassettina d'arcipresso chon più fazzoletti da chapo e benduci
1° leghato d'aghora sottile chon verghe bianche
1° schanello dipinto introvi
1ª schatola nuova entrovi
1° libricino di Nostra Donna chon fibia d'ariento
1° sciughatoio da donna sottile chon verghe bianche
2 fazzoletti da chapo chon verghe bianche
2 sciughatoi da donna sottile chon verghe bianche
2 veletti de fiori sottili
½ veletto di fiori sottile
1° fazzoletto sottile da donna da chapo
1° sacchettino di taffettà chon grofani
1ª chassettina pichola chon chuffie da fanciulli
1° mantile usato di braccia 4 incircha
3 chassoni appichati insieme chon ispalliera di noci in un de' quali sono le'nfrascritte chose
1ª choltre grande biancha chon gigli e più lavori da letto
1ª choltre biancha e altro lavoro da letto
1° ghuanciale di chordovano rosso
4 choverte da muli alla divixa di chaxa e non finite
1° tapeto grande fine di braccia 7 incircha
1° tapeto fine di braccia 4
1° usciale d'arazzo con 3 fighure soppannato
1° mantello da vedove di saia milanese
1ª ghamurra di panno vecchio cho maniche di rascia
1ª cioppa di panno nero usata fine da vedove
1ª cioppa di panno nero fine usata da vedova
1ª ghamurra di panno mossa voliere maniche nere
1° sciughatoio grande chon verghe nere usato
2 ghamurette di saia verde brune delle fanciulle sanza maniche
1ª chotta di taffettà d'ore con maniche di domaschino bianco della Albiera
1ª chotta di taffettà verde delle Albiera cho maniche alla perchata

1ª chotta di raso alessandrino cho'maniche di veluto alessandrino
1ª chamurra di panno paghonazza della Tita cho maniche di terzanello
1ª robetta di panno tane da fanciulli
1º chamurino di suentone paghonazzo sanza busste
1º pitoccho di fregi da fanciulli
1ª saia di panno paghonazzo foderata parte di taffettà verde
3 farsettini, 1º verde, 1º azzuro di seta e 1º di ghuarnella

[fol.369r]

[col.1]

2 chappeletti, 1º rosso e 1º nero da fanciulli
1ª chaperuccia usata paghonazza
2 sciughatoi grandi da chassoni
1ª channa e 1º passetto da misurara
1º choltrone di banbagia da letto grande
1ª choltre da lettuccio grande chon lavori bianchi
1º choltrone chon banbagia da letto piccholo
1ª celone grande verghato da letto da serve
1ª sargia verde dipinta usata
1º ghamurino sanza busti usato
1ª ghamurra di fregio da donna usata
1ª cioppetta di rascia da donna vedove buona
2 ghamurre di saia azzurra delle fanciulle
1ª giornea alla divixa al'anticha di chasa
1º chapello di pelo nero
1º chappello choperto di saia
2 ghamurini da fanciulli 1º bigio e 1º azzurro
1ª chovertina nera usata da donna
2 sciughatoi grandi verghati di nero usati
1ª ghamurra usata nera da donna
3 braccia di tela di buratello
1º leghato di foderaccia e pezzi di ghamurinaccio
1º panno biancho chavalescho da letto
1ª choltre da letto grande a rose e altri lavori belli in biancha
1ª choltre da letto grande sottile chon più lavori biancha
4 lenzuola a 3 teli ½ l'uno grandi usate
1º lenzuolo di pannello sottile a 5 teli buono
1º lenzuolo da parto a 4 teli usato
1º paio di lenzuola a 3 teli usate
1º lenzuolo a 3 teli usato piccholo
4 lenzuola a 2 teli ½ l'uno buone da forzeretti
1º lenzuolo a 2 teli ½ usato da lettino
1º mantile nosstrale di braccia 4 sottile
1ª tovaglia alla parigina di braccia 10 incircha usata

1ª ghuardonappa alla parigina di braccia 10 incircha usata
1ª tovaglia alla parigina usata di braccia 8 incircha sottile
1ª tovaglia alla parigina sottile di braccia 8 incircha usata
1ª ghuardonappa alla parigina di braccia 3 incircha usata
1ª ghuardonappa alla parigina col verghe usata di braccia 12 incircha
1º mantile nosstrale di braccia 4 usato
1ª ghuardonappa alla parigina di braccia 8 incircha usata sottile
1ª ghuardonappa alla parigina sottile di braccia 8 incircha usata
1ª tovaglia alla parigina sottile di braccia 8 incircha usata
1ª tovaglia alla parigina sottile di braccia 8 incircha usata
1ª tovaglia alla parigina sottile di braccia 8 incircha usata
1ª tovaglia alla parigina sottile di braccia 8 incircha usata
1ª tovaglia alla parigina di braccia 7 incircha usata
1ª tovaglia alla parigina fine di braccia 9 incircha usata
1ª tovaglia nosstrale chon verghe nere di braccia 10 incircha usata
1ª tovaglia nosstrale chon verghe nere usata di braccia 12 sottile
1ª tovaglia alla parigina di braccia 13 incircha usata
1ª ghuardonappa nosstrale sottile di braccia 14 incircha usata
1ª ghuardonappa alla parigina di braccia 7 incircha usata
1ª ghuardonappa di rensa grossa di braccia 8 incircha
1ª ghardonappa alla parigina di braccia 8 incircha usata
2 ghuardonappe alla parigina di braccia 4 incircha l'una usate
1º lenzuoletto da lettino usato e da una chredenziera
1º mantile nostrale usato di braccia 4

[col.2]

1ª tovaglia nosstrale di braccia 6 usata
1ª tovaglia nosstrale chon buchi vecchia di braccia 6 incircha
1ª tovaglia nosstrale di braccia 7 usata
1ª tovaglia nosstrale usata di braccia 5 incircha
1ª tovaglia nosstrale usata di braccia 7 incircha
1ª ghuardonappa chon verghe e buchi nosstrale di braccia 10 usata
1ª tovaglia alla parigina buona di braccia 8 incircha sottile usata
1ª ghuardonappa nosstrale sottile di braccia 10 incircha
1ª ghuardonappa sottile nostrale di braccia 9 incircha
6 tovagliolini di rensa grossi in un filo
2 tovagliuole alla parigina di braccia 4 incircha l'una usate
1ª tovaglia alla parigina fine di braccia 9 incircha fine
1ª ghuardonappa alla parigina fine di braccia 9 incircha
1ª tovagliuola verghata chon buchi nosstrale buona
2 tovagliuole alla parigina chon buchi
1ª tovagliuola alla parigina chon buchi usata
10 tovagliolini di rensa usati
4 anvoglie da mano usate
8 chanavacci d'aquaio usati

16 braccia di pannolino nosstrale da lenzuola
26 braccia di pannello stretto biancho
14 sciughatoi chon verghe bianche in un filo da chapo
11 sciughatoi grossi in un filo da ppiè e 1° pezzuolo
1ª tela di pannolino sottile di braccia 110 nosstrale
1ª tela di pannolino sottile di braccia 95 nosstrale da lenzuola
1ª tela di pannolino sottile nosstrale da chamice di braccia 43 incircha
1ª spada e 1° chappello da bereria

Nelle chasse a ppiè de letto

4 sciughatoi sottili da chappellinaio chon lavori sottili
2 sciughatoi sottili chon verghe bianche in un filo d'oro fini
4 fazzoletti in un filo da chapo
2 sciughatoi in un filo sottili chon verghe bianche fine
7 fazzoletti ½ da chapo sottili in un filo
8 fazzoletti sottili in un filo da mano di braccia 9 di dette teli in un filo
5 fazzoletti da mano non filo sottili
15 benducci con verghe bianche in un filo
5 fazzoletti da mano in un filo sottili da chollo e ½
3 benducci grandi in un filo
5 sciughatoi da reticelle da ghuanciali di più lavori
10 matasse di refe bianche churato
1° sciughatoio di più lavori d'oro e seta da battesimo
1ª federa di rete da ghuanciali chon più fazzoletti di più sorte e []
½ sciughatoio di fiore
4 chamice da uomo usate
1° paio di forbice e 1° paio di scharpellini doreti da choredi
3 borse una di raso verde cho'richamo e perle 1ª di raso rossa e 1ª di velluto alessandrino
1ª borsa di velluto alessandrino
1° cinto dell'oretta chon oro filato
3 tagliuoli di velluto

Uno forzeretto da soma dipinto introvi

1ª federa chon accia bianca in matasse sottile di libre in tutto 7 oncie 4 netta incircha
1° sacchetto chon accia bianca in matasse sottile di libre 9 oncie 2 netta incircha
1° sacchettino chon accia sottile sottile e matasse di libre 4 oncie 2 netta incircha
1ª federa chon accia biancha in matasse sottile di libre 7 oncie 6 netta
1ª federa chon accia biancha i' matasse de libre 3 oncie 3 netta incircha
1° sacchettino chon accia biancha fine di libre 1° oncie 1ª netta incircha
2 pettini d'avorio grandi e 2 di legnio

[fol.369v]

[col.1]

1° stendarto di taffettà azurro da giosstranti

1ª choverta da chavallo di taffettà azurro a liviera di giostranti

4 quarti di giornea di brocchato ariento verde da uomo

3 becche di veluto nero da suomi

3 quarti di taffettà nero rosso da luccha

2 teli da zane lavorati belli

1° chordone di seta biancho verde e rosso di braccia 20 incircha

1ª scharsella di veluto chermisi entrovi 1° paio di choltelini cholle forbicine

1° forzerettino dipinto da spose entrovi

2 paia di ghuanti di chamoscio

1° sacchettino di pannolino chon reticelle

2 federine da libriccino di pannolino

1° borsotto di raxo verde con richami d'oro e perle con 9 bottoni di perle

1° ograiuolo di velluto chermixi richamato in oro e perla

3 ghuaine fornite d'ariento bianche con 5 choltelli con maniche d'ariento e 3 forchette

e 1° punteruolo

2 ograiuolo di brocchato

2 puntali chon choregine di brochato da libriccino

1ª cintola chon fetta nera velutata chon fibia e puntale e tutta piena di spranghe d'ariento

dorate

2 fazzoletti da mano chon più lavori

12 paternostri d'anbra nere e 6 choralli e spranghe

2 d'ariento dorate

1° mazzo sciughatoio da donna sottile fine e 2 ghomitolini d'accia sottile

 Sotto i letto

2 spiedi in asste

1ª ronchola in asste

1ª chiaverina in asste

 Seghuita nello schrittoio e prima

1° saccho chon accia in ghomitoli e matasse bianche di più sorte sottile di libre 14 netta

12 libre daccia di sstoppa e matasse chon 2 ghomitoli bianche grossa

20 libre ½ d'accia in ghomitoli biancha da lenzuola

1° sacchettino d'accia biancha sottile sottile di più sorte e matasse libre 1ª oncie 4 netta

1ª libre d'accia in matasse sottile chruda

1ª bolgietta grande introvi

1° libricino d'Uficio di donna e altre orazioni chon serami d'ariento dorato choverta di

raxo chermisi richamato d'oro sanza puntale e perle e col beruciolo d'oro con 3 spigholi

di perle

1° libricino di Nostra Donna e altri Ufici choverta di brochato d'oro sanza puntale
2 veletti e aspi delle fanciulle
1° sacchetto lavorato di panno lino

Nella prima chassetta a lato alla finestra di noce e prima

1° forzerino di chuoio dipinto introvi:
24 anpolline di polvere di cipri
1ª chiociola marina
1° paio di paternosstri di diaspero di numero 45 sanza bottoni
1° paio di paternosstri di madreperla di n° 36 e bottoni 7 d'ariento dorati
1ª filza di paternosstri d'anbre picchole
1° anello di madreperle

[col.2]

1ª fibia e 1° puntale da fanciulli d'ariento biancho
1ª cintola chon fetta verde chon fibia fornita a fischo d'ariento netta
1ª cintoluzza velutata nera con fibia puntale e 12 spranghuzze d'ariento da uomo
1ª cintoluzza velutata paghonazza e verde chon fibia e puntale e 12 spranghe d'ariento rotta
1ª cintoluzza velutata nera chon fibia e puntale smaltato d'ariento dorato con 12 spranghe
1° ferro di scharsella alla tedescha
1° cassettino di chuoio da gioie introvi
1° diamelenzi in tavola leghato in n'oro
1ª chrocetta da rubini e 1ª perla grossa con pendente e 4 picchole
1° balascio leghato in oro
1° zaffino leghato in oro
1ª turchina leghato in oro
1° zaffino leghato in oro per pendente
1ª chorniuola leghata in n'oro per sugulare
2 anella d'ariento da donna
1° cichole d'ariento di chapo di chuchiaio
1° pezzuolo di diaspro chon ghiere d'ariento
1° sstuzichatoio da denti chon orecchio d'ariento
2 grossi d'ariento della Vergine Maria
2 vezzi di choralli
1° dente chanino chon ghiere d'ariento
15 choralli mezzani in duo fili
1° serrame di fili da libriccini dorato
1ª chornuiola di diaspro sciolta in una chartuza, 2 rubinuzzi e 1° zaffino e 1ª verchettuzza sciolti
1° bossolo d'aquaio dipinto introvi
1° vezzolino di perle minute e choraluzzi
1° Agniusdeo da banbini leghato in ariento dorati

1º Agniusdeo 'n uno chastrone d'oro con uno balascio e 1ª perla mezzana per pendente
1º rubinuzzo leghato in n'oro
1ª perla schozia mezzana
1º pezzuolo di chorallo con un pocho di ghiera d'ariento
1º rubinuzzo leghato in oro
1ª fibiuza e 1º puntale piccino d'ariento da cigniere
2 Agniusdei d'ariento picchini
1º bossolo di vetro cholorato introvi fl. uno largo d'oro in oro gienovino e l. 5 s. 15 e più monete

 Nella s[econ]dª chassetta entrovi

la charta della chonpera del podere al ccholatoio
la charta della chonpera della Boncetta
1º libretto in charta pechora dove sono le chonpere delle posesioni di Biuigliano
2 pezzi … in una borsa
1ª scharsella di raxo nero fornita d'ariento

 Seghue nella 3ª chassetta

12 chuchiai d'ariento con Ercholi dorati in uno
12 chucchiai d'ariento con Ercholi chon ghuaina nera nuovi
12 chuchiai d'ariento chon Ercholi dorati chon ghuaina gialla nuovi

[fol.370r]

[col.1]

12 forchette d'ariento a bare dorate
12 forchette d'ariento a palle dorate chon ghuaina gialla
12 forchette d'ariento a palle usate
5 chucchiai d'ariento chon Ercholi che ve n'è uno sanza
4 chucciai d'ariento chon Ercoli e 8 sanza

 Nella ¼ chasetta

7 chanelle d'otone da aqua chon' più lavori
1ª chassettina di noce introvi
2 fazzoletti d'accia sottili da chapo
2 sogholi da vedove
1º sciughatoio da donna sottile chon vergha biancha
1º bossolo rosso introvi lire quattro soldi 8 denari 8 piccoli e lire 2 soldi 16 denari […]
In una schatolina rossa
1º nappetto d'ariento chol'arme di chasa
1ª schatola d'acero nuova entrovi

1ª filza di paternosstri d'anbra neri
2 leghatuzza da chora
1º vezzo di choralli mezzani
1º rotoletto di reticelle a rose
1º sacchettino con 8 nappe da ghuanciali
1ª chassetta d'arcipresso introvi
1ª benda de fiore nuova
1ª coverta da libriccino de fiore
1º grenbiule de fiore da fanciulli
1º cintazo di nastro paghonazzo col' perto d'ariento picholi
1ª tazza di vetro da Murano introvi
1ª filzolina di moglie d'ariento e 1º Agnius Deo
1ª schodella di vetro da Murano entrovi
1ª brancha di choralla grande chonchiera d'ariento disse di messer Simone Ughuccioni
1ª filza si paternostri d'anbra gialla
1º vaxo di vetro rotto di Murano di più cholori
1ª medaglia di bronzo con testa del San Sismondo
1º tenperatoio chon manicha biancha
2 tazzoni d'ottone
1º quadretto dove intro el Chrocifisso e San Giovanni chon Vergine Maria
1º quadro di mia passioni di sacho
1º vasetto d'ottone
1ª lucerna d'ottone col manicho
1º infreschatoio di vetro di Murano introvi
4 tazze di vetro christallino
1º vasetto di marmo
2 saliere di vetro
9 vasi di più sorti di vetri di Marano[3] chon più lavori
5 bicchieri grandi christallini
1ª saliera di latimo
1º nappo d'ariento chon arme di chasa e Paghanelli chon più lavori

Sotto il descho dello schrittoio

1º secchione d'ottone grande chon più lavori
1ª miciroba grande a boccha aperta
1ª schatola chon fusa da filare
2 paia di maniche di raso rosso e azzurro
1ª schatola dipinta introvi
5 pezzuoli di nasstri e 1º ghomitolo di nasstri da donna
1ª schatolina moresca introvi

[col.2]

1ª balzana di seta cholorate e chordelline
1ª pezza di nasstro larghi da donna

1ª schatola di legnio entrovi più chanelli d'accia sottili e 2 ghomitolini e 1ª matassa

1ª chassettina dove sugielli chol'armi e forbicine e punteruoli di ferro

1ª schatola chon occhiali col occhiali e berulegi di Gismondo

1ª schatola lungha introvi

1° mazzo di cignie nuove

1° paio di ghuanti nuovi

1° secchettino di medaglie d'ottone

1° ferro di gianetta

1° chanone d'ottone

1° tondo di marmo serpentino

1° saccho grande

4 pezze grosse

1ª schatolina entrovi

3 paia di forbici dorate chon più lavori

1° tenperatoio cho' manicha smaltata

1° paio di moletti da chandelieri

1ª choltelliera chon 12 choltelli mezzani e 2 grande e 2 forchette tutte cho' maniche e ghiere d'ottone

1ª bolgietta d'asse vecchia entrovi

1° sacchetto chon accia in matasse sottile sottile di libre 2 once dieci chol sacchetto

Nelle chasse dove si siede entrovi

1ª choltelliera nera con choltelle mezzane e 2 grande chon chaperozzoli d'ariento chon armi di chaxa e Paghanelli cho' maniche d'avorio fornite d'ariento chon 2 forchette fornite d'ottone

1° in busto cho' maniche di taffettà d'ore

1° buratello chon disegni da richami

1° leghato chon più pezzi di taffettà verde

1° sacchetto entrovi più pezzi di frangie e tagli di tafetta di più cholori

1° leghato di frangie di più cholori e ritaglio di drappo

1ª bolgietta nera d'asse chome nuova introvi 1° sacchettino introvi libre una oncia 1ª d'accia in matasse sottile sottile chol sacchetto

1° sacchetto d'accia in matasse, inghomitoli biancha di libre 7 chol sacchetto da panno da chamice

1° sacchetto entrovi uno altro sacchetto pieno di più schritture che di poi se n'è fatto nota in quessto inventario

2 libri uno choverto di rosso e 1° choverto di biancho non v'è schritto nulla

1° libro choperto d'asse e chuoio rosso che tratta di Pisstole e vochaboli che non era schritto nel primo inventario

1° libro choverta di charta pechora in forma chiamato le Pistole di San Ghrighoro

1ª libri choverto di charta pechora fogli chomuni titolato Memoriale di mano di Gismondo

1° quadernuccio lungo di chonti e richordi di Gismondo del anno 1469 al anno 1489

1° libreto choverta di charta pechora di più chonti e richordi del anno 1482

1° quaderno di fogli chomuni del Prato dell [] del podere di Chapalle fece m[on]ª Chaterina donna fu di Gismondo per la dota sua

[fol.370v]

[col.1]

1° quadernetto di charta pechora di poche charte della chonpera de' poderi possti a Settimo cioè a Santa Maria a Chastagnioli della Arte del Lana
1° libro sciolto in forma del chonte Giovanni della Mirandola
3 federe da ghuanciali chon riticelle
1° tovagliolino di rensa usato
1° mantile da parto alla parigina
1° sciughatoio da ppiè grosso
1° fazzoletto da chapo sottile
2 chamice da donna buone
1° libro di fogli mezzani choverto di charta pechora chon 2 choregie azzure titolato in m[on]ª Chaterina donna fu di Gismondo schritto da charta 1 a charta 24 del anno 1489 al anno 1494

In chamera degli sparbieri di sopra

1ª lettiera senpice di braccia 5 incircha chon predella da lato chon trespolo e mazze
2 forzieri dorati al'anticha da spose
1° deschetto grande con ispalliera grande
1ª giarra grande di terra
1ª tinella grande di legnio da bagnio chon sua fornimenti
2 chassoni a sepoltura dipinti da spose
1ª chassone grande di braccia 3½ incircha d'albero
1ª valigia grande da soma
1ª trabaccha da chanpo chon sua fornimenti e tende
2 tavole di noci nuovi di braccia 5 incircha chon trespoli
1° orditoio chon sua chasette e fornimenti
3 segiole usate da sedere
1ª targha cholla tascha chol'arme di chaxa
1° paio di cesste da v'uova
1ª ghabbia di legniame da fagiani dipinta
1ª predella dipinta a divixa di chasa
1ª materasse di chanovaccio cho'lana
1° materassino chon isstoppa
1° chandelliere d'ottone cholla lucerna d'ottone
1° paio di molle grande
1° paiuolo di rame di libre 8½
1° orciuolo di rame di libre 7½
1ª padella mezzana chol manicho
2 teghie di rame pichole di libre 3 in tutto
1ª padella di rame mezzana da vuova a foghate
1° chatino di rame buono di libre 4
1° treppie grande di libre 10½

1º treppie da teghia e 3 tessti di ferro da pentole
2 gratugie
1º paio di sstadere di libre 52 da grosso
1º rinfreschatoio di maiolicho piano
2 sstagniate da olio e aceto chol ceppo
2 ferri per ischidoni e 1ª messtola forata e 1º ramaiuolo piccholo
15 pezzi di stagnio di più sorte di libre 21

In uno de detti chassoni

2 paia di sproni nuovi
2 palle da sparbiere de legnio
3 chandellieri grande dipinti

[col.2]

1º chalamaio di legnio intagliato
2 lame di chatelane
1º paio d'arnexi chon isstimeri
1ª testiera de ferro da chavallo
1ª celata di ferro
1ª beretta di valescio di lame
1º farsetto de lame di ferro
1ª chorazzina choperta di veluto biancho
1º giacho di maglie
1ª falda di maglie
2 giachi di maglie e 1ª falda in un sacchetto
1º giacho di maglie in un altro sacchetto
1ª materassa di ghuarnello biancho pieno di pilo da letto da forzeretti

Nel s[econ]dº forziere al'anticha

1º libro grande di leggie antiche choverte d'asse in charta pechora d'Opere di San
Anbruogio e altre
2 valigiette mezzane da groppe da chavalla buone
1ª palla dorata da sparbiere
4 alberelli grandi dipinti di terra
1ª vite di bronzo chon sua fornimenti
1º stagnione da utriacha
2 pezzuoli da federa vecchia chon una fascia
1º libriciolo d'Uficio di chiexa vecchio
1º libro choverto d'asse in charta banbagina di latino e grecho
1º rinfreschatoio di vetro piccholo e 1ª saliera

In uno di forzieri dipinti in sepoltura

1ª choltrice chon federa amezzata buona da letto di braccia 5 incircha chon piè san g[iovann]° di libre []
2 primacci di detto pieno a detto letto

I nel chassone d'albero

1ª valigia buona grande da chavallo
1ª valigietta da portare in groppa buona

I nel forziere a sepultura dipinto

3 materasse choverta di federa piene di lana da forzeretti buona
1° primaccio chon federa nuova chon piè lonbardi da detti forzeretti
1ª ghuanciale da letto sanza federa

Nel antichamera di detta chamera

1° charatello di braccia 4 incircha chon un pocho d'aceto
1° botticello di braccia 3½ incircha pieno d'aceto
1° botticino pieno d'agresto
1° orcetto entrovi ½ barili d'olio incircha chon romaiuolo
1° piedistallo da bacino
1ª spalliera di giunchi alla moresca di braccia 12 incircha nuova
1° paio di forzeretto ingiessati per uso di letto
1° forzeretto biancho da soma pieno di lettere e altre schritture antiche
1° forzeretto ferato vecchio all'anticha
3 telaia da finestre inpanate
2 gianette in asse
2 piallettini da cerbottana
1ª ghabia da papaghalli
1° tondo d'una testa invetriata

[fol.371r]

[col.1]

1ª segiola e 1ª predella da sedere usata
2 bussti chon tesste di dame dipinto
1° focholare de fuocho mezzano de ferro
1ª targha d'arme di Richaxoli dipinta
1° bassto da portare le valigie
1° strettoio di noce da lettiera
1ª filza di chanpanelle di ferra da usci di circha a 25 in 30 e più altre chanpanelle di ferro grosse e mezzane da uscio

2 spade a dua mano da schermire e più legniami da letto da portare
1° chorbello pieno di libri e schritture vecchie
1ª forchetta da fuocho e 1° ferro torto da nughole
1ª chassetta introvi 1° telaio da fare riticelle
4 chassette a' magliate chon più fighure di giesso
1ª chassettaccia chon 2 chalamai
3 targhe, 2 chol'arme di Richasoli e 1ª chol'arme di chasa dice sono per non divixe

In chamera di sopra overo in chucina

1° schadaletto e più pentole grande da gielatina e vasi dice per non divixi ch'erono a chomune

Nel granaio

Più legniami vecchi e forzieri e chorbelli e armi in asste e altre chose vecchie che sono a chomune e per non divixe
1° focholare de ferro per non divixo

In sul terrazzo

7 targhoni
6 targiette dipinte alla divixa di chasa chol'armi
1ª targha nuova chon arme di chasa
1ª tavola vecchia di braccia 6 incircha

In una stanza in sul detto terrazzo

Più some di legniami e usci vecchi e altre chose che sono anchora a chomune

In chamera della serva

1ª lettiera di braccia 3½ ingiessata
1° sacchone in un pezzo
1° materassa di chanovaccio chon chapecchio
1° choltrice chon federa usata chon piè lonbardo
1° primaccio a detto letto
1° paio di lenzuola a 3 teli usate
1ª choltre biancha a detto letto rotta
1ª chassetta a 2 serami a ppiè a detto letto
1° chassone di braccia 2½ d'albero trissto chon pentole
1ª chassetta da merce vecchia
1° chassone grande a 2 serrami chon più armi di più sorte e più schritture antiche a chomune
1° materassino di boldo chon pelo vechio
1° choltroncino pel pane usato

1ª chassa d'albero di braccia 3 cho' un serame
1ª madia nuova
1ª archa da farina nuova
1° chassone di braccia 2½ tristo
2 assa da pane
1° rinfreschatoio piano di maiolicha
1ª predella dipinta e 1ª altra minore

[col.2]

Nella chamera su di sopra

1ª vergine maria di giesso in un tabernacholo
1ª tavola di braccia 9 incircha d'albero regholata di noci vecchia
1° lettuccio al'anticha di braccia 5 incircha
1° paio di cesste da uuova cho' serami
1ª chassapancha a 2 serami al'anticha
1ª predella da' nfermi
1° tondo a uxo di descho da famigli

In chamera de lioni

2 forzieri grandi dipinti dorati a sepoltura chon predella di sotto da spose belli
1ª legniame di chorenti da lettiere

In sala principale

1ª tavola di pino di braccia 6½ incircha chon trespoli
1ª mezza schatola da tenere argiento che s'usa per metere il pane

Nel chassone che si truova in Sant Orsola introvi

1ª tela di pannolino largho da lenzuola di braccia 90
1ª tela di pannello sottile di braccia 50 ando braccia 8 la libra
1ª tela sottile di braccia 100 ando braccia 6 la libra
1ª tela di panno grosso di braccia 18 ando braccia 4 la libra
1ª tela di panello di braccia 28 ando braccia 5 la libra
1ª tela di pannolino sottile di braccia 40 ando braccia 8 la libra
1ª tela di pannolino da chamice di libre 100 ando braccia 5 la libra
1ª tela di pannolino da chamice di libre 20 ando braccia 4 la libra
1ª tela di pannolino largho di braccia 114 ando braccia 5 la libra
5 paia di lenzuola nuove chon reticelle chenne 9 lenzuola a 4 teli e 1° a tre teli ½ di braccia 7 incircha l'uno
1° paio di lenzuola nuove sottile chon più lavori da parte
4 tovaglie alla parigina sottile in un filo di braccia 30
4 ghuardonappe in un filo alla parigina di braccia 30 chon un pezzo

3 tovaglie nostrale grossette in un filo di braccia 12 incircha

1ª tovaglia nostrale grossetta di braccia 4½ incircha

2 mantili in un filo alla parigina da parto

1ª tovalgia di rense usata di braccia 8 incircha

48 tovagliolini di rensa in 4 pezzi chon verghe azzure

8 sciughatoio da vixo in un filo e 1° picholo chon verghe

2 sciughatoi grandi in un filo da barbiere

14 sciughatoi sottile in un filo

6 sciughatoi in un filo da chapo

3 sciughatoi in un filo davixo

17 sciughatoi grossi da chapo

12 sciughatoi in un filo davixo

6 sciughatoi grande da barbiere

23 fazzoletti in un filo da mano sottili

23 fazzoletti in un filo da mano so

20 fazzoletti da mano sottili in un filo

48 benducci sottili in un filo chon braccia 8 da bende in un filo incircha

18 benducci grossi in un filo da lato

4 chamice da uomo sottile n°

3 chamice da donna sottile

4 chamice da donna usate sottile

1° grenbiule sottile lavorate

2 grenbiuli di pannolino grossetto

1° grenbiule di pannolino nuovo

6 paia di chalcetti da donna novella lavorati

3 sacchetti nuovi chon più lavori

[fol.371v]

1° sciughatoio sottile chon verghe nere

1ª tela di panno banbagine sottile mano messa di braccia 25 incircha

1° paio di ghuanciali grandi da lettuccio choperti di tafettà rosso chon federe di bisso cho' reticelle a rosette

1° paio de ghuanciali grandi choperti di taffettà rosso chon federe sottile lavorate tutte e chon reticelle

1° chassone d'albero di braccia 3 incircha voto

1° chassone d'albero di braccia 3½ dove sono le dette chose

E sono tutte le dette chose a chusstodia di suora Tadea di Giovanni Mutini da Pistoia in detta San' Orsola

Cose venuta di villa dal Cholatoio

1° paio di lenzuola a 3 teli usate

Cose venuta di villa da Bevigliano

1° mantile di famiglia usato
15 tovagliolini tra buoni e chativi
1° paio di lenzuola a 4 teli usate
1° chanovaccio d'aquaio
1° saccho chol'arme di chasa

In chamera de famigli

1° descho suvi 1° armario d'asse d'abeto
2 chassapanche apichate insieme

In chamera terena

parecchi migliaia di marmi in più pezzi
1ª sella da muletto chon sua fornimenti
1° chapello di penna da paghone da uomo choperto di taffettà nero rotto
1° rastrello di pino chon archa al piùoli a uxo di chappelinaio

[col.2]

1ª tela di panno lino sotile di braccia 50 fatta d'accia che'era in sul lo'inventario

Notes

1. Angelo Poliziano *Coniurationis Commentarium* (*c.* 1478); trans. E.B. Welles, 'The Pazzi Conspiracy', in B.G. Kohl and R.G. Witt, eds, *The Earthly Republic*, Manchester (1978): pp. 313–4.

2. See fol.367r: '1ª provisione fatta per gli oportuni chonsigli per il ghoverno de figliuoli di Gismondo e Lorenzo de' Medici'. For an overview of Gismondo's book collection see: A.F. Verde, 'Libri tra le pareti domestiche', *Memorie Domenicane*, ns. 18 (1987): pp. 124–40.

3. Murano.

Appendix 3

The *camera bella* of Lorenzo di Giovanni Tornabuoni (1497)
MPAP 181 fol.148r

Lorenzo di Giovanni Tornabuoni (born 1466) was executed at the Bargello in August 1497 for his role in the attempted coup d'etat to bring his nephew Piero de' Medici back to power in Florence. On the expulsion of the Medici in 1494, Lorenzo went into partnership with his father Giovanni who had been Manager of the Medici bank in Rome since 1464. The Tornabuoni palace was constructed between 1466–69 in connection with the marriage of Giovanni Tornabuoni and Francesca Pitti, and described in Vasari's *Life of Michelozzo* as 'similar in almost every way to the palace that he had made for Cosimo [de' Medici] save that the façade is not in rustic-work and has no cornices above, but is quite plain.'[1] By the mid-sixteenth century the Tornabuoni's prominence had declined and the palace was sold to the Ridolfi family.

Nella chamera di L[orenz]° bella in su la sala in palco

Uno tondo chon chornicione d'oro di Nostra Donna e Magi che ofersono a Christo
1ª lettiera chon lettuccio e chappellinaio apichato a chassone tutto di nocie chon più lavori e messo d'oro e ariento di braccia 4½ in circha
1° sacchone in 2 pezzi in su mazze
1ª choltricina da zana chon pieno Lombardo amezata
1ª materassina da zana di banbagia di fustano
1ª materassa di fustano piena di chotone
1ª choltricie con tela verghata forestiero buona chon pieno di piuma }
2 primacci con dette federe } peso in tutto libre 136
1° paio di lenzuola di tela forestiere a 4 teli
1° choltrone da letto chon banbagia buono
1ª choltre biancha da letto chon più lavori
3 ghuanciali chon federe da letto
1° chortinagio a padiglione chon dua pendenti
1° materassino di fustano pieno di chotone
1° choltre a detto lettuccio chon lavori e frangie
2 ghuanciali da lettuccio chon federe senpricie
1ª segiola choperta di velluto tane chon frangie e palle d'ottone dorate
2 banbini dorati abracciati insieme
1° bronchone dorato in 1ª basetta
1° schudo chon l'arme del Re di Francia
2 'appamondi chon chornicie dorati
1° descho di braccia 1° ½ a 4 piè suvi 1° tappeto di braccia 2½ n°
1ª tavola d'albero senpricie di braccia 3 con trespoli
1° tappeto di braccia 4 vecchio
2 forzieri da spose dorati e dipin[t]o chon ispalliere dorate e dipinte

[col.2]

1° forziere di nocie chon prospettiva e altri lavori di nocie chon dette spalliere choperto di tela azurra
5 predelle da sedere e 5 segiole
1° paio d'alari di libre 30
1ª paletta e 1ª forchetta e 1° paio di molle
1ª chassapancha di nocie a 4 serrami chon ispalliere di nocie
2 vasi di Murano christallino chon lavori
1° deschetto chon la spalliera
2 armari chon chasse di nocie
1° choltrone grande da letto nel chassone della prospettiva
1° pitoccho di bocchaccino biancho buono
1ª chappa di panno bigio Fiandresco a chollare di velluto nero
1ª chappa di saia nera alla Spagniuola buona
1° farsetto di raso paghonazzo a maniche lunghe
2 paia di chalze nere soppannate di soventone

1° chappuccio di saia Milanese
1° specchio in 1° tondo dorato chon più lavori
1° piattello grande di maiolicha
5 berrette rosate e paghonaze di più sorte

Note

1. 'quasi in tutto simile al palazzo che aveva fatto a Cosimo, eccetto che la facciata non è di bozzi né con cornici sopra, ma ordinaria.' Giorgio Vasari, *Vita di Michelozzo Michelozzi* (1568) in Pergola, P., Grassi, L. and Previtali, G., eds, *Le vite de' più eccellenti pittori, scultori e architettori*. Vol. II Milan (1962): p. 343; trans. G. De Vere, *Lives of the most eminent painters sculptors and architects*. Vol. I, London, 1912–4 (reprinted 1996): p. 386.

Bibliography

Archives

Florence, Archivio di Stato:
Acquisti e Doni
Carte Gondi
Carte Strozziane
Corporazione Religiose Soppresse dal Governo Francese
Magistrato dei Pupilli
Medici avanti il Principato

Manuscript Libraries

Florence, Biblioteca Nazionale
Florence, Laurenziana
Florence, Riccardiana

London, British Library
London, National Art Library

Published Primary Sources

Alberti, Leon Battista: Grayson, C., ed., *Alberti On Painting*. London: Phaidon Press, 1972 (reprinted 1991).
_____, Grayson, C., ed., *Opere Volgari*. III vols. Bari: G. Laterza, 1960.
_____, J. Rykwert, N. Leach and R. Tavernor, eds, *On the Art of Building in Ten Books*. Cambridge, Mass.: MIT Press, 1988.
_____, Watkins, R.N., *The Family in Renaissance Florence*. Columbia, S.C.: University of South Carolina Press, 1969.
_____, Orlandi, G. and Portoghesi, P., eds, *De re aedificatoria*. Milan: Edizioni il Polifilo, 1966.

Aquinas, St Thomas: Caramello, P. ed., *Summa Theologiae*. II vols. Torino: Marietti, 1952.

Arienti, Giovanni Sabadino degli: Gundersheimer, W.L., ed., *Art and Life at the Court of Ercole I d'Este: the 'De Triumphis religionis' of Giovanni Sabadino degli Arienti*. Geneva: Librarie Droz, 1972.

Aristotle: Rackham, H. trans, *The Nicomachean Ethics*. Cambridge, Mass.: Harvard University Press, 1956.

――――, Thomson, J.A.K. trans, *The Ethics of Aristotle: The Nicomachean Ethics*. London, 1953: Penguin Books (reprinted 1976).

Beroaldo, Filippo: *De optimo statu*. Bologna, 1497.

Bicci, Neri di: Santi, B., ed., *Neri di Bicci: Le Ricordanze (1453–1475)*. Pisa: Marlin, 1976.

Biondo, Flavio: *De Roma triumphante libri decem, Romae instauratae libri tres, Italia illustrata, Historiarum ab inclinato Romae imperio decades tres*. Basel: Froben, 1531.

Biringuccio, Vannoccio: Smith, C.S. and Gnudi, M.T., eds, *The Pirotechnia of Vannoccio Biringuccio: the classic sixteenth century treatise on metals and metallurgy*. New York: Dover Publications, 1990.

Bisticci, Vespasiano da: Gillmore, M. trans., *The Vespasiano Memoirs: The Lives of Illustrious Men of the XVth Century*. London, 1926, reprinted Toronto: Toronto University Press, 1997.

――――, Greco, A., ed., *Le Vite: Edizione critica*. III vols. Florence: Istituto nazionale di studi sul Rinascimento, 1970–6.

Bracciolini, Poggio: Fubini, R. ed., *Opera Omnia*. Turin: Bottega d'Erasmo, 1964.

Brunelleschi, Filippo: Saalman, H. ed., *The Life of Brunelleschi by Antonio di Tuccio Manetti*. University Park, Pa.: Pennsylavania State University Press, 1970.

Bruni, Leonardo: Toffol, G. de, ed., *Panegirico della città di Firenze. Testo italiano a fronte di Frate Lazaro da Padova*. Florence: La Nuova Italia, 1974.

Castellani family: Ciapelli, G. ed., *Una famiglia e le sue ricordanze. I Castellani di Firenze nel Tre-Quattrocento*. Florence: L.S. Olschki, 1995.

Castellani, Francesco di Matteo: Ciapelli, G. ed., *Ricordanze*, vol. I: Ricordanze A (1436–1459) vol. II: Quaternuccio e Giornale B (1459–1485). Florence: L.S. Olschki, 1992 and 1995.

Cavalcanti, Giovanni: Grendler, M.T. ed., *The 'Trattato politico-morale' of Giovanni Cavalcanti (1381–1451): A critical edition and interpretation*. Geneva: Droz, 1973.

――――, Polidori, F. ed., *Istorie fiorentine scritte da Giovanni Cavalcanti*. II vols. Florence: Tipografia all'insegna di Dante, 1838–9.

Certaldo, Paolo di Pace da: Schiaffini, A. ed., *Libro di buoni costumi*. Florence: Le Monnier, 1945.

Chellini, Giovanni: Sillano, M.T. ed., *Chellini, Giovanni, Le ricordanze di Giovanni Chellini da San Miniato*. Milan: F. Angeli, 1984.

Cicero: Hubbell, H.M., trans., *De inventione*. Cambridge, Mass.: Harvard University Press 1949 (reprinted 2000).

――――, Hodge, H.G., trans., *Orations: Pro Cluentio*. Cambridge, Mass.: Harvard University Press 1927 (reprinted 2000).

――――, Macdonald, C., trans., *Orations: Pro Flacco*. Cambridge, Mass.: Harvard University Press 1927 (reprinted 2001).

――――, Miller, W., trans, *De Officiis*. Cambridge, Mass.: Harvard University Press, 1913.

Compagni, Dino: Burnstein, D.E., trans. and ed., *Dino Compagni's Chronicle of Florence*. Philadelphia: University of Pennsylvania Press, 1986.

――――, Lungo, I. del, *La cronica di Dino Compagni*. Florence: Le Monnier, 1924.

_____, Lungo, I. del, ed., *La Cronica di Dino Compagni delle cose occurrenti ne' tempi suoi.* Città del Castello: Rerum Italicarum Scriptores, 1913–16.

_____, Benecke, E.C.M. and Howell, A.G.F., eds, *The Chronicle of Dino Compagni.* London: Dent, 1906.

Cortesi, Paolo: Weil-Garris, K. and D'Amico, J.F., *The Renaissance Cardinal's Ideal Palace: A Chapter from Cortesi's 'De Cardinalatu',* Studies in Italian Art History, vol.1. Rome: American Academy in Rome, 1980.

Dei, Benedetto: Barducci, R. ed., *La Cronica dall'anno 1400 all'anno 1500 di Benedetto Dei.* Florence: Francesco Papafava, 1984.

Fiamma, Galvano: Castiglioni, C., ed., Gualvanei de la Flamma, 'Opusculum de rebus gestis ab Azone, Luchino et Johanne Vicecomitibus ab anno MCCCXXVIII usque ad annum MCCCXLII', in *Rerum Italicarum Scriptores*, vol.12, part 4. Bologna: Nicola Zanichelli, 1938.

Filarete (Antonio di Piero Averlino): Finoli, A.M. and Grassi, L., eds, *Trattato di Architettura.* II vols. Milan: Il Polifilo, 1972.

_____, Spencer, J.R., *Filarete's Treatise on Architecture*, II vols. New Haven: Yale University Press, 1965.

Florio, John: *Queen Anna's New World of Words.* London, 1611 (reprinted 1968).

Landucci, Luca: Rosen Jervis, A. de, *A Florentine Diary from 1450–1516.* London: J.M. Dent and Sons, 1927.

Libro Cerimoniale: Trexler, R., ed., *The Libro Cerimoniale of the Florentine Republic by Francesco Filarete and Angelo Manfridi.* Geneva: Droz, 1978.

Livy: Sage, E.T. and Schlesinger, A.C., *Historiae Romanae.* Cambridge, Mass.: Harvard University Press, 1938.

Maffei, Timoteo: Fraser Jenkins, A., *Timoteo Maffei's 'In Magnificentiae Cosmi Medicei detractors libellus' and the problem of patronage in mid-fifteenth century Florence.* MPhil Thesis, Warburg Institute, University of London, 1969.

Maio, Giuniano: Gaeta, F., ed., *De maiestate.* Bologna: Commissione per i testi di lingua, 1956.

Martelli, Ugolino di Niccolo: Pezzarossa, F., ed., *Ricordanze dal 1433 al 1483.* Rome: Edizioni di storia e letteratura, 1989.

Martini, Francesco di Giorgio: Scaglia, G., *Francesco di Giorgio: checklist and history of manuscripts and drawings in autographs and copies from ca.1470 to 1687 and renewed copies (1764–1839).* London: Associated University Presses, 1992.

_____, Maltese, C. and Degrassi, L.M., *Trattati di architettura ingegneria e arte militaria.* II vols. Milan: Il Polifilo, 1967.

Masi, Bartolomeo: Corazzini, G.O., ed, *Ricordanze di Bartolomeo Masi calderaio fiorentino dal 1478 al 1526.* Florence: G.C. Sansoni, 1906.

Medici (Giovanni di Bicci, Cosimo and Lorenzo di Giovanni, Piero di Cosimo): Spallanzani, M ed., *Inventari Medicei 1417–1465.* Florence: Associazione amici del Bargello, 1996.

Medici, Lorenzo de': Spallanzani, M. and Bertelà, G.C. eds, *Libro d'inventario dei beni di Lorenzo il Magnifico.* Florence: Associazione amici del Bargello, 1992.

Montecatini, Ugolino di Giovanni da: Nardi, M.G., ed., *Tractatus de balneis.* Florence: L.S. Olschki, 1950.

Palmieri, Matteo: Belloni, G., ed, *Della vita civile.* Florence: Sansoni, 1982.

Parenti, Marco: Phillips, M., trans, *The 'Memoir' of Marco Parenti. A Life in Medici Florence.* Princeton, N.J.: Princeton University Press, 1987. Reprinted Toronto: Broadview Press, 2000.

Piccolpasso, Cipriano: Lightbown, R. and Caiger-Smith, A., eds, *I tre libri dell'arte del*

vasaio. II vols. London: Scholar Press, 1980.

Pius II: Bellus, I. and Boronkai, I., *PII Secundi Pontificis Maximi Commentari*. Budapest: Balassi Kaidó, 1993.

_____, Gragg, F.A. trans, *Memoirs of a Renaissance Pope. The Commentaries of Pius II*. Smith College Studies in History. London: Allen and Unwin, 1960.

Il Platina (Bartolomeo Sacchi): Battaglia, F., ed., *De optimo cive*. Bologna: Nicola Zanichelli, 1944.

Pliny the Elder: Rackham, H., trans, *Naturalis Historia*. X vols. Cambridge, Mass.: Harvard University Press, 1938–52.

Pontano, Giovanni: Tateo, F., ed., *I Libri Delle Virtù Sociali*. Rome: Bulzoni, 1999.

_____, Tateo, F., ed., *I trattati delle virtù sociali De Liberalitate, De Beneficentia, De Magnificentia, De Splendore, De Conviventia*. Rome: Edizioni dell'Ateneo, 1965.

Pucci, Puccio: Merkel, C., 'I beni della famiglia di Puccio Pucci: Inventario del Sec. XV illustrato', *Miscellanea Nuziale Rossi-Theiss*. Pavia, 1897.

Rucellai, Giovanni: Perosa, A., ed., *Giovanni Rucellai e il suo Zibaldone*. London: Warburg Institute, University of London, 1960.

Strozzi, Alessandra Macinghi: Gregory, H., trans, *Selected letters of Alessandra Strozzi*. Berkeley: University of California Press, 1997.

_____, Guasti, C., ed., *Lettere di una gentildonna Fiorentina del secolo XV ai figliuoli esuli*. Florence: G.C. Sansoni. 1877.

Strozzi, Filippo: Bini, G. and Bigazzi, P., eds, *Vita di Filippo Strozzi il Vecchio scritta da Lorenzo suo figlio*. Florence: Tipografia della Casa di Correzione, 1851.

Suetonius: Rolfe, J.C, *De vita Caesarum*. Cambridge, Mass.: Harvard University Press, 1914.

Uzzano (Angelo da Uzzano, 1424 and Ludovico di Gino Capponi, 1534): Bombe, W., 'Nachlass-Inventare des Angelo da Uzzano unde des Lodovico di Gino Capponi', *Beiträge zur Kunstgeschichte des Mittelalters und der Renaissance herausgegeben von Walter Goetz*, vol. 36. Leipzig and Berlin: B.G. Teubner, 1928.

Vasari, Giorgio: Pergola, P., Grassi, L. and Previtali, G., eds, *Le vite de' piu eccellenti pittori, scultori e architettori*. III vols. Milan: Edizioni per il Club del Libro, 1962–3.

_____, De Vere, G., *Lives of the most eminent painters sculptors and architects*. London: Everyman's Library, 1912 reprinted 1996.

Villani, Giovanni, Matteo and Filippo: Selfe, R.E., partial trans, *Selections from the first nine books of the Croniche fiorentine*. London, 1896.

_____, Moutier, I. and Dragomanni, F.G., eds, *Croniche*. Milan, 1848.

Vitruvius: Rowland, I.D. and Dewar, M.J., *Ten Books on Architecture*. Cambridge: Cambridge University Press, 1999.

_____, Granger, F., trans, *On Architecture*. II vols. Cambridge, Mass.: Harvard University Press, 1931.

Secondary sources

Ahl, D.C, *Benozzo Gozzoli*. New Haven: Yale University Press, 1996.

_____, 'Renaissance Birth Salvers and the Richmond Judgement of Solomon', in *Studies in Iconography*, 7–8 (1981–2): pp. 157–74.

Ajmar-Wollheim, M. and Dennis, F., eds, *At Home in Renaissance Italy*. London: Victoria and Albert Museum, 2006.

Alpers, S.L., 'Ekphrasis and aesthetic attitudes in Vasari's Lives', *Journal of the Warburg and Courtauld Institutes*, 23 (1960): pp. 190–215.

Alsop, J., *The Rare Art Traditions: The History of art collecting and its linked phenomena wherever these have appeared.* London: Thames and Hudson, 1982.

Ames-Lewis, F., 'The Political iconography of the Palazzo Medici in Florence', in Ames-Lewis, F. and Paszkiewicz, P., eds, *Art and Politics: Proceedings of the Third Joint Conference of Polish and English Historians.* Warsaw: Institute of Art (1999): pp. 19–30.

——, ed., *Cosimo 'il vecchio' de' Medici, 1389–1464: essays in commemoration of the 600ᵗʰ anniversary of Cosimo de' Medici's birth.* Oxford: The Clarendon Press, 1992.

——, 'Donatello's bronze David and the Palazzo Medici courtyard', *Renaissance Studies*, 3 (1989): pp. 235–51.

——, *The Library and Manuscripts of Piero di Cosimo de' Medici.* New York: Garland Publishing, 1984.

——, 'Early Medicean devices', *Journal of the Warburg and Courtauld Institutes*, 42 (1979): pp. 122–43.

——, and Rogany, M., eds, *Concepts of Beauty in Renaissance Art.* Aldershot: Ashgate, 1998.

——, and Bednarek, A., eds, *Decorum in Renaissance Narrative Art.* London: Birkbeck College, University of London, 1992.

Appadurai, A., *The Social Life of Things: Commodities in Cultural Perspective.* Cambridge: Cambridge University Press, 1986.

Ascheri, M. et al, *Forestieri e stranieri nella città basso-medievali: atti del seminario internazionale di Studio Bagno a Ripolo, Firenze 4–8 giugno 1984.* Florence: Libreria editrice Salimbeni, 1984.

Bagemihl, R., 'The Trevisan Collection' (1465), *The Burlington Magazine*, 135 (1993): pp. 559–63.

Barasch, M. and Sandler, L.F., eds, *Art the Ape of Nature: Studies in Honour of H.W. Janson.* New York: Englewood Cliffs, N.J., 1981.

Bargellini, P., *I buonomini di San Martino.* Florence: Cassa di Risparmio di Firenze, 1972.

Baron, H., 'Franciscan Poverty and Civic Wealth as factors in the Rise of Humanistic Thought', *Speculum*, 13 (1938): pp. 1–37.

Barriault, A.B., *Spalliera Paintings of Renaissance Tuscany: Fables of Poets for Patrician Homes.* University Park, Pa: Pennsylvania State University Press, 1994.

Baskins, C.L., *Cassone Painting, Humanism, and Gender in Early Modern Italy.* Cambridge: Cambridge University Press, 1998.

Baxandall, M., *Painting and Experience in Fifteenth Century Italy.* Oxford: Clarendon Press, 1972.

——, *Giotto and the Orators: Humanist Observers and the discovery of pictorial composition, 1350–1450.* Oxford: Clarendon Press, 1971.

Bec, C., *Les livres des Florentins, 1413–1608.* Florence: L.S. Olschki, 1984.

——, 'Une librarie Florentine de la fin du XVe siècle', *Bibliothèque d'Humanisme et Renaissance*, 31 (1969): pp. 321–332.

Berti, L., *Palazzo Davanzati: Il museo di Palazzo Davanzati a Firenze.* Florence: Electa, 1972.

Beyer, A. and Boucher, B., eds, *Piero de' Medici 'il Gottoso' (1416–69): Art in the service of the Medici.* Berlin: Akademie Verlag, 1993.

Birbari, E., *Dress in Italian Painting 1460–1500.* London: J. Murray, 1975.

Bistort, G., *Il Magistrato alle Pompe nella Republica di Venezia. Studio Storico.* Bologna: Forni, 1969.

Black, R., *Humanism and education in medieval and Renaissance Italy: tradition and innovation in Latin schools from the twelfth to the fifteenth century.* Cambridge: Cambridge University Press, 2001.

Blake McHam, S., ed., *Looking at Italian Renaissance Sculpture*. Cambridge: Cambridge University Press, 1998.

Bolgar, R.R., ed., *Classical Influences on European Culture, A.D. 500–1500*. Cambridge: Cambridge University Press, 1971.

Borsook, E., 'A Florentine Scrittoio for Diomede Carafa', in Barasch, M. and Sandler, L.F., eds, *Art in the Ape of Nature: Studies in Honour of H.W. Janson*. New York: Englewood Cliffs, N.J. (1981): pp. 91–3.

——, 'Documents for Filippo Strozzi's Chapel in Santa Maria Novella and Other Related Papers', *Burlington Magazine*, 112 (1970): pp. 737–45.

——, 'Documenti relativi alle cappelle di Lecceto e delle selve di Filippo Strozzi', *Antichità Viva*, 3 (1970): pp. 3–20.

——, 'Decor in Florence for the Entry of Charles VIII of France', *Mitteilungen des Kunsthistorichen Institutes in Florenz*, 12 (1961–2): pp. 106–22, 217.

Braham, A, 'The Bed of Pierfrancesco Borgherini', *Burlington Magazine*, 121 (1979): pp. 754–65.

Branca, V., ed., *Mercanti Scrittori: Ricordanze nella Firenze tra Medioevo e Rinascimento*. Milan: Rusconi, 1986.

Brown, A., 'Lorenzo de' Medici's new men and their mores: the changing lifestyle of Quattrocento Florence', *Renaissance Studies*, 16 (2002): pp. 113–142.

——, ed., *Language and Images in Renaissance Italy*. Oxford: Clarendon Press, 1995.

——, 'Lorenzo and Public Opinion in Florence. The Problem of Opposition', in Garfagnini, G.C., ed., *Lorenzo il Magnifico e il suo mondo: convegno internazionale di studi (Firenze, 9–13 giungo 1992)*. Florence: L.S. Olschki, 1994.

——, 'The Guelf Party in the Fifteenth Century: The transition from Communal to Medicean state', *Rinascimento*, 20 (1980): pp. 41–86.

——, 'The humanist portrait of Cosimo de' Medici, pater patriae', *Journal of the Warburg and Courtauld Institutes*, 24 (1961): pp. 186–221.

——, and Mare, A.C. de la, 'Barolomeo Scala's dealings with booksellers, scribes and illuminators, 1459–63', *Journal of the Warburg and Courtauld Institutes*, 39 (1976): pp. 237–45.

Brown, C.M., 'An Art Auction in Venice, 1506', *L'Arte*, 17 (1972): pp. 121–36.

——, and Lorenzoni, A.M., 'Major and minor collections of antiquities in documents of the later sixteenth century', *Art Bulletin*, 66 (1984): pp. 496–507.

Brown, R.G., 'The reception of Anna Sforza in Ferrara, February 1491', *Renaissance Studies*, 2 (1988): pp. 231–9.

——, *The Politics of Magnificence in Ferrara 1450–1505: a study of socio-political implications of Renaissance spectacle*, PhD Thesis, University of Edinburgh, 1982.

Bullard, M., 'Heroes and their workshops: Medici patronage and the problem of shared agency', *Journal of Medieval and Renaissance Studies*, 22 (1994): pp. 179–98.

Bulst, W., 'Uso e transformazione del palazzo medice fino ai Riccardi', in Cherubini, G. and Fanelli, G., eds, *Il palazzo medice di Firenze*. Florence: Giunti, (1990): pp. 98–129.

——, 'Die ursprüngliche innere Aufteilung des Palazzo Medici in Florenz', *Mitteilungen des Kunsthistorischen Institutes in Florenz*, 14 (1970): pp. 369–92.

Burke, J., *Changing Patrons: Social identity and the Visual Art in Renaissance Florence*. University Park, Pa: Pennsylvania State University Press, 2004.

Burns, H., 'Quattrocento Architecture and the Antique: Some Problems,' in Bolgar, R.R., ed., *Classical Influences on European Culture, A.D. 500–1500*. Cambridge (1971): pp. 269–88.

Burroughs, C., *The Italian Renaissance Palace Façade: Structures of Authority, Surfaces of Sense.* Cambridge: Cambridge University Press, 2003.

Byatt, L.M.C., 'The concept of Hospitality in a Cardinal's household in Renaissance Rome', *Renaissance Studies*, 2 (1988): pp. 312–20.

____, '*Una suprema magnificenza': Niccolò Ridolfi, a Florentine Cardinal in Sixteenth Century Rome.* PhD Thesis, European Institute, Florence, 1983.

Cadogan, J., *Domenico Ghirlandaio, Artist and Artisan.* New Haven: Yale University Press, 2001.

Caferro, W., 'The silk business of Tommaso Spinelli, fifteenth-century Florentine merchant and papal banker', *Renaissance Studies*, 10 (1996): pp. 417–439.

Callmann, E., 'Masolino da Panicale and Florentine cassone painting', *Apollo*, 150 (1999): pp. 42–49.

____, 'William Blundell Spence and the transformation of Renaissance cassoni', *Burlington Magazine*, 141 (1999): pp. 338–348.

____, 'Apollonio di Giovanni and painting for the early Renaissance room', *Antichita, Viva*, 27 (1988): pp. 5–18.

____, *Beyond Nobility: Art for the Private Citizen in the Early Renaissance.* Allentown, Pa: The Museum (1980): pp. 66–67.

____, 'The Triumphal Entry into Naples of Alfonso I', *Apollo*, 109 (1979): pp. 24–31.

____, *Apollonio di Giovanni.* Oxford: Clarendon Press, 1974.

Campbell, L., 'The Art Market in the Southern Netherlands in the Fifteenth Century', *Burlington Magazine*, 118 (1976): pp. 188–98.

Caplow, H.M., 'Sculptors' Partnerships in Michelozzo's Florence', *Studies in the Renaissance*, 21 (1974): pp. 145–175.

Carew-Reid, N., *Les fêtes florentins au temps de Lorenzo il Magnifico.* Florence: L.S. Olschki, 1995.

Carl, D., 'Das inventar der werkstatt von Filippino Lippi aus dem Jahre', *Mitteilungen des kunsthistorischen Institutes in Florenz*, 31 (1987): pp. 373–91.

Chabot, I., '"La sposa in nero". La ritualizzazione del lutto delle vedove fiorentine (sec. XIV–XV)', *Quaderni storici*, 86 (1994): pp. 421–462.

Chambers, D.S., *A Renaissance Cardinal and His Worldly Goods: The Will and Inventory of Francesco Gonzaga, 1444–1483.* London: Warburg Institute, University of London, 1992.

____, and Martineau, J., eds, *Splendours of the Gonzaga.* London: Victoria and Albert Museum, 1981.

Ciappelli, G., 'Libri e letture a Firenze nel XV secolo: Le 'ricordanze' e la ricostruzione delle biblioteche private', *Rinascimento*, 29 (1989): pp. 267–91.

____, and Rubin, P.L., eds, *Art, Memory and Family in Renaissance Florence.* Cambridge: Cambridge University Press, 2000.

Cicchetti, A. and Mordenti, R., 'La scrittura dei libri di famiglia', in *Letteratura italiana: Volume terzo La forme del testo; II. La Prosa.* Rome: Edizioni di storia e letteratura (1984): pp. 1117–1155.

Clarke, G., *Roman House – Renaissance Palaces: Inventing Antiquity in Fifteenth-Century Italy.* Cambridge: Cambridge University Press, 2003.

____, 'Magnificence and the city: Giovanni II Bentivoglio and architecture in fifteenth-century Bologna', *Renaissance Studies*, 13 (1999): pp. 397–411.

Cohn, S.K., *Women in the Streets: Essays on sex and power in Renaissance Italy.* Baltimore: Johns Hopkins University Press, 1996.

____, *The Cult of Remembrance and the Black Death: Six Renaissance Cities in Central Italy.* Baltimore: Johns Hopkins University Press, 1992.

_____, *The laboring classes in Renaissance Florence.* New York: Academic Press, 1980.

Cole, B., 'The interior decoration of Palazzo Datini in Prato', *Mitteilungen des kunsthistorischen Institutes in Florenz*, 13 (1967): pp. 61–82.

Connell, S., 'Books and their Owners in Venice 1345–1480', *Journal of the Warburg and Courtauld Institutes*, 35 (1972): pp. 163–86.

Courcey-Bayley, C. de, *House and Household: A study of Families and Property in the Quarter of Santa Croce, Florence during the Fifteenth Century.* D.Phil Thesis, University of York, 1998.

Covi, D.A., 'A documented lettuccio for the Duke of Calabria by Guliano da Maiano', in Bertelli, S. and Ramakus, G., eds, *Essays to Myron P. Gilmore.* vol.II. Florence: La Nuova Italia (1978): pp. 121–30.

D'Ancona, M.L., *Miniatura e miniatori a Firenze dal XIV al XVI secolo: Documenti per la storia della miniatura.* Florence: L.S. Olschki, 1962.

Davis, C.T., 'Topographical and Historical Propaganda in Early Florentine Chronicles and in Villani', *Medioevo e Rinascimento*, 2 (1988): pp. 3–51.

Davis, N.Z., 'Beyond the Market: Books as Gifts in Sixteenth Century France', *Transactions of the Royal Historical Society* 33 (1983): pp. 69–88

Dean, T. and Lowe, K.J.P., eds, *Marriage in Italy 1300–1650.* Cambridge: Cambridge University Press, 1998.

Duby, G. and Ariès, P., eds, *A History of Private Life. Vol II. Revelations of the Medieval World.* Cambridge, Mass.: Harvard University Press, 1988.

Duits, R., 'Figured Riches: The Value of Gold Brocades in Fifteenth-Century Florentine Painting', *Journal of the Warburg and Courtauld Institutes*, 62 (1999): pp. 60–92.

Eckstein, N.A., *The District of the Green Dragon. Neighbourhood Life and Social Change in Renaissance Florence.* Florence: L.S. Olschki, 1995.

Edwards, N.E., *The Renaissance Stufetta in Rome: The Circle of Raphael and the Recreation of the Antique*, PhD Thesis, University of Minnesota, 1983.

Eisenstein, E.L., *The Printing Press as an Agent of Change: Communication and cultural transformations in early modern Europe.* II vols. Cambridge: Cambridge University Press, 1979.

_____,'The Advent of Printing and the Problem of the Renaissance', *Past and Present*, 45 (1969): pp. 19–89.

Elam, C., 'Lorenzo's architectural and urban policies' in Garfagnini, G.C., ed., *Lorenzo il Magnifico e il suo mondo: convegno internazionale di studi (Firenze, 9–13 giugno 1992).* Florence (1994): pp. 357–84.

_____, 'Lorenzo de Medici's Sculpture Garden', *Mitteilungen des Kunsthistorischen Institutes in Florenz*, 36 (1992): pp. 41–84.

_____, 'Lorenzo de Medici and the Urban Development of Renaissance Florence', *Art History*, 1 (1978): pp. 43–66.

Esch, A., 'Roman customs registers 1470–80: Items of interest to historians of art and material culture', *Journal of the Warburg and Courtauld Institutes*, 58 (1995): pp. 72–87.

Fantoni, M. et al., eds, *The Art Market in Italy: 15th–17th centuries.* Modena: F.C. Panini, 2003.

Fargo, C., ed., *Re-framing the Renaissance – Visual Culture in Europe and Latin America 1450–1650.* New Haven: Yale University Press, 1995.

Febvre, L. and Martin, H.J., *The Coming of the Book: The Impact of Printing 1450–1800.* trans. Gerard, D. London: N.L.B., 1976.

Fisher, C, *The state as surrogate father: State guardianship in Renaissance Florence, 1368–1532.* PhD Thesis, Brandeis University, 2003

Floridia, A. and Gregori, M., *Palazzo Panciatichi in Firenze*. Rome: Instituto della enciclopedia italiana, 1993.

Forster, K.W., 'The Palazzo Rucellai and Questions of Typology in the Development of Renaissance Buildings', *Art Bulletin*, 58 (1976): pp. 109–13.

Fortini Brown, P., *Private Lives in Renaissance Venice: Art, Architecture and the Family*. New Haven: Yale University Press, 2004.

Fossati, I.P., 'L'interno della casa dell'artista e dell'artigiano nella Venezia del cinquecento', *Studi Veneziani*, 7 (1984): pp. 109–53

Franceschi, F., 'Florence and Silk in the Fifteenth Century: the Origins of a Long and Felicitous Union', *Italian History and Culture*, 1 (1995): pp. 3–22.

Fraser Jenkins, A.D., 'Cosimo de' Medici's Patronage of Architecture and the Theory of Magnificence', *Journal of the Warburg and Courtauld Institutes*, 33 (1970): pp. 162–70.

Frick, C.C., *Dressing Renaissance Florence: Families, Fortunes and Fine Clothing*. Baltimore and London: The Johns Hopkins University Press, 2002.

Frigo, D., *Il padre di famiglia: governo della casa e governo civile nella tradizione dell' 'economica' fra Cinque e Seicento*. Rome: Bulzoni, 1985.

Frommel, C., *Der Romische Palastbau der Hochrenaissance*. III vols. Tübingen: E. Wasmuth, 1973.

Fusco, L.S., and Corti, G., 'Giovanni Ciampoloni (d.1505), a Renaissance Dealer in Rome and his Collection of Antiquities', *Xenia*, 21 (1991): pp. 7–47.

Garfagnini, G.C., ed., *Lorenzo il Magnifico e il suo mondo: convegno internazionale di studi (Firenze, 9–13 giungo 1992)*. Florence: L.S. Olschki, 1994.

Gerulaitis, L.V., *Printing and Publishing in Fifteenth Century Venice*. Chicago: American Library Association, 1976.

Gilbert, C., 'What Did the Renaissance Patron Buy?' *Renaissance Quarterly*, 51 (1998): pp. 392–450.

_____, 'The Earliest Guide to Florentine Architecture, 1423', *Mitteilungen des Kunsthistorichen Institutes in Florenz*, 14 (1969): pp. 33–46.

Goldthwaite, R., *Banks, palaces and entrepreneurs in Renaissance Florence*. Aldershot: Variorum, 1995.

_____, *Wealth and the Demand for Art in Italy, 1300–1600*. Baltimore and London: Johns Hopkins University Press, 1993.

_____, 'L'interno del palazzo e il consumo dei beni,' in Lamberini, D., ed., *Palazzo Strozzi meta millennio, 1489–1989*. Rome: Instituto della enciclopedia italiana (1991): pp. 159–166.

_____, 'The Economic and Social World of Italian Renaissance Maiolica', *Renaissance Quarterly*, 42 (1989): pp. 1–32.

_____, 'The Empire of Things: Consumer Demand in Renaissance Italy', in Kent, F.W. and Simons, P., eds, *Patronage, Art and Society in Renaissance Italy*. Oxford: Oxford University Press (1987): pp. 153–75.

_____, 'The Economy of Renaissance Italy: The Preconditions for Luxury Consumption', *I Tatti Studies*, 2 (1987): pp. 15–39.

_____, *The Building of Renaissance Florence: An Economic and Social History*. Baltimore and London: Johns Hopkins University Press, 1980.

_____, 'The Building of the Strozzi Palace: the Construction Industry in Renaissance Florence', *Studies in Medieval and Renaissance History*, 10 (1973): pp. 97–194.

_____, 'The Florentine Palace as Domestic Architecture', *American Historical Review*, 77 (1972): pp. 977–1012.

_____, *Private Wealth in Renaissance Florence: A study of four families.* Princeton, N.J.: Princeton University Press, 1968.

Gombrich, E., 'The Early Medici as Patrons of Art: A Survey of Primary Sources', in *Norm and Form.* London: Phaidon Press, 1966, (reprinted 1993): pp. 35–57.

_____, 'Alberto Avogadro's descriptions of the Badia of Fiesole and of the Villa of Careggi', *Italia Medioevale e Umanistica,* 5 (1962): pp. 217–29.

Gordon, P. and Goodhart, W., *Two Renaissance Book Hunters: The Letters of Poggius Bracciolini to Nicolaus de Niccolis.* New York: Columbia University Press, 1974.

Grafton, A., *Commerce with the Classics: Ancient Books and Renaissance Readers.* Ann Arbor: University of Michigan Press, 1997.

_____, 'Renaissance Readers and Ancient Texts: Comments on Some Commentaries', *Renaissance Quarterly,* 38 (1985): pp. 423–45.

Green, L., 'Galvano Fiamma, Azzone Visconti, and the Revival of the Classical Theory of Magnificence,' *Journal of the Warburg and Courtauld Institutes,* 53 (1990): pp. 98–113.

Gregori, M., Paolucci, A. and Luchinat C.A., eds, *Maestri e botteghe. Pittura a Firenze alla fine del Quattrocento.* Exh cat Palazzo Strozzi Florence: Silvana, 1992.

Grendler, P.F., 'Form and Function in Italian Renaissance Popular Books', *Renaissance Quarterly,* 46 (1993): pp. 451–85.

_____, 'Schooling in Western Europe', *Renaissance Quarterly,* 43 (1990): pp. 775–87.

_____, *Schooling in Renaissance Italy. Literacy and Learning 1300–1600.* Baltimore and London, 1989.

Griffiths, G., Hankins, J. and Thompson, D., trans., *The Humanism of Leonardo Bruni: Selected Texts.* Binghampton N.Y.: Renaissance Society of America, 1987.

Grubb, J., 'Memory and identity: why Venetians didn't keep ricordanze', *Renaissance Studies,* 8 (1994): pp. 375–87.

Guerzoni, G., 'Liberalitas, Magnificentia, Splendor: The Classic Origins of Italian Renaissance Lifestyles', in Marchi, N. de and Goodwin, C.D.W., eds, *Economic Engagements with Art.* Durham N.C.: Duke University Press (1999): pp. 332–378.

Gundersheimer, W.L., 'The Patronage of Ercole I d'Este', *Journal of Medieval and Renaissance Studies,* 6 (1976): pp. 1–19.

_____, *Ferrara: The Style of a Renaissance Despotism.* Princeton, N.J.: Princeton University Press, 1973.

_____, ed., *Art and Life at the Court of Ercole I d'Este: the 'De Triumphis religionis' of Giovanni Sabadino degli Arienti.* Geneva: Librarie Droz, 1972.

Hart, V. and Hicks, P., eds, *Paper Palaces – The Rise of the Renaissance Architectural Treatise.* New Haven: Yale University Press, 1998.

Hatfield, R., 'Cosimo de' Medici and the Chapel of his Palace' in Ames-Lewis, F ed., *Cosimo 'Il vecchio' de' Medici (1389–1464).* Oxford: The Clarendon Press (1992): pp. 221–44.

_____, 'Some Unknown Descriptions of the Medici Palace', *Art Bulletin,* 52 (1970): pp. 232–49.

_____, 'The Compagnia dei Magi', *Journal of the Courtauld and Warburg Institutes,* 33 (1970): pp. 107–61.

Herald, J., *Renaissance Dress in Italy 1400–1500.* London: Bell and Hyman, 1981.

Herlihy, D., 'Did Women Have a Renaissance? A Reconsideration', *Medievalia et Humanistica,* 13 (1985): pp. 1–22.

_____, and Klapisch-Zuber, C., *Tuscans and their Families: A Study of the Florentine Catasto of 1427.* New Haven: Yale University Press, 1985.

Hill, G.F., *A Corpus of the Italian Medals of the Italian Renaissance Before Cellini.* II vols. London: British Museum, 1930.

Hills, P., *Venetian Colour: Marble, Mosaic, Painting and Glass, 1250–1550*. New Haven: Yale University Press, 1999.

Hirsch, R., *Printing, Selling and Reading 1450–1550*. Wiesbaden: Harrassowitz, 1967.

Howard, D., *Venice and the East: The Impact of the Islamic World on Venetian Architecture 1100–1500*. New Haven: Yale University Press, 2000.

____, 'Sumptuary Law and Social Relations in Renaissance Italy,' in Bossy, J., ed., *Disputes and Settlements: Law and Human Relations in the West*. Cambridge: Cambridge University Press, 1983.

Hughes, G., *Renaissance Cassoni – Masterpieces of Early Italian Art: Painted Marriage Chests 1400–1550*. London: Art Books International, 1997.

Husband, T., 'Valencian Lusterware of the Fifteenth Century', *The Metropolitan Museum of Art Journal*, 29 (1970): pp. 11–32.

Hyman, I., 'Notes and Speculations on S. Lorenzo, Palazzo Medici, and an Urban Project by Brunelleschi', *Journal of the Society of Architectural Historians*, 34 (1975): pp. 98–120.

____, *Fifteenth Century Florentine Studies: The Palazzo Medici and a Ledger for the Church of San Lorenzo*. PhD Thesis, University of New York, 1968.

The Illustrated Incunabula Short-Title Catalogue. Primary Source Media, Second Edition, 1998

Jacks, P., 'Michelozzo di Bartolomeo and the "Domus Pulcra" of Tommaso Spinelli in Florence', *Architectura*, 26 (1996): pp. 47–83.

____, and Caferro, W., *The Spinelli of Florence: Fortunes of a Renaissance merchant family*. University Park, Pa: Pennsylvania State University Press, 2002.

____, and Caferro, W., *The Spinelli: Merchants, Bankers and Patrons in Renaissance Florence*. University Park, Pa: Pennsylvania State University Press, 1997.

Jardine, L., *Wordly Goods: A History of the Renaissance*. London: Macmillan, 1996.

____, and Brotton, J., *Global Interests: Renaissance Art between East and West*. London: Reaktion Books, 2000.

Joannides, P., 'Masaccio, Masolino and "Minor" Sculpture', *Paragone: Arte*, 38 (1987): pp. 3–24.

Johnson, G.A., 'Art or artefact? Madonna and Child reliefs in the early Renaissance', in Currie, S. and Motture, P., eds, *The Sculpted Object, 1400–1700*. Aldershot: Scolar Press (1997): pp. 1–24.

____, and Grieco, S.F.M., *Picturing Women in Renaissance and Baroque Italy*. Cambridge: Cambridge University Press, 1997.

Jones, P., 'Florentine Families and Florentine Diaries in the Fourteenth Century', *Papers of the British School in Rome*, 24 (1956): pp. 183–205.

Kanter, L.B., 'The "cose piccolo" of Paolo Uccello', *Apollo*, August (2000): pp. 11–20.

____, Goldfarb, H.T. and Hankins, J., eds, *Botticelli's Witness: Changing Style in a changing Florence*. Exh cat Isabella Stewart Gardner Museum, Boston Mass., 1997.

Kemp, M., *Behind the Picture. Art and Evidence in the Italian Renaissance*. New Haven: Yale University Press, 1997.

____, 'From "Mimesis" to "Fantasia" the Quattrocento vocabulary of creation, Inspiration and genius in the visual arts', *Viata*, 8 (1977): pp. 347–98.

Kent, D.V., *Cosimo de' Medici and the Florentine Renaissance: the patron's oeuvre*. New Haven: Yale University Press, 2000.

____, 'The Importance of Being Eccentric: Giovanni Cavalcanti's View of Cosimo de' Medici's Florence', *Journal of Medieval and Renaissance Studies*, 20 (1979): pp. 101–32.

____, *The Rise of the Medici: Faction in Florence, 1426–1434*. Oxford: Oxford University Press, 1978.

Kent, F.W., *Lorenzo de' Medici and the Art of Magnificence.* Baltimore and London: The Johns Hopkins University Press, 2004.

____, 'Palaces, Politics and Society in Fifteenth Century Florence,' *I Tatti Studies*, 2 (1987): pp. 41–71.

____, 'The Making of a Renaissance Patron of the Arts', in Kent, F.W., et al., *Giovanni Rucellai ed il suo zibaldone, II: A Florentine Patrician and his Palace.* London: Warburg Institute, University of London (1981): pp. 9–95.

____, '"Piu superba di quella di Lorenzo": Courtly and Family interest in the building of Filippo Strozzi's Palace', *Renaissance Quarterly*, 30 (1977): pp. 311–23.

____, *Household and lineage in Renaissance Florence: the family life of the Capponi, Ginori and Rucellai.* Princeton, N.J.: Princeton University Press, 1977.

____, 'The Rucellai Family and its Loggia', *Journal of the Courtauld and Warburg Institutes*, 35 (1970): pp. 397–400.

____ and Kent, D.V., *Neighbours and Neighbourhood in Renaissance Florence: The District of the Red Lion in the Fifteenth Century.* Locust Valley, N.Y: J.J. Augustin, 1982.

____, and Kent, D.V., 'Two comments of March 1445 on the Medici Palace', *Burlington Magazine*, 121 (1979): pp. 795–6.

____ and Simons, P., eds, *Patronage, Art and Society in Renaissance Italy.* Oxford: Oxford University Press, 1987.

____, et al., *Giovanni Rucellai ed il suo zibaldone, II: A Florentine Patrician and his Palace.* London: Warburg Institute, University of London, 1981.

Kidwell, C., *Pontano: Poet and Prime Minister.* London: Duckworth, 1991.

Killerby, C.K., *Sumptuary Law in Italy: 1200–1500.* Oxford: Clarendon Press, 2002.

____, 'Practical Problems in the enforcement of Italian Sumptuary Law 1200–1500,' in Dean, T., and Lowe, K.J.P. eds, *Crime, Society and the Law in Renaissance Italy.* Cambridge: Cambridge University Press (1994): pp. 99–120

King, M.L, 'Caldiera and the Barbaros on marriage and the family: humanist reflections of Venetian realities', *Journal of Medieval and Renaissance Studies*, 6 (1976): pp. 19–50.

____, 'Personal, Domestic and Republican Values in the Moral Philosophy of Giovanni Caldiera', *Renaissance Quarterly*, 28 (1975): pp. 535–74.

Kirschner, J. and Molho, A., 'A Dowry Fund and the Marriage Market in Early Quattrocento Florence', *Journal of Modern History*, 50 (1978): pp. 403–38.

Klapisch-Zuber, C., 'Les coffres de marriage et les plateaux d'accouchées à Florence: archive, ethnologie, iconographie', in Deswarte-Rosa, S. ed., *A travers l'image: lecture, iconographie et sens de l'oeuvre.* Paris: Klincksieck (1994): pp. 309–23.

____, *Women, Family, and Ritual in Renaissance Italy.* Chicago: University of Chicago Press, 1985.

____, and Herlihy, D., *Tuscans and their Families: A Study of the Florentine Catasto of 1427.* New Haven: Yale University Press, 1985.

Kohl, B.G. and Witt, R.G., *The Earthly Republic.* Philadelphia: University of Pennsylvania Press, 1978.

Krautheimer, R., 'Alberti and Vitruvius,' in *Studies in Western Art: Acts of the Twentieth International Congress of the History of Art, II: The Renaissance and Mannerism.* Princeton, N.J.: Princeton University Press (1963): pp. 42–52.

Kraye, J., 'The printing history of Aristotle in the fifteenth century: A bibliographical approach to Renaissance philosophy', *Renaissance Studies*, 9 (1995): pp. 189–211.

Krinsky, C.H., 'A View of the Palazzo Medici and the Church of San Lorenzo', *Journal of the Society of Architectural Historians*, 28 (1969): pp. 133–5.

____, 'Seventy-Eight Vitruvius Manuscripts', *Journal of the Warburg and Courtauld Institutes*, 30 (1967): pp. 36–70.

Kuehn, T., *Emancipation in Late Medieval Florence.* New Brunswick: Rutgers Unversity Press, 1984.

Kwastek, K., *Camera: Gemalter und vealer Raum der italienischen Frührenaissance.* Weimar: VDG, Verlag und Datenbank für Giesteswissenschaften, 2001.

Lavin, M.A., 'On the Sources and Meaning of the Portrait Bust', *Art Quarterly*, 33 (1970): pp. 207–26.

Liefkes, R., *Glass.* London: Victoria and Albert Museum, 1997.

Lewis, C.T., and Short, C., *A Latin Dictionary founded on Andrew's edition of Freund's Latin Dictionary, revised, enlarged and in great part rewritten.* Oxford: Clarendon Press, 1945.

Liebenwein, W., *Lo Studiolo: Die Entstehung eines Raumtyps und seine Entwicklung bis um 1600.* Berlin: Gebr. Mann, 1977.

Lillie, A., 'The Palazzo Strozzi and Private Patronage in Fifteenth Century Florence', in Millon, H.A., ed., *The Renaissance from Brunelleschi to Michelangelo: The representation of architecture.* London (1994): pp. 519–20

———, *Florentine Villas in the Fifteenth Century: A Study of the Strozzi and Sassetti Country Properties.* PhD Thesis, Courtauld Institute, University of London, 1986

Lindow, J.R., 'Splendour', in Ajmar-Wollheim, M. and Dennis, F., eds, *At Home in Renaissance Italy.* London: Victoria and Albert Museum (2006): pp. 306–7.

———, 'For use and display: selected furnishings and domestic goods in fifteenth-century Florentine interiors', in Olson, R.J.M., Reilly, P.J. and Shepherd, R., eds, *The Biography of the Object in Late Medieval and Renaissance Italy.* London: Blackwell Publishing (2006): pp. 54–66.

———, 'For use and display: selected furnishings and domestic goods in fifteenth-century Florentine interiors', *Renaissance Studies* Special Issue, 19 Issue 5 (2005): pp. 634–646.

———, *Magnificence and Splendour: The Palace in Renaissance Florence.* PhD Thesis, The Royal College of Art, 2004.

Lisci, L.G., *The Palazzi of Florence. Their History and Art,* trans. Grillo, J. II vols. Florence: Giunti Barbèra, 1985.

———, *I Palazzi di Firenze.* II vols. Florence: Giunti Barbèra, 1972.

Litta, P., *Famiglie celebri Italiane.* Milan: Typografia del Giusti, 1819–94.

Lowe, K.J.P., ed., *Cultural Links between Portugal and Italy in the Renaissance.* Oxford: Oxford University Press, 2000.

Lydecker, J.K., 'Il patrizio fiorentino e la committenza artistica per la casa', in *I ceti dirigenti nella Toscana del quattrocento: atti del V e VI Convegno, Firenze 10–11 decembre 1982; 2–3 decembre 1983.* Monte Oriolo: Papafava (1987): pp. 211–21.

———, *The domestic setting of the arts in Renaissance Florence.* PhD Thesis, The Johns Hopkins University Press, 1987.

Lyttle, G.F. and Orgel, S., eds, *Patronage in the Renaissance.* Princeton, N.J.: Princeton University Press, 1981.

Mack, C.R., 'Building a Florentine Palace: The Palazzo Spinelli', *Mitteilungen des Kunsthistorisches Institutes in Florenz*, 27 (1983): pp. 261–84.

———, 'The Rucellai Palace: Some New Proposals', *Art Bulletin*, 56 (1974): pp. 517–29.

Mack, R.E., *Bazaar to Piazza: Islamic Trade and Italian Art, 1300–1600.* California: University of California Press, 2002.

Maczak, A., 'Renaissance travellers' power of measuring', in Céard, J. and Margolin, J-C., eds, *Voyager à la Renaissance: actes du colloque de Tours, 30 juin-13 juillet 1983.* Paris: Maisonneuve et Larose (1987): pp. 245–56.

Mallett, M. and Mann, N., eds, *Lorenzo the Magnificent: Culture and Politics.* London: Warburg Institute, 1996.

Mare, A.C. de la, 'The library of Francesco Sassetti (1421–90)', in Clough, C.H., ed., *Cultural Aspects of the Italian Renaissance: Essays in Honour of Paul Oskar Kristeller.* Manchester: Manchester University Press (1976): pp. 160–201.

———, 'The shop of a Florentine "Cartolaio" in 1426', in Biagiarelli, B.M. and Rhodes, D.E., eds, *Studi offerti a Roberto Ridolfi direttore de 'La Bibliofilia'.* Florence (1973): pp. 237–48.

———, *Vespasiano da Bisticci, Historian and Bookseller.* PhD Thesis, Warburg Institute, University of London, 1965.

Martin, J. and Romano, D., eds, *Venice Reconsidered: The History and Civilization of an Italian City-State, 1297–1797.* Baltimore and London: Johns Hopkins University Press, 2000.

Martines, L., *Power and Imagination: City-States in Renaissance Italy.* London: Allen Lane, 1980.

———, *The Social World of the Florentine Humanists, 1390–1460.* London: Routledge and Kegan Paul, 1963.

Martini, G.S., 'La bottega di un cartolaio fiorentino della seconda metà del quattrocento: Nuovi contributi biografici intorno a Gherardo e Monte di Giovanni', *La Bibliofilia: Supplemento* (1956): pp. 6–82.

Matteini, A.T., 'La decorazione festiva e l'intinerario di 'rifondazione' della città negli triofali a Firenze tra XV e XVI secolo', *Mitteilungen des Kunsthistorisches Institutes in Florenz,* 34 (1990): pp. 165–98.

———, 'La decorazione festiva e l'itinerario di 'rifondazione' della città negli triofali a Firenze tra XV e XVI secolo', *Mitteilungen des Kunsthistorisches Institutes in Florenz,* 32 (1988): pp. 323–52.

Matthew, L.C., 'Vendecolori a Venezia: the reconstruction of a profession', *Burlington Magazine,* 144 (2002): pp. 680–6.

Mattox, P., *The Domestic Chapel in Florence 1440–1550.* PhD Thesis, Yale University, 1996.

McClure, G., 'The Art of Mourning: Autobiographical Writings on the Loss of a Son in Italian Renaissance Thought, 1400–1461', *Renaissance Quarterly,* 39 (1986): pp. 440–75.

McCray, W.P., *Glassmaking in Renaissance Venice: The Fragile Craft.* Aldershot: Ashgate, 1999.

Millon, H.A. and Lampugnani, V., eds, *The Renaissance from Brunelleschi to Michelangelo: The Representation of Architecture.* London: Thames and Hudson, 1994.

Mitchell, B., *The Majesty of the State: Triumphal progresses of the foreign sovereigns in Renaissance Italy, 1494–1600.* Florence: L.S. Olschki, 1986.

———, *Italian Civic Pageantry in the High Renaissance. A descriptive bibliography of Triumphal Entries and selected other Festivals for State occasions.* Florence: L.S. Olschki, 1979.

Molho, A., *Marriage and Alliance in Late Medieval Florence.* Cambridge, Mass.: Harvard University Press, 1994.

———, 'Visions of the Florentine Family in the Renaissance', *Journal of Modern History,* 50 (1978): pp. 304–11.

Monnas, L., 'The Artists and the Weavers: The design of woven silks in Italy 1350–1550', *Apollo,* 125 (1987): pp. 416–24.

Moradini, F., 'Statuti e Ordinamenti dell'Ufficio dei Pupilli et Adulti nel periodo della Repubblica fiorentina (1388–1534)', Part I: *Archivio storico Italiano,* 113 (1955): pp. 522–551; Part II: *Archivio storico Italiano,* 114 (1956): pp. 92–117; Part III: *Archivio storico Italiano,* 115 (1957): pp. 86–104.

Muir, E., 'The Virgin on the Street Corner: The Place of the Sacred in Italian Cities', in Ozment, S., ed., *Religion and Culture in the Renaissance and Reformation*. Kirksville, Mo: Sixteenth Century Journal Publishers (1989): pp. 25–42.

Musacchio, J.M., *The Art and Ritual of Childbirth in Renaissance Italy*. New Haven: Yale University Press, 1999.

____, 'The Medici-Tornabuoni Desco da Parto in Context', *Metropolitan Museum of Art Journal*, 33 (1998): pp. 137–51.

Neuschel, K.B., 'Noble Households in the Sixteenth Century: Material Settings and Human Communities,' *French Historical Studies*, 15 (1988): pp. 595–622.

Nevola, F.J.D., '"Per Ornato Della Città": Siena's Strada Romana and Fifteenth Century Urban Renewal', *The Art Bulletin*, 132 (2000): pp. 26–50.

____, *Urbanism in Siena (c. 1450–1512): Policy and Patrons: Interactions between Public and Private*. PhD Thesis, Courtauld Institute, University of London, 1998.

Newbery, T.J., Bisacca, J. and Kanter, L.B. eds, *Italian Renaissance Frames*. Exh. cat., New York: Metropolitan Museum of Art, 1990.

Newett, M.M., 'The Sumptuary Laws of Venice in the Fourteenth and Fifteenth Centuries,' in Tout, T. and Tait, J., eds, *Historical Essays by Members of the Owens College*. Manchester: Manchester University Press, 1907.

Newton, S.M., *The Dress of the Venetians, 1495–1525*. Aldershot: Ashgate, 1988.

Noakes, S., 'The Development of the Book Market in Late Quattrocento Italy: Printers' Failures and the Role of the Middleman,' *Journal of Medieval and Renaissance Studies*, 11 (1981): pp. 23–55.

Norman, A., *The Wallace Collection Catalogue of Ceramics*. Vol. I. London: The Wallace Collection, 1976.

North, M. and Ormond, D., *Art Markets in Europe, 1400–1800*. Aldershot: Ashgate, 1998.

Olson, R.J.M., *The Florentine Tondo*. Oxford: Oxford University Press, 2000.

____, 'Lost and Partially Found: The Tondo, a Significant Florentine Art Form in Documents of the Renaissance', *Artibus et Historiae*, 27 (1993): pp. 31–67.

____, 'Gross expenditure: Botticelli's Nastagio degli Onesti panels', *Art History*, 15 (1992): pp. 146–70.

Onians, J., *Bearers of Meaning: The Classical Orders in Antiquity, the Middle Ages, and the Renaissance*. Princeton, N.J.: Princeton University Press, 1988.

____, 'L.B. Alberti and Φιλαϱετη', *Journal of the Warburg and Courtauld Institutes*, 34 (1971): pp. 96–114.

Origo, I., *The World of San Bernardino*. London: Jonathan Cape, 1963.

____, *The Merchant of Prato*. London: Jonathan Cape, 1960.

Orlandi, G.L., *Il palazzo dei Sassetti: banchieri fiorentini*. Florence: Vallecchi Editore, 1990.

Pandiani, E., *Vita Private Genovese nel Rinascimento*. Genoa: Atti della società ligure di storia patria , 1915.

Panizza, L., ed., *Women in Italian Renaissance Culture and Society*. Oxford: University of Oxford, 2000.

Paoletti, J.T., 'The Banco Medico in Milan: urban politics and family power', *Journal of Medieval and Renaissance Studies*, 22 (1994): pp. 199–238.

Paolini, C., *Il mobile del Rinascimento: La collezione Herbert Percy Horne*. Florence: Edizioni della Meridiana, 2002.

Park, K., *Doctors and Medicine in early Renaissance Florence*. Princeton, N.J.: Princeton University Press, 1985.

____, 'The readers at the Florentine Studio according to Communal Fiscal Records 1357–1380 and 1413–46', *Rinascimento*, 20 (1980): pp. 249–310.

Passerini, L., *Genealogia e storia della famiglia Panciatichi.* Florence: Galileiane, 1858.

Pellecchia, L., 'Architects read Vitruvius: Renaissance interpretations of the Atrium of the Ancient House', *Journal of the Society of Architectural Historians*, 51 (1992): pp. 377–416.

——, 'The Patron's Role in the Production of Architecture: Bartolomeo Scala and the Scala Palace', *Renaissance Quarterly*, 42 (1989): pp. 258–291.

Pennell, S., 'Consumption and Consumerism in early Modern England', *The Historical Journal*, 42, (1999): pp. 549–64.

Phillips, M., *The Memoir of Marco Parenti: A life in Medici Florence.* Toronto: Broadview Press, 2000.

——, 'A Newly Discovered Chronicle by Marco Parenti', *Renaissance Quarterly*, 31 (1978): pp. 153–160.

Pincus, D., ed., *Small Bronzes in the Renaissance.* New Haven: Yale University Press, 2002.

Preyer, B., 'Florentine Palaces and Memories of the Past', in Ciappelli, G. and Rubin, P.L., eds, *Art, Memory and Family in Renaissance Florence.* Cambridge (2000): pp. 176–194.

——, 'Planning for Visitors at Florentine Palaces', *Renaissance Studies*, 12 (1998): pp. 357–74.

——, 'L'architettura del palazzo mediceo,' in *Il palazzo Medici Riccardi di Firenze*, Cherubini, G., and Fanelli, G., eds, Florence: Giunti (1990): pp. 58–75.

——, 'The "chasa overo palagio" of Alberto di Zanobi: A Florentine Palace of about 1400 and its Later Remodeling', *Art Bulletin*, 65 (1983): pp. 387–401.

——, 'The Rucellai Palace', in F.W. Kent, et al., *Giovanni Rucellai ed il suo Zibaldone: A Florentine Patrician and his Palace.* Vol. II. London (1981): pp. 155–207.

——, 'The Rucellai Loggia', *Mitteilungen des Kunsthistorisches Institutes in Florenz*, 21 (1977): pp. 183–98.

——, and Darr, A.P., 'Donatello, Desiderio da Settignano and his brothers, and Macigno sculpture for a Boni Palace in Florence', *The Burlington Magazine*, 141 (1999): pp. 720–31.

Rainey, R., 'Dressing down the dressed–up: Reproving feminine attire in Renaissance Florence', in Monfasani, J. and Musto, R.G., eds, *Renaissance Society and Culture: Essays in Honour of E.F. Rice Jr.* New York: Italica Press (1991): pp. 217–39.

——, *Sumptuary Legislation in Renaissance Florence.* PhD Thesis, Columbia University, 1985.

Reynolds, L.D. and Wilson, N.G., eds, *Scribes and Scholars: A Guide to the Transmission of Greek and Latin Literature.* Oxford: Clarendon Press, 1974.

Richards, G.R.B., ed., *Florentine Merchants in the Age of the Medici. Letters and Documents from the Selfridge Collection of Medici Manuscripts.* Cambridge, Mass.: Harvard University Press, 1932.

Richardson, B., *Printing, Writers and Readers in Renaissance Italy.* Cambridge: Cambridge University Press, 1999.

——, *Print Culture in Renaissance Italy: The Editor and the 'Vernacular' Text.* Cambridge: Cambridge University Press, 1994.

Rochon, A., *La Jeunesse de Laurent de Médicis (1449–1478).* Paris: Société d'édition 'Les Belles Lettres', 1963.

Rogers, M., ed., *Fashioning Identities in Renaissance Art.* Aldershot: Ashgate, 2000.

Roover, E. de, 'Andrea Banchi, Florentine Silk Manufacturer and Merchant of the Fifteenth Century', *Studies in Medieval and Renaissance History*, 3 (1966): pp. 223–85.

Roover, R. de, *San Bernardino of Siena and Sant'Antonino of Florence: The two great economic thinkers of the Middle Ages.* Boston, Mass.: Baker Library, Harvard Graduate School of Business Administration, 1967.

_____, *The Rise and Decline of the Medici Bank*. Cambridge, Mass.: Harvard University Press, 1963.

_____, 'A Florentine firm of cloth manufacturers: Management and organization of a sixteenth century business', *Speculum*, 16 (1941): pp. 3–32.

Roscoe, W., *The Life of Lorenzo de' Medici called the Magnificent*. Liverpool: J. M'Creey, 1795.

Rosenberg, C.M., 'Courtly decorations and the decorum of interior space', in *La corte e lo spazio: Ferrara estense*, ed. Papagno, G. and Quondam, A., Rome: Bulzoni (1982): pp. 529–44.

Rosenthal, J.T., *The Purchase of Paradise: Gift-Giving and the Aristocracy, 1307–1485*. London: Routledge and Kegan Paul, 1972.

Ross, J., *Lives of the Early Medici as Told in Their Correspondence*. London: Chatto and Windus, 1910.

Rouse, M.A. and Rouse, R.H., *Cartolai, Illuminators and Printers in Fifteenth-Century Italy: The Evidence of the Ripoli Press*. Los Angeles: University of California, 1988.

Rubin, P.L., 'Domenico Ghirlandaio and the Meaning of History in Fifteenth Century Florence', in Prinz, W. and Seidel, M., eds, *Domenico Ghirlandaio 1449–1494. Art del Convegno Internazionale, Firenze 16–18 Ottobre 1994*. Florence: Centro Di, 1996.

_____, 'Magnificence and the Medici', in Ames-Lewis, F., ed., *The Early Medici and their Artists*. London: Birkbeck College, University of London (1995): pp. 37–49.

_____, 'Vasari, Lorenzo and the Myth of Magnificence', in Garfagnini, E., ed., *Lorenzo il Magnifico e il suo mondo*. Florence: L.S. Olschki (1994): pp. 178–88.

_____, '"What men saw": Vasari's Life of Leonardo da Vinci and the Image of the Renaissance Artist', *Art History*, 13 (1990): pp. 33–45.

_____, and Wright, A., *Renaissance Florence: The art of the 1470s*. London: National Gallery Publications, 1999.

Rubinstein, N., *The Palazzo Vecchio, 1298–1532*. Oxford: Clarendon Press, 1995.

_____, *The Government of Florence under the Medici (1434–94)*. Oxford: Clarendon Press, 1966.

_____, 'The Storie Fiorentine and the Memorie di Famiglia by Francesco Guicciardini', *Rinascimento*, 4 (1953): pp. 171–225.

Saalman, H., 'Tommaso Spinelli, Michelozzo, Manetti, and Rosselino', *Journal of the Society of Architectural Historians*, 2 (1965): pp. 151–64.

_____, 'The Authorship of the Pazzi Palace', *Art Bulletin*, 46 (1964): pp. 388–94.

_____, and Mattox, P., 'The First Medici Palace', *Journal of the Society of Architectural Historians*, 44 (1985): pp. 329–45.

Schiaparelli, A., *La casa fiorentina ed i suoi arredi nei secoli XIV e XV*. Florence: Sansoni, 1908.

Schofield, R., 'Ludovico il Moro and Vigevano', *Arte Lombarda*, 62 (1982): pp. 93–140.

Schubring, P., *Cassoni, Truhen und Truhenbilder der Italienischen Frühenrenaissance: ein Beitrag zur Profanmalerei im Quattrocento*, II vols. Leipzig: Karl W. Hiersemann, 1923.

Shearman, J., 'The Collections of the Younger Branch of the Medici', *Burlington Magazine*, 117 (1975): pp. 12–27.

Shepherd, R., 'Giovanni Sabadino degli Arienti and a practical definition of magnificence in the context of Renaissance architecture', in Ames-Lewis, F. and Rogers, M., eds, *Concepts of Beauty in Renaissance Art*. Aldershot (1998): pp. 52–65.

_____, *An examination of Giovanni Sabadino degli Arienti's writings on art and architecture*. PhD Thesis, Courtauld Institute, 1997.

_____, 'Francesca Venusta, the "Battle of San Ruffillo" and Giovanni Sabadino degli Arienti', *Renaissance Studies*, 10 (1996): pp. 156–70.

_____, 'Giovanni Sabadino degli Arienti, Ercole I d'Este and the decoration of the Italian Renaissance court', *Renaissance Studies*, 9 (1995): pp. 19–57.

_____, and Neher, G., eds, *Revaluing Renaissance Art*. Aldershot: Ashgate, 2000.

Sicca, C.M., 'Consumption and trade of art between Italy and England in the first half of the sixteenth century: the London house of the Bardi and Cavalcanti', *Renaissance Studies*, 16 (2002): pp. 163–201.

Smith, C., *Architecture in the Culture of Early Humanism: Ethics, Aesthetics, and Eloquence 1400–1470*. Oxford: Oxford University Press, 1992.

Soudek, J., 'A Fifteenth Century Humanist Bestseller: The Manuscript Diffusion of Leonardo Bruni's Annotated Version of the pseudo-Aristotelian Economics', in Mahoney, E.P., ed., *Philosophy and Humanism: Renaissance Essays in Honour of Paul Oskar Kristeller*, Leiden: E.J. Brill (1976): pp. 129–43.

Spallanzani, M., 'Metalli islamici nelle collezioni medicee dei secoli XV–XVI', in Adelson, C., et al., *Le arti del principato mediceo*. Florence: S.P.E.S (1980): pp. 95–115.

_____, 'The Courtyard of Palazzo Tournabuoni-Ridolfi and Zanobi Lastricati's bronze Mercury', *The Journal of the Walters Art Gallery*, 37 (1979): pp. 6–21.

_____, *Ceramiche Orientali a Firenze nel Rinascimento*. Florence: Cassa di Risparmio, 1978.

_____, 'Il vaso Medici-Orsini di Detroit in un documento d'archivio', *Faenza*, 60 (1974): pp. 88–90.

Summers, D, *Michelangelo and the Language of Art*. Princeton, N.J.: Princeton University Press, 1981

Syson, L. and Thornton, D., *Objects of Virtue: Art in Renaissance Italy*. London: British Museum, 2001.

Tateo, F., 'Le virtù sociali e l'immanità nella trattistica Pontaniana', *Rinascimento*, 5 (1965): pp. 119–154.

Thomas, A., *The Painter's Practice in Renaissance Tuscany*. Cambridge: Cambridge University Press, 1995.

Thomson, D., *Renaissance Architecture: Patrons, Critics and Luxury*. Manchester: Manchester University Press, 1993.

Thornton, D., 'The Status and Display of Small Bronzes in the Italian Renaissance Interior', *The Sculpture Journal*, 5 (2001): pp. 33–41.

_____, *The Scholar in His Study: Ownership and Experience in Renaissance Italy*. New Haven: Yale University Press, 1997.

Thornton, P., *The Italian Renaissance Interior 1400–1600*. London: Weidenfeld and Nicolson, 1991.

_____, 'Cassoni, forzieri, goffani e cassette. Terminology and its problems', *Apollo*, 120 (1984): pp. 246–51.

Trexler, R., *Public Life in Renaissance Florence*. New York: Academic Press, 1980.

Trionfi Honorati, M., 'A proposito del lettuccio', *Antichità Viva*, 20 No.3 (1981): pp. 39–47.

_____, 'Il Palazzo degli Antinori', *Antichità Viva*, 7 (1968): pp. 65–80.

Tuohy, T., *Herculean Ferrara, Ercole d'Este 1471–1505, and the invention of a ducal capital*. Cambridge: Cambridge University Press, 1996.

Ullman, B.L., *The humanism of Coluccio Salutati*. Padua: Antenore, 1963.

Verde, A.F, 'Libri tra le pareti domestiche', Memorie Domenicane, ns. 18 (1987): pp. 1–225.

_____, 'Inventario e divisione dei beni di Pierfilippo Pandolfini', *Rinascimento*, 9 (1969): pp. 307–24.

Vidas, M., *Representation and Marriage: Art, Society and Gender Relations in Florence from the Late Fourteenth through the Fifteenth Century*. PhD Thesis, New York University, 1997.

Volpi, G., ed., *Ricordi di Firenze dell'anno 1459 di autore anonimo*. Città di Castello: Rerum Italicarum Scriptores, 1907.

Wackernagel, M., *The World of the Florentine Renaissance Artist: Projects and Patrons, Workshop and Art Market*, trans. Luch, A., Princeton, N.J.: Princeton University Press, 1981.

Watson, P., 'A descho da parto by Bartolomeo di Fruosino', *Art Bulletin*, 56 (1974): pp. 4–9.

Weatherill, L., *Consumer behaviour and material culture in Britain 1660–1760*. London: Routledge, 1988.

Welch, E., 'Public Magnificence and Private Display: Giovanni Pontano's "De Splendore" (1498) and the Domestic Arts', *Journal of Design History*, 15 (2002): pp. 211–29.

____, *Art and Society in Italy 1350–1500*. Oxford: Oxford University Press, 1997.

Whitehouse, D., 'Glass in the Epigrams of Martial', *Journal of Glass Studies*, 41 (1999): pp. 73–82.

Williams, R., *Art, Theory and Culture in Sixteenth Century Italy: From techne to metatechne*. Cambridge: Cambridge University Press, 1997.

Wilson, T., 'Pollaiuolo's lost "Hercules and the Lion" recorded on Maiolica?', *Journal of the Warburg and Courtauld Institutes*, 53 (1990): pp. 299–301.

____, 'Maiolica in Renaissance Venice', *Apollo*, 123 (1987): pp. 184–9.

Winter, P.M. de, 'A little known creation of Renaissance decorative arts: the white lead pastiglia box', *Saggi e Memorie di Storia dell'Arte*, 14 (1984): pp. 9–42.

Witt, R.G., *In the footsteps of the ancients: the origins of humanism from Lovato to Bruni*. Leiden: Brill, 2000.

____, *Hercules at the crossroads: the life, works, and thought of Coluccio Salutati*. Durham, N.C: Duke University Press, 1983.

Witthoft, B., 'Marriage Rituals and Marriage Chests in Quattrocento Florence', *Artibus et Historiae*, 5 (1982): pp. 43–59.

Wohl, H., *The Aesthetics of Italian Renaissance Art: A Reconsideration of Style*. Cambridge: Cambridge University Press, 1999.

Wright, A., 'Antonio Pollaiuolo, "maestro di disegno"', in E. Cropper ed., *Florentine Drawing at the Time of Lorenzo the Magnificent*, Villa Spelman Colloquia, vol.4. Bologna: Nuova Alfa Editoriale (1994): pp. 131–46.

____, and Marchand, E., eds, *With and Without the Medici – Studies in Tuscan Art and Patronage, 1434–1530*. Aldershot: Ashgate, 1998.

Index

Note: Page references in *italics* relate to illustrations